Writing in Space, 1973–2019

Edited and with an Introduction by **Aruna D'Souza**

Lorraine O'Grady **Writing in Space, 1973–2019**

DUKE UNIVERSITY PRESS DURHAM AND LONDON 2020

Library of Congress Cataloging-in-Publication Data
Names: O'Grady, Lorraine, author. | D'Souza, Aruna, editor.
Title: Writing in space, 1973–2019 / Lorraine O'Grady ; edited and with
an Introduction by Aruna D'Souza.
Description: Durham : Duke University Press, 2020. | Includes index.
Identifiers: LCCN 2020008119 (print)
LCCN 2020008120 (ebook)
ISBN 9781478010074 (hardcover)
ISBN 9781478011132 (paperback)
ISBN 9781478012658 (ebook)
Subjects: LCSH: O'Grady, Lorraine. | Conceptual art. | Words in art.
Classification: LCC N6537.O315 A35 2020 (print) | LCC N6537.O315
(ebook) | DDC 700—dc23
LC record available at https://lccn.loc.gov/2020008119
LC ebook record available at https://lccn.loc.gov/2020008120

Contents

3 Reclaiming Black Female Subjectivity

4 Hybridity, Diaspora, and Thinking Both/And

Illustrations

Acknowledgments

LORRAINE O'GRADY and I first met via email in late spring 2018, when I was trying to convince her to join me on a panel discussion at the Brooklyn Museum. In the long, delicate negotiations—Lorraine does nothing by half measures, so every invitation requires careful consideration—she sent me photos of members of her Jamaican family who shared my last name. I was struck by the significance of this connection—one that was both banal (my last name is a very common one among South Asians, as Lorraine must have known) and weighted (what were the historical contingencies that led to Lorraine's relatives ending up in Jamaica since the nineteenth century, while my parents ended up in Canada in the 1960s; how could her relatives be black while mine were brown?). She agreed to take part in the panel, and ever since then we have continued our conversations about diaspora, hybridity, and the way that art and writing can reveal, make strange, and heighten the contradictions inherent in whiteness.

I would like to thank Lorraine, first and foremost, for entrusting me with this project. Jarrett Earnest, the person who originally conceived the endeavor and got it off the ground, gave us a great foundation to build on. Members of Lorraine's studio team, especially Laura Lappi, were of great assistance in gathering images and information. Friends and colleagues, including Rebecca Solnit, Nancy Locke, and Christopher Campbell, also offered particular help in securing images and permissions. Catherine Morris,

with whom I am cocurating a retrospective exhibition of Lorraine's work at the Brooklyn Museum of Art (*Lorraine O'Grady: Both/And*), and her colleagues Allie Rickard, Chelsea Adewunmi, and Jenée-Daria Strand have been constant presences as I thought about an artist whose words have always been as important as her images. Robert Ransick, Anjuli Fatima Raza-Kolb, Aaron Gemmill, and Paul Chan have provided useful editorial feedback, and Bryan Siegel and Priya D'Souza have offered sage advice and loving support throughout the process. Finally, Ken Wissoker and his team at Duke University Press, including Nina Foster, Amy Ruth Buchanan, Liz Smith, and Joshua Gutterman Tranen, have shared their enthusiasm and expertise from the start.

<div align="right">

—Aruna D'Souza

</div>

A BOOK AS ECLECTIC AS THIS could not have been conceived, let alone brought to coherency, without a variety of contributions and support. I am grateful, first, to those editors and publishers who thoughtfully and sometimes stubbornly guided so many of the articles here into print earlier. Their success formed the bedrock of the current collection and made it possible to move forward, adding unpublished items that had not yet received focused attention. One such editor to whom I owe a special debt is the superbly talented Jarrett Earnest, who in 2016, after exercising the laser-like prep work needed to convert our conversation into a cover article for the *Brooklyn Rail*, turned still more intensely to my art and writing as a whole. He saw the possibility of a book of collected writings before I did, and his enthusiasm shaped my belief. The proposal Jarrett crafted received a positive expression of interest within days from Duke University Press, the first publisher to whom we'd submitted it.

But I've leaped ahead of myself here. This is a book about becoming an artist and about making art. I will soon be eighty-five, and my career as a visual artist goes back more than forty years, to 1977, when I made *Cutting Out the New York Times (CONYT)*. The earliest debts I incurred in the art world were to curators. The first was in 1980 to Linda Goode Bryant, founder-director of Just Above Midtown gallery, who could easily have pulled away from me and *Mlle Bourgeoise Noire*, given the subject matter, but instead embraced me and her and helped us go further. Linda provided an indelible example of how a commitment to experimentation in art could expand the mind (and the world). In the early 1990s, two important solo exhibits—curated by Judith Wilson at the INTAR Gallery in Manhattan's Theater District, and by

Andrea Miller-Keller and her then assistant curator, James Rondeau, at the Wadsworth Atheneum in Hartford—allowed me, at a time when few opportunities were available, to initiate my turn to the wall by creating a new series (*Photomontages*, later known as *Body Is the Ground of My Experience*, at INTAR) as well as to elaborate my concept of the "Both/And" by connecting seemingly disparate bodies of work (*Mlle Bourgeoise Noire* and *Miscegenated Family Album* in the Matrix Gallery of the Atheneum).

The contemporary phase of my career, which began in roughly 2008, was jump-started in 2006–7 by three unlikely curatorial events. In 2006, the young artist Nick Mauss remembered having seen a diptych from *Miscegenated Family Album* (MFA) and took it and four other pieces from MFA for a show he was curating for Daniel Reich at the Chelsea Hotel. He fell in love with *Cutting Out the New York Times* and took five multipanel poems from CONYT as well. The show was reviewed in the *New York Times*, and my work received special mention. The same year, James Rondeau, now curator of contemporary art at the Art Institute of Chicago, made the first museum purchase of the full sixteen-diptych MFA installation. He also nominated me for a residency at ArtPace San Antonio. In 2007, Connie Butler made *Mlle Bourgeoise Noire* one of the entry-points of her landmark exhibit *WACK! Art and the Feminist Revolution*. It was the first time most people in the contemporary art world could see this vaguely mythic piece in context, the costume together with the photo-document installation. It was a breakout moment for the work. A week after the *WACK!* exhibition opened, I went down to San Antonio to begin the residency James had made possible. There I made my first video piece, an eight-channel wall installation called *Persistent*. Because of perceptive and generous curators like these, I could move confidently into the future.

But it hasn't been just curators. There have been critics, too. In the very opening moments, in a review by Patricia Spears Jones for *Live Performance 5* of "Dialogues"—a two-night live series in October 1980, featuring eight performance artists from alternative downtown spaces at Just Above Midtown, in which I represented JAM with the first performance of *Nefertiti/Devonia Evangeline*—being singled out as having created one of only two successful performances in the series gave me a belief in my future in the art form I had chosen, a belief that never left me. I have been privileged with a slow but steadily increasing quality in the response to my work; the two most recent reviews of my new work *Cutting Out CONYT*, one by Colby Chamberlain in *Artforum* and one by Chase Quinn in *Hyperallergic*, are perhaps best of all. I cannot thank writers like these enough. And throughout, I have had the un-

wavering support of the art critic I respect the most, Holland Cotter of the *New York Times*, to whom I will be eternally grateful.

But art is also an industry, and one must make the work. In 2008 I joined a gallery, Alexander Gray Associates, where I have always been proud to show. In their quiet, steady representation of me, the principals, Alexander Gray and David Cabrera, have made me feel less like part of a business than part of a family. Over the years, three of the gallery's employees, through their intellectual acuity and their emotional connection to my work, have helped me understand more deeply what I am doing and its potential value: Maggie Liu Clinton, Carly Fischer, and Ursula Davila-Villa. In 2008, I also set up a studio. I have been blessed since then with assistants of unparalleled loyalty, talent, work ethic, and patience: Nahna Kim, Stacy Scibelli, and Laura Lappi. They have helped in more ways than I can count.

Before the professionalization and during, though, there were and are two who have helped make my work and life in art possible. Sur Rodney (Sur), my friend of nearly forty years and my studio manager since its first days in 2008: it was Sur who straightened out my taxes and settled my space rental, Sur who assembled and shipped sixty-five boxes of my paper archive to Wellesley College; it is Sur with whom I can discuss every issue before I make a decision in the art world, Sur who knows what I will need before I do. And also Robert Ransick, whom I think of as my second son: Robert was first my student at the School of Visual Arts (SVA) in 1989, then my assistant in 1990 when together we produced the INTAR show. Now he is my executor and one of the trustees of my estate. Robert always has my best interests at heart, and his clairvoyant intelligence has always been there to help me see— what should be done and should not be done for my work and career, how to get from square A to square B. He is never afraid to cast a jaundiced eye when I try to fly too high or to correct me firmly when I don't believe enough.

Although it "took a village" to help me do this book, mostly it has taken Aruna D'Souza. I remember a different meeting than she does. I first met her when she came to a lecture performance I did for Simone Leigh's *Waiting Room* residency at the New Museum. Not only had she come with Robert Ransick, whom she knew from Bennington, she'd also arrived with her editor at the *Wall Street Journal*, Adam Thompson, for whom I once occasionally babysat (I'd introduced his father to his mother). Even before Aruna and I exchanged a word, she felt like family. And then there was her last name. How often I'd fantasized what my life would be like if my mother and father had met in Jamaica instead of Boston, if like my father I had grown up with my DeSouza cousins? When she emailed to invite me for her panel, I knew,

but wanted to be sure. The panel would be on politically sensitive topics, and in the end it was the brilliance of her book *Whitewalling* that convinced me to accept her invitation. And it was the generosity and, above all, the light touch of her remarks that evening that determined me, in turn, to invite her to be my editor. I believed that together we could navigate these shoals. We were so different yet had so much in common. She, raised by South Asian parents in Western Canada, and I, raised by Jamaican parents in New England. I had come of intellectual age via *Third Text* with "political blackness" in Britain, and believed in allyship that understood and respected difference. It's been rocky and it's been clear. Thank you, Aruna, for this fruitful collaboration! And thanks, too, to Ken Wissoker, senior executive editor at Duke University Press, for his unfailing support and warm encouragement of our book.

Thank you most of all to my family who have, somehow, not given up on me despite the weird life I've led: my son Guy and my daughter-in-law Annette, whose thirty-five-year marriage has me in awe; my three incredible and loving granddaughters, Ciara, Kristin, and Devon; and my two astonishing great-grandsons, Kevin Elijah and Royce Marco, who make me want to live another twenty years to see how "my little prodigies" turn out. But you can't have everything!

—Lorraine O'Grady

Introduction For Those Who *Will Know*

ARUNA D'SOUZA

"IF PRESSED TO DESCRIBE WHAT I DO," wrote the artist Lorraine O'Grady in a 1983 statement, "I'd say that I am *writing in space*. I guess that comes from being trained as a writer (I went to the Iowa Writers' Workshop, etc.). But I was never able to accommodate to the linearity of writing. Perhaps I'm too conscious of the stages I've lived through and the multiple personalities I contain. . . . The fact is, except for the lyric poem, writing is the art form most closely bound to time; but to layer information the way I perceived it, I needed the simultaneity I could only obtain in space."[1]

Over the past forty-plus years, whether she was operating in performance, conceptual photography, the moving image, collage, or the written word, text and image have played mutually supporting and endlessly complicating roles in O'Grady's groundbreaking and prescient work: they reinforce and undermine each other, illuminate and complicate, contradict and explain, resolve and explode. This attention to the interaction between the textual and the visual is signaled in the poetry of her earliest artwork, *Cutting Out the New York Times* (1977), in which she clipped out resonant words and phrases from the paper of record to produce a deeply personal found poetry. It is further developed in the verses that her performance alter ego, Mlle Bourgeoise Noire (Miss Black Middle Class), shouted in her guerrilla interventions in the art world, and it can be seen in the literal layering of words and pictures in her studies for the planned photographic installation *Flowers of Evil and Good*. The relation of image to text is often emphasized in the form of the

work itself, in what she describes as the book-like structure of performances like *Nefertiti/Devonia Evangeline* or the "folktale" that was *Rivers, First Draft* or the "novel in space" format of *Miscegenated Family Album*.[2] It is also elaborated in the scripts and image descriptions that she has produced in order to document and preserve her visual and performance work, demonstrating the care with which she approaches language and its translation into form. And it is present, too, in her practice as a writer per se—of criticism, of theory, of analysis, of history—describing, mapping out, and making visible, whether explicitly or implicitly, the contexts for her art, which revolves around issues of black female subjectivity, hybridity and diasporic identities, and colonial and racist histories, as well as the inscription of history on the self, the political possibilities of art, and more.[3] O'Grady's approach of "writing in space" has allowed her to build a theoretical foundation for her practice (to work out what she wants her art to do) and to prepare the ground for its reception (to give viewers of her work the tools to see what she saw).

This volume gathers the vast range of this important artist's written output. It begins, chronologically speaking, in 1973, and continues to the present; the last few years especially have seen a flurry of statements, essays, interviews, and historical recollections as a new generation of curators, critics, and artists discover her work. Also included are a number of interviews and conversations: the artist almost always edits her oral interviews, or conducts interviews via email, and thus considers them part of her writing. While each text has a potency of its own, the accumulation and recurrence of her ideas as one moves through time is equally revealing. In her carefully chosen words, she reprises anecdotes, descriptions, and histories—but always with a subtle change; O'Grady is constantly reframing her own artistic record as the significance of her practice discloses itself to her over the course of time.

The effect is not so much repetitive as iterative and emphatic—illuminating when it comes to both her working method as an artist and her goals as an artist who writes. In the introduction to the script of a lecture-performance she gave in 2013 while standing in front of slides of what she considers one of her most important pieces—an installation of photographs from her one-time-only performance *Rivers, First Draft*—O'Grady drew the audience's attention to the relationship of the words she was reading to the imagery behind her: "The installation being projected here is silent when on the wall or on pages in a catalogue, titles newly added. Imagine my voice now reading a text which bears on it only tangentially. Of course, you may not be able to follow the installation and the spoken text simultaneously. But whether you wander in and out of the installation and the text in alter-

nation, or attend to them sequentially, it's OK. Cognitive dissonance can be overcome when you slow down and repeat."[4] She then repeated the slides while speaking the text a second time.

If O'Grady's texts exist in a ceaseless, unresolvable, endlessly complicating (and endlessly stimulating) conversation with her artwork, they also function as such with each other, which makes putting them together in a single volume a difficult and delicate task. The artist launched her archival website in 2007, anticipating the renewed—and, frankly, criminally belated—attention her work would receive thanks to its inclusion in *WACK! Art and the Feminist Revolution*, a major traveling exhibition curated by Connie Butler.[5] The website is designed to make apparent the multiple, overlapping relationships in time and space between the various aspects of her practice— images and visual documentation, her own texts, and other writers' analysis of her work—and to make available the materials necessary for a future theorization of her art. (O'Grady, then in her seventies, designed the site's information architecture herself.) The layering she sought via the concept of "writing in space" has been translatable in the digital world; it is harder to achieve in the linear, one-page-after-another form of the book. In addition, many of the texts gathered here were originally conceived to be presented alongside imagery, or to describe imagery—whether in the form of performance scripts, or slide lectures, or wall labels for exhibitions. While the volume includes an insert of images created by O'Grady herself—a carefully composed, allusive distillation of her visual output to a few dozen trenchant images—the emphasis in this book is on the writing as writing: it is an opportunity to see O'Grady's practice from another angle. Gathering these texts in such a volume offers its own insights: most strikingly, the opportunity to slow down and savor her language and ideas; the ability to see the development of her thinking over the years; the recurrence and repetition of themes, concepts, and stories; and the sheer *density* of her textual analysis.

O'GRADY BECAME AN ARTIST late in life, at age forty-five, after years of being steeped in language. On graduating from Wellesley College in 1955 with a degree in economics and a minor in Spanish, she took up positions as an intelligence analyst at the Departments of Labor and State in Washington, DC, scanning international publications and internal reports. "After five years of reading ten newspapers a day in different languages, plus mountains of agents' classified reports and unedited transcripts of Cuban radio, language had melted into a gelatinous pool. It had collapsed for me," she has

said.[6] In spite of, or perhaps because of, this collapse, O'Grady moved briefly to Europe to attempt to write a novel; when she discovered she didn't have the tools to do so, she returned to graduate school—the Iowa Writers' Workshop, one of the most prestigious creative writing programs in the United States. She worked as a translator and then ran her own translation agency in Chicago.

She eventually moved to New York City, leaving the translation business to become a rock critic for the *Village Voice* and *Rolling Stone* while exploring the edges of the mainstream art world. One of her early reviews for the *Voice* was a 1973 piece on a joint residency at Max's Kansas City by two acts about to make it big: the Wailers, fronted by Bob Marley, and Bruce Springsteen. Of the latter, O'Grady wrote, in her typically lively and confident prose: "He's the real thing. An authentic talent, with a rushing stream-of-conscious imagery that is banked by a solid rock-and-roll-rhythm-and-blues beat. At times the imagery becomes less of a stream and more of a torrent. It's enough to make a Freudian analyst rub his hands in glee."[7]

But O'Grady's editor at the downtown weekly decided not to publish the piece, saying, "It's too soon for these two."

This might have been the first—it certainly was not the last—instance of a phenomenon that has dogged O'Grady throughout her career. As an artist and a writer, she has always been very conscious of the notion that her ideas have come *too soon*, before others could see the theoretical landscape she was traversing. "The problem is that I'm always saying things that haven't been said before, so it takes a while before they can be heard," she lamented (not without a sense of humor) in 1996.[8] From the beginning of her artistic career, as expressed in her 1983 performance statement, she saw her job as an artist not only to create work but also to create the audience for her work, or, failing that, to find ways to make her work available to an audience that would emerge in the future: "Right now, my goal is to discover and create the true audience, and something tells me that, for a black performance artist of my ilk, this will take a many-sided approach. Because I sense that the true audience may be *coming*, not here now, I try to document my work as carefully as I can." She goes on to explain, via a reading of Heidegger's "The Origin of the Work of Art," something she intuits: "that the work requires an audience who, whether or not they are *like me*, can see what I see."[9]

Back then, she found it "possible to imagine a day when we can stop being unique and simply concentrate on doing our work. A day when, finally, the 'preservers' [a term she borrows from Heidegger to signify "audience"] will no longer be 'coming' but will already be there." Sure enough, more than

forty years later her audience has started to catch up with her, as the wave of interest in her practice over the past decade will attest. Even so, in a recent conversation with the artist Juliana Huxtable, she once again alluded to the ways she is relying on writing to ensure the perpetuation of her ideas and the possibility of a deferred comprehension of her project: "At least the writing gives a ballast, a weight to the visuals so that people do get the sense that maybe they don't understand, and that sense of not understanding allows the work a bit of room to at least—I'm not going to say grow—but at least persist."[10]

O'Grady's belief in the futurity of her audience and the imminence of her work is more than confidence in her own genius—it is also a recognition of the structural conditions facing "black performance artists of [her] ilk."[11] Her 1983 performance statement was made, let's remember, before the mainstream art world finally, later in that decade, turned its attention to David Hammons and Adrian Piper—figures who, like herself, were producing challenging, difficult-to-categorize work that grappled with questions of race in a way that disrupted easy perceptions of what black art could and should do. In 1983, at the beginning of her career in performance, she had few peers, outside the small coterie of performance artists she encountered early on at JAM, including Senga Nengudi and Maren Hassinger. (She did not even discover that Piper was a black—or, as Piper describes her mixed-race identity, "gray"—artist until years after she first encountered the work.) As a consequence, she had a strong sense that the art world she aspired to was only beginning to come into formation. With great optimism and not a little determination, she saw the situation as a temporary one:

> I don't take this as a permanently limiting condition of the work. The problem as I see it is simply that, so far, the context of black art hasn't been broad enough for either whites or blacks to become so familiar with it that they can cross barriers of race or sex to seek themselves—the way anyone can in a Jewish novel, for instance, or even in a Merce Cunningham dance concert. At the moment, individual black performance artists are still exotic oddities. But already this is beginning to change.[12]

O'Grady has always remained keenly aware of how the obligation to explain oneself still weighs more heavily on black artists than on white, and may always be so—because, as she recognizes, the demands for explanation and justification from artists of color, especially women, are part of how white supremacy continues to shape the (art) world and its institutions. In 1994, in a postscript reflecting on her groundbreaking essay "Olympia's

Maid"—presented first on a panel at the College Art Association's annual conference in 1992—she noted, not without frustration, that "whether I will it or not, as a black female artist my work is at the nexus of aggravated psychic and social forces as yet mostly uncharted," which required explaining not only her own view and the implications of her work but also "the multiple tensions between contemporary art and critical theory, subjectivity and culture, modernism and postmodernism, and, especially for a black female, the problematic of psychoanalysis as a leitmotif through all of these."[13] As recently as the eve of this book's publication, O'Grady has written about this almost impossibly onerous obligation, quoting Toni Morrison:

> It's not enough to make the work. First, one may have to answer questions of motivation: Why this? Why now? What are you *doing*? More often, one must find or invent language so the work can be understood, be *seen*, by us as well as them. This can frequently take years. I love the quote by Toni Morrison: "the function, the very serious function of racism . . . is distraction. It keeps you from doing your work. It keeps you explaining over and over again."[14]

THE ROLES OF ARTIST and critic have always been simultaneous for O'Grady. Her education in the art world—with its possibilities and its blind spots, with its shocking segregation—required critical analysis and visual elaboration, and indeed she claimed at one point to want to make "art as an art critic."[15] At the same time, she was writing art criticism *as an artist*. Finding the models for her approach to art criticism was no easier than finding those for her art making, as she revealed in a recent email:

> When I began reading art magazines seriously in the late 70s . . . I was struck by how badly written *Artforum* was. French theory seemed to have come to the art world a decade after it had conquered literature. The effort to "speak French" by "American talkers" had left them tongue-tied. That plus the fact that words often seemed treated more like physical objects than like signifiers tethered to meaning made the essays unintentionally annoying and funny, as in LOL funny. For a while, I didn't know what to read (other than *Third Text*).[16]

A number of her pieces for *Artforum*, to which she contributed regularly till around 1994, attest to the ways in which she refused to separate her criticism from her art, taking every opportunity to reveal the underlying racial

logic of the art world and to map out the terrain in which a black woman steeped in the most challenging literary and critical race theory could find a provisional footing. An article on the Women's Action Coalition ("Dada Meets Mama") discusses her ambivalent relationship with the almost entirely white feminist activist group, which both provided her with opportunities to engage in direct action and revealed to her the limitations of white bourgeois feminism to deal with racial and class difference. In "The Cave," she uses an opportunity presented by the zeitgeist—Hollywood's embrace of black film directors—to ask, "Where are the women?"[17] In her quest to discover the reasons for the occlusion of black women filmmakers, she allows us at once to understand the ways in which these structural conditions are driven by the particular economies, critical landscapes, and biases of the movie industry and to see how these limitations might function in the art world (and in fact many other spheres). A piece on Sean Landers, a much-celebrated bad boy of the New York art scene in the early 1990s, offers what seems to be the first—and, for a long time, only—serious critique of the then-emerging art historical/critical language of "the abject" from a critical, race-focused perspective.[18] Against the scholarly tide, O'Grady saw "the abject" functioning not as a race-neutral means of admitting to the clean spaces of modern art the messy, the impure, and the degraded but, rather, as a rhetorical tool for admitting everything formerly associated with blackness into the art world without actually admitting blackness itself.

In the case of the Sean Landers piece especially, one is struck by O'Grady's prescience, her ability to analyze and assess a discourse *at the moment of its formation*. But equally important is her insistence on speaking, in almost all of her art criticism, of how her own art, by proposing a different set of conceptual terms than that of the mainstream, is an equal and necessary part of that art world. Comparing her own iterative artistic practice to Landers's unwillingness to self-censor or self-contain his adolescent white male voice, she writes: "I find a difference between Landers' logorrhea and the way my own work is driven from medium to medium and from style to style by the compulsion to get it all in. This lack and this over-abundance are dialectically related, and I don't want to choose between them. . . . Even the dullest of us should by now be able to sense that the cultural projects of the West and the non-West are each implicated in a larger history. And if we don't all keep getting it said, how will we find out what that is?"[19] This insistence on keeping in play the two sides of this dialectic—Landers's logorrhea (a privilege of his white masculinity) and her own compulsion to get it all in (an imperative born of her position as a black woman)—rather than privileging one

over the other or erasing the difference between them is, as we will see, one of the most foundational, and radical, aspects of O'Grady's project.

IN THE EARLY 1990S, another theme emerged in O'Grady's writings, one that arose from and fed her larger artistic practice and would go on to solidify her influence on other artists: an exploration of black female subjectivity as both the expression of the most intimate and personal aspects of selfhood *and* a function of larger cultural and historical forces. She articulated the idea in early texts such as "Black Dreams" (1983), a first-person dream journal that made clear that even her unconscious desires and fears were framed and determined by the experience of racism, and in performances like *Nefertiti/Devonia Evangeline*, in which she sought to come to terms with her relationship with her deceased older sister by recourse to ancient Egyptian history, cross-cultural mythology, and psychoanalysis. But it was with "Olympia's Maid"—published first in 1992, and then again with a postscript in 1994—that she homed in on "the need to establish our subjectivity in preface to theorizing our view of the world."[20] Drawing on a breathtaking range of cultural theorists, including Stuart Hall, Edward Said, Homi Bhabha, Paul Gilroy, Gayatri Spivak, Trinh Minh-ha (many of whom were involved in the important postcolonial studies journal *Third Text*), the art historian Judith Wilson, the literary and cultural theorist Hortense Spillers, and others, O'Grady begins with the question of who, exactly, was the black woman who posed as the attendant in Manet's *Olympia*. While a number of white feminists had addressed the question of the model for Olympia herself—attempting to wrest subjectivity for her from the male artist's flattening and objectifying gaze—no one had proposed the same for Laure, the model for her maid.[21]

O'Grady's question pointed to an important historical lacuna that, in years since, has engaged a number of black women artists but—another instance of her too soon-ness, perhaps—is only now, a quarter century later, being addressed by art historians.[22] Whatever its influence on the discipline, however, her goal was not simply an academic one: "Olympia's Maid" marked a turning point for O'Grady, one that acknowledged "the need to establish our subjectivity in preface to theorizing our view of the world." "Critiquing *them*," she wrote, "does not show who *you* are: it cannot turn you from an object into a subject of history."[23]

To establish subjectivity for the black woman at the moment of a sort of stiffening of postmodern theory in the American academy—when analysis was purportedly moving toward the *dismantling* of the subject in favor of

pure discursive construct—was no easy feat. But it was necessary nonetheless: how to countenance throwing out the subject before black people had a chance to occupy such a position? While much postmodern thought had addressed itself to identifying—and even dismantling—foundational oppositions such as male/female, white/black, culture/nature, and mind/body, O'Grady was one of a number of feminist thinkers who saw such deconstructive moves as, paradoxically, *retrenching* the unequal power relations on either side of these binaristic divides. "When Western modernist philosophy's 'universal subject' finally became relativized . . . , rather than face life as merely one of multiple local subjects, it took refuge in denying subjectivity altogether," she observed dryly.[24] By imagining that such oppositions had been overcome in discourse, the primacy of the male-white-culture-mind had been stealthily upheld once again. Even with the challenges posed by deconstruction, O'Grady recognized, the basic Western ontology, in which "somebody always has to win," remains intact.

In the face of this, she cites the theorist Gayatri Spivak as a model for her thinking about the need to retain terms like "nature" and "the body"—terms most often associated with the black subject—in our analysis of subjectivity, despite the charges of "essentialism" that often resulted. Embracing Spivak's "strategic essentialism"[25]—her willingness to admit to an irreducible, non-discursive form of being at the point that femininity, and specifically brown femininity, was at risk of slipping away in theoretical analysis—was, for O'Grady, a means of tackling an urgency: the need to map a self that existed beyond culture, not forever trapped by a racist logic in which the black subject would always be lesser.

> It is no overstatement to say that the greatest barrier I/we face in winning back the questioning subject position is the West's continuing tradition of binary, "either: or" logic, a philosophic system that defines the body in opposition to the mind. Binaristic thought persists even in those contemporary disciplines to which black artists and theoreticians must look for allies. Whatever the theory of the moment, before we have had a chance to speak, we have always already been spoken and our bodies placed at the binary extreme, that is to say, on the "other" side of the colon. Whether the theory is Christianity or modernism, each of which scripts the body as all-nature, *our* bodies will be the most natural. If it is poststructuralism/postmodernism, which through a theoretical sleight of hand gives the illusion of having conquered binaries, by joining the once separated body and mind and then taking this "unified" subject, perversely called

"fragmented," and designating it as all-culture, we can be sure it is *our* subjectivities that will be the most culturally determined.[26]

This critique of Western thought was articulated, in "Olympia's Maid" and over the course of her career, as a political manifesto: a call to the barricades for black artists and other artists of color to reveal the moments in which a more hybrid and philosophically sophisticated notion of "both/and" could replace a Manichean structure that was, at root, the sustaining concept that made antiblackness possible and persistent. Rejecting either/or-ism and embracing both/and-ism was and continues to be, for O'Grady, the most urgent task in the fight against white supremacy.

> If artists and theorists of color were to develop and sustain our critical flexibility, we could cause a permanent interruption in Western "either: or-ism." And we might find our project aided by that same problematic imbrication of theory, whose disjunctive layers could signal the persistence of an unsuspected "both: and-ism," hidden, yet alive at the subterranean levels of the West's constructs. Since we are forced to argue both that the body is more than nature, and *at the same time* to remonstrate that there is knowledge beyond language/culture, why not seize and elaborate the anomaly? In doing so, we might uncover tools of our own with which to dismantle the house of the master.[27]

For O'Grady, an embrace of blackness as a condition of being was central to this endeavor—she refers often to W. E. B. Du Bois's observation of the "double consciousness" required of black people who were compelled by a history of enslavement and forced migration into a diasporic condition that required being able to imagine a self constituted of multiple centers (a here and a there) versus a single locus of subjectivity.[28] To resist the subtle but devastating erasure of black subjectivity enacted by postmodern theory would require an acknowledgment and embrace of the idea that Africans in the diaspora were in fact "the first postmoderns." She elaborated this idea in written form, in pieces like "Olympia's Maid," and in artworks such as *The First and Last of the Modernists*, which compared and contrasted the figures Charles Baudelaire and Michael Jackson, and *Flowers of Evil and Good*, which explored the lives of Baudelaire's mistress Jeanne Duval and O'Grady's own mother, Lena. To reclaim black female subjectivity "not as an object of history, but as a questioning subject" would require rejecting the "either/or" oppositions of emotion and intellect, of public and private, of personal and historical/cultural.

PERHAPS PARADOXICALLY, from very early in her career, O'Grady was convinced that it was not simply her blackness but the particular manifestation of her blackness—her multiracial background, typical of black people outside the African continent to greater or lesser degrees thanks to historical exigencies and colonial violence—that was "a crucible for the lessons that blackness teaches."[29] In fact, O'Grady has long embraced terms like "mulatto" and "miscegenation"—terms that recall legalistic notions of race rooted in America's ongoing history of slavery and its effects—to refer to her own complex heritage. Works like *Landscape (Western Hemisphere)*, a video from 2010, finds a bodily correlate for the long history of displacement and diaspora that has resulted in the uneasy, unstable, wholly ideological but still oppressive concept of blackness in the West. On a large screen in a darkened space, we see the artist's own hair, in extreme close-up, in different lights and at different times of day, ruffled by air currents that seem to change direction. Its texture ranges from silky waves to tightly wound kinks—it is not one thing, but many simultaneously. The accompanying audio suggests this multiplicity is tied to geography, as soundscape of the ocean waves and squawking birds shift from the Caribbean to New England, two of the origins the artist can claim as her own.

For O'Grady, hybridity is not an erasure of difference—the synthesis of black and white into an indistinct "gray," the white liberal's Kumbaya fantasy that as black and white mix further racism will disappear—but, rather, a means to allow both sides of the racialized coin, along with the myriad complexities and correlates that emerge from the opposition, to be recognized simultaneously, outside the inevitable hierarchies imposed by "either/or" thinking. It is, moreover, a fact of—a product of—history. For her, the idea of miscegenation is one to be thought *through*. "My attitude about hybridity," she has said,

> is that it is essential to understanding what is happening here. People's reluctance to acknowledge it is part of the problem. . . . The argument for embracing the other is more realistic than what is usually argued for, which is an idealistic and almost romantic maintenance of difference. But I don't mean interracial sex literally. I'm really advocating for the kind of miscegenated *thinking* that's needed to deal with what we've already created here.[30]

The double—or triple, or endlessly multiplying—consciousness of the mulatto subject has served, in O'Grady's work, to reveal the operations of white supremacy and the productively troubling presence of blackness in a variety

of forms in Western culture, from the writing of ancient Egyptian history, to the birth of modern poetry, to the construction of late twentieth-century celebrity. The intellectual vantage point of the diasporic subject's always-riven experience, and the hybridity that marks her very being, is necessary not just for understanding black subjectivity but in fact, as O'Grady made clear in a 1994 lecture, for survival (of our communities? of our species?); this hybridity is a means of psychological *and civic* equilibrium. Her words seem especially resonant now, twenty-five years later, as we face a global crisis of forced migration due to war, economic injustice, racial and sectarian violence, and climate change:

> It is diaspora peoples' straddling of origin and destination, their internal negotiation between apparently irreconcilable fields that can offer paradigms for survival and growth in the next century. Well, I should say that the caveat is if, and always if, they choose to remember the process of straddling and negotiation and to analyze the resulting differences. A simplistic merging with the host or captor always beckons. But I do think that in a future of cultural crowding, the lessons of diaspora and hybridity can help us move beyond outdated originary tropes, teach us to extend our sensitivities from the inside to the outside, perhaps even help us to maintain a sense of psychological and civic equilibrium.[31]

This conceptual realization has driven O'Grady's work in all of its manifestations. The formal device that O'Grady landed on to tackle this ontological problem was that of the diptych, an arrangement whose doubling set up an irresolvable, endless, mutually inflecting play of signification. In a text from 2018, O'Grady explained,

> For me, the diptych can only be both/and. When you put two things that are related and yet totally dissimilar in a position of equality on the wall, for example, they set up a conversation that is never-ending. It's a totally unresolvable, circular conversation. And I think that that "both/and" lack of resolution—the acceptance and embrace of it, as opposed to the Western "either/or" binary, which is always exclusive and hierarchical—needs to become the cultural goal. The diptych, which is actually anti-dualistic, has served me to make the point against "either one, or the other."[32]

Look closely at O'Grady's work and you will find diptychs everywhere. Take one example: *The Clearing*, part of the artist's project *Body Is the Ground of My Experience* (1991), consists of two photomontaged panels mounted side by side, one showing the ecstasy of sexual union between a black woman

and white man, the other showing the simultaneous violence adhering to such unions by transforming the woman into a cadaver and the man into a tattered knight. Though hardly explicit or prurient, O'Grady has spoken extensively of the ways that the deceptively simple "both/and" form of the work, and its literalization of the implications not only of interracial relationships but of "miscegenated thinking," have troubled viewers even to this day.[33] "With no resolution, you just have to stand there and deal," she once explained to a visitor to her studio.[34] But the diptych operates in more conceptual—even metaphorical—ways as well: in the both/and of anger and joy that marked the performance of *Mlle Bourgeoise Noire*; in the simultaneity of defiance and celebration of her street performance at Harlem's African American Day Parade in 1983, *Art Is . . .* ; in the one-to-one pairing of white and black artists in *The Black and White Show*; in the relationship to her earliest bodies of work (*Cutting Out the New York Times*) and one of her most recent (*Cutting Out CONYT*), and so on.

The word "diptych" itself refers to ancient, hinged writing tablets and to early European altarpieces that could fold like a book, confusing the boundary between image making and writing. This is hardly an accident. In addition to functioning within O'Grady's visual output, and between her various art projects, the concept also allows us to situate O'Grady's writings in relation to her artwork. In a lecture she gave in 1994 to coincide with the first installation of *Miscegenated Family Album* at Wellesley College, she spoke of the way in which her speech could operate as a complicating factor, the other side of a diptych to those photographic pairings that hung on the walls:

> I have tried to examine my practice in words that hopefully cut a crevice between the magic of the installation and my overdetermined creation of it. I wanted to set up a situation where the movement back and forth between the experience of the piece and the process of hearing me talk about it might be disorienting, might create the feeling of anxiously watching your feet as you do an unfamiliar dance. Because it's what happens when you get past that, when you can listen to the music without thinking, that is most of what I mean by hybridism and diaspora.[35]

In the following pages, the reader is invited to take part in the unfamiliar dance that O'Grady offers us by attending to the many textual diptychs contained therein. As with most collections of artists' writings, the individual essays and interviews here are grouped together under various rubrics that speak to the dominant themes in O'Grady's work. "Statements and Performance Transcripts" offers up a series of texts that will stand in

for an art historical overview of the artist's career. "Writing in Space" includes essays and interviews in which O'Grady has articulated her relationship to the means and media she explores, including the written word. "Reclaiming Black Female Subjectivity" comprises texts that clarify the roots and consequences of O'Grady's concern with Eurocentric theory, including mainstream, or white, feminism, dating from her early involvement with the feminist collectives Heresies and the Women's Action Coalition, and centers on her crucial essay "Olympia's Maid." "Hybridity, Diaspora, and Thinking Both/And" gathers essays in which the productive complications introduced by her insistence on "miscegenated" thinking are explored, in relation to both her own work and the cultural productions of others, including Flannery O'Connor, William Kentridge, and the surrealists. "Other Art Worlds" includes a number of examples of the ways in which O'Grady has, over the years, shone a light on the oversights of the mainstream art world and revealed, to those who would attend to them, the existence and persistence of the black avant-garde; the writings in this section are almost startling in their demonstrations of her prescient thinking—she was saying things about the art worlds of the 1980s and 1990s that are only now being fully recognized and understood by curators, critics, and historians. Finally, "Retrospectives" comprises a pair of wide-ranging and in-depth interviews along with a narrative of her early career and two examples of her forays into rock criticism. The pieces are for the most part organized chronologically within each section. Unless otherwise indicated, ellipses are in the original; they do not indicate omitted text.

But despite these organizing themes, there are countless opportunities for making connections between texts and allowing each to complicate, contradict, and illuminate the other. Some signposts have been provided, in the form of editor's notes (marked by an [Ed.]), brief introductory paragraphs, and "See Also" sections placed at the end of the individual texts that point out ways in which O'Grady's writings relate not only to specific artworks but also to each other. For example, just as *Cutting Out the New York Times* (1977), the artwork itself, needs to be read in tension with *Cutting Out CONYT* (2018), her recent "remix" of that older piece, so too does the text O'Grady wrote about the earlier work need to be read in concert with one that she penned to illuminate the later one ("On Creating a Counter-confessional Poetry"). A 1998 conversation with a studio visitor on her choice of the diptych form ("The Diptych vs. the Triptych") should be seen in light of a recent gathering of email snippets, "Notes on the Diptych, 2018." And "My 1980s," a 2012 article written for the College Art Association's *Art Journal*,

based on a lecture she gave at the Chicago Museum of Contemporary Art as part of programming for the traveling exhibition "This Will Have Been," curated by Helen Molesworth, is to be paired with the 2018 "On Creating a Counter-confessional Poetry." O'Grady and I have offered some of these connections; readers will, in the course of their engagement, find other points of contradiction and affinity. The point is not to explain away that which seems irresolvable, but to see what we can learn by allowing those tensions to coexist—by sitting with the differences. The goal is to allow this volume to introduce—not simply by its contents, but by the experience of reading over time, by the experience of connecting essays and interviews in nonlinear ways—this central idea of O'Grady's aesthetic and theoretical project: the productive value of thinking many things at once.

ONE OF THE ENDURING "both/and" qualities of O'Grady's practice is her ability to offer both seriousness and joy, pleasure and critique, beauty and politics in a single experience—dualities that are most often thought of as contradictory or mutually exclusive in contemporary art, as she has noted in the past.[36] She describes herself as an "equal-opportunity critic" and considers her critique "a back-and-forth between anger and love"[37]—a both/and approach that has been apparent from her earliest forays into performance, especially in regard to *Mlle Bourgeoise Noire*. The piece was born of her disappointment in going to the *Afro-American Abstraction* show at PS1 in 1979: at first she was struck by the crowd, full of chic, brilliant, interesting artists with whom she could (at last!) aspire to build a creative community; she was brought down to earth when she realized that some of the work they were making was too tame, too polite, too clearly hemmed in by the rules of the white art world. *Mlle Bourgeoise Noire* was first performed at another opening at which many of these same PS1 artists were in attendance, at Just Above Midtown gallery, the space run by Linda Goode Bryant that was in many ways the epicenter of the black avant-garde in New York in the late 1970s and 1980s. O'Grady, in her beauty queen persona, dressed in a gown covered in white gloves (symbols of middle-class black culture's aspirations to white cultural status and achievement) and wielding a cat-o-nine-tails ("the whip that made plantations move"), decried the internalized and externalized racism limiting black artists from creating art that challenged the institutions that were excluding them. The performance climaxed with Mlle Bourgeoise Noire shouting a poem that ended with the line "BLACK ART MUST TAKE MORE RISKS!"

O'Grady did not limit her critique to her black artistic peers, however: when she restaged her "kamikaze performance" at the opening of a show at the New Museum titled *Persona* in 1981, which included not a single black artist, the poem Mlle Bourgeoise Noire intoned declared, "NOW IS THE TIME FOR AN INVASION." In her retrospective account of the work, she notes that she had been invited by the museum, before the performance, to design some educational programming for schoolchildren visiting the show and that the offer was withdrawn after her action. The detail is telling—a signal, at least in part, for why the embrace of her practice by museums has been so slow in coming, despite her centrality in the art world since the first moments of her career.[38]

It may be that the curators at the New Museum could only see *Mlle Bourgeoise Noire* as a performance of hostility toward the institution. (The enduring misrecognition of artists' protest as unproductive aggression, as opposed to constructive intervention, is a leitmotif of American art institutions.) But when it was included in *WACK! Art and the Feminist Revolution* in 2007, O'Grady posted a number of unpublished photos of the performance on the exhibition's website. She wanted to counter, she said, the too-common impression people had that the piece was just about anger: by sharing pictures that showed her engaged in full-throated laughter and conversation with the other artists, critics, and curators associated with JAM who were there the night she performed there, she hoped to convey the joy also embodied in her alter ego. While O'Grady has often referred to the productive value of anger in her thinking, she is no less motivated by pleasure, delight, and laughter.

As will become clear in the following pages, O'Grady's sense of humor and deep belief in the transformative possibilities of art leavens her bracing, surgically precise, and sometimes even brutal approach to analysis. Take this, a parenthetical remark in her analysis of the spectacle around Jean-Michel Basquiat's treatment by the mainstream art world: "It was an uncomfortable reminder that more was at stake than a game. (At some point between the Greeks and the free-agent clause, sport gave up its pretense to a cultural meaning beyond narco-catharsis.)"[39] Or this description of her friend George Mingo, a fixture at Just Above Midtown whose aspirations to art stardom couldn't survive the realities of a segregated art world: "George didn't take art seriously until late high school, when he saw a picture of Salvador Dali wearing a top hat and cape and carrying a gold-knobbed cane. With dreams of limousines and good-looking broads, he went off to Cooper Union and discovered he was black a few years before multiculturalism. That was the end of that."[40] Or this, a devastatingly pithy takedown of a darling of the

bad-boy artist set: "Blissfully tone-deaf, he writes as if unconscious of how a phrase like 'Surely pity for a whiner of my magnitude must be impossible' echoes differently in the corridors of power than when it is overheard by someone who really has something to whine about."[41]

Indeed, after I had passed along to O'Grady a first draft of this introduction, I received a very long email. It contained the following paragraphs:

Basically, the text splits in two. There are about twenty-eight paragraphs. The first thirteen or so are about as first draft as you can get. You could drop them and no one would hear a splash. Episodic, and then and then and then, and nothing but description that's not providing answers because it's not asking questions.

Suddenly, in paragraph fourteen, the first sign of real thinking. Gradually it gets better and better, until by paragraph twenty or so you are flying. The last paragraphs are as close to first class as the first half is to less than first draft.[42]

The metaphor of dropping paragraphs and not hearing a splash, the charge that the writing was not asking questions—all this is countered by the enthusiasm for what she sees, despite it all, happening in the text. She even saw that sad first draft as a diptych ("the text splits in two"). I laughed when I read it—especially at the rhyming riff at the end of the second paragraph—then dug into her notes, and ended by completely rewriting the essay. I knew that O'Grady's critique is a form of love—born of a desire for all of us to do the work that needs to be done. Why would I not attend to that, no matter how difficult the task, with the joy that comes from thinking through the world on these new terms, and letting myself be changed in the process? If they are read with as much care as they were written, O'Grady's words are a gift, a call to action, and a vision of a world as it could be.

1 Statements and Performance Transcripts

Two Biographical Statements
(2012 and 2019)

O'Grady wrote these biographical statements seven years apart: the first for her showing of *Miscegenated Family Album* in the 2012 Paris Triennial curated by Okwui Enwezor, the second to accompany her 2019 "Diptych Portfolio" in a volume of the New Museum–MIT "Critical Anthologies in Art and Culture" series and later revised for her website. Unlike most examples of the "artist's bio" genre, O'Grady's foreground the conceptual import of her work—the ideas she is grappling with—rather than privileging a résumé of her activities. The artist has long used the form of the biographical statement to refine and revisit her understanding of what she has been doing—they function as retrospective assessments of her oeuvre and its through lines.

2012

Lorraine O'Grady
Born in 1934, Boston, United States
Lives in New York, United States

Conceptual artist Lorraine O'Grady uses performance, photo installation, and video as well as written texts to explore hybridity, diaspora, and black female subjectivity. Born in Boston to Jamaican immigrant parents, O'Grady was strongly marked by a mixed New England–Caribbean upbringing which

left her an insider and outsider to both cultures. She has said, "Wherever I stand, I must build a bridge to some other place."

O'Grady came to art late following several successful careers—as an intelligence analyst for the Departments of Labor and State, a commercial translator with her own company, and even as a rock critic for *Rolling Stone* and *The Village Voice*. Her first public art work, the well-known performance *Mlle Bourgeoise Noire* (1980–83), which critiqued the segregated art world of the time, was done initially at the age of 45. This broad background accounts, in part, for her distanced, critical view of the art world and for her eclectic attitude as an art maker. Ideas come first, then the medium to best execute them. However, the work's apparently different surfaces are characterized by their unique amalgam of rigorous political content and formal elegance and beauty. Beneath the surface, there is often a unifying concern with hybrid identity.

The pejorative word "miscegenation," coined in 1863 and then used for the post–Civil War laws making interracial marriage illegal—laws not struck down by the Supreme Court until 1967—has been recuperated in O'Grady's photo-installation title *Miscegenated Family Album* (1994). In this strongly feminist "novel in space," O'Grady attempts to resolve a troubled relationship with her only sister Devonia, who died early and unexpectedly, by inserting their story into that of Nefertiti and her younger sister Mutnedjmet. Building on remarkable physical resemblances, the paired images span the coeval distance between sibling rivalry and hero worship through "chapters" on such topics as motherhood, ceremonial occasions, husbands, and aging. At the same time, the work also reflects O'Grady's view of Ancient Egypt as a "bridge" country, the cultural and racial amalgamation of Africa and the Middle East which flourished only after its southern half conquered and united with its northern half in 3000 BC. Both families featured in the photographs—one ancient and royal, the other modern and descended from slaves—are products of historic forces of displacement and hybridization.

2019

Lorraine O'Grady is a conceptual artist and cultural critic whose work over four decades has employed the diptych, or at least the diptych idea, as its primary form. While she has consistently addressed issues of diaspora, hybridity, and black female subjectivity and has emphasized the formative roles these have played in the history of modernism, O'Grady also uses the diptych's "both/and thinking" to frame her themes as symptoms of a larger

problematic, that of the divisive and hierarchical either/or categories under-pinning Western philosophy. In O'Grady's works across various genres including text, photo installation, video, and performance, multiple emotions and ideas coexist. Personal and aesthetic attitudes often considered contradictory, such as anger and joy or classicism and surrealism, are not distinguished. Even technical means seem governed by both chance and obsessive control so as to express political argument and unapologetic beauty simultaneously. And across the whole, essays and images interpenetrate. While O'Grady's diptychs are sometimes explicit, with two images side by side, at other times they are implicit, as when two types of hair—silk and tumbleweed, videotaped on the same scalp at different hours of the same day—alternate and interact to create permeating worlds. The goal of her diptychs is not to bring about a mythic "reconciliation of opposites," but rather to enable or even force a conversation between dissimilars long enough to induce familiarity. For O'Grady, the diptych helps to image the kind of "both/and" or "miscegenated" thinking that may be needed to counter and destabilize the West's either/or binary of "winners or losers," one that is continuously birthing supremacies from the intimate to the political, of which white supremacy may be only the most all-inclusive.

An early adopter of digital technology, O'Grady has also created a website, lorraineogrady.com, which is considered a model of the online abbreviated-archive, and her paper archive is in the collection of the Wellesley College Library. Among O'Grady's writings, the 1992/94 long-form essay "Olympia's Maid: Reclaiming Black Female Subjectivity" has proved an enduring contribution to the fields of art history and intersectional feminism and is now considered canonical. O'Grady's art works have been acquired by, among other institutions, the Art Institute of Chicago, IL; the Museum of Modern Art, NY; the Tate Modern, London, UK; the Museum of Fine Arts, Boston, MA; and the Whitney Museum of American Art, NY.

Cutting Out the New York Times (CONYT), 1977 (2006)

In 2006, O'Grady was included in an exhibition called *Between the Lines*, curated by artist Nick Mauss at Daniel Reich Contemporary in the Chelsea Hotel. O'Grady showed five poems containing forty-five panels from the original twenty-six collaged poems (approximately 250 panels in all) making up *Cutting Out the New York Times (CONYT)*, her earliest artwork, created with found text from the Sunday edition of the paper of record every week from June 5 to November 20, 1977. The following statement was written for the *Between the Lines* binder. The *CONYT* series, a deliberate spin-off from Dada and surrealist poetry, topics about which O'Grady taught at the School of Visual Arts (SVA) in New York, was instead an attempt to wrest private meaning from public language and create what she called a "counter-confessional" poetry. In 2017, she revisited the original twenty-six collaged poems, reducing and remixing them into twenty-five "Haiku Diptychs" plus one "Statement" with a total of just fifty-one panels, now called *Cutting Out CONYT*.

AT THE TIME, two things had happened simultaneously: I began to think that psychoanalysis might not be a bad idea; and I had to have a biopsy on my right breast. I took some books by André Breton to the hospital to help take my mind off it. *Nadja* and the *Manifestoes* may have got mixed up with coming out of the general anesthetic.

When the biopsy proved negative, I wanted to make a collage for my doctor. I thought it would feature the cult statue of Diana of Ephesus, the "many-breasted Artemis Ephesia." But I needed some text . . . As I flipped through the *Sunday Times*, I saw a headline on the sports page about Julius Erving that said "The Doctor Is Operating Again." It seemed too good to waste on the collage, so I made a poem instead. But since I'd been flirting with the doctor, the poem turned into an imaginary love letter for an imaginary affair.

Then I began to wonder, what if . . . instead of Breton's random assemblages . . . I did cutouts and consciously shaped them? What would I discover about the culture and about myself? (In the place I was then, questions like "Who am I?" didn't seem so academic). And, if I reversed the process of the confessional poets everyone still read at the time . . . like Plath and Sexton, who'd made the unbearably private public . . . if I pushed the cutouts further, could I get a "counter-confessional" poetry that made the public private again?

To find myself in the language of the news didn't strike me as odd. In my first job after college, I'd been an intelligence analyst, at the Department of Labor and then the Department of State. After five years of reading ten newspapers a day in different languages, plus mountains of agents' classified reports and unedited transcripts of Cuban radio, language had melted into a gelatinous pool. It had collapsed for me. That's when I'd quit.

For six months in 1977, I made a poem a week from the *Sunday Times*. Cutting out the *National Inquirer* would not have interested me. This wasn't about condescending to the culture, it was about taking back from it. It was just raw material. I think the process may have worked. When he read the cutouts, my ex-husband said it had been like leafing through the *Times* and coming across a photo of me accidentally. I never bought the *Sunday Times* again.

See also *"On Creating a Counter-confessional Poetry"; "Sketchy Thoughts on My Attraction to the Surrealists"; "Two Exhibits: The Diptych vs. the Triptych and Notes on the Diptych"; "My 1980s"*

Mlle Bourgeoise Noire 1955 (1981)

Mlle Bourgeoise Noire 1955 is the earliest appearance of O'Grady's best-known performance character—a guerrilla action that took place on June 5, 1980, at Just Above Midtown/Downtown. At JAM, one of the country's only black avant-garde art galleries at the time, her critique was focused on the timidity of the black art establishment to challenge the hegemonic whiteness of the art world. Mlle Bourgeoise Noire's "invasion," as she termed it, was her response to the "well-behaved" art shown by many JAM-associated artists in the recent *Afro American Abstraction* show at PS1. She went on to perform similar interventions, always uninvited, at other venues. These included the New Museum, where it functioned as a protest against the 1981 all-white exhibition *Persona*.[1] While often treated as a singular performance, O'Grady considered it part of a larger *"Mlle Bourgeoise Noire* project"—one that included her street performance *Art Is . . .* and her curatorial intervention *The Black and White Show.* She would have continued elaborating the project had her performance career not been interrupted by the need to move to Boston to care for her ailing mother in 1983.

TWENTY-FIFTH ANNIVERSARY of the international beauty pageant held in Cayenne, French Guiana, June 5, 1955. The crown of "Mlle Bourgeoise Noire 1955" awarded to Miss Black Bourgeoise of Boston, MA.

Cast

LORRAINE O'GRADY—playing Mlle Bourgeoise Noire 1955 on the 25th Anniversary of her coronation. Ms. O'Grady is wearing her crown, her coronation gown and cape (together made of 180 pairs of white gloves), and a white cat-o-nine-tails studded with white chrysanthemums as her bouquet.

DR. EDWARD B. ALLEN—playing the Master of Ceremonies. Dr. Allen, a dentist from Stamford, CT, and Ms. O'Grady's brother-in-law, plays tennis with Bert Parks. ("He can't play worth shit.") Dr. Allen has borrowed a tuxedo jacket from Bert Parks especially for this occasion.[2]

PHOTOGRAPHERS, VIDEO CAMERAMEN, DISCO BAND, and GUESTS at the opening of the Just Above Midtown/Downtown gallery—playing the court and subjects attending Mlle Bourgeoise Noire's Silver Jubilee.

MLLE BOURGEOISE NOIRE and her Master of Ceremonies arrive for her 25th Anniversary celebration at precisely 9:00 p.m. They have difficulty entering (their names having been omitted from the guest list at the door). After a few peremptory commands by Mlle Bourgeoise Noire, they are let in, passing through the tight pink maze especially designed by artist David Hammons and featuring three salt fish hanging from hooks.

At last they can greet the crowds awaiting them. Oohs and aahs on all sides for Mlle Bourgeoise Noire's gown. After all these years, it still fits.

She smiles, she smiles, she smiles. Mlle Bourgeoise Noire has lost none of the charm that originally won her crown.

Each of her nine tails has three white chrysanthemums, which she gives to her subjects one at a time as she says, while smiling brightly, "Won't you help me lighten my heavy bouquet?" She moves gradually around the room.

Photographers and video cameramen are having a field day. Mlle Bourgeoise Noire, in her 180 pairs of white gloves, white cat-o-nine-tails, and rhinestone and seed pearl crown, is very photogenic. Unreluctantly, she obliges them.

But Mlle Bourgeoise Noire has had a change of heart between 1955 and 1980. She has come to a conclusion. As the band goes on its break, she discreetly retires. All her flowers have been given away, and now she removes her cape, handing it to her Master of Ceremonies. She is wearing a backless, white-glove gown. Her MC, by prearranged signal, hands her a pair of above-the-elbow gloves, which she proceeds to put on.

Back and forth she paces, like a caged lion and trainer all in one. She beats herself with the whip.

All these years she has been waiting for this 25th Anniversary to give her subjects her final conclusion. And stalking back and forth in front of the art in this 50%-black gallery, beating herself with greater and greater frenzy, suddenly she stops.

Cayenne, where she was crowned so many years ago, is not just the other side of nowhere. It is the birthplace of the great mulatto poet Léon Damas, who knew so many things before she did.[3] Tonight she will speak through him. Of course, she will make her own additions.

"THAT'S ENOUGH!" she shouts as she lays down her whip. "No more boot-licking . . .

"No more ass-kissing . . .

"No more buttering-up . . .

"No more pos . . . turing

"of super-ass . . . imilates . . .

"BLACK ART MUST TAKE MORE RISKS!!!"[4]

Then she quickly exits, leaving the court to think what it will.

See also *"Statement for Moira Roth re:* Art Is . . . , *1983"; "Interview with Amanda Hunt on* Art Is . . . , *1983"; "Mlle Bourgeoise Noire and Feminism"; "The Black and White Show, 1982"; "My 1980s"; "The* Mlle Bourgeoise Noire *Project, 1980–1983"*

Rivers, First Draft, 1982
Working Script, Cast List,
Production Credits (1982)

Rivers, First Draft was a one-time-only performance created by
O'Grady for *Art across the Park*, curated by Gilbert Coker and
Horace Brockington. It was staged in the Loch, a northern section
of Central Park, on August 18, 1982, in front of a small audience
and a few onlookers who happened upon the scene. O'Grady has
described the piece as "a three-ring circus of movement and sound
that, unlike the randomness of Futurists attempting to shout each
other down, played more like a unitary dream." The piece is part
biographical, tracing in broad form O'Grady's evolution from child
to artist within the doubled structures of racism and sexism; it
travels a conceptual distance from the West Indies to New Eng-
land. (The image of the Fir-Palm, which represents this diasporic
and hybrid condition, first emerged as a prop for this Central Park
performance; a decade later, it would appear in O'Grady's photo-
montage series *Body Is the Ground of My Experience*.) O'Grady took
on the role of the Woman in Red, and, among the other cast mem-
bers, the artist Fred Wilson played the Young Man. Of note—given
her earlier career as a rock critic—is the careful selection of music,
noted at the end of the script. The performance was considered
a "draft"—O'Grady planned to restage it, and applied to do so at
the Judson Memorial Church in 1982. This, along with plans to
extend the project under the rubric "Invisible Landscapes," never
came to pass because of her withdrawal from performance in 1983.

This script and a set of photo documents are the only remaining records of *Rivers, First Draft*.

Still Images (Silent)

1. The Woman in the White Kitchen

On the near bank of the stream, there is a house frame [made] of 2 × 4's painted enamel white. It is of the front of the house only and has no wall.

On the ground, in front of the frame and extending inside the "house," is a bed of white pebbles forming a square white garden. It flows from under the kitchen furniture, which consists of a white stool and miniature white table.

A brown-skinned woman wearing a white halter dress and white wedges, with a '40s hairstyle (pompadour type) and bright red lipstick, sits at the table preparing white food—either grating coconut, or flaking codfish and mixing it with chopped onion and flour.

In front of the house frame is an artificial potted plant: it is a fir-palm (the combination hybrid of a fir and a palm) and seems to be a metaphor for the West Indian transplanted to New England.

In the kitchen, a short-wave radio tuned to a New York station (WLIB) blasts a 5-minute newscast delivered in a West Indian accent.[1] The broadcast has been creatively taped by selecting out the most pompous statements, the most stereotypically eager to appear sophisticated and American, and repeating them.

The image that the Woman in White projects with her repetitive grating, flaking, chopping, or sifting actions is that of a perfectionist, not one who is tight and determined, but more relaxed—her perfectionism seems less an inner need to *be* perfect than a need to *appear* perfect to the alien world in which she now lives.

Her activity continues uninterrupted throughout the entire performance, from just before the start of the West Indian newscast until after the procession goes down the stream at the end.

2. The Nantucket Memorial

A statuary complex reminiscent of New England granite. One or two men, in nor'easters, slickers, and fishermen's boots, enter the stream at the same time the Woman in White sits down at her kitchen table. They wear a row-

boat structure suspended from their bodies in such a way as to leave their hands free. On the side facing the audience, the boat is painted with the words "NANTUCKET MEMORIAL." The whaler(s) stand still as statues in the boat, hands resting on its frame. The whole image, men and boat, is colored granite grey.

The stone whaler(s) are positioned at the far end of the stream, standing perfectly still all the while, until the next-to-last scene. They should look and feel (and be ignored) like statues that are part of the park landscape, ultimately blending in.

3. Black Male Artists in Yellow

On the other side of the stream, behind a grey door off the castle corridor (the space of the castle is marked by four tall poles with grey banners), there are four black men dressed in yellow shirts and black pants.

The men are engaged in silent intellectual and artistic activities—reading, writing, drawing, painting, whatever. They can be working individually and consulting with each other occasionally. Or two can be working individually, two collaboratively.

Whatever activities they are engaged in, their impression is of concentration, engagement (whether of pleasure or of frustration) with what they are doing.

They are in place at the start of the performance, and except for their interruption by the woman in red, they remain totally enclosed in their own world(s). They pay no attention to the movements and sounds going on in the rest of the performance, and continue to do so through the end of the performance.

Still Images (Speaking)

1. Young Girl in White Memorizing Lessons

Approximately 2–3 minutes after the Woman in White and "The Nantucket Memorial" have taken their places, and the West Indian broadcast begins in the woman's kitchen, a young, fair-skinned black girl, about 10–12 years old, comes out and occupies a space midway between the audience and the stream.

The girl is wearing a white cardboard Greek helmet (like that worn by Pallas Athena), a short white organdy dress (rather sedate), white ankle socks and shoes, with a bright pink sash around her waist, and she is carrying a

green Harvard book bag over her shoulder that is filled with books. Though she looks dressed for a party, she is actually about to do her homework.

Over the sound of the West Indian radio broadcast, which gradually lowers and disappears, the girl begins to memorize her lessons by rote: she studies, in order: in Bennet's *New Latin Grammar*, Section 297, "Substantive Clauses of Result"; and Section 324, "Subjunctive by Attraction"; and, in another book, the 1775 Resolution of Congress ordering the Convention of Massachusetts Bay to call an Assembly for electing a Council to govern the colony in place of the King's Governor.

The girl's activity of memorizing continues until the next-to-last scene, her voice ebbing and flowing depending on whether or not it is reinforced by her megaphone, with the Latin phrases and their English translations acting at times as a kind of poetic comment on the rest of the action.

For instance, over the section in which the debauchees dance in the castle corridor, such phrases as: *ex quo efficitur, ut voluptas non sit summum bonum*, FROM WHICH IT FOLLOWS THAT PLEASURE IS NOT THE GREATEST GOOD; and *gravitas morbi facet ut medicina egeamus*, THE SEVERITY OF DISEASE MAKES US NEED MEDICINE.

Over the section where the Woman in Red enters and attempts to stay in the room with the Black Male Artists in Yellow, who are artists and intellectuals, such phrases as: *cum diversas causas afferrent, dum formam sui quisque et animi et ingenii redderent*, THEY BROUGHT FORWARD DIFFERENT ARGUMENTS, WHILE EACH MIRRORED HIS OWN INDIVIDUAL TYPE OF MIND AND NATURAL BENT.

When each of the two lessons from Bennet's *New Latin Grammar* is successfully completed, the little girl recites a poem from memory that begins:

> Back home deep in the woods of Vermont,
> I dropped the first atomic bomb.
> Good old Yankee know-how:
> ten years, a few good men
> and stubbornness beyond belief
> The center held . . .

and ends with:

> Come to our place for Thanksgiving.
> We'll serve you the Caribbean with all the
> trimmings.
> Come to Jamaica—all we have to offer

is three days on an island
where dance is a way of life
Isn't it time you took a vacation?[2]

The actress should bear in mind that the combined lessons take a total of six minutes and the poem takes one minute to recite at a normal pace, and time herself accordingly, keeping aware of the pace of the other actions. She may have to contract or expand the action of memorizing, depending on what else is happening. She needs to be beginning to memorize the Resolution of Congress Concerning the Massachusetts Bay Colony while the Woman in Red is still in the castle kitchen, but she doesn't have to finish memorizing the Resolution. It is OK if her memorization is interrupted when it is time for her to go into the stream.

The actress should set her microphone so that her voice competes equally with the West Indian newscast at the beginning, or is slightly lower. Later, the setting should be increased to allow her voice to drown out the New Wave and reggae music on the other side of the stream.

In addition, the sound of her voice should go in and out. She only goes on mic when she can do the recitation. In other words, a couple of attempts, either in a normal voice or silently while clearly mouthing the words, then a third successful recitation on mike. Tasks should be broken down, so that there is only one Latin phrase and English translation at a time. Probably the Resolution of Congress should be recited in blocks of three or four lines.

Overall, the affect the little girl gives should be one of intelligence and vitality, of creative energy being used up by these reductive exercises, without her seeming to mind. She enjoys what she is doing, takes pride in accomplishing her tasks.

The actress should feel free to sit, stand, pace back and forth, engage in any activities she feels natural to the process of memorizing and reciting.

2. Art Snobs

The two Art Snobs come on during the action of the Debauchees, about the same time that the Woman in Red begins circling the other dancers. Wearing purple and electric blue T-shirts and motorcycle goggles, they stand on the path that represents the castle parapet. They are carrying megaphone/microphones and engaging in conversation.

The Art Snobs are the opposite of the Debauchees. Instead of being self-involved, they give the impression of having no selves at all, of being all-

concerned with outward effect and impressions. They carry on a snobbish "who's who and what's what in the art world" conversation guaranteed to make everyone who hears it feel put down. They are more shallow than intellectual, but they are just intellectual ENOUGH to give their comments a cutting edge.

Since the Art Snobs come on about 7:30 into the performance and cut out at about 21:00 minutes, this gives them about 13:30 minutes of extemporaneous conversation. As opposed to the Little Girl's rote memorization, their exchanges are totally improvised, with the actors chosen for their knowledge of the art world. Their conversation is in counterpoint with the Little Girl's school lessons. Their voices should be over and under hers, as well as over and under the New Wave and reggae music that is on the soundtrack at that time.

But whereas the Little Girl's lesson recitations have almost the effect of poetic comment on the action, the Art Snobs' commentary should have the effect of social static, the stuff that goes on constantly as while we lead our private, inner lives—media overload, too many social and professional obligations, distracting phone calls, and the petty jealousies that keep us from developing our best potential. The effect of the Art Snobs on the Woman-in-Red, though she pays no apparent attention to them throughout the performance, or if she does, only as though to one more distracting message she can't quite get, is to make her feel badly, put down, and above all, aware of passing time. They make her feel out of it, as if she is going to have to do *something* either to catch up with them or to make them not count.

Moving Images

1. The Debauchees

About two minutes after the entrance of the Little Girl Memorizing Her Lessons, music starts up on the other side of the stream. It sounds very New Wave (e.g., Gang of Four, et al.) and contrasts strongly with the image of the little girl reciting her Latin lesson. If there is more than one source of sound, the New Wave music will gradually drown out the West Indian talk show; if there is just one sound source it will simply replace it.

Approximately 30 seconds after the music begins, four dancers in exotic costumes made of brightly colored silk ranging in hue from pure yellow to pure red begin to dance randomly, individually, but somewhat following the lead of the dancer in yellow.

The first two dancers are white women, the third a white man in an orange-ish dress, the fourth a mulatto woman in red.

The effect each dancer should give is of a totally self-involved pursuit of private pleasure. A waking dream, with music, movement, individual props such as wine bottles, hand mirrors, etc. The selection of props and quality of image should be left up to each dancer to fulfill his/her private fantasy of self-absorption.

The only dancer without props is the Woman in Red.

2. The Woman in Red

The Debauchees first come into view dancing along the imaginary stone corridor of the castle. Two minutes after their entrance, the Woman in Red separates out from the group (she entered last in line).

While the other Debauchees make their slow progress along the corridor, the Woman in Red begins to move somewhat faster. She circles in and out of the Debauchees, as if trying to interact with them. They stay completely self-absorbed, paying her no attention.

3. The Girl in Magenta

A fair-skinned black girl/woman, about 18 years old, comes out onto the near bank of the stream. She is dressed in a tube top and a pair of pedal-pushers that are halfway in color between the Little Girl's bright pink sash and the Woman in Red's carmine dress.

The Girl in Magenta is obviously depressed. When she comes on, she walks listlessly, with her head down, her eyes not focusing (if the actress has any private "depression habits," they will come in handy here). However, she isn't definitively depressed. She goes in and out of self-absorption and shallow awareness of the surrounding environment. When the Young Man in Green comes strolling up the bank from the opposite end of the stream, she gradually becomes aware of him.

4. The Young Man in Green

He is considerably older than the Girl in Magenta, about 27, and this will ultimately be the source of difficulty. He responds to the Girl in Magenta's overtures tentatively, but she is very persuasive. Throughout their lovemaking,

which is quite gentle, he is thoughtful and attentive. However, when it is over, he is searching for a way to let her down easy, so that he can leave.

The Girl in Magenta compulsively tries to hold on to him. She has not really been relating to him, but rather using him as a way to escape from her depression. If he goes, she will be alone again.

When the Young Man in Green discovers that he is basically an object, it turns him off and makes it easier for him to break away rather abruptly.

After the Young Man in Green leaves, the Girl in Magenta feels terribly afraid. Now she goes into an even deeper depression, so deep that after wandering about in a daze, she lies down and goes to sleep on the bank of the stream. Her lying down is in preparation for the Woman in Red's lying down on the bed jutting out into the stream. When the Girl in Magenta lies down, the Art Snobs leave.

5. The Woman in Gold

After circling and intersecting the Debauchees and getting no response from them, and perhaps having been made a little uneasy by the conversation of the Art Snobs overheard on the parapet, the Woman in Red begins to dance in a different direction from the other Debauchees. She starts slowly down the corridor toward the grey door.

About a minute and a half later, she reaches the door and tries to open it. It is stuck closed. She tries and tries, and after about half a minute, she is finally able to get into the room where the Black Men in Yellow have been engaged in silent intellectual and artistic pursuits from the beginning of the performance.

When she sees what they are doing, the Woman in Red tries to join in their activities. The Black Artists in Yellow firmly refuse to let her stay. They quickly escort her to the door and point out to her the way downstairs.

But instead of going downstairs, the Woman in Red dances back up the corridor. Soon she is intersected by the Debauchees who are coming back down again.

The Woman in Gold, the dancer leading the Debauchees, pins the Woman in Red against an imaginary wall and makes love to her against her will, but without the Woman in Red protesting too strongly.

When the Woman in Gold breaks away and continues dancing with the others, the indignity of this experience seems to have strengthened the Woman in Red's will. She begins to move back down the corridor and to de-

scend the stairs, slowly, hesitantly. It takes her a minute and a half to reach the castle kitchen.

6. The Production Assistants

As the Woman in Red approaches the castle kitchen, reggae music begins playing on a radio in the Woman in White's kitchen, with cuts from Jimmy Cliff's *Unlimited* album—"Under the Sun, Moon, and Stars" and "On My Life." The New Wave music has already cut out a minute earlier, and the Debauchees have disappeared. The Girl in Magenta and the Young Man in Green, their lovemaking spent, are lying quietly. The Art Snobs and the Little Girl, after being temporarily quiet, start up again under the sound of the reggae music.

When the Woman in Red picks up a spray can and starts painting the stove red, the Girl in Magenta tries to make love to the Young Man in Green again, but he resists.

The Woman in Red picks up a red enamel pot and appears to cook something, which, when she tastes it, seems to be missing something. At this point, the Young Man in Green breaks free from the Girl in Magenta.

The two production assistants bring an accordion-folded photo album, made of 50 to 75 eight-by-ten black-and-white glossies. It takes all three of them, including the Woman in Red, to hold it as she looks at the images. They keep folding and unfolding it, as it seems to go on forever. When she is ready to lie down, the PAs fold up the album and give it to her to take with her to bed. During the process of looking at the album, the reggae music stops and the Art Snobs disappear. The Little Girl continues, her voice the only sound.

7. The Nude Swimmer

As the Woman in Red lies down on the bed with the folded photo album, the Little Girl's voice continues reciting, the Girl in Magenta is lying down on the bank in a depressed sleep, the Black Men in Yellow continue their silent intellectual and artistic activities behind the grey door off the castle corridor, the Woman in White continues grating coconut in her now silent white kitchen, and the Nantucket Memorial statue stands in its place at the far end of the stream.

The Woman in Red lays the photo album down on the bed beside her and

(depending on the prop) either watches a movie on TV or goes to sleep and dreams.

Suddenly the image she is seeing (either watching TV or dreaming) materializes physically. A nude swimmer comes onto the bed where she is lying (either through the TV screen or out from under the bed, emerging from the end nearest her head), and brushkisses her lightly in a sweeping, rolling motion, and then says: "I'm not interested in meaning or significance or importance."

Next the two Production Assistants come to the foot of the bed and say: "And what about the Bomb?" "Will anything last?"

As if responding to this, the Woman in Red breaks free of the Nude Swimmer and forces him off the bed.

Apparently trying to get back to something real, she picks up the photo album and looks at it again, carefully, as if either remembering or making aesthetic decisions, it's hard to tell.

8. The Nantucket Memorial

Soon after the Woman in Red has started perusing the photo album again, the whaler in the Nantucket Memorial suddenly begins to furiously bail for dear life. As he does, the Little Girl concludes her recitation and stays quite still.

Now the Nantucket Memorial moves purposefully toward the Woman in Red lying on her bed. When he reaches her, he extends his hand and helps her enter the stream. As he does, the sound of a woman's voice, singing the Episcopal Advent hymn "O Come Emmanuel" in a flat West Indian accent, begins.

While the Nantucket Memorial waits for her in the stream, the Woman in Red approaches the bank where the Girl in Magenta lies asleep and the Little Girl stands quietly. The Woman in Red bends down over the Girl in Magenta, and as she does, the Little Girl, in her white dress and bright pink sash, comes toward them. Together, the Little Girl and the Woman in Red rouse the Girl in Magenta from her deep sleep. They put their arms around her and incline their heads toward her reassuringly and help her into the stream.

As the Nantucket Memorial proceeds down the stream and the West Indian woman's voice continues to sing the Advent hymn, the three figures—the Woman in Red, the Girl in Magenta, and the Little Girl with Pink Sash—walk together toward the end of the stream. They are not holding

hands nor are their arms linked, but their attitudes are obviously relaxed and friendly toward each other. Every once in a while the Woman in Red spontaneously hugs the Girl in Magenta.

On either bank of the stream, the Black Male Artists in Yellow and the Woman in the White Kitchen continue as before.

Cast

WOMAN IN WHITE	Marilyn Worrel
NANTUCKET MEMORIAL	Robert Feinberg
MALE ARTISTS	Lorenzo Pace, Noah Jemison, George Mingo
LITTLE GIRL	Bouqui Kya-Hill
ART SNOBS	Andrea Radu, Cesar Palma
WOMAN IN GOLD	Beverly Trachtenberg
DEBAUCHEES	Francine Berman, Richard De Gussi
WOMAN IN RED	Lorraine O'Grady
TEENAGER	Darnell Martin
YOUNG MAN	Fred Wilson
PRODUCTION ASSISTANTS	Emily Velde, Bern 1905
NUDE SWIMMER	Richard De Gussi

Production Credits

WRITER, PRODUCER	Lorraine O'Grady
DIRECTORS	Lorraine O'Grady, Ellen Sragow, Emily Velde
COSTUME DESIGNER	Bern 1905
SET DESIGNERS	Noah Jemison, Lorenzo Pace
SOUND EDITOR	Richard De Gussi
NEW WAVE TAPE	Bill O'Connor
WEST INDIAN NEWSCAST	Claude Tate
WLIB FLYERS AND PROGRAMS	Beverly Trachtenberg
ATHENA HELMET	Fons

Music Credits

Jimmy Cliff, "Under the Sun, Moon, and Stars," "On My Life," Warner Bros. Records

Nina Hagan, "Smack Jack," by F. Karmelk, CBS Records

Tom Tom Club, "Wordy Rappinghood," Sire Records

John Foxx, "Metal Beat," Island Music Ltd.

Public Image Ltd., "Graveyard," Warner Bros. Records

See also "Body Is the Ground of My Experience, *1991: Image Descriptions*"; "*Perfor-mance Statement #2: Why Judson Memorial? or, Thoughts about the Spiritual Attitudes of My Work*"; "*Black Dreams*"; "*Interview with Linda Montano*"; "*Some Thoughts on Dias-pora and Hybridity: An Unpublished Slide Lecture*"; "*My 1980s*"; "Rivers *and Just Above Midtown*"; "*The Wailers and Bruce Springsteen at Max's Kansas City, July 18, 1973*"

Statement for Moira Roth re: *Art Is . . .* , 1983 (2007)

In the course of an email exchange with the feminist art historian and critic Moira Roth, O'Grady sent Roth a copy of Lucy Lippard's review of *Art Is . . .* , which had appeared in *Z Magazine* in 1988.[1] Roth's questions prompted O'Grady to elaborate on the making and meaning of the performance.

APRIL 27, 2007

Dear Moira,

Besides working on the piece for Artpace, every day I am trying to do at least one thing for the website. Last night, I typed out the piece Lucy Lippard wrote in 1988 in *Z Magazine* on *Art Is . . .* , a performance I did in the Harlem parade. Reading back through 20 years of an archive is like passing yourself on a train going in the opposite direction.

Lorraine

Dear Lorraine,

This is a piece (would you call it a performance? or?) that I know of, albeit mainly as a single image . . . so it is a pleasure to see the admirably complex reading of it by L[ucy] L[ippard]. Could you tell me a little more about the history of *Art Is* . . . ?

How and why did you come up with the idea? Were you living in New York? In Manhattan or Harlem or? What artists did you know, feel close to at the time? Writers? Critics? Historians? Activists? And/or . . . ? Who else had written about your work at this time?

Moira

Dear Moira,

I'm not surprised when people don't know much about *Art Is* . . . I did it during my "Duchamp" years. At the time, I was teaching the Dadas and the Futurists at SVA and thinking of myself as a purist. Because the piece wasn't addressed to the art world, I didn't advertise it. I've changed a lot since then! The answers to your questions are fairly intertwined.

When I did the piece I was living in the West Village, in the same building where I'd been living since arriving in New York via Chicago in '72. . . . I'm definitely a "downtown" type and had dreamt of being in the Village since I was ten years old. When I was a teenager in the late '40s growing up in Boston, I would devour magazines with pictures of girls in long black skirts, black turtlenecks, and black berets, drinking espresso and puffing on cigarettes in 4th Street cafes.

By late 1982, I'd been "out" as an artist for more than two years and had been invited by the Heresies collective, not to join the mother collective, but to work on issue #13 of their journal, the one that was named "Racism Is the Issue."[2] The "issue" collective was a mixed group of artists and non-artists that included Ana Mendieta, Cindy Carr, Carole Gregory, Lucy, and many others. It was a fractious group. One of the women in it was a black social worker whose name I don't recall. I only remember that one evening at a meeting she said to me scathingly: "Avant-garde art doesn't

have anything to do with black people!" I didn't know how to answer her, but I wanted to prove she was wrong.

Her comment stayed with me. But where would I find the "black people" to answer her?

Perhaps because I am West Indian and a great believer in Carnival, the idea of putting avant-garde art into a parade came to me. But I knew instinctively that I couldn't put it into the West Indian Day Parade in Brooklyn. There was so much real art in that parade it would drown out the avant-garde! So I decided on the Afro-American Day Parade in Harlem, which was comparatively tame and commercial—you know, ooompa-ooompa marching bands and beer company adverts. My first idea was to mount several pieces on a parade float and just march it up 7th Avenue. But when I went to rent a flatbed from the company in New Jersey that supplies them, the owner told me: "You know, you have a maximum of three minutes, from the time a float comes into view on the horizon, stops-and-starts, then is out of sight at the other end." That shook me. So I switched, from putting art into the parade to trying to create an art experience for the viewers. I asked the artists George Mingo and Richard DeGussi to help me. They built a 9 × 15 foot antique-styled, empty gold frame on the flatbed, which we covered with a gold metallic-paper skirt that had "Art Is . . ." in big, black letters on both sides. Then I put an ad in *Billboard* and hired fifteen gorgeous young black actors and dancers, male and female, dressed them in white, and gave them gold picture frames of various styles and told them to frame viewers along the parade route. They did this while hopping on and off the parade float, according to how fast it was moving or whether it was stalled.

The piece was done in 1983, with a grant from the New York State Council on the Arts, but as I said, it was done during my "Duchamp" years. Hahaha. I told the people at Just Above Midtown, the black avant-garde gallery I showed with, and the women in the Heresies racism collective knew about it, but almost no one else. The only person I gave slides to was Lucy Lippard, who was in both the Heresies mother and issue collectives and wrote about the piece five years later in *Z*. Lucy later printed two images in her book *Mixed Blessings*. But nothing else happened with that piece. I was shocked when, a few years ago, Johanna Drucker asked me for slides for a book she was writing. I thought no one had noticed.

It's funny. The organizers of the parade were totally mystified by me and by the performance.

The announcer made fun of the float as it passed the reviewing stand: "They tell me this is art, but you know the Studio Museum? I don't understand that stuff."

But the people on the parade route got it. Everywhere there were shouts of: "That's right. That's what art is. WE're the art!" And, "Frame ME, make ME art!" It was amazing.

Lorraine

See also *"Interview with Amanda Hunt on* Art Is . . . , *1983"; "My 1980s"; "The* Mlle Bourgeoise Noire *Project, 1980-1983"*

Body Is the Ground of My Experience, 1991
Image Descriptions (2010)

For a 1991 show in the art gallery at INTAR (International Art Re-
lations, Inc., one of the longest-running Latino theaters in the
United States), O'Grady wrote the following paragraphs about the
photomontages on display from her series *Body Is the Ground of My
Experience*. These included *The Clearing*, one of her most important
(and often misunderstood) works. In these texts, O'Grady points
out the difference of her approach to that of Dada and surreal-
ist artists—rather than the randomness produced by unexpected
juxtapositions or dream images, her compositions made argu-
ments by twisting rational sources, so that unfamiliar subjective
material of the "other" might enter. O'Grady uses the term "col-
lapsed diptychs" in some of her descriptions, referring to images
that, while consisting of only one panel, incorporated a "both/and"
structure in their subject matter and formal composition.

Body Is the Ground of My Experience
Black-and-white photomontages, varied sizes, 1991

Diptychs

THE CLEARING: OR, CORTÉS AND LA MALINCHE, THOMAS
JEFFERSON AND SALLY HEMINGS, N. AND ME.

The diptych presents the both/and extremes of ecstasy and exploitation of this troubled and still undertheorized historic relationship. In the left panel, a naked couple deliriously "floats on air" above the trees while in the clearing below two mixed-race children play near a forgotten pile of clothing where a gun rests, threatening the scene. In the right panel, the skull-headed male figure proprietarily grasps the passive female's breast.[1] He is clothed in tattered chain mail as if to argue that this foundational relationship of the Western Hemisphere, and its attendant duplicities, were the death of medieval "courtly love."

DRACULA AND THE ARTIST. LEFT PANEL: "DREAMING
DRACULA." RIGHT PANEL: "DRACULA VANQUISHED BY ART."

The image in the left panel, "Dreaming Dracula," shows a black woman with broken, unkempt hair, dressed in a loose white shift. Her attention is focused on the flight of broken-toothed combs descending toward her on a shaft of light. To the right, in the panel "Dracula Vanquished by Art," the same woman sits at a small wood table writing on a pad. Though there is a desk lamp, the illumination seems to come from the table itself, and her hair, still broken but now more "intentional," is haloed by its light. The flight of combs lies spent in a corner of the room.

Collapsed Diptychs

THE FIR-PALM

The foliage of a New England fir tree grows from a tropical palm trunk that in turn springs from an African woman's navel. Before becoming a photomontage, this botanical conceit for the artist's cultural background was originally a prop in the 1982 performance *Rivers, First Draft.*

The artist's mother Lena (second from left) and her maternal and paternal aunts have been montaged from photos dating from 1915 to 1925, the great period of West Indian migration to the United States. They are sprouting from a New England mansion of the type they had to work in as ladies' maids when they first arrived. The mansion-on-wheels rolls down the African woman's back.

LILITH SENDS OUT THE DESTROYERS

Destroyer-class warships spray out from the African woman's crotch, but some return to wound the woman herself. Lilith, the African model for *Body Is the Ground of My Experience*, coincidentally shared the name of Adam's first wife, who, having been created at the same time and from the same clay as Adam, felt herself his equal. Lilith refused to submit to Adam, instead left Eden and was replaced by Eve.

She then gave birth to 100 babies a day by countless lovers of her choice, causing trouble in the world.

GAZE AND DREAM

Models from the arts were elements of an idealized portrait of reality and potential.

In GAZE they were asked, for the outer figure, to express a combination of anger and contempt—the kind of look they might have if they thought someone were stupid, but couldn't say so; and for the inner figure, quiet pleasure, as if a secret thought had made them smile to themselves.

Those in DREAM were asked to pretend, for the outer, that they were having a light and amusing dream; and for the inner, to imagine themselves submerged in deep spiritual trance.

GAZE info: *Gaze 1* was a sculptor and performance artist; *Gaze 2*, a jazz band leader; *Gaze 3*, a choreographer; and *Gaze 4*, a classical music composer.

DREAM info: *Dream 1* was an art historian; *Dream 2*, a painter and installation artist; *Dream 3*, a costume conservator; and *Dream 4*, a sculptor.

> **See also** *"Black Dreams"; "Olympia's Maid: Reclaiming Black Female Subjectivity"; "On Being the Presence That Signals an Absence"; "Two Exhibits: The Diptych vs. the Triptych and Notes on the Diptych"; "Interview with Laura Cottingham"; "Introducing: Lorraine O'Grady and Juliana Huxtable"*

Studies for a Sixteen-Diptych Installation to Be Called *Flowers of Evil and Good*, 1995–Present (1998)

The following is an artist statement for the first showing of studies #3 and #4 from O'Grady's series *Flowers of Evil and Good* in 1998 at Thomas Erben Gallery in New York City. O'Grady's text sees a postmodernist context for the relationships between the father of modernism, Charles Baudelaire, and a later modern, Pablo Picasso, as well as that between two women whom she sees as postmodern: Baudelaire's Haitian-born common-law wife, Jeanne Duval, and O'Grady's own mother, the Jamaican-born Lena. O'Grady had taught a course at the School of Visual Arts in New York on the subject of nineteenth-century French poetry, and on Baudelaire in particular, since 1976, before her first forays into performance. The title of O'Grady's series is a play on the poet's most famous collection, *Les Fleurs du mal* (*Flowers of Evil*). As a project, *Flowers of Evil and Good* has remained at the level of "studies"; O'Grady revisited the ideas first elaborated here in her 2010 project for the Whitney Biennial, *The First and the Last of the Modernists*, which juxtaposed Baudelaire with the King of Pop, Michael Jackson.

CHARLES BAUDELAIRE is often referred to as both the West's first modern poet and its first modern art critic. It would be no exaggeration to say that Baudelaire created his most important poetry out of his responses to an al-

legedly destructive relationship with Jeanne Duval, his black common-law wife of 20 years. A close reading of his poetry would indicate that he may also have developed his aesthetic theory, that of a beauty which is contradictory and ambiguous and of its time, based on the example she provided as well.

Les Fleurs du mal (*Flowers of Evil*), published in 1857, was a turning point for European poetry, like that given painting 50 years later in Picasso's *Les Demoiselles d'Avignon*. Each work embodies the psychologically complex ways modernism constructed itself out of Europe's encounter with the worlds it colonized. Seen in this way, *Les Fleurs du mal* is the more interesting: whereas the *Demoiselles* struggled to contain already mediated forms of art, *Flowers* was dealing with the body and psyche of a live and messy human being.

None of Duval's own words remain: she does not speak for herself in Baudelaire's poetry or prose, and there is an indication that Charles' mother may have destroyed her letters to him.[1] In addition, there are no civil documents permitting a reconstruction of her life, though most evidence points to her having emigrated to Paris from Haiti in the 1830s. They met in 1842, when Baudelaire was 21 and she was possibly the same age.

The language component of the final installation, *Flowers of Evil and Good*, each of whose 16 diptychs contains one panel representing Baudelaire and one Duval, will be in sustained disequilibrium: Charles speaks in poetry, Jeanne "speaks" in prose.

On Baudelaire's side of the diptychs, the language is taken from my own translations of *Les Fleurs du mal*—I found it necessary to do my own because later translators, like the critics, erased and demonized Jeanne in a way that Charles had not. On the Duval side, her words are a fiction, written by me, to fill the silence of this woman-without-speech, and I know that I am as guilty as Charles. I too am using Jeanne. Perhaps to understand my mother, Lena—who emigrated from Jamaica to Boston in the 1920s, when little had changed for the metropolitan woman of color—and, in turn, to understand myself.

Jeanne's demonization began almost immediately in the memoirs of Baudelaire's friends and has continued for 150 years to a greater extent in the writings of his critics. Joseph D. Bennett, in a book published by Princeton University Press in 1944 and frequently reprinted, in describing Baudelaire as a Louis XV out of time, made the following extreme but symptomatic statement: "This Bourbon Louis took his pleasures not in the Parc au Cerfs but in a cheap furnished room with a mulattress. His *lever* was elaborate; he took two hours to perform his immaculate toilette every morning. But the only courtier was the maniac on the bed, the raucous gesticulat-

ing Jeanne, rolling her white nigger eyeballs, chattering incoherently like a monkey."[2]

Charles often admitted his need for her—and his debt to her—speaking in one prose poem of "his beloved, delicious and execrable wife, that mysterious wife to whom he owed so many pleasures, so many sorrows, and perhaps too a large part of his genius."[3]

Because Baudelaire was a great poet, even at his angriest and most petty, although Jeanne is presented externally it is surprising how well she may be discerned by the sympathetic reader, not just in the "Black Venus" cycle but throughout *Les Fleurs du mal*. I am not so much interested in the literal Jeanne as in the figurative one—the hybrid woman caught up in the dilemmas of diaspora. We all are now from some other place, trying to orient ourselves, using and being used, struggling to gain a foothold.

One frustration in trying to present Jeanne and Charles's relationship as that of a complex couple at a particular historical moment, i.e., the apex of Europe's political and cultural empire, is that the attempt to show them as pictorial equals is constantly subverted. Baudelaire was photographed by some of the greatest photographers of the day—Neys, Carjat, and Nadar— but all we have of Duval is a few casual pen-and-ink drawings by Baudelaire himself and an indifferent painting by Manet from the end of her life. For me, layering images of Charles and Jeanne with that of Picasso's *Les Demoiselles d'Avignon*, while hardly eliminating the obvious differentials in power, is a way to show that they were both subject to forces outside their control. Another device for equalizing Jeanne and Charles's humanity is the use of color: a single hue across each of two panels, changing from diptych to diptych throughout the installation, with the colors also taken from *Les Demoiselles*.

It's not a fair match. Charles is the master of a tongue charged with the power of its historical moment; he can afford the luxury of exploring his language's vulnerabilities. Jeanne's struggle is for a language to comprehend a situation which has, for all purposes, never before existed: a post-modernist condition in a modernist time. As a chart of her struggle, her side of the diptychs may often be difficult to read, wavering between obscurity and clarity. For the viewer, this is a project in which she may or may not succeed.

Study #3, digital Cibachrome diptych, each panel 40" × 30", 1998

Red Jeanne Duval

BACKGROUND TEXT

The place not what I expect, it lonely and cold. Windows stare, courtyards close, doors frown. If I could I would go home, stretch out my hair like a bridge and cross the abyss.

HEADLINE

stretch out my hair like a bridge

Red Charles Baudelaire

BACKGROUND TEXT

Her belly, her breasts, those grapes on my vine, moved forward, cajoling more than angels of evil, disturbed my soul from its sleeping retreat, tumbling it from the rock-crystal throne where, calm and alone, it was seated.

HEADLINE

tumbling my soul from the crystal throne

Study #4, digital Cibachrome diptych, each panel 40" × 30", 1998

Yellow Jeanne

BACKGROUND TEXT

They said, he'll use you. I said nothing happen unless you take a chance in this world. When he touch me, my skin felt like it scraped by stars.

HEADLINE

he scrape my skin with stars

Yellow Charles

BACKGROUND TEXT

I prefer to opium, to wine, to aperitifs the elixir of your mouth where love dances the *pavane*; and when, by caravan, my desire sets out for you, your eyes are the well where my boredom drinks.

HEADLINE

your eyes the well my boredom drinks

> **See also** *"Two Biographical Statements"; "*Nefertiti/Devonia Evangeline, *1980"; "Interview with Cecilia Alemani: Living Symbols of New Epochs"; "On Creating a Counter-confessional Poetry"; "Olympia's Maid: Reclaiming Black Female Subjectivity"; "Some Thoughts on Diaspora and Hybridity: An Unpublished Slide Lecture"*

2 Writing in Space

Performance Statement #1
Thoughts about Myself, When Seen as a Political Performance Artist (1981)

O'Grady wrote the following text in response to a request for her thoughts on politics in art by the curator and critic Lucy Lippard, who had invited her to perform in "ACTING OUT: The First Political Performance Art Series." The series was held at the Elizabeth Irwin High School in Soho in February and March 1981; Martha Rosler, Stan Baker, Suzanne Lacy, and Laurie Anderson were also included in the lineup. O'Grady's letter, which has not been published previously, was her first written statement on her work in performance and introduces two important themes: the productive value of anger, and the idea of her split or doubled subjectivity. In discussing the latter, one sees hints of what would emerge as a major conceptual and formal element of her work—that of the diptych.

YOU'VE ASKED ABOUT my political concerns . . . I guess I experience art as a way of discovering what I really think and feel. In an odd way, I also look to art to help me define my political beliefs. I find it so much easier to know what I'm *against* (monopoly capitalism, personal and social cruelties of every kind) than to know what I'm *for*. But the achieving of aesthetic form frequently gives me something in which I can believe, about which I can feel, "This is true." And because, more often than not, the aesthetic process is

set in motion by an angry response to a political perception, the result has frankly political implications.

As an advantaged member of a disadvantaged group, I've lived my life on the rim—a dialectically privileged location that's helped keep my political awareness acute. But the main reason my art is "political" is probably that anger is my most productive emotion. I think that, for me, politics will always be more a matter of emotion than ideology—and I say that in spite of the fact that I was trained in the social sciences (for several years I was a career officer with the U.S. Departments of Labor and State) . . .

But certainly no one is going to go out and man the barricades after seeing a piece by me (at least, none that I've produced so far). My work is too complex for that kind of response. And where the critique gets most specific, the audience is often most limited (as in *Mlle Bourgeoise Noire*'s criticism of black art that doesn't take risks).[1] Performance is the art form with the most limited audience, and my part of it is even more so. To believe that a performance piece, or even Performance, can have a political effect is like having a Great Man theory of history. The most I really expect my work can accomplish politically is a small contribution to the task of creating a climate of questioning and refusal.

The reasons I go on with Performance are two: first, because I'm stuck with it. It's the only art form I feel capable of both mastering and expanding aesthetically. And second, because I believe it is an acceptable political option. I'm convinced the struggle for a just society is a kaleidoscopic one that has to be fought in all shapes and colors simultaneously. An upper-middle-class black woman making art that insists on cultural equality performs just one necessary political function.

I confess [that] in my work I keep trying to yoke together my underlying concerns as a member of the human species with my concerns as a woman and black in America. It's hard, and sometimes the work splits in two—within a single piece, or between pieces. But I keep trying, because I don't see how history can be divorced from ontogeny and still produce meaningful political solutions. (I'm referring to the long-range result of the work, of course, not to what I actually do.)

. . . As I said, I'm sure my art will always be political because of who and what I am. And I seem to get my best political ideas when looking for aesthetic solutions.

See also *"Dada Meets Mama: Lorraine O'Grady on WAC"; "Flannery and Other Regions"; "Responding Politically to William Kentridge"; "Two Exhibits: The Diptych vs. the Triptych and Notes on the Diptych"; "Introducing: Lorraine O'Grady and Juliana Huxtable"; "A Day at the Races: Lorraine O'Grady on Jean-Michel Basquiat and the Black Art World";* "The Black and White Show, *1982"; "Email Q&A with* Artforum *Editor"; "The* Mlle Bourgeoise Noire *Project, 1980–1983"*

Performance Statement #2
Why Judson Memorial? or, Thoughts about the Spiritual Attitudes of My Work (1982)

In a letter dated October 27, 1982, O'Grady proposes to restage
***Rivers, First Draft* at the Judson Memorial Church, a venue with an**
important avant-garde history of dance and performance. The
text illuminates the rarely noted spiritual aspects of O'Grady's
art—in content, concept, and form—and articulates why her work
often centers on radical disjunctions: she does not aim to resolve
difference, fragmentation, or division, or to achieve a simplistic
synthesis of these elements; rather, she hopes to make space for
the coexistence and preservation of contradiction.

I HAVE PURELY performance reasons for wanting to do *Rivers* at Judson Memorial. The first is my feeling that *Rivers* is important, ambitious work that should play in a significant space. A more practical reason is the spatial requirement of the piece itself. *Rivers* is designed on the ancient theme of The Crossroads (particularly important in Haitian Vodoun). It needs an upper and lower playing level, so the piece can develop on a visual vertical while, at the same time, having a horizontal line that clearly divides "above" from "below." The raised altar of Judson's sanctuary would provide this. In addition, the piece's deliberately tempestuous soundtrack demands good acoustics. Though not perfect, Judson would work well.

Another reason for my choice of Judson has to do with the content of the

piece. Although the work for which I've become known is heavily political, throughout all of it there has been an underpinning of religious concern—as in the funeral ritual of *Nefertiti/Devonia Evangeline*, or the water symbolism and hymn singing of *Rivers, First Draft*. Sometimes the religious concern disappears into the purely aesthetic—for instance, the chasuble-like design of Mlle Bourgeoise Noire's cape. As a child of Jamaican immigrants, I was raised an Anglo-Catholic, or High Episcopalian, and I have been permanently influenced by the church's attitude toward ritual and form.

The "religious attitude" is an involuntary aspect of my mental landscape. I've long since renounced the church, but my life and work are marked by a quest for "wholeness," a variant, I guess, of the old spiritual search for significance in the cosmos. As a good post-modernist, I undertake the quest for "wholeness" and "meaning" knowing that it's doomed. But I can't help harboring a secret hope that I will be able to achieve psychological and artistic unity. The predominant aesthetic of my work is that of collage, i.e., of disparate realities colliding, of fragmentation and multiple points of view (I teach a course in Futurism, Dada, and Surrealism at SVA), but with me, the collage aesthetic reflects a desire to unify and contain *everything*. It isn't intended to be merely descriptive; it is never a capitulation to the fragmentation and division.

The governing aim of my work is to undermine the concept of opposites, and my subject matter often deals with this explicitly, as in the equivalence between past and present in *Nefertiti/Devonia Evangeline*; between the West Indies and New England in *Rivers, First Draft*; and between aspects of the divided self in *The Dual Soul* and *Indivisible Landscapes*.[1] In the work's form as well, I try to create work that is both abstract and concrete, which is to say, both formally beautiful and capable of delivering specific intellectual and political content. I try to find formal ways to combine an obsession with autobiography and the inner life of dream and myth with my attitude of political intransigence (you might say I am both a Jungian and a Marxist in my fashion). But the work proceeds in this direction only awkwardly: I am aiming for the "perfect balance" between personal and political, abstract and concrete, and whenever the work is too heavily weighted toward one or the other—which it most often is—I feel that I have failed. But I keep trying to juggle all of these elements.

Although I hope to make *Rivers* a much less personal and a more political piece than was *Rivers, First Draft*, at the same time, my main reason for wanting to perform it at Judson Memorial is my even greater desire to have both

the personal and political content of the piece interact so strongly with the religious nature of the church's space that they will produce a result larger than either the personal *or* the political.

See also *"Interview with Linda Montano"; "Sketchy Thoughts on My Attraction to the Surrealists"; "Rivers and Just Above Midtown"*

Performance Statement #3
Thinking Out Loud: About Performance Art and My Place in It (1983)

The following is a letter to Tony Whitfield, written in preparation for an interview that was to appear in Just Above Midtown's *Afro-Pop* exhibition catalogue. The text reflects very directly on the inextricable connection between O'Grady's artistic practice and her work as a writer (including her training at the Iowa Writers' Workshop). She describes her fraught relationship to the term "performance art" and instead calls her practice "writing in space." The letter is remarkable for O'Grady's self-awareness as an artist just a few years into her career: both when it comes to the specificity about the multidisciplinary artists whose work might resonate with hers (Adrian Piper, Robert Wilson, Ping Chong, and—with a great deal of ambivalence—Vito Acconci), and in her understanding of the futurity of her ideas and her audience.

I Am Not a Performance Artist

I have a problem with the name "performance." That's what Vito Acconci called the things he did, which came out of Erving Goffman's theories, and I suppose historically we are stuck with it.[1] But my own work has so little to do with "performance" and "self-presentation" that I may soon stop performing and write and direct my pieces exclusively.

If pressed to describe what I do, I'd say that I am *writing in space*. I guess

that comes from being trained as a writer (I went to the Iowa Writers' Workshop, etc.). But I was never able to accommodate to the linearity of writing. Perhaps I'm too conscious of the stages I've lived through and the multiple personalities I contain. I think I'm also too aware of the interstices between consciousness and the unconscious: I have a dream journal that goes with my day journal, and it now has 175 totally recalled dreams with elaborate responses to them. The fact is, except for the lyric poem, writing is the art form most closely bound to time; but to layer information the way I perceived it, I needed the simultaneity I could only obtain in space.

I haven't stopped writing or thinking literarily; but for now, performance is the way I write most effectively. To me, *Mlle Bourgeoise Noire* is actually a didactic essay written in space, while the form of *Nefertiti/Devonia Evangeline* approximates that of a book—a family photo album, interlaced with personal reminiscence and ritual. And, to overextend the metaphor, there is a sense in which *The Dual Soul* is a duo of short stories, *Rivers, First Draft* is a folktale, and *Indivisible Landscapes* an epic poem. But now I think I'm getting pretentious. I don't know what form *Fly By Night* (the performance I'm doing at Franklin Furnace on Feb. 10) will take, because I haven't written it yet. But I'm already working on a novel-in-space, my next big project after *Indivisible Landscapes*.

I also think visual artists and writers who've gone "live" have moved into a dimension where our native vocabularies no longer apply (no wonder we're usually incoherent!). Visual artists, in venturing out from space-bound art forms into the area of time, are as ill at ease and inept in dealing with sequentiality as a writer like myself is in handling space. And what's more, neither of us has the time or desire to master the vocabulary of the dimension that is new to us. We're too busy "grokking" on the ways the new dimension is modifying our original vocabulary: in my case, the ways in which space transforms the possibilities of narrative. We may even fear that mastering the new vocabulary would make us miss what's most vital and important in the amalgamation we are now uncovering. This is why I insist on calling my work "amateur." And I question whether well-trained, accomplished performing artists who use mixed media can have the common denominator I've just described here.

"Performance," as I conceive it and as it most interests me, has nothing to do with a simple multiplication of media. In its most profound sense, "performance" is a matter of artists shifting *dimensions*, putting themselves at risk by changing their accustomed relation to space/time. For all that dancers, mimes, musicians, and stand-up comedians have been taking advantage of the audiences that performance artists have softened up for them by doing

pirouettes and taking pratfalls in a now crazily disoriented space/time, the relation of these other artists, both to the audience and to space/time, remains the same. Dancers, for instance, who use multi-media are adding new props, but they are still trained bodies moving in space, no matter how outrageously. This is why they offer more audience satisfaction and are more traditionally successful than artists and writers doing performance. And why they are much less interesting.

To me, "performance" artists are explorers, primarily motivated by the sense of play. They leave to others the production of perfect artworks. At its best, "performance" is dedicated to uncovering possibilities, to enlarging what is known about both old and still-unnamed art forms. I think the high point of performance by *visual* artists came in the late '60s and early '70s, with the work of Smithson, Oppenheim, Acconci, and Piper. Although feminist agit-prop performance of the mid-'70s was politically exciting, it had almost nothing to do with the disinterested exploration of art forms.

I suppose the reason I still find "performance" a viable mode is that performance by *writers* (and I'm excluding Acconci here) has up to now accomplished so little that's theoretically or artistically exciting. I'd like to discover new lands of narrative, lands whose shape I won't be able to imagine until I get there. If there's any time left, I'll try to explore and map the territory.

I Have Many Influences, but None That I Can Follow

Perhaps because I think of myself more as a live writer than a live artist, I haven't found any influences I could incorporate directly. But there have been lots of inspirations. Lucy Lippard's book *Six Years: The Dematerialization of the Art Object* hit me like a bolt of lightning.[2] It made me see for the first time that "I could do that too." And whenever I read an issue of *High Performance* I still tingle with the original electricity.

But intellectually, the most solid and long-lasting inspirations have been the works of F. T. Marinetti, Tristan Tzara, and André Breton. And Duchamp, of course, who subsumed them all. I do feel that Futurism, Dada, and Surrealism, though encapsulated in art history, are movements the 20th century hasn't come to grips with. And they are still conductive. I know this from gauging students' reactions when I teach my course at SVA. As for me, I never go far without re-touching base with those guys. Fortunately, there's a long way to go before the "law of diminishing returns" sets in with avant-garde literature the way it has in avant-garde visual arts, and to some extent in avant-garde theatre. I like those old guys for their warrior spirit.

Aesthetically, for ideas as opposed to inspiration, there have been far fewer places to turn to. I suppose the work that's been most helpful, particularly with respect to the treatment of dream-based material, has been Robert Wilson's (I've never seen it but I've read about it in depth) and Ping Chong's.[3] Wilson shows what could be accomplished with unlimited time and funding, while Chong helps me see what is do-able here and now. I like the cleanness of their visual presentation, their layering of conscious and unconscious material, their grasp of myth and folktale, and especially, in Chong's case, the willingness to take intellectually difficult approaches. They give me permission to do what I would have done anyway. If nothing else, it's convenient to be able to say to someone who's never seen or doesn't know how to place my work, "Have you seen anything by Robert Wilson? His *Deafman Glance* gave *Rivers, First Draft* permission to be." Or, "Ping Chong is the artist my work is closest to in intention, though not in style." That's glossing it, of course. It establishes a false lineage that makes people feel comfortable and gives me courage. If those others are out there, then I can't be crazy. But the fact is, my work has always proceeded out of its own necessities. I didn't know anything about either Wilson or Chong until after I did *Nefertiti/Devonia Evangeline.* And I'd never heard of either of them when I wrote *The Dual Soul.*

Personally, though, the two artists who've been most important to me are Vito Acconci and Adrian Piper. Acconci, not because of his work (which I find bullies and manipulates the audience in a way I consider fascist), but because of the guts he had as a poet in declaring himself as a visual artist. Knowing that Acconci had been in the Humanities Department at SVA, had been teaching the same First Year English course that I was teaching when he nominated himself a "performance artist," and that he had got the art world to take him seriously, was critically important to me. It fed into my own "I-can-do-anything-and-succeed" brand of arrogance.

But Piper's example has been the primary one. Although her *Catalyses* are totally beyond my temperamental capability, they were the pieces that most impressed me in Lippard's *Six Years.* I'd circled them three times because they were the most radical art project of which I could conceive. But years later, in 1980, to accidentally pick up an old copy of *Heresies #8 (Third World Women)* and read her "Political Self-Portrait #2" and discover that she was black, and that her socio-cultural experience was a duplicate of my own—I can't tell you what an effect that had on me! Not only could I admire her work, but here was a woman I could completely identify with as a black/white artist, or, as Adrian prefers to say, "grey." We've disagreed with my use of the word

"mulatto": I believe in wearing the badges of oppression proudly. But black/white, grey or mulatto, whatever you call it, from that moment, my acquaintance with Adrian Piper and her brilliantly provocative art helped me stop feeling alone. Sadly, there have been too few opportunities to see it. I really only know what I've seen reproduced.

Who Is the Audience?

Work can't exist alone any more than the artist can.

There's a wonderful passage in Heidegger where he speaks of the need for "preservers," that combination of presenters, critics, and audience required for the work to come into *existence*, into *being*, after it has been created by the artist. He describes that group's function as "preserving the work, as *knowing*" (my emphasis).

I take that to mean that it's a matter of who understands the work, who needs the work in order to *be* themselves. Right now, my goal is to discover and create the true audience, and something tells me that, for a black performance artist of my ilk, this will take a many-sided approach. Because I sense that the true audience may be *coming*, not here now, I try to document my work as carefully as I can. It may seem odd for a performance artist to be concerned with the preservation of the work. But despite my devotion to the fluidity of performance, its privatistic and ephemeral aspects have never interested me much.

Instead, I'm concerned about the future audience of the work, about those who *will know*. In this regard, I've received solace and encouragement from a passage in Heidegger I'd like to quote in full (God knows, with his peculiar diction Heidegger is difficult enough to understand in context, and out of context, probably impossible. But if you just think of his words as poetry, I think you'll get what he means). It's a passage that gives philosophical underpinning to something I intuit . . . that the work requires an audience who, whether or not they are *like me*, can see what I see. For Heidegger, those who preserve the work *know* the work in the deepest way:

> This knowledge, which as a willing makes its home in the work's truth and only thus remains a knowing, does not deprive the work of its independence, does not drag it into the sphere of mere existence, and does not degrade it to the role of a stimulator of experience.
>
> Preserving the work does not reduce people to their private experiences, but brings them into affiliation with the truth happening in the

work. Thus it grounds being for and with one another as the historical standing-out of human existence in reference to unconcealedness. Most of all, knowledge in the manner of preserving is far removed from that merely aestheticizing connoisseurship of the work's formal aspects, its qualities and charms.

Knowing as having seen is a being resolved; it is *standing within* the conflict that the work has fitted into the rift. (Emphasis mine)[4]

Of course, preservation at this level is difficult for any artist to find. Such *standing within* can only be achieved through the profoundest identification with the work: not just with its form, but with its content as well. And it's precisely this sort of identification that is hardest for the avant-garde black artist to come by. For one can only succeed in *knowing* at this depth if one is seeking to know his/her *self*.

My experience has been that the audiences for my pieces have been typically elite, with a fairly good mix of both black and white artists and intellectuals. But though a large cross-section have liked and appreciated the work, the most multi-dimensional "knowing" hasn't come from a formal eye or a grounding in avant-garde art forms (although both may be requisite). It's come from the intellectual and emotional need to find a "home in the work's truth." Those who've understood the work best have been primarily women, particularly black women such as the critics Gylbert Coker and Patricia Jones.

But I don't take this as a permanently limiting condition of the work. The problem as I see it is simply that, so far, the context of black art hasn't been broad enough for either whites or blacks to become so familiar with it that they can cross the barriers of race and sex to seek themselves—the way anyone can in a Jewish novel, for instance, or even in a Merce Cunningham dance concert. At the moment, individual black performance artists are still exotic oddities. But already this is beginning to change. Just this season we've seen the *Parallels* series of six avant-garde black choreographers at Danspace.

That's why I find the prospect of the Afro-American Pop Culture performance series so exciting (even if it *does* include dancers and mimes!). The idea of II to I3 of the best black performance artists in America being presented at one time, of a context finally being established, makes it possible to imagine a day when we can stop being unique and simply concentrate on doing our work. A day when, finally, the "preservers" will no longer be "coming" but will already be there.[5]

See also "Rivers, First Draft, *1982: Working Script, Cast List, Production Credits*"; "Nefertiti/Devonia Evangeline, *1980*"; "*On Creating a Counter-confessional Poetry*"; "Mlle Bourgeoise Noire *and Feminism*"; "*The* Mlle Bourgeoise Noire *Project, 1980–1983*"; "*First There Is a Mountain, Then There Is No Mountain, Then . . . ?*"

Nefertiti/Devonia Evangeline, 1980 (1997)

This article was written for a special issue of *Art Journal* on the topic of performance, edited by the artist and Franklin Furnace founder Martha Wilson. It focuses on O'Grady's work *Nefertiti/Devonia Evangeline*, a performance pairing the image of the artist's deceased older sister and the ancient Egyptian queen, and that performance's relationship to her later photo installation on the theme, *Miscegenated Family Album*. *Nefertiti/Devonia Evangeline*, along with *Miscegenated Family Album* and *Flowers of Evil and Good*, explored personal histories via larger cultural and historical narratives, insisting on seeing even the most intimate, psychological aspects of the self as shot through with colonial, racist, and misogynist power.

IN 1980, when I first began performing, I was a purist—or perhaps I was simply naive. My performance ideal at that time was "hit-and-run," the guerilla-like disruption of an event-in-progress, an electric jolt that would bring a strong response, positive or negative. But whether I was doing *Mlle Bourgeoise Noire* at a downtown opening or *Art Is . . .* before a million people in Harlem's Afro-American Day Parade, as the initiator, I was free: I did not have an "audience" to please.

The first time I was asked to perform for an audience who would actually pay (at Just Above Midtown Gallery, New York, in the "Dialogues" series,

1980)—I was nonplussed. I was not an entertainer! The performance ethos of the time was equally naive: entertaining the audience was not a primary concern. After all, wasn't it about contributing to the dialogue of art and not about building a career? I prepared *Nefertiti/Devonia Evangeline* in expectation of a one-night stand before about fifty cognoscenti and friends. It was a chance to experiment and explore. Performance's advantage over fiction was its ability to combine linear storytelling with nonlinear visuals. You could make narratives in space as well as in time, and that was a boon for the story I had to tell.

My older sister, Devonia, had died just weeks after we'd got back together, following years of anger and not speaking. Two years after her unanticipated death, I was in Egypt. It was an old habit of mine, hopping boats and planes. But this escape had turned out unexpectedly. In Cairo in my twenties, I found myself surrounded for the first time by people who looked like me. This is something most people may take for granted, but it hadn't happened to me growing up in the 1940s in "virtually" all-white Boston or visiting my godparents in "virtually" all-black Harlem. Here on the streets of Cairo, the loss of my only sibling was confounded with the image of a larger family gained. When I returned to the States, I began painstakingly researching Ancient Egypt, especially the Amarna period of Nefertiti and Akhenaton. I had always thought Devonia looked like Nefertiti, but as I read and looked, I found narrative and visual resemblances throughout both families.

Though the invitation to perform before a seated audience at Just Above Midtown was initially disconcerting, I soon converted it into a chance to objectify my relationship to Dee by comparing it to one I could imagine as equally troubled: that of Nefertiti and her younger sister, Mutnedjmet. No doubt this was a personal endeavor; I was seeking a catharsis. The piece interwove partly subjective spoken narrative with double slide-projections of the two families. To the degree that the audience entered my consideration, I hoped to say something about the persistent nature of sibling relations and the limits of art as a means of reconciliation. There would be subsidiary points as well: on hybridism, elegance in black art and Egyptology's continued racism.

Some people found the performance beautiful. But to tell the truth, few were sure of what I was up to. Nineteen eighty was seven years before the publication of Martin Bernal's *Black Athena*, and a decade before "museology" and "appropriation" reached their apex. As one critic later said to me, in 1980 I was the only one who could vouch for my images. I will always be grateful to performance for providing me the freedom and safety to work through my

ideas; I had the advantage of being able to look forward, instead of glancing over my shoulder at the audience, the critics, or even art history.

Performance would soon become institutionalized, with pressure on artists to have a repertoire of pieces that could be repeated and advertised. I would perform *Nefertiti* several more times before retiring it in 1989. And in 1994, now subject to the exigencies of a market that required objects, I took about one-fifth of the original 65 diptychs and created a wall installation of framed Cibachromes. Oddly, rather than traducing the original performance idea, *Miscegenated Family Album* seemed to carry it to a new and inevitable form, one that I call "spatial narrative." With the passage of time, the piece has found a broad and comprehending audience.

The translation to the wall did involve a sacrifice. Now *Miscegenated Family Album*, an installation in which each diptych must contribute to the whole, faces a new set of problems, those of the gallery exhibit career. The installation is a total experience. But whenever diptychs are shown or reproduced separately, as they often must be, it is difficult to maintain and convey the narrative, or performance, idea. As someone whom performance permitted to become a writer in space, that feels like a loss to me.

See also "*Studies for a Sixteen-Diptych Installation to Be Called* Flowers of Evil and Good, *1995–Present*"; "*On Creating a Counter-confessional Poetry*"; "*Interview with Linda Montano*"; "*Some Thoughts on Diaspora and Hybridity: An Unpublished Slide Lecture*"; "*Two Exhibits: The Diptych vs. the Triptych and Notes on the Diptych*"; "*Introducing: Lorraine O'Grady and Juliana Huxtable*"; "*My 1980s*"; "*Interview with Jarrett Earnest*"

Interview with Cecilia Alemani
Living Symbols of New Epochs (2010)

**O'Grady's *The First and the Last of the Modernists* was featured in the
2010 Whitney Biennial and generated a great deal of attention.
This interview with Cecilia Alemani was conducted shortly after
the exhibition's opening and appeared in the summer issue of the
Milan-based publication *Mousse*. O'Grady discusses the genesis and
implications of the work, its relationship to her decades of teach-
ing Baudelaire at the School of Visual Arts, and her plans for the
related project *Flowers of Evil and Good*.**

CECILIA ALEMANI I would like to speak in this interview about your con-
tribution to the 2010 Whitney Biennial, the work *The First and the Last of the
Modernists* (2010). The piece is composed of four photographic diptychs de-
picting a seemingly unusual couple: Charles Baudelaire and Michael Jack-
son. The French poet has previously appeared in your work, in particular in
Flowers of Evil and Good, a photo installation portraying Baudelaire and his
black muse, common-law wife Jeanne Duval. Can you tell me about your
fascination for Baudelaire?

LORRAINE O'GRADY I taught a course for nearly two decades here at SVA
in which we read just two books, Baudelaire's *Flowers of Evil* and Rimbaud's
Illuminations.

It was crazy. Each year, I never knew which I would prefer, whose book

I would teach better. It's a generalization, of course, but on balance Charles and Arthur seemed to divide two halves of the human mind, the impressionist and the expressionist, the dada and the surrealist if you will, and I never knew which half of my own mind would dominate when I encountered them. In the end, while I remain more excited, or perhaps I should say intellectually titillated, by Arthur's poetry, Charles captured me on the human level. I couldn't explain all the reasons why. He was a less gifted but more complex poet than Rimbaud, but that wasn't it. When I tried to understand my love for him, the answers seemed pointed toward his bravery, the condition of mind needed to embrace the unprecedented cultural change in Europe, to leap from romanticism to modernism, to carry that flag. And also toward the figure of Jeanne.

ALEMANI What does Jeanne and her relationship with Baudelaire represent for you?

O'GRADY At first I was fixated on their having stayed together for twenty years without either wedding or children, on the diminution of self in maintaining even a dysfunctional relationship so long after sexual obsession has disappeared. But soon I began to see these two aspects of Charles, the relationship with Jeanne and the meeting of modernism's challenges, as somehow connected. So many forces were colliding in Europe when Jeanne and Charles came of age—the chaos of industrialization, sudden shifts of rural populations to the cities, colonies established to shove raw materials into the always open maw of factories, Europe's first real encounter with the "other." Modernism was the aesthetic attempt to understand and control and reflect all of this. In the period of romanticism, it had been so easy to see God in the daffodils, in babbling brooks that ran through the trees. It was still easy even for the artist in cities to view himself as a servant, making art in God's image. But now the city had changed. One had to see God and beauty in homelessness, in the oil slick on a mud puddle, in the noise and greed. And Charles was one of the first who could do this. I suppose you might say that the modernist moment was the first time art had to be made without God, without guideposts. We'd soon see even the alternative to God, rationalist intellect, being discarded as an incomplete tool.

When I tried to understand what qualities helped Charles make the leap from romanticism to modernism so fully, as a poet and art critic, even as a dandy and flâneur, I kept coming back to Jeanne. For sure, Charles's own qualities of intellect and psyche drew him to her in the first place. But as a black woman who has had white partners, I was convinced his alliance (not

just "encounter") with an "other" had given him views into his own culture he might not otherwise have had. Such relationships always prove more than one bargained for. Charles not only observed what Jeanne experienced day to day, he himself once lost a job because of her. It seemed to me that the insider-outsider position he occupied with her, while not a cause, enabled, perhaps made inevitable the completeness of his transition to modernism.

I was fascinated by Jeanne. But the more I looked for her, the more elusive she became. No letters, not even the dozens she must have written in an age without telephones in that spelling Charles ridiculed. His mother seems to have burned them after he died. Her words exist only as paraphrase in his poems, her image remains mostly in his quick sketches on scrap paper. It was discouraging. I wanted to do a piece showing the two as the equals I felt they must have been. I knew her in my bones, but how would Jeanne speak?

ALEMANI Besides your personal admiration for Charles and Jeanne, there seems to be resonances with your own life: you intertwine Jeanne's world with hints to your own mother, Lena.

O'GRADY It may seem odd, but for me as an artist, theory freed the imagination. In the early '90s, delving into the texts of the Birmingham school of cultural theory, Stuart Hall and others, proved a blessing. It gave me not just Jeanne, but something I had not anticipated—it gave me Lena, my mother. We tend to forget how little the world has changed until recently, even with the cataclysm of industrialization. We've had more change since World War II than in all the time before. Lena was 80 years younger than Jeanne, but the world they experienced as fair-skinned black women moving from the Caribbean to the metropole, Jeanne to Paris, Lena to Boston, was substantially the same. Cultural theory shed new light on that world and helped me to feel what it was like. When that happened, things were turned on their head. If most definitions of postmodernism, however contested, contain elements of globalization, diasporic movement of peoples, hybridity of cultures, and increasing gender equality, then while Charles was waging his valiant struggle with modernism, Jeanne was already living a postmodern life. She was closer to me and to current generations than she had been to Charles!

ALEMANI What happened in the piece when you intertwined Jeanne and Lena's histories?

O'GRADY Imagining Jeanne in turn helped me imagine Lena. It's a sad admission to make, but even just secondhand through Charles's poetry, I knew Jeanne better than I knew my own mother. Through his hands, I could guess

at her inner life while Lena remained opaque to me. But you know, like the tinted air you remember swirling between those glass beakers in chemistry class, Lena's Jamaican patois let Jeanne speak. They brought each other to life in an odd reciprocity. And in the diptychs in *Flowers of Evil and Good*, I freely interchanged photographs of my mother and my aunts with Jeanne. It was a shock when I first saw Charles married to Lena that way. But it explained a lot about why Charles and Jeanne had been together so long. I could see that she had led him a merry chase!

ALEMANI Going back to *The First and the Last of the Modernists*, here Baudelaire appears paired with another icon, Michael Jackson, who died in June 2009. According to the title, the work seems to depict the two fathers of our modern culture, the first one a key figure for Western modernism and the latter the king of American pop culture. Are you a fan of Michael?

O'GRADY When Michael died, I couldn't stop bawling like a child, as if a member of my own family were gone. But where had those tears come from? I had been a Prince fan! The piece about Charles and Michael was the culmination of the effort to learn why I'd sobbed so uncontrollably that day.

ALEMANI How did you get involved with his music and his myth?

O'GRADY Before making my first public art work in 1980 at the age of 45 with the performance *Mlle Bourgeoise Noire*, I'd had several careers. My undergraduate degree from Wellesley College was in economics and Spanish literature. I'd been among other things an intelligence analyst for the Department of State, a literary and commercial translator, a civil rights activist, a housewife. But nothing ever satisfied me. In the early 1970s, I left Chicago where I'd lived with my second husband and came to New York to be with a lover who'd managed rock bands and was now head of publicity for Columbia Records.

I didn't want to be just a pretty rock chick, some guy's "old lady" going to parties and concerts. So I began writing about rock and pop music—the first above-ground review of Bruce Springsteen for *The Village Voice*, the first article on reggae published in *Rolling Stone*, a cover story on the Allman Brothers Band, reviews of the New York Dolls and Sly and the Family Stone. Pretty eclectic. The Jackson 5, fronted by little Michael, had been huge and were beginning to decline. I didn't write about them. They were simply part of the air we breathed.

By 1982 when Michael was dominating the world as a solo act with *Off the Wall* and *Thriller* and Prince had broken through with *Controversy*, I'd found

a life and career as a visual artist that would never bore me and was just another pop culture consumer. What made us have to choose between them? Between the lineages of James Brown and Parliament Funkadelic? Perhaps it was like Baudelaire vs. Rimbaud. Some spaces can only be occupied in alternation.

ALEMANI What did Michael represent for you?

O'GRADY After he died, in an obsessive search for the source of my own tears, I plunged into the internet for months and emerged stunned. We'd all known that Michael was a talent like no other. But the demonization of his character (and the rock establishment's need to keep the world safe for Bruce and Elvis?) had created a consensus that after *Thriller* he had lost his way. We'd stopped listening and looking. It was the self-consciousness of his achievements that most surprised me, the control he exercised over everyone and everything around him. Quincy Jones responsible for *Thriller*? Think again. No album was ever more deliberately crafted or had a more ambitious agenda. Masterpieces tailored for every demographic, with the outcome firmly in mind—to break the ghettoization of black talent in *Billboard*'s "R&B" chart forever. He'd been horrified by the treatment of *Off the Wall*, for which he'd won just one Grammy, as a "soul" singer.

It's hard not to lapse into hyperbole when thinking about Michael. Don Cornelius, the creator of *Soul Train*, said that when he first saw Michael in a variety show two years before the family signed with Motown, he felt like he was in one of those cartoons where the two-ton safe falls out of the sky and lands on your head. An eight-year-old who could already sing as well as Aretha, dance as well as James Brown, and control an audience with Jackie Wilson's aplomb! And all the evidence on YouTube showed that, in the annals of child prodigies, he was one of the rare ones who could keep developing until the end. I found myself returning to Baudelaire to make sense of him.

ALEMANI What do they have in common, Charles and Michael, in spite of their very different origin? What happens when two different worlds and times clash?

O'GRADY They were so much alike, Charles and Michael. The similarities I felt in their lives—their indeterminate sexuality, their urgent need to be different from the norm, the drugs, the flamboyant clothes, the makeup, and the father and stepfather too young and sexually vital ever to be overcome. Somewhere beyond that lay their similarity as intellectual symbols.

I really saw them not as figures of two different modernisms but rather as two ends of a continuum. If modernism was the aesthetic attempt to deal with industrialism, urbanization, the de-naturalization of culture, and the shock of difference, then it was an effort in which all sides shared and were equally affected—from Charles trying to find his way in the stench of the torn-up streets of Baron Haussman's Paris, to Michael with lungs permanently impaired from a childhood in Gary when the steel mills still belched fire. While the old dichotomies between white and black cultures, and between entertainment and fine art, are understandable—it's hard to live on both sides simultaneously—the hierarchies between these imagined oppositions seem not just passé but fundamentally untrue. When I drew a line from Charles's *Les Fleurs du Mal*, written out of Jeanne's living body, to Picasso's *Les Demoiselles*, made with abstract African sculptures, and on to Michael's insertion of his own body into black-and-white film clips through the miracles of computer-generated imagery in *This Is It*, it seemed the triangulation of a circle in which all sides were contained. What's most striking about Charles and Michael as artists is the similarity of their attitudes. The modernist artist who could no longer be the servant of God would always be tempted by a perceived obligation to become God. And no one succumbed to the temptation more than these two. It was there in the relentless perfectionism that limited their output, in the fanatical domination of their craft and its history, in the worship of their instrument. I find it so touching to think of Michael warming up for one to two hours with his vocal coach before going on stage or into the studio. And what could be more quixotic, imitate God more than the desire to unify the whole world through music? The amazing thing is how close he came—the most famous person on the planet, a billion mourners crying at his eulogies.

I never found the source of my own tears. The search had exhausted me. I'd kept ricocheting between loving him unreasonably and thinking about him analytically. In the end, King of Pop seems such an inadequate term for him. I couldn't have done *The First and the Last* if that's all he was. He and Charles had lived out the modernist myth of the suffering artist to the point of cliché.

But there was more to both of them than that.

The first of the new is always the last of something else. Charles was both the first of the modernists and the last of the romantics. He was bound to forever live in the forest of symbols. And Michael may have been the last of the modernists (no one can ever aspire to greatness that unironically again), but he was also the first of the postmodernists. Will anyone ever be as ideal a

symbol of globalization, or so completely the product of commercial forces? In the end, the two, together and in themselves, were perfect conundra of difference and similarity. When I replaced Jeanne and Lena with Michael and put the two men on the wall, I couldn't decide whether they would be seen more as lovers or as brothers.

See also *"Studies for a Sixteen-Diptych Installation to Be Called* Flowers of Evil and Good, *1995–Present"; "On Creating a Counter-confessional Poetry"; "Some Thoughts on Diaspora and Hybridity: An Unpublished Slide Lecture"; "Two Exhibits: The Diptych vs. the Triptych and Notes on the Diptych"; "Interview with Jarrett Earnest"*

Interview with Amanda Hunt on
Art Is . . . , 1983 (2015)

In 2015, the Studio Museum in Harlem showed the complete *Art Is . . .* photo installation, a new work O'Grady had composed in 2009 from the documentation of one of her important early works, the 1983 *Art Is . . .* performance event presented in that year's Afro-American Day Parade in Harlem. In this interview, O'Grady speaks with Amanda Hunt, then assistant curator of the Studio Museum, about the issues involved in translating the project from one medium (performance) to another (photographic installation), almost a quarter of a century later. This process of translation had also occurred when O'Grady selected performance slides from *Nefertiti/Devonia Evangeline* to create the "novel-in-space" installation *Miscegenated Family Album*. It would again be deployed to convert photo-documents from her 1982 Central Park performance *Rivers, First Draft* into a newly imagined installation piece in 2015.

AMANDA HUNT Lorraine, we began talking about the photographic documentation of your performance *Art Is . . .* , and about the potential configuration of images we would present at the Studio Museum, and we came to something really interesting. You touched on the idea of the "greatest hits"—the images that people have been most drawn to in this series—and how over the course of more than thirty years, there are some more anomalous moments that have stuck with you for other reasons.

LORRAINE O'GRADY I think that what I'm really talking about is the issue of ambiguity—a question of "What is it?" I mentioned to you that in one of the images there is a large apartment building caught in the large frame on the float that didn't have any distinguishing aspects to it. People weren't sitting out on the steps of the building the way they had been in other parts of the parade. There was a blankness to its architecture, so it was impossible to get a mental or emotional grip on it. There was something about not being able to imagine the life behind the blank windows, or even beyond the strange fluorescent lights in the long entrance leading to an inner courtyard—not being able to see anything, really. Whenever I look at that building, it still has this impenetrable mystery that fascinates me. And then there is the only vertical image in the series, the one I call *Girl Pointing*. It's of a young girl, but now I find it's hard to say exactly how old she is. As the frame approaches her, she points at it—she has this sort of smile on her face—and you can't tell whether she is smiling at you or with you. You don't know what she's actually feeling. I can never settle on a feeling for her.

HUNT Was there a feeling that she was being confrontational?

O'GRADY I had the feeling that it was not so much confrontational as conversational, a level of equality that you don't always get from the subject of a photograph.

HUNT How did you collect these images?

O'GRADY I'd hired a couple of friends to help me document. They each gave me two rolls, I think, which I had developed. And whenever I saw people taking photos, I got their phone numbers. Later, when I met them, they gave me slides that they didn't want, that didn't have their friends in them. I got a lot of that.

 A couple of people gave me slide rolls that I processed. One woman sent me black-and-white prints, but I couldn't use them.

HUNT As background and context to this moment, there was also the issue of the impending crack epidemic in Harlem.

O'GRADY Yes, 1983 was really one of the last moments that these photographs could have been taken, with a whole population so open to the camera. The business of framing is really problematic now, as you know. I don't think this piece could have worked now, in 2015. Just this past fall, we did a shoot at the Brooklyn Parade for a video I was doing on Carnival. Before and during the parade—just talking to people and trying to take their pictures

with a still camera, or interview them on video—they wouldn't cooperate. Nobody would talk to you!

HUNT So what brought you to Harlem? How did you get into this idea of participating in something as spectacular as a parade?

O'GRADY Parades were big entertainment for us as kids, perhaps because my family is from the West Indies. We never missed a single one! The parade idea came from wanting to expose the avant-garde to the largest number of black people I could find at one time—that was it. My first thought was to just put artworks on the float and let people LOOK at art. A woman had recently said to me that avant-garde art doesn't have anything to do with black people. That was so infuriating to me. It's where the whole idea for the piece came from—to do something that would prove this woman wrong, a piece about art in front of a million people. Of course it didn't end up with them looking at art. They were more making the art themselves. I didn't live in Harlem, so I was going to an alien territory. I did not know how this piece was going to work. I mean, the only instructions I could give people on the parade route were the words on the sides of the float—"Art Is . . ."—right? I didn't know what would happen. Would they get it? Would they do anything? It could have been something or it could have been nothing, and I had no idea which, so it was scary for me. But then when I heard people calling the photographers over to them, it was like "Wow!" They wanted to be on camera! Everybody wanted to be on camera, you know. I guess I didn't realize how much people wanted to be on camera.

HUNT Who were your performers? How did you assemble them?

O'GRADY I advertised in the back pages of some dailies or weeklies. I can't remember, but I think they were called *Stage Door* and *Billboard*. They had ads for actresses and dancers, that sort of thing. I got a mix of people, of dancers and actors. They were beautiful and they were up for it—really, really up for it. You can see how the people on the parade route liked being in photographs, and you can see how these performers liked framing them for the photos. It was wonderful, just wonderful.

What I learned in the process of the parade is that a parade is not a continuous motion. In a parade there are moments when you are just standing still and not getting anywhere, and then there are moments you are rushing to catch up. To me, a film was going on behind that big frame, like a moving proscenium on the float. But as if it were in an old Moviola editing machine . . . it started and stopped . . . started and stopped . . .

See also "Mlle Bourgeoise Noire 1955"; "Statement for Moira Roth re: Art Is . . . , 1983"; "Performance Statement #1: Thoughts about Myself, When Seen as a Political Performance Artist"; "The Black and White Show, 1982"; "My 1980s"; "The Mlle Bourgeoise Noire Project, 1980–1983"

On Creating a Counter-confessional Poetry (2018)

In 2017, O'Grady revisited her earliest body of work—*Cutting Out the New York Times (CONYT)*, made forty years before. In a new set of collages titled *Cutting Out CONYT*, she transformed the original work—250 panels collaged with headlines and phrases clipped from the paper of record to form twenty-six personal and resonant poems of various lengths—by once again taking up her conceptual scissors, reworking and distilling fifty-one of those panels into what she calls "haiku diptychs." The following text, written with Lauren O'Neill-Butler and appearing in *Artforum*, offers an explanation of O'Grady's play with language, her embrace of the diptych form, and her search for a "counter-confessional poetry." While the original series was motivated by the idea of taking the public language of the newspaper and finding the means to articulate the self, the latter series recombines those articulations of the self into a repoliticized language. At root, this new series revisits a theme present in O'Grady's work since its earliest moments: an insistence that the subject, even at the most basic psychoanalytic levels, is never detached from the ideological, political, or cultural field in which she can discover herself.

THE FORM OF MY WORK has proven to me to be more important than the content. If you had told me when I started forty years ago that I would be saying that, I would probably have laughed. But the diptych has always been,

in a sense, my primary form, even in the performances. For me, the diptych can only be both/and. When you put two things that are related and yet totally dissimilar in a position of equality on the wall, for example, they set up a conversation that is never-ending. It's a totally unresolvable, circular conversation. And I think that that "both/and" lack of resolution—the acceptance and embrace of it, as opposed to the Western "either/or" binary, which is always exclusive and hierarchical—needs to become the cultural goal. The diptych, which is actually anti-dualistic, has served me to make the point against "either one, or the other."

I taught a course in Futurism, Dada, and Surrealism at the School of Visual Arts for twenty years. I admired those artists that dodged the draft in World War I and went off to Zurich. But I also felt they'd suffered an acute shock: Their teachers and parents, formed in the nineteenth century, had led them to believe that European culture was built on the mind, on rationality. And then, of course, they'd had to face the irrationality of European culture with the outbreak of a war that even today makes no real sense. Their response to that was to willingly surrender to the irrationality they'd witnessed, and to create from the language of the subconscious a *sur-realité*, an above-reality. While I understood their need to surrender to the random, that could never ever interest me as a goal, since I'd always felt the culture I was immersed in was completely irrational. My trajectory instead was not to surrender but to try to conquer the random, to wrest some rationality from the irrationality that so many "others" to the normative culture have to live with.

When I hit the New York art world in the early 1980s, it was a shock to my system. Not only was it segregated between races—it was also segregated along lines that were so subjective there was no logical countering of them. Everywhere I'd been in the world up to that point there had at least been objective measurements of my accomplishments, from SATs to exams for federal service. The year I graduated from college, out of twenty thousand who took the Management Intern Exam I was one of two hundred, and the first girl from Wellesley, to pass. I didn't have to *prove* myself. And later, when I became a translator, I mean, either you could translate accurately or you couldn't. So when you come in to the art world and you see a totalized worldview that is quite provincial, because it's isolated everything but itself, and *that's* what's telling you that you are derivative—that you are not interesting—well, it seemed a little out of line with reality. But now I think it was more like a dislocation from reality, an exaggeration of the irrationality that, as a woman of color, I had experienced all along.

What I found in Surrealist language was the obverse of what the Surreal-

ists had found: it enabled me not to surrender to the random but to control it. That's why I did *Cutting Out the New York Times (CONYT)* in 1977. During the 1960s Cuban Missile Crisis I'd been a contract analyst at the Department of State and had to read like ten newspapers and three transcripts of Cuban radio a day, so language had just melted away at that point. I wanted to see if I could take the public language of the *New York Times* and make it personal. And unlike the confessional poets of the time who confessed from the inside out, I wanted to see if I could create a "counter-confessional" poetry that would "confess" from the outside in.

In 2017, forty years later, I felt an urgent need to reconnect to the voice of that 1977 piece, which I'd begun as a writer but finished more as a visual artist. The shock of entering the art world in 1980 had caused a distortion in what I produced, it seemed, away from the more experiential and toward the more argumentative. I wanted to go back to that earlier voice so as to get on with new work. *Cutting Out the New York Times (CONYT)* had succeeded in its first goal to make public language private, but it had failed, I believed, in its second goal—to create counter-confessional poetry. Too many rules of cutout composition had overwhelmed those poems of ten and twelve or even more panels each. But I thought forty years of experience might correct the failure. And they did.

At first, I felt simple relief. I called the show at the Savannah College of Art and Design *From Me to Them to Me Again* to signal a return. But now I think that was the wrong title. I should have called it *From Me to Them to We Again*. Because creating these totally new haiku-like objects in *Cutting Out CONYT* had not only illuminated the role of the diptych in my personal work, it had given me a glimpse into what might be my contribution to culture as a whole.

See also "Cutting Out the New York Times (CONYT), *1977*"; "*Black Dreams*"; "*Olympia's Maid: Reclaiming Black Female Subjectivity*"; "*Some Thoughts on Diaspora and Hybridity: An Unpublished Slide Lecture*"; "*Two Exhibits: The Diptych vs. the Triptych and Notes on the Diptych*"; "*My 1980s*"

3 Reclaiming Black Female Subjectivity

Black Dreams (1982)

This piece, which appeared in "Racism Is the Issue," an issue of the journal published by feminist collective Heresies, was O'Grady's first attempt to deal publicly with the question of black female subjectivity. Taking the form of a dream journal, it is an important demonstration of the ways in which O'Grady insists that personal and psychic experience are always shaped by the social—even, or especially, by the social construction of race. Desire, the alienated and divided self, and other fraught issues are narrated in a way to suggest that even in the space of dreaming, the question of overcoming the endless binaries of Western culture—self/other, black/white, difference/identity, and so on—is nearly (but not entirely) impossible to describe. The piece ends on a cautiously optimistic note: "The cab actually drives off. Is it possible that change can take place after all?"

"WHICH WOULD YOU GUESS was the biggest category?" I asked as I handed my new black woman therapist the organization chart I'd made of nine months' worth of dreams.

I'd finally located her in September. Even in New York it hadn't been easy. Only 1 percent of the therapists in America are black, and I'd spent July and August going to one white therapist after another who'd ask the standard

question: "Why have you come into therapy?" When I was too embarrassed to answer directly, they'd accused me of being an aesthete, of wanting to take a symbolic journey into self-discovery.

There was the estrangement from my son, of course. But even if I'd been able to talk about it, I couldn't have placed it in its deepest perspective by describing the specter standing behind not just my problems with motherhood, but those with my family, sex, and my artistic persona. With these male and female therapists I couldn't break out of the defense I'd adopted toward the whole white world, the mystique that everything was all right, that I had no racial problems. Even when I trusted their capacity for empathy, I couldn't talk to them about the subtle identity problems of a fair-skinned black woman, born and raised in Boston at a time when "social" blacks (the families who sent their children to Ivy League schools) were still trying to be white.

Meanwhile, shopping for a therapist was becoming expensive. Jung had said that series of dreams were far more informative than dreams taken singly, and since I'd begun collecting my dreams at the beginning of the year, I now had nearly 150. To save time and money I decided to organize them. At the end of August, after saying goodbye to my last white therapist, I took my journal to Martha's Vineyard and arranged the dreams into 24 categories with names like *Upstairs/Balconies* and *Downstairs/Basements, Papa, Mama, Devonia* (my sister), *Sex, Art, Fear of Ending Up Alone,* and *Blacks/Racial Attitudes.*

The results were startling. The *Blacks/Racial Attitudes* series was the largest, with roughly 30 dreams containing the motif, 10 more than the next-largest series. I knew I'd been kidding myself, as well as white people, about the extent of my problem, but seeing it statistically tabulated like this unnerved me.

The black woman therapist, an M.D. who'd gone to Vassar and was 10 years older than I, looked over the list.[1] "I don't want to guess which category contains the most dreams, Lorraine, because I don't know you. But," she hesitated, "experience would lead me to . . . could it be *Blacks/Racial Attitudes?*"

On Thursday, August 20, I was feeling depressed about Reagan, and paranoid about the fascism lying in wait just below the surface of the country. In my worst-case fantasies, the dragon breaks out and, as in Nazi Germany, gobbles up those closest at hand: assimilated blacks first.

That afternoon I wrote in my art journal a proposal for an installation to be called *Walter Benjamin Memorial Piece (A Black Intellectual Gets Ready in Time),* with a wall plaque containing the following quote:

On September 26, 1940, Walter Benjamin, who was about to emigrate to America, took his life at the Franco-Spanish border. The Gestapo had confiscated his Paris apartment, which contained his library (he had been able to get "the more important half" out of Germany) and many of his manuscripts. How was he to live without a library? How could he earn a living without the extensive collection of quotations and excerpts among his manuscripts? [Hannah Arendt][2]

Mounted on three dry walls was to be a life-sized photo reproduction of my library alcove (the shelves contain about 3,000 volumes). In the center of the alcove, my actual desk, extremely cluttered, a typing table and chair, and scattered about on the floor, a jumble of packing crates with labels not yet filled in.

That night I had the following black dreams. I made the journal responses a couple of months later and gave them, together with the dreams, to the black woman psychiatrist.

Dream 1: The Internment Camp

A prison camp, like the Nazi concentration camps or Nisei internment camps of World War II. Fifteen or sixteen people have been rounded up from the general prison population to be specially tortured. No rhyme or reason for the selection, just the private hatreds and prejudices of the guard, a small-boned, rat-faced Hispanic male about 35 years old.

Men and women, mostly white, but one or two blacks, including me. As a whole, an intellectual group. Forced to sit in straight-backed chairs, four or five to a row, facing rigidly front. I am in the front row. The rat-faced Hispanic guard paces back and forth, issuing peremptory commands at unpredictable moments.

Kept in this position for days, without sleep, without food, without being able to get up and stretch our legs. Soon the chairs are covered with shit, the place begins to stink. But somehow everyone manages to keep themselves looking presentable. This group has pride. As a result, when the international inspection comes through, they don't think we're really being tortured.

"Do you see that?" I say, pointing to the back of the chair. Draped over the wooden slats are dripping pieces of intestine where even I had expected there to be just shit. "Do you see that?" I say. "That's *me*."

Perhaps this is what finally convinces the inspection team. We are re-

leased back into the general prison population. When I pass the rat-faced guard, who'd had a special thing against me (I really set him off in some way), his face glazes over as if he didn't recognize me.

"Shit. So that's the way it's going to be," I say to myself. "We're going to pretend that it didn't happen, that it never really was."

Needless to say, this pisses me no end. It's a pattern I recognize only too well, and this time I'm determined not to play along with that game. I'm getting the hell out of there.

Response

No matter who revolts against whom, I won't be safe. If the whites decide to quarantine, or if the blacks and browns rise up, there I am. In the middle.

Driving to work with my boss, Alice Shurtcliff, a Brahmin from Boston's Beacon Hill, but now my neighbor in the fluid Dupont Circle area. She talks about buying a co-op in a more exclusive part of Washington. It is the early '60s. The new apartment has "reasonable resale restrictions, of course."

"How many rooms will you have?" I ask, and the car does not explode.

Back from Europe, temporarily teaching in an inner-city high school, Valerie, a 16-year-old shy beauty, my pet, arrives one morning, eyes swollen, red with tears. She's been assaulted by a white male customer outside the restaurant where she has to work midnights after school.

"What do you know?" she hisses at me as I try to put my arm around her to console her. "The way you live, the way you look. What do you know about being black?"[3]

Marty, my beautiful Jew, my big love, after two years of mutual fantasizing about permanent commitment, announces: "I just don't want to marry a . . ." He can't even say the words.

Later I see him at a party with his not very attractive French-Canadian wife. We smile and chat.

This time, though, I am not going to play along. I vow to get the hell out of there. But what will I do when I leave? Will I avoid and sublimate, or will I revolt? Against whom?

Dream 2: The Futurist Dream

I am alone, walking across an empty lot. When I get to the main street, I don't know where I am. The people coming toward me look unfamiliar. They are dressed strangely, heterosexual couples joined inside sarongs of colorful

cotton wrapped three times around the women and once around the men, leaving each room enough to move.

As I continue, I realize I have walked into the future, I am on a narrow business street, like the kind they have in Copenhagen. Music is issuing from the steeple of a bank. Phenomenal Latin jazz. I'm amazed. You mean the future has good taste? I go indoors and find myself in a private living room. People are sitting in intimate attitudes, talking, reading, playing solitaire. The decor is dark red, faintly Middle Eastern, and reminds me of the apartment Marinetti described in *The Founding and Manifesto of Futurism*.

I sit down at one end of a couch in front of a coffee table. At the other end, a small black man plays chess by himself. When he looks up, he is quite taken with me. As I get up to leave, he offers to take me home.

I say, "No. Someone is going to be there."

As I say this, I seem to half-believe that someone *will* be there. But when I'm walking down the stairs, I realize I've only told this man no because he was black, and that the man I'm hoping to have home is white, but he won't be there.

When I get outside, I'm in a back alley. A cab is standing there. I have a feeling that someone else wants it and I have to rush. I run over, open the front door quickly, and throw a piece of fruit (a pear) down on the seat to claim the cab. Then I open the rear door. Before I can get in, I am shoved aside. I am pushed away by a large white man with a large white wife, and several stupid-looking kids—real middle-American types. He has taken my pear and tossed it on the ground, and thrown a greasy, airy sugar donut down on the seat instead. Somehow I end up with this donut as the consolation prize. As the cab drives away, I look down at the donut in disgust.

Response

Passing a mirror in the company of a man, a sudden clear glimpse of what I've become. The more independent and self-validating, the more like Mama and my West Indian aunts, turning men into children by waiting on them like slaves. The deeper I get into my career, the more simply convenient men are for me.

In the future I see men and women yoked, not like the undivided parts of Plato's androgyne, but in a *shammah*, the shawl Ethiopian women wrap around their shoulders and carry their infants in.

What does it matter that Latin jazz is blasting from the steeples of European banks? What difference does taste make in Erewhon?[4] *Plus ça change,*

plus c'est la même chose. I have brought the past with me, and so have all the people playing solitaire.

The slightly built jazz musician with a limp, who takes me to lunch, without asking me a single question about myself, talks non-stop about his hatred of white people. The famous black judge takes me to dinner and tells me of the day when, a senior in high school, the dean of the Ivy League college denied him the scholarship he'd already won on seeing that he was black. Then he says: "I can't imagine that you'd ever find a black man interesting, either intellectually or aesthetically." I decide that black men of a certain age are carrying a heavier burden than I can cope with.

But I already know the white man won't be there, that he won't bring me *that* protection.

And something must be wrong if I'm competing for the same cab as the middle-American.

Something has to give. But what? Where?

Dream 3: Carrying My Suitcase on My Back

I'm at a "therapy camp." I have to prove that I belong there. Two or three therapists, including a black woman, keep asking me the same question: "Why are you here?"

I struggle with the words, but I can't sort out the answer. I realize that I am going to have to leave.

In the camp's community room, a young black woman is singing, rehearsing for a concert she's giving in a few days. She is extraordinarily talented. Her song is excellent and I listen to it with rapt attention. The words seem very significant (but I can't remember them). She goes over to straighten out details of the show with the musicians, a signal that it is time for me to begin packing. When I ask someone about the singer, I'm told she is an off-duty policewoman. I marvel at this, and feel the police are no longer as bad as people think. I finish packing, and go outside to get a cab.

Suddenly I have many relatives with me. Mama, and the various aunts. They are supposed to be helping me with my bags, but they really don't. When we hail a cab, Dan Goldberg comes along driving a gorgeous antique, fully outfitted as the living room of a European country house on wheels. Mama and the others are fascinated by the decor and climb in.

First I put the small suitcase inside, and then I have to go back for the big one. I return carrying it on my back. Bent over under the load, I think:

"That's interesting. I would have expected it to be much heavier. Perhaps that's the best way to carry heavy loads. On your back. It distributes the weight more evenly than carrying them by hand."

I dump the suitcase into the cab, still filled with relatives, and climb in. Danny is in a good mood. I tell him to put the meter on, because I know he's been waiting a long time. We drive off.

Response

The black woman singer, whose song is so significant, is the most positive black figure of my dreams to date. She determines me to leave my German-American male Jungian analyst from Wisconsin and look for a black woman therapist.

But I still have to struggle with the question: "Why are you here?"

Mama and the aunts can't help me—they're part of the baggage I'm carrying. Problems of racial identity. It's their fascination with European elegance that's been transmitted to me.

The "European country house on wheels" is driven by Dan Goldberg, a friend whose rich, liberal parents sent him to a racially mixed high school. Danny identified so completely with his black classmates he became a junkie to keep up with them.

Are we meeting in the middle here? Is this a projection of my belief in the mulatto as the crucible and the solution?

Earlier today, flipping back through pages of responses to dreams in other categories, I felt short-circuited. I had an intuition:

> You know, Lorraine, your unconscious may contain too many issues for one consciousness to integrate. Mama. Papa. Dee. Blackness. Child abuse. Dozens of others. You may have to make arbitrary decisions, deal with each problem as it comes up. As if the others didn't exist.

But now, seeing the image of the two suitcases makes me feel less depressed. The easier, lighter one first; then the heavier, more difficult one. Spread the weight out evenly.

And at the end of the dream, a vision of opposites reconciled: the black white man, the white black woman, the "European country house on wheels" transformed by laughing Caribbean women.[5]

This cab actually drives off. Is it possible that change can take place after all?

See also "Rivers, First Draft, *1982: Working Script, Cast List, Production Credits";* "Body Is the Ground of My Experience, *1991: Image Descriptions"; "Olympia's Maid: Reclaiming Black Female Subjectivity"; "On Being the Presence That Signals an Absence"; "Sketchy Thoughts on My Attraction to the Surrealists"*

Interview with Linda Montano (1986)

In June 1986, feminist performance artist Linda Montano inter-
viewed Lorraine O'Grady for the "Ritual" section of her book *Per-
formance Artists Talking in the Eighties: Sex, Food, Money/Fame, Ritual/
Death*. In this unedited transcript of the conversation, O'Grady is
prompted by Montano to reflect on the connection between her
early life and her performances, especially in relation to *Mlle Bour-
geoise Noire* and *Nefertiti/Devonia Evangeline*. Of note is O'Grady's
insistence on understanding intimate life as shot through with
historical constructions of race, as, for example, the racist under-
pinnings of Egyptology.

LINDA MONTANO What were your childhood rituals?

LORRAINE O'GRADY When I was born, my mother was thirty-seven and my
only sister was eleven. I guess I came along just when my mother was imag-
ining that she was about to become free, and the feeling that I was an after-
thought, that I wasn't really wanted, was somehow always conveyed to me.

Because I was unhappy in my family and, even then, dissatisfied with their
version of middle-class black culture, which I somehow sensed as provincial
in an unattractive way, I began very early to reject the rituals offered me
and to think up others. At family picnics, for instance, I would be ten years

younger than any of my cousins. Everybody else would be having a great time playing and kidding around, while I would just be bored. Even though I participated in some of the happy times, like Christmas and Thanksgiving, I always had this feeling that these occasions weren't for me, that they were for the real family that I wasn't part of.

I think that what I unconsciously began to do was to search out rituals that wouldn't interest my family, in particular my immediate family, at all . . . like going to church. Most people's rebellion takes the form of rejecting their family's church, but mine was the reverse. My parents were generically Episcopalian because they were middle-class British West Indians who never went to church, except for funerals and weddings. They thought all that kind of socializing too simple, almost lower class. Perhaps I did, too, because that wasn't the part of church that attracted me. What I liked were the rituals and the idea of belief in God. While everyone else hung around the house on Sundays, I sought out the most ritualized Episcopal church I could find in Boston, not the West Indian parish, which was very Protestant and low church, but one that was so high church as to be almost indistinguishable from Catholic. By the time I was fourteen I didn't just go on Sundays; in Lent I went to mass every morning before going to school. When I look back, I think that what I was doing as a child and what I continue to do as an adult is to define myself by those rituals I accepted and those I rejected.

By late adolescence, the rituals had less to do with things like family and church and more to do with the outside world. At sixteen there was the birthday party. I didn't want a birthday party. I wanted a formal sit-down dinner. At seventeen there was the cotillion. The two most prestigious black social clubs each sponsored an annual cotillion, and both invited me, but by that time, my passion of rejecting the usual rituals was already established. I seemed to be the only girl from that social set who didn't come out that year. A year later at college, the expected bids to join the two nationwide black sororities, Alpha Kappa Alpha and Delta Sigma Theta, came in. Even though my sister had been president of the Boston chapter of Alpha Kappa Alpha, and everyone assumed I would go AKA, I didn't. I refused to have anything to do with that sort of thing. The irony is, here I'd refused the cotillion, refused the sorority, but when I created *Mlle Bourgeoise Noire*, a satirical international beauty pageant winner with a gown and cape made of one hundred eighty pairs of white gloves, she was described by critics as a debutante. I guess I was doing those rituals in my own way in my art later on, but distanced, as anti-rituals. They have nothing to do with nostalgia or an acknowledged longing

but are more critical modes of attack than of participation. But who knows? They could be a longing that doesn't know its own name!

MONTANO Did you go through a traditional art school education before this character emerged?

O'GRADY I'd had an exceptionally traditional and elitist education, which I had to work hard to rid myself of in order to become an artist. I went to Girls Latin School in Boston, where I had to study six years of Latin and three of ancient history, and then to Wellesley College, where I majored in economics. After graduating, I worked in the Bureau of Labor Statistics in Washington and then at the Department of State. Altogether I was an officer in the U.S. government for five years, at which point the disparity between who I was and what I was doing became so great that I had to quit, and I have never held a full-time job since. I left Washington to write a novel, but my technical skills and my understanding of art were so limited, I wasn't able to do anything remotely like that. It took a long time to find out what I wanted to do, what I could do, and I discovered it in a very accidental way.

About twelve years ago I left a second marriage and came to New York as the girlfriend of a big-time rock music exec. In order not to be just his girlfriend, I began writing rock criticism and feature articles, first for the *Village Voice* and then for *Rolling Stone*. I guess you could say I had a meteoric career. My very first piece was the cover story of the *Voice*. A few weeks later, I was traveling in private jets with top rock bands. It was weird; I wasn't making any money, was living in this sixth-floor walk-up in Chelsea, but every day, a chauffeur-driven limousine would pick me up to take me to some glamorous place that other people would kill for. Within six months I was totally frustrated and bored. I knew that life would just be the same old, same old.

Then my life completely changed. A friend of mine was teaching at the School of Visual Arts and was so involved in a breakup with his girlfriend, he couldn't handle all of his classes. He called me to find out if I would take one of them, a first-year English course, and I said, "Fantastic!" It was a way out of this crazy world where I was a forty-year-old rock groupie. But when I went to SVA, at first I was dislocated. Here I'd gone to Wellesley, a four-hundred-acre campus designed by Frederick Law Olmsted, the richest women's college in America, and SVA looked like a bombed-out factory. Yet there was such incredible energy there. I threw myself into my teaching, learned everything I could to relate to those students, whom I found wonderful.

That first week, I went to the Eighth Street Bookstore to look for books

on visual art. The first book that attracted me looked like no other I'd seen before. It was a small-format book, wider than it was high, and had a strange red cover totally filled with print. It was Lucy Lippard's *Six Years: The Dematerialization of the Art Object*. It was the first art book I ever read, and it totally changed my life. It was an almost artless chronological catalog of documents and events, and I'm sure Lucy never anticipated that someone would read the book from cover to cover, but I did. By the time I finished that history of the conceptual art movement and all its subgenres—performance art, body art, earth art, and so on—I said to myself, "I can do that, and what's more, I know I can do it better than most of the people who are doing it." You see, I was always having those ideas, but I didn't know what to do with them. I didn't know they could be art, and until then, I hadn't been in a position, in an intellectual milieu to discover it. After that, the struggle became focused: to discover what my art was, where it came from in me.

Several years after that discovery and consequently undertaking the journey within, I felt ready to go outside. I didn't have anything specific yet, but I knew I was ready. I went to the opening of an exhibit at PSI called *African American Abstraction*. I'd seen it advertised in the newspaper, and it interested me. When I got there I was blown away. The galleries and corridors were filled with black people who all looked like me, people who were interested in advanced art, whose faces reflected a kind of awareness that excited me. For the first half hour of the opening I was overwhelmed by the possibilities of a quality of companionship I hadn't imagined existed. But then I settled down intellectually and became quite critical. By the time I left, I was disappointed because I felt the art on exhibit, as opposed to the people, had been too cautious—that it had been art with white gloves on.

Then when I went down to Just Above Midtown to work as a volunteer helping to open their new space, I began to associate with some of the artists whose work had been in the PSI exhibit. I wanted to tell them what I'd felt, but in an artistic way. One afternoon, on my way from SVA to JAM, I was walking across Union Square. That was before the square had been urban-renewed; it was still incredibly filthy and druggy. As I entered the park—perhaps to get away from its horrible reality—a vision came to me. I saw myself completely covered in white gloves. That's how my persona Mlle Bourgeoise Noire was born. It was a total vision, and by the time I emerged from the park, three blocks later, it was complete. The only element I added after that was her white whip. I understood that the gloves were a symbol of internalized oppression, but knew I needed a symbol of the external oppression, which was equally real. The whip came that evening when I got home.

MONTANO Did the character have a script?

O'GRADY Well, JAM's opening was to be in three weeks, and that was when she would have to appear. I spent most of that time going to every thrift shop in New York buying white gloves: it was very important to me that the gloves should have been worn by women who had actually believed in them. Then I had to make them into the gown and cape. I didn't have much time to think about the script, but I knew I wanted her to shout out a poem that would embody the response to *African American Abstraction*, that black art should take more risks. An adaptation of a poem by Leon Gontran Damas, a black poet from French Guiana who was part of the Négritude movement in Paris in the thirties, came quickly to me. Damas was a mulatto in revolt against his bourgeois black background, and his poem was perfect, although I made it address bourgeois black art.

MONTANO As a form of protest?

O'GRADY Traditionally, and certainly when I was growing up in the forties and fifties, bourgeois black life has been geared to gaining acceptance in the white world, to securing recognition from it. It's not so much a desire to be part of, to actually socialize in the white world—most blacks would find that quite boring, dead, not fun—but to be acknowledged as really equal. The problem is that, in the desire for materialistic parity with the white world and the psychological need for recognition from it, the real essences of internal culture have too often been left slighted, undeveloped, and unexplored. Measures of success are defined by the white world, and styles of being and behavior are inept adaptations of white styles instead of developments of original black personal and cultural modes. Of course, this is a far greater danger for the upwardly mobile black middle class than it is for the still almost totally isolated lower class, who have fewer barriers to the development of authentic style—except those invariably presented by the corruption of the mass media. *Mlle Bourgeoise Noire* was a response to a perceived need for internal development, the kind that can only be achieved through willingness to risk failure.

MONTANO How did the character progress?

O'GRADY I don't think she has fully developed, and I am still searching for ways to make her more accessible. She grew out of the black middle class, and her original message was for them. But her next appearance was at the New Museum, at the opening of what she called the "Nine White Personae" show,

to which she was not invited. There she was protesting not just those passive black artists who accept their own marginalization, but white curators who do not feel they have to look beyond a small circle of friends. The appearance at the New Museum and the one at JAM were alike in that they were guerrilla actions in which, uninvited and unexpected, she invaded a space to give a message that presumably would be painful to hear. I will always admire Linda Bryant, JAM's "black bourgeois" founder-director, for not only listening, but receiving thoughtfully my criticism of an activity she was deeply involved in.

Only two months after Mlle Bourgeoise Noire's invasion of Bryant's space, I was invited to represent JAM as the performance artist in a show called *Dialogue*. I've been interested in Egyptology for a long time, and coincidentally, the day the call from Linda came, I had just bought a book called *Nefertiti*. When she asked what I would do as a performance, I looked at the book in my hand and said, never having thought of it previously, "I'm going to do a piece called *Nefertiti/Devonia Evangeline*." Devonia Evangeline was my sister's name, and the piece would be about the similarity of their lives as beautiful women placed on stifling pedestals, so the piece had feminist overtones. But for me its main political import was the placing of images on the screen that focused on the physical resemblances of a black American and an ancient Egyptian family. Egyptology has always been such a racist discipline. Because of Western European attitudes and policies, so ingrained as to be hardly thought-out, ancient Egypt has always been denied as belonging to Africa. For instance, I will never forget that when I was a little girl in the third grade in the early forties in one of those old-fashioned schools where the maps got pulled down over the blackboards during the geography lessons, when we had our lesson on Africa and the teacher pulled down the map and pointed at it to our class of twenty-five kids, all but two or three of whom were white, she said quite blithely and unreflectively, "Children, this is Africa except for this"—the long wooden pointer touched Egypt. "This is Egypt," she said, "and it isn't in Africa but in the Middle East." The worst of it is that this is the way Egypt has always been presented, even at the most sophisticated museum levels. It has only really been since the sixties and the breakup of the empire, combined with the knowledge explosion, that there has been something of a revision of imperialist intellectual attitudes, but it takes generations to get an idea out of currency. Even now, when I did this performance in the eighties, it was revolutionary and, perhaps, arrogant to put those images up on the screen. Putting a picture of Nefertiti beside my sister was a political action.

MONTANO And that performance was an action by Mlle Bourgeoise Noire?

O'GRADY I wasn't aware of it at the time. It wasn't until a few years later that I began to realize that everything I did in art was done by her. *The Black and White Show*, which I curated at Kenkeleba Gallery, with 28 artists, half of them black, half white, and all the work in black and white. And then *Art Is . . .* , a parade float I put in the Harlem Afro-American Day Parade, the biggest black parade in America. I wanted to give the people on 7th Avenue an experience of advanced black art, and since I couldn't mount actual art-works, because a float has a maximum of one-and-a-half to three minutes viewing time, I had to aim, instead, for the art experience. With my collabo-rators Richard DeGussi and George Mingo, I mounted a nine-by-fifteen-foot, empty, old-fashioned gold frame, so that as it passed, everything it framed was art. I had it accompanied by fifteen black dancers and actors dressed in white and carrying empty old frames with which they "framed" people on the parade route. The amazing thing is that those black lay people actually got it. They would shout: "That's right! That's what art is! *We*'re the art." And: "Frame *me*! Make *me* art!"

MONTANO Is your mother's illness releasing in your character a new way?

O'GRADY Today I'm leaving on a trip to Boston, not just to see her but to prepare to work on something which needs Boston to feed it. I know that going back to Boston for the summer is not just about taking care of my mother but about going back to the source. I also know that her illness has released a lot in me. It's released tenderness, and the ability to take care of someone, which isn't a role I've ever imagined myself successful in. It's evok-ing all those things, and I sense that the trip is going to release incredible creative energy.

See also "Mlle Bourgeoise Noire 1955"; "Rivers, First Draft, *1982: Working Script, Cast List, Production Credits*"; "Performance Statement #2: Why Judson Memorial? or, *Thoughts about the Spiritual Attitudes of My Work*"; "Nefertiti/Devonia Evangeline, *1980*"; "Some Thoughts on Diaspora and Hybridity: An Unpublished Slide Lecture"

Dada Meets Mama
Lorraine O'Grady on WAC (1992)

O'Grady was one of a handful of women of color active in the Women's Action Coalition. WAC had been founded by women in the New York art world in response to Anita Hill's denigration during the congressional hearing on Clarence Thomas's nomination to the Supreme Court. This essay, which originally appeared in *Artforum*, offers important insights into O'Grady's engagement with mainstream feminist activism, which offered important opportunities for action in relation to specific issues, but was limited by its too-specific focus on the concerns of middle-class white women.

TODAY, AGAIN, it feels like a World War I moment, what with a breakdown in bourgeois certainties and the new order nowhere in sight. The world seems cut deep with trenches out of which heads pop only to be shot off by mortars from the opposing side. That Dada arose then, and WAC now, proves that the sleep of reason produces not only monsters but millenarian dreams of bliss.

WAC (for anyone who hasn't been watching) is the Women's Action Coalition, and for me it's become a sort of "guilty pleasure." Begun anonymously in New York last January by some fifteen women, mostly artists, WAC in five months multiplied a hundred times to become a more heterogeneous grouping. But it still retains the sensibilities of the art world, and for an artist, that's the pleasure of it. As with ACT UP, on whose nonhierarchical model of

spontaneity they are based, WAC meetings and actions have the compelling quality of process art: things come together, and then they intuitively click.

At a meeting, the first thing you notice is the anger, a fissioning energy that seems as though it might lead anywhere. The room has the excitement of danger; at the Friends Meeting House, the high ceilings and consecrated space seemed to damp down some of it, but earlier meetings at the Drawing Center felt about to explode. Attending may be six hundred mostly upper-middle-class white women between their late 20s and their late 30s, many of whom, in the wake of the second feminist movement of the '60s and '70s, expected the doors to their lives to be open but have found them stuck instead. Now, Anita Hill/Clarence Thomas, William Kennedy Smith/Jane Doe, and the threats to *Roe v. Wade* have pushed these women to the edge.

Educated to know the purposes of analysis, they often seem to have decided not to think. At WAC, the line from idea to action is unmediated and direct, and little distinction is made between the sublime and the trivial: between collecting personal statements from junior high school girls to defeat the parental-consent abortion bill in Albany, and the "breastival," a topless beach-party supposed to promote awareness of breast cancer, every proposal is presented and received with the same intensity. Votes are taken with delirious speed; minutes are kept, but there is no time to read them. Each meeting is so dense that two weeks ago feels like two years, and two months ago is ancient history. There is an awesome shortness of organizational memory, then—not to mention the irrecollection of real history. Those of us old enough to remember how the second feminist movement died only recently because it couldn't make itself meaningful to working-class white women feel almost irrelevant.

As in Dada, the sum of activity is itself a collage, a simultaneity of chaos, with actions on the streets and in the media, and the sounds of drum corps and chants combined with collaborative visuals of wildly varied effectiveness. The meetings and actions have set in motion an aleatory process that generates ideas beyond what the mind might supply. (What other group would make a connection between abortion clinics and the Guggenheim?) But the Dada and Surrealism of the teens and '20s were, as we know, the last art-world effluents to believe that states of mind could change the world. Dada may have been "the chameleon of rapid, interested change," and may, like WAC, have had "391 different attitudes and colors depending on the sex of the chairman,"[1] but after applying larger and larger doses of shock, it was finally outdistanced by the bourgeoisie's own chaos. It makes you wonder about WAC's long-term survival.

Without a focused program grounded in theory, some of WAC's most effective actions have been in support of other groups, such as WHAM! and NARAL, for which its willing cadres and visual talents have proved estimable.[2] On its own, WAC has sometimes made mistakes. An ill-conceived slide-show/speak-out during the Republican convention in Houston, for example, consumed a privately raised budget of $35,000—more than all previous activities combined—and produced a crisis of definition for the group as a whole.

Though the general information bombardment of the culture may account for much of WAC's historical amnesia, one suspects there is something else. Which brings me to the guilty part of my pleasure.

In its earliest planning stages, WAC made a decision not to deal with difference head-on, not to risk discussions that might impede getting the job done. It may have started so white that it cannot now recover. At a philosophy meeting in late March, one young woman stunned the room by saying, "I don't think WAC is too white or too anything. I didn't come for the women. I didn't come for the coalition. I came for the action!" It's a statement that as the months have passed has come to seem more and more central. Even WAC's bias against analysis seems to support it: If you don't want to talk, read, think, then nothing will change, and white women will maintain their privilege within the movement of determining what and where the action is.

So why am I still here? Perhaps because, like Dada, WAC offers an opportunity to act and to observe at the same time. There is the thrill of watching social forces work themselves out along a new Maginot Line. Besides, with the emergence of the Multicultural Caucus (now called the Committee on Diversity and Inclusion) and the Lesbian Issues Caucus, and with the coming to the fore of more politically evolved members, WAC appears to be changing in spite of itself; as one lesbian says, "It's not about making friends. It's about making allies."

Yet unless there is sustained coalition building with non-artists and more action directly related to the concerns of nonwhite women, the number of women of color in the group won't dramatically increase. The room now is probably a fair manifestation of the art world. In addition, with the careers of nonwhite artists as much as ten years behind those of white artists of comparable talent, and with less discretionary time and income and proportionately greater demands on them, the women of color will not be as active. But, unlike the black woman who told me, "I have to deal with white people all day. I don't have the energy to jump into that bag at night," those who do come seem to feel comfortable. We are able to speak freely and occasion-

ally we are heard. Mostly middle-class artists ourselves, we may not have the temperament for the politically necessary task of organizing poor women outside.

We have our own differences. Though for all of us the traditional gender issues of white feminists—reproductive rights, sexual abuse, parity in the workplace—seem a tired throwback to the '70s unless inflected by economics, class, and race, not all are as theoretically oriented, or as protective of their time, as I am. Together with those white women who are their allies, some women of color have willingly taken on the permanent task of educating *them*, resigned to WAC as a microcosm of the world.

As for me, I am impatient with educational processes that take time from pressing goals, such as advancing in my own work, and helping African-American visual arts become established as a total field. But until someone figures out a way to get middle-class black women—all those doctors, lawyers, teachers, and administrators—"out of the stores and into the streets"[3] in what little time they have between jobs and family, WAC is as interesting a political activity as I can imagine. Dangerous and unpredictable, as exciting to observe as to participate in, it has all the qualities of the art I like best. I can't help hoping it comes sooner rather than later to the understanding of Tristan Tzara: "Dada remains within the European frame of weaknesses it's shit after all but from now on we mean to shit in assorted colors and bedeck the artistic zoo with the flags of every consulate."[4] By finding the means to change itself, through thinking as well as acting, WAC *could* just change the world.

See also *"Olympia's Maid: Reclaiming Black Female Subjectivity"; "Mlle Bourgeoise Noire and Feminism"; "Sketchy Thoughts on My Attraction to the Surrealists"; "My 1980s"; "Job History (from a Feminist 'Retrospective')"*

The Cave
Lorraine O'Grady on Black Women Film Directors (1992)

Written during a tentative "breakthrough" year for black film directors, this piece, which appeared in *Artforum*, was a search for answers to the question of why so few black women were being included in the celebration. The article demonstrates O'Grady's ability to combine reportage, criticism, and theoretical analysis in order to discuss wide-ranging topics—movies and pop culture, for example—and their relation to the structural conditions of inequality facing black women, who were constrained by virtue of both their race and their gender. In the almost three decades since O'Grady published her piece, little has changed, as far as big-budget Hollywood films go: according to the USC Annenberg Inclusion Initiative's annual "Inclusion in the Director's Chair" report, while the number of black-directed films among the industry's 100 top-grossing movies reached a record high of 14 percent in 2018, only one among these was directed by a woman; of the 1,200 top-grossing films released between 2007 and 2018, only nine were directed by black women.[1]

THE INVISIBILITY of black women has been much on my mind of late. Asked recently to speak on the topic "Can women artists take back the nude from a voyeuristic male gaze as a site to represent their own subjectivity?,"[2] I have

to discard the premise: from mass culture to high culture, white women may have been objects of the fetishizing gaze, but black women have had only the blank stare. In fact we feel lucky when we get to take our clothes off. Manet's *Olympia*, Picasso's *Demoiselles d'Avignon*, and Judy Chicago's *Dinner Party*, 1973–78, are landmarks in our unseeing erasure by both the multi-colored male and the white female. I believe in the mathematics of myth, which is why I'm always asking, "How many black women in this anthology? In this exhibit? In this picture? What are they made to signify?" Of the thirty-nine places at Chicago's dinner table, thirty-five are set with plates painted with vaginas that glow miraculously. Sojourner Truth, the only black guest, must make it without a pussy. She alone has a face, and not one but three: one screaming, one smiling, and one weeping a clichéd tear.[3] And Manet's Laure, fully dressed behind the nude and oh so white Olympia, is two-in-one: she is Jezebel united with Mammy, the whore combined with the female eunuch, who can only escape from an undialectical fate by disappearing into the background drapery.

This kind of bookkeeping does wear me down, and over the years I've had to defend against it. For instance, I've learned to keep my news at one or two removes: I read the *Sunday Times* instead of the daily, the *Nation* instead of watching TV. There's something consoling, when it finally lands on the cover of the *New York Times Magazine*, about having my festering intuition assume myth's sharp impermeable shape. Last July a *Times Magazine* cover appeared with a mountain of black film directors, from the bottom to the top of the frame. Eight, with a missing figure. I can't help myself. I start bookkeeping again. In a story that I count at 60 paragraphs, seven black women directors are barely listed in the second paragraph from the end.[4]

I tell myself not to get into this, since I don't see how I can be philosophical. But: who made the decision, the writer or the editor, not to discuss Euzhan Palcy, whose *Sugar Cane Alley* (1983) and *Dry White Season* were not only brilliant but profitable? And what about fully treating Julie Dash—the buzz for her forthcoming *Daughters of the Dust* is sounding more like a ringshout. The trouble with being erased for so long is that you come to think of your erasure as natural—until the moment when something, a novel by Toni Morrison, an essay by Hortense Spillers, an artwork by Adrian Piper, pierces your invisibility to yourself and becomes real. Palcy's *Sugar Cane Alley*, from France by way of Martinique, was my first glimpse of even a portion of my own peculiar African-Antillean-European-American sensibility on screen. Her negation in the *Times Magazine* article makes me mad.

I set out to discover how the official and the real reasons for black women's erasure differ.

For a Hollywood take on "Why there are no great black women directors"[5] I talk to Candace Allen, who is a founder and board member of Reel Black Women, a forward-looking organization of professional black women behind the camera. Allen guides me through the standard litany: in an industry run by 50-year-old white men to appeal to a core audience of 17-year-old boys, 25 percent of whom are black, sexism looms larger than racism. In fact the violence of inner-city movies is a turn-on for big boys who are still getting off with guns, bitches, and hard music. Is it true there are more black men directors in Hollywood than there are white women directors? Probably. Women, who may have gentler stories to tell, are best off being wives and/or daughters of Hollywood insiders, in the tradition of industry nepotism, or performers who have already made money for them. The only black woman who comes close to this profile is *Fame* TV director/performer Debbie Allen. And with not one black man or white woman currently in a position to greenlight a project for motion pictures, the barrier isn't getting easier to break. An October *Time* cover story on women directors, featuring Jodie Foster, implicitly confirms the sex/race double bind.[6] Fifteen women are treated, and not a single black.

Black women have done better in TV, where federal licensing enforces affirmative-action guidelines, and the recognition of a 25 percent black audience has produced several shows with black casts. But in the film industry there is no accountability—the only rule is the bottom line. And in a town where money is not just money but reputation and sex appeal, the line is not subtly inflected. "The attitude here is, if you can make money for us, we're on your side, for as long as you make it. We don't know who you are, don't care who you are, if you do this," says Allen. "But there's a narrow consciousness on what can make money, and until a black woman's story breaks through, the men here won't believe it. Maybe John Singleton will pave the way with *Poetic Justice*," she adds, resigned to the irony that the industry's one upcoming film about a black woman, a young rapper, is the project of *Boyz n the Hood*'s boy-wonder writer/director.

Allen is undeterred by the glitch between her pragmatic vision and her ambitions. Working in Hollywood since getting out of Harvard and NYU Film School, she's been a 1st AD, saving the asses of more directors than she cares to number. Now she hopes to push "above the line" with her screenplay *How High the Moon*, an interracial love triangle set in Harlem in the '40s. It covers all the bases, with a professional Lindy Hopper at the Savoy, a leftist

journalist, and a young woman writer who doubles as a pick-up dancer at the Apollo. And, she says, it can be done for under $3 mil.

Nor is Allen alone in being sanguine: on the East Coast, Jacqueline Shearer, a producer/director whose credits include segments for PBS's *The American Experience* and *Eyes on the Prize II*, is confident the breakthrough will happen "within a year." Ada Griffin, executive director of Third World Newsreel, insists that "a climate of acceptance can be *created* for black women's film, just as it has for other 'difficult' products, like rap music. All it takes is critics getting behind it, and the right kind of marketing."

Yet Palcy has gone back to France to work on a film, and is deflecting, for now, the calls that continue to come from Hollywood. "I know in my heart," she has said, "that if I was African-American they would never call me."[7] It's the samo samo: other people's blacks are acceptable—if you're in Italy, don't be Ethiopian; if you're in France, don't be French West Indian; and if you're in the United States, don't be African-American. Says Palcy: "Maybe they are scared of opening the door to black Americans because of the subjects they would explore." And now we're down to it. Just what stories would "she" tell? Would "everybody's Other" give away all the secrets, including her own? If, as in Barbara Johnson's famous quote, "the black woman is both invisible and ubiquitous: never seen in her own right but forever appropriated by the others for their own ends," why would any of "them" risk hearing from her?[8]

Certainly if our subjugated knowledges were to become primary, we would change the world. Imagine what would happen if we were to refuse banishment to the unnameable chaos that defines what woman is not. If we were to claim our stereotypes and make Jezebel the sign of our acceptance of our own bodies, Mammy the symbol of our ability to nurture, and Sapphire the signifier of our resilience and strength.[9] If we could share and build on what we've learned about ourselves and others from an exploitative work world. At the very least we would, as Spillers suggests, write a radically new text for female empowerment.[10] But even more dismaying to "them" might be our self-involvement, the discovery that *we* and not they are the center of our universes. Perhaps it is because many black women novelists have made a strategic choice to describe a world without white people that so few of their works have been translated to film, despite their publishing successes. And perhaps this is also why in the two exceptions, *The Color Purple* and *The Women of Brewster Place*, the books have been tamed by directors who are not black women.

Everyone I talk to can name from fifty to sixty black women awaiting their verb,[11] but outside the anonymous world of TV and Palcy's two theatri-

cal releases, most of the work has not been seen. Dash's *Daughters of the Dust*, before airing on PBS's *American Playhouse*, was previewed at private screenings in Hollywood in August. The biggies who were invited did not attend, and Dash came away without a Hollywood agent or distributor.

I borrow a video of *Daughters* from Kino International, the art-house distributor that has since negotiated rights to the film, and watch it with my studio assistant, a 23-year-old white male from the Midwest.[12] I have been warned that *Daughters*, about a family planning to migrate north from the Sea Islands off South Carolina in 1902 and filmed in the Gullah dialect, may be hard to follow. Two hours later, we are still riveted. The film, told in African-griot style and photographed with more long shots than I remember in a single movie, to embed its characters firmly in nature, has the remarkable authority of a work that creates its own syntax. And Robert seems to have got everything, even points I missed, though Gullah and the Jamaican patois I was raised with are almost identical.

Despite *Daughters*' $1 million PBS budget and Allen's dreams of "$3 mil," most black women spend years trying to raise less than $100,000. A bit luckier than some has been Martina Attille of Sankofa, a black British film collective that has received modest government sponsorship. Attille's half-hour film *Dreaming Rivers*, 1988, is the story of a West Indian woman who follows her lover to England and then commits suicide. Her three British children must lay her down ritually before they can take on a complex postcolonial identity.[13] *Rivers* has a touch of film school about it, but beyond its artiness and slow pace, a mesmerizing sensibility stretches the bounds of realism by combining theoretical issues with images of haunting beauty.

In the short course I have taken on black women in film, I've discovered that the dramatic feature is not everyone's goal. Camille Billops and her husband James Hatch are happy with the documentary and with the audience they've found through Third World Newsreel. Their one-hour *Finding Christa* (1991), which has been selected for both the Sundance and the Rotterdam festival this month, may be the most artistically interesting of the films I've seen. A personal movie on Billops' encounter with the daughter she gave up for adoption, it expands the concept of the documentary into something for which I still can't find a name. It was shot in the stops and starts of erratic funding, and Billops, an accomplished ceramic sculptor but untrained as a filmmaker, has used this lurching quality to advantage. She's produced an amazing home movie that seems to define the revolutionary potential in what Richard Rorty calls "abnormal discourse," the new thing that can happen when one is either unaware of or sets aside the rules.[14]

There are still too few films to define a "black women's esthetic," and more than likely our experience is too diverse for anything so uniform to emerge (isn't that the happiest evidence of the Anita Hill hearings?). But I am more convinced than ever that the culture needs our voice, though I can't bring myself to believe that it will be heard.

At my local supermarket, the cover of the November *Elle* arrests me: a black and a white model stare out together, a first for magazine publishing, I think. Is this the new dispensation? I buy the issue, but as soon as I get it home, I start bookkeeping. Of the eighty-nine ad models I count, there are two women of color: one for "ivory" and one for "mahogany" in an ad for All Skin Prescriptives. In the fashion editorials, except for two Latinas (both with straight auburn hair), even beige, which two or three years ago threatened to become normative, seems to have disappeared.

See also "Rivers, First Draft, *1982: Working Script, Cast List, Production Credits*"; "*Olympia's Maid: Reclaiming Black Female Subjectivity*"; "Mlle Bourgeoise Noire *and Feminism*"; "*Email* Q&A *with* Artforum *Editor*"

Olympia's Maid
Reclaiming Black Female Subjectivity (1992/1994)

First presented at the 1992 College Art Association conference on a panel that analyzed the role of the nude in feminist art, and then expanded in 1994 to include a lengthy postscript, "Olympia's Maid" was the first work of cultural criticism that focused on the black female body. The essay, alongside her photo project *Body Is the Ground of My Experience* from 1991, marks a shift of sorts in O'Grady's thinking, from a postmodernist emphasis on critique (manifest in the *Mlle Bourgeoise Noire* project, for example) toward a recognition that postmodernism's easy disposal of the "essentialized" subject was another way of reinscribing white masculinity at the center of critical theory. (She was joined in this thinking by Gayatri Spivak, whose work she discusses in depth here.) In the essay, O'Grady draws on a breathtakingly broad range of thinkers to posit the need for "both/and" ways of thinking—an approach that allows the multiplicity of black women's experience to be expressed—to short-circuit the binaristic "either/or" tendencies that structure Western thought, and white supremacist thought above all.

THE FEMALE BODY in the West is not a unitary sign. Rather, like a coin, it has an obverse and a reverse: on the one side, it is white; on the other, non-white or, prototypically, black. The two bodies cannot be separated, nor can one body be understood in isolation from the other in the West's meta-

phoric construction of "woman." White is what woman is; not-white (and the stereotypes not-white gathers in) is what she had better not be. Even in an allegedly postmodern era, the not-white woman as well as the not-white man are symbolically and even theoretically excluded from sexual difference.[1] Their function continues to be, by their chiaroscuro, to cast the difference of white men and white women into sharper relief.

A kaleidoscope of not-white females, Asian, Native American, Latina, and African, have played distinct parts in the West's theater of sexual hierarchy. But it is the African female who, by virtue of color and feature and the extreme metaphors of enslavement, is at the outermost reaches of "otherness." Thus she subsumes all the roles of the not-white body.

The smiling, bare-breasted African maid, pictured so often in Victorian travel books and *National Geographic* magazine, got something more than a change of climate and scenery when she came here.

Sylvia Ardyn Boone, in her book *Radiance from the Waters* (1986), on the physical and metaphysical aspects of Mende feminine beauty, says of contemporary Mende: "Mende girls go topless in the village and farmhouse. Even in urban areas, girls are bare-breasted in the house: schoolgirls take off their dresses when they come home, and boarding students are most comfortable around the dormitories wearing only a wrapped skirt."[2]

What happened to the girl who was abducted from her village, then shipped here in chains? What happened to her descendants? Male-fantasy images on rap videos to the contrary, as a swimmer, in communal showers at public pools around the country, I have witnessed black girls and women of all classes showering and shampooing with their bathing suits on, while beside them their white sisters stand unabashedly stripped.

Perhaps the progeny of that African maiden feel they must still protect themselves from the centuries-long assault that characterizes them, in the words of the *New York Times* ad placed by a group of African American women to protest the Clarence Thomas–Anita Hill hearings, as "immoral, insatiable, perverse; the initiators in all sexual contacts—abusive or otherwise."[3]

Perhaps they have internalized and are cooperating with the West's construction of not-white women as not-to-be-seen. How could they/we not be affected by that lingering structure of invisibility, enacted in the myriad codicils of daily life and still enforced by the images of both popular and high culture? How not to get the message of what Judith Wilson calls "the legions of black servants who loom in the shadows of European and European-American aristocratic portraiture,"[4] of whom Laure, the professional model that Edouard Manet used for Olympia's maid, is in an odd way only the

most famous example? Forget "tonal contrast." We know what she is meant for: she is Jezebel *and* Mammy, prostitute and female eunuch, the two-in-one. When we're through with her inexhaustibly comforting breast, we can use her ceaselessly open cunt. And best of all, she is not a real person, only a robotic servant who is not permitted to make us feel guilty, to accuse us as does the slave in Toni Morrison's *Beloved* (1987). After she escapes from the room where she was imprisoned by a father and son, that outraged woman says: "You couldn't think up what them two done to me."[5] Olympia's maid, like all the other "peripheral Negroes,"[6] is a robot conveniently made to disappear into the background drapery.

To repeat: *castrata* and whore, not Madonna and whore. Laure's place is outside what can be conceived of as woman. She is the chaos that must be excised, and it is her excision that stabilizes the West's construct of the female body, for the "femininity" of the white female body is ensured by assigning the not-white to a chaos safely removed from sight. Thus only the white body remains as the object of a voyeuristic, fetishizing male gaze. The not-white body has been made opaque by a blank stare, misperceived in the nether regions of TV.

It comes as no surprise, then, that the imagery of white female artists, including that of the feminist avant-garde, should surround the not-white female body with its own brand of erasure. Much work has been done by black feminist cultural critics (Hazel Carby and bell hooks come immediately to mind) that examines two successive white women's movements, built on the successes of two black revolutions, which clearly shows white women's inability to surrender white skin privilege even to form basic alliances.[7] But more than politics is at stake. A major structure of psychic definition would appear threatened were white women to acknowledge and embrace the sexuality of their not-white "others." How else explain the treatment by that women's movement icon, Judy Chicago's *Dinner Party* (1973–78), of Sojourner Truth, the lone black guest at the table? When thirty-six of thirty-nine places are set with versions of Chicago's famous "vagina" and recognizable slits have been given to such sex bombs as Queen Elizabeth I, Emily Dickinson, and Susan B. Anthony, what is one to think when Truth, the mother of four, receives the only plate inscribed with a face?[8] Certainly Hortense Spillers is justified in stating that "the excision of the genitalia here is a symbolic castration. By effacing the genitals, Chicago not only abrogates the disturbing sexuality of her subject, but also hopes to suggest that her sexual being did not exist to be denied in the first place."[9]

And yet Michele Wallace is right to say, even as she laments further in-

stances of the disempowerment of not-white women in her essay on *Privilege* (1990), Yvonne Rainer's latest film, that the left-feminist avant-garde, "in foregrounding a political discourse on art and culture," has fostered a climate that makes it "hypothetically possible to publicly review and interrogate that very history of exclusion and racism."[10]

What alternative is there really—in creating a world sensitive to difference, a world where margins can become centers—to a cooperative effort between white women and women and men of color? But cooperation is predicated on sensitivity to differences among ourselves. As Nancy Hartsock has said, "We need to dissolve the false 'we' into its true multiplicity."[11] We must be willing to hear each other and to call each other by our "true-true name."[12]

To name ourselves rather than be named we must first see ourselves. For some of us this will not be easy. So long unmirrored in our true selves, we may have forgotten how we look. Nevertheless, we can't theorize in a void, we must have evidence. And we—I speak only for black women here—have barely begun to articulate our life experience. The heroic recuperative effort by our fiction and nonfiction writers sometimes feels stuck at the moment before the Emancipation Proclamation.[13] It is slow and it is painful. For at the end of every path we take, we find a body that is always already colonized. A body that has been raped, maimed, murdered—that is what we must give a healthy present.

It is no wonder that when Judith Wilson went in search of nineteenth-century nudes by black artists, she found only three statues of non-black children—Edmonia Lewis's *Poor Cupid* (1876); her *Asleep* (1871); and one of the two children in her *Awake* (1872)[14]—though Wilson cautions that, given the limits of current scholarship, more nudes by nineteenth-century blacks may yet surface.[15] Indeed, according to Wilson, the nude, one of high art's favorite categories, has been avoided during most of "the 200-year history of fine art production by North American blacks."[16] Noting exceptions that only prove the rule, that is, individual works by William H. Johnson and Francisco Lord in the thirties and Eldzier Cortor's series of Sea Island nudes in the forties, she calls "the paucity of black nudes in U.S. black artistic production prior to 1960 . . . an unexamined problem in the history of Afro-American art."[17] And why use 1960 as a marker of change? Because, says Wilson, after that date there was a confluence of two different streams: the presence of more, and more aggressive, black fine artists such as Bob Thompson and Romare Bearden, and the political use of the nude as a symbol of "Black Is Beautiful," the sixties slogan of a programmatic effort to establish black ethnicity and achieve psychic transformation.[18]

Neither of these streams, however, begins to deal with what I am concerned with here: the reclamation of the body as a site of black female subjectivity. Wilson hints at part of the problem by subtitling a recent unpublished essay "Bearden's Use of Pornography." An exterior, pornographic view, however loving, will not do any more than will the emblematic "Queen of the Revolution." But though Wilson raises provisional questions about Bearden's montaging of the pornographic image, her concerns are those of the art historian, while mine must be those of the practitioner.[19] When, I ask, do we start to see images of the black female body by black women made as acts of auto-expression, the discrete stage that must immediately precede or occur simultaneously with acts of auto-critique? When, in other words, does the present begin?

Wilson and I agree that, in retrospect, the catalytic moment for the subjective black nude might well be Adrian Piper's *Food for the Spirit* (1971), a private loft performance in which Piper photographed her physical and metaphysical changes during a prolonged period of fasting and reading of Immanuel Kant's *Critique of Pure Reason*.[20] Piper's performance, unpublished and unanalyzed at the time (we did not have the access then that we do now), now seems a paradigm for the willingness to look, to get past embarrassment and retrieve the mutilated body, as Spillers warns we must if we are to gain the clear-sightedness needed to overthrow hierarchical binaries: "Neither the shamefaced of the embarrassed, nor the not-looking-back of the self-assured is of much interest to us," Spillers writes, "and will not help at all if rigor is our dream."[21]

It is cruelly ironic, of course, that just as the need to establish our subjectivity in preface to theorizing our view of the world becomes most dire, the idea of subjectivity itself has become "problematized." But when we look to see just whose subjectivity has had the ground shifted out from under it in the tremors of postmodernism, we find (who else?) the one to whom Hartsock refers as "the transcendental voice of the Enlightenment" or, better yet, "He Who Theorizes."[22] Well, good riddance to him. We who are inching our way from the margins to the center cannot afford to take his problems or his truths for our own.

Although time may be running out for such seemingly marginal agendas as the establishment of black female subjectivity (the headlines remind us of this every day) and we may feel pressured to move fast, we must not be too conceptually hasty. This is a slow business, as our writers have found out. The work of recuperation continues. In a piece called *Seen* (1990) by the conceptual artist Renee Greene, two of our ancestresses most in need,

Saartjie Baartman ("the Hottentot Venus") and Josephine Baker, have been "taken back." Each in her day (early nineteenth and twentieth century, respectively) was the most celebrated European exhibit of exotic flesh.

Greene's piece invited the viewer to stand on a stage inscribed with information about the two and, through a "winkie" of eyes in the floor and a shadow screen mounted on the side, to experience how the originals must have felt, pinned and wriggling on the wall. The piece has important attributes: it is above all cool and smart. But from the perspective being discussed here—the establishment of subjectivity—because it is addressed more to the other than to the self and seems to deconstruct the subject just before it expresses it, it may not unearth enough new information.

The question of to whom work is addressed cannot be emphasized too strongly. In the 1970s, African American women novelists showed how great a leap in artistic maturity could be made simply by turning from their male peers' pattern of "explaining *it* to *them*," as Morrison once put it, to showing how it feels to *us*.[23]

Besides, pleading contains a special trap, as Gayatri Spivak noted in her discussion of the character Christophine in Jean Rhys's *Wide Sargasso Sea*: "No perspective *critical* of imperialism can turn the Other into a self, because the project of imperialism has always already historically refracted what might have been the absolutely Other into a domesticated Other that consolidates the imperialist self."[24] Critiquing *them* does not show who *you* are: it cannot turn you from an object into a subject of history.

The idea bears repeating: self-expression is not a stage that can be bypassed. It is a discrete moment that must precede or occur simultaneously with the deconstructive act. An example may be seen in the work of the painter Sandra Payne. In 1986, at the last show of the now legendary black avant-garde gallery Just Above Midtown in Soho, Payne presented untitled drawings of joyously sexual and sublimely spiritual nudes. The opening reception was one of those where people speak of everything but what is on the walls. We do not yet have the courage to look.

Understandably, Payne went into retreat. Three years later, she produced attenuated mask drawings that, without the hard edge of postmodernism, are a postmodern speech act in the dialogue of mask and masquerade. Without the earlier subjective nudes, she may not have arrived at them.

A year ago, as a performance artist in a crisis of the body (how to keep performing without making aging itself the subject of the work?), I opted for the safety of the wall with a show of photomontages. My choice of the nude was innocent and far from erotic; I wanted to employ a black self stripped

of as many layers of acculturation as possible. The one piece in the show with explicitly represented sexuality, *The Clearing* (1991), a diptych in which a black female engaged with a white male, was to me less about sex than it was about culture. It was not possible to remain innocent for long, however. I soon encountered an encyclopedia of problematics concerning the black body: age, weight, condition, not to mention hair texture, features, and skin tone. Especially skin tone. Any male and female side by side on the wall are technically married. How to arrange a quadriptych such as *Gaze* (1991), composed of head-and-shoulder shots of differently hued black men and women? Should I marry the fair woman to the dark man? The dark woman to the fair man? What statements will I be making about difference if I give them mates matching in shade? What will I be saying about the history of class?

There was another problematic, as personal as it was cultural. Which maimed body would be best retrieved as the ground of my biographic experience? Young or middle-aged? Jezebel or Mammy? The woman I was or the woman I am now? And which body hue should I use to generalize my upper-middle-class West Indian–American experience? A black-skinned "ancestress," or the fairer-skinned product of rape? I hedged. In the end, I chose an African-British high-fashion model, London-born but with parents from Sierra Leone. For me, she conveyed important ambiguities: she was black-skinned, but her nude body retained the aura of years of preparation for runway work in Europe. In *The Strange Taxi: From Africa to Jamaica to Boston in 200 Years*, where the subject was hybridism itself, my literal ancestresses, who to some may have looked white, sprouted from a European mansion rolling on wheels down the African woman's back. Although they may have been controversial, I liked the questions those beautifully dressed, proudly erect, ca. World War I women raised, not least of which was how the products of rape could be so self-confident, so poised.

As I wrestled with ever shifting issues regarding which black woman to shoot, I came to understand and sympathize with Lorna Simpson's choice of a unified response in such montages as *Guarded Conditions* (1989), in which a brown-skinned woman in a shapeless white shift is shot from behind—with every aspect of subjectivity both bodily and facial occluded, except the need to cover up itself—and then multiplied. No doubt about it. This multiple woman showers and shampoos in her shift.

But, I tell myself, this cannot be the end. First we must acknowledge the complexity, and then we must surrender to it. Of course, there isn't any final answering of the question, "What happened to that maid when she was brought here?" There is only the process of answering it and the com-

plementary process of allowing each answer to come to the dinner party on its own terms. Each of these processes is just beginning, but perhaps if both continue, the nature of the answers will begin to change and we will all be better off. For if the female body in the West is obverse and reverse, it will not be seen in its integrity—neither side will know itself—until the not-white body has mirrored herself fully.

Postscript

The paragraphs above were drafted for delivery before a panel of the College Art Association early in 1992.[25] Rereading them, I can see to how great an extent they were limited by the panel's narrowly feminist brief. The topic assigned was "Can the naked female body effectively represent women's subjectivity in contemporary North American media culture, which regularly presents women's bodies as objects for a voyeuristic and fetishizing male gaze?"

I think I was invited because I was the only black female artist employing the nude anyone on the panel had heard of. I felt like the extra guest who's just spilled soup on the tablecloth when I had to reject the panel's premise. The black female's body needs less to be rescued from the masculine "gaze" than to be sprung from a historic script surrounding her with signification while at the same time, and not paradoxically, it erases her completely.

Still, I could perhaps have done a better job of clarifying "what it is I think I am doing anyway."[26] Whether I will it or not, as a black female artist my work is at the nexus of aggravated psychic and social forces as yet mostly uncharted. I could have explained my view, and shown the implications for my work, of the multiple tensions between contemporary art and critical theory, subjectivity and culture, modernism and postmodernism, and, especially for a black female, the problematic of psychoanalysis as a leitmotif through all of these.

I don't want to leave the impression that I am privileging representation of the body. On the contrary: though I agree, to alter a phrase of Merleau-Ponty, that every theory of subjectivity is ultimately a theory of the body,[27] for me the body is just one artistic question to which it is not necessarily the artistic answer.

My work in progress deals with what Gayatri Spivak has called the "'winning back' of the position of the questioning subject."[28] To win back that position for the African American female will require balancing in mental solution a subversion of two objects that may appear superficially distinct:

on the one hand, phallocentric theory; and on the other, the lived realities of Western imperialist history, for which all forms of that theory, including the most recent, function as willing or unwilling instruments.

It is no overstatement to say that the greatest barrier I/we face in winning back the questioning subject position is the West's continuing tradition of binary, "either: or" logic, a philosophic system that defines the body in opposition to the mind. Binaristic thought persists even in those contemporary disciplines to which black artists and theoreticians must look for allies. Whatever the theory of the moment, before we have had a chance to speak, we have always already been spoken and our bodies placed at the binary extreme, that is to say, on the "other" side of the colon. Whether the theory is Christianity or modernism, each of which scripts the body as all-nature, *our* bodies will be the most natural. If it is poststructuralism/postmodernism, which through a theoretical sleight of hand gives the illusion of having conquered binaries, by joining the once separated body and mind and then taking this "unified" subject, perversely called "fragmented," and designating it as all-culture, we can be sure it is *our* subjectivities that will be the most culturally determined. Of course, it is like whispering about the emperor's new clothes to remark that nature, the other half of the West's founding binary, is all the more powerfully present for having fallen through a theoretical trapdoor.

Almost as maddening as the theories themselves is the time lag that causes them to overlap in a crazy quilt of imbrication. There is never a moment when new theory definitively drives out old. Successive, contradictory ideas continue to exist synchronistically, and we never know where an attack will be coming from, or where to strike preemptively.

Unless one understands that the only constant of these imbricated theories is the black body's location at the extreme, the following statements by some of our more interesting cultural theorists might appear inconsistent.

Not long ago, Kobena Mercer and Isaac Julien felt obliged to argue against the definition of the body as all-nature. After noting that "European culture has privileged sexuality as the essence of the self, the innermost core of one's 'personality,'" they went on to say: "This 'essentialist' view of sexuality . . . *already contains racism*. Historically, the European construction of sexuality coincides with the epoch of imperialism and the two interconnect. [It] is based on the idea that sex is the most basic form of naturalness which is therefore related to being *un*civilized or *against* civilization" (my emphasis).[29]

Michele Wallace, on the other hand, recently found herself required to defend the black body against a hermeneutics of all-culture. "It is not often

recognized," she commented, "that bodies and psyches of color have trajectories in excess of their socially and/or culturally constructed identities."[30] Her statement is another way of saying: now that we have "proved" the personal is the political, it is time for us to reassert that the personal is not *just* political.

Wallace and Mercer and Julien are all forced to declare that subjectivity belongs to *both* nature *and* culture. It's true, "both: and" thinking is alien to the West. Not only is it considered primitive, but it is now further tarred with the brush of a perceived connection to essentialism. For any argument that subjectivity is partly natural is assumed to be essentialist. But despite the currency of anti-essentialist arguments, white feminists and theorists of color have no choice: they must develop critiques of white masculinist "either: or-ism," even if this puts them in the position of appearing to set essentialism up against anti-essentialism. This inherent dilemma of the critique of binarism may be seen in Spivak's often amusing ducking and feinting. To justify apparent theoretical inconsistencies, Spivak once explained her position to an interviewer as follows:

> Rather than define myself as specific rather than universal, I should see what in the universalizing discourse could be useful and then go on to see where that discourse meets its limits and its challenge within that field. I think we have to choose again strategically, not universal discourse but essentialist discourse. I think that since as a deconstructivist—see, I just took a label upon myself—I cannot in fact clean my hands and say, "I'm specific." In fact I must say I am an essentialist from time to time. There is, for example, the strategic choice of a genitalist essentialism in antisexist work today. How it relates to all of this other work I am talking about, I don't know, but *my search is not a search for coherence.* (My emphasis)[31]

Somebody say Amen.

If artists and theorists of color were to develop and sustain our critical flexibility, we could cause a permanent interruption in Western "either: or-ism." And we might find our project aided by that same problematic imbrication of theory, whose disjunctive layers could signal the persistence of an unsuspected "both: and-ism," hidden, yet alive at the subterranean levels of the West's constructs. Since we are forced both to argue that the body is more than nature, and *at the same time* to remonstrate that there is knowledge beyond language/culture, why not seize and elaborate the anomaly? In doing so, we might uncover tools of our own with which to dismantle the house of the master.[32]

Our project could begin with psychoanalysis, the often-unacknowledged linchpin of Western (male) cultural theory. The contradictions currently surrounding this foundational theory indicate its shaky position. To a lay person, postmodernism seems to persist in language that opposes psychoanalysis to other forms of theoretical activity, making it a science or "truth" that is not culturally determined. Psychoanalysis's self-questioning often appears obtuse and self-justifying. The field is probably in trouble if Jacqueline Rose, a Lacanian psychologist of vision not unsympathetic to Third World issues, can answer the question of psychoanalysis's universality as follows: "To say that psychoanalysis does not, or cannot, refer to non-European cultures is to constitute those cultures in total 'otherness' or 'difference': to say, or to try to demonstrate, that it can is to constitute them as the 'same.' This is not to say that the question shouldn't be asked."[33] The implication of such a statement is that no matter how many times you ask the question of the universality of psychoanalysis or how you pose it, you will not arrive at an answer. But the problem is not the concept of "the unanswerable question," which I find quite normal. The problem is the terms in which Rose frames the question in the first place: her continuing use of the totalizing opposition of "otherness" and "sameness" is the sign of an "either: or" logic that does not yet know its own name.

If the unconscious may be compared to that common reservoir of human sound from which different peoples have created differing languages, all of which are translated more or less easily, then how can any of the psyche's analogous products be said to constitute total "otherness" or "difference"? It's at this point that one wants, without being *too* petulant, to grab psychoanalysis by the shoulders and slap it back to a moment before Freud's Eros separated from Adler's "will-to-power," though such a moment may never have existed even theoretically. We need to send this field back to basics. The issue is not whether the unconscious is universal, or whether it has the meanings psychoanalysis attributes to it (it is, and it does), but rather that, in addition, it contains contradictory meanings, as well as some that are unforeseen by its current theory.

Meanwhile, psychoanalysis and its subdisciplines, including film criticism, continue having to work overtime to avoid the "others" of the West. Wallace has referred to "such superficially progressive discourses as feminist psychoanalytic film criticism which one can read for days on end without coming across any lucid reference to, or critique of, 'race.'"[34]

But that omission will soon be redressed. We are coming after them. In her most brilliant theoretical essay to date, "The Oppositional Gaze," bell

hooks takes on white feminist film criticism directly.[35] And Gayatri Spivak brooks no quarter. She has declared that non-Western female subject constitution is the main challenge to psychoanalysis and counterpsychoanalysis and has said: "The limits of their theories are disclosed by an encounter with the materiality of that other of the West."[36]

For an artist of color, the problem is less the limits of psychoanalysis than its seeming binarial *rigidity*. Despite the field's seeming inability to emancipate itself from "either: or-ism," I hope its percepts are salvageable for the non-West. Psychoanalysis, after anthropology, will surely be the next great Western discipline to unravel, but I wouldn't want it to destruct completely. We don't have to reinvent that wheel. But to use it in our auto-expression and auto-critique, we will have to dislodge it from its narrow base in sexuality. One wonders if, even for Europeans, sexuality as the center or core of "personality" is an adequate dictum. Why does there have to be a "center: not-center" in the first place? Are we back at that old Freud/Adler crossroad?[37] In Western ontology, why does somebody always have to win?

"Nature: culture," "body: mind," "sexuality: intellect," these binaries don't begin to cover what we "sense" about ourselves. If the world comes to us through our senses—and however qualified those are by culture, no one says culture determines *everything*—then even they may be more complicated than their psychoanalytic description. What about the sense of balance, of equilibrium? Of my personal *cogitos*, a favorite is "I dance, therefore I think." I'm convinced that important, perhaps even the deepest, knowledge comes to me through movement, and that the opposition of materialism to idealism is just another of the West's binarial theorems.

I have not taken a scientific survey, but I suspect most African Americans who are not in the academy would laugh at the idea that their subjective lives were organized around the sex drive and would feel that "sexuality," a conceptual category that includes thinking about it as well as doing it, is something black people just don't have time for. This "common sense" is neatly appropriated for theory by Spillers in her statement: "Sexuality describes another type of discourse that splits the world between the 'West and the Rest of Us.'"[38]

Not that sex isn't important to these folks; it's just one center among many. For African American folk wisdom, the "self" revolves about a series of variable "centers," such as sex and food; family and community; and a spiritual life composed sometimes of God or the gods, at others of aesthetics or style. And it's not only the folk who reject the concept of a unitary center of the "self." Black artists and theorists frequently refer to African Americans

as "the first postmoderns." They have in mind a now agreed understanding that our inheritance from the motherland of pragmatic, "both: and" philosophic systems, combined with the historic discontinuities of our experience as black slaves in a white world, have caused us to construct subjectivities able to negotiate between "centers" that, at the least, are double.[39]

It is no wonder that the viability of psychoanalytic conventions has come into crisis. There is a gulf between Western and non-Western quotidian perceptions of sexual valence, and the question of how psychic differences come into effect when "cultural differences" are accompanied by real differences in power. These are matters for theoretical and clinical study. But for artists exploring and mapping black subjectivity, having to track the not-yet-known, an interesting question remains: Can psychoanalysis be made to triangulate nature and culture with "spirituality" (for lack of a better word) and thus incorporate a sense of its own limits? The discipline of art requires that we distinguish between the unconscious and the limits of its current theory, and that we remain alive to what may escape the net of theoretical description.

While we await an answer to the question, we must continue asserting the obvious. For example, when Elizabeth Hess, a white art critic, writes of Jean-Michel Basquiat's "dark, frantic figures" as follows, she misses the point: "There is never any one who is quite human, realized; the central figures are masks, hollow men. . . . It can be difficult to separate the girls from the boys in this work. *Pater* clearly has balls, but there's an asexualness throughout that is cold."[40] Words like "hot" and "cold" have the same relevance to Basquiat's figures as they do to classic African sculptures.

The space spirituality occupies in the African American unconscious is important to speculate upon, but I have to be clear. My own concern as an artist is to reclaim black female subjectivity so as to "de-haunt" historic scripts and establish worldly agency. Subjectivity for me will always be a social and not merely a spiritual quest.[41] To paraphrase Brecht, "It is a fighting subjectivity I have before me," one come into political consciousness.[42]

Neither the body nor the psyche is all-nature or all-culture, and there is a constant leakage of categories in individual experience. As Stuart Hall says of the relations between cultural theory and psychoanalysis, "Every attempt to translate the one smoothly into the other doesn't work; no attempt to do so can work. Culture is neither just the process of the unconscious writ large nor is the unconscious simply the internalization of cultural processes through the subjective domain."[43]

One consequence of this incommensurabilty for my practice as an artist is that I must remain wary of theory. There have been no last words spoken

on subjectivity. If what I suspect is true, that it contains a multiplicity of centers and all the boundaries are fluid, then most of what will interest me is occurring in the between-spaces. I don't have a prayer of locating these by prescriptively following theoretical programs. The one advantage art has over other methods of knowledge, and the reason I engage in it rather than some other activity for which my training and intelligence might be suited, is that, except for the theoretical sciences, it is the primary discipline where an exercise of calculated risk can regularly turn up what you had not been looking for. And if, as I believe, the most vital inheritance of contemporary art is a system for uncovering the unexpected, then programmatic art of any kind would be an oxymoron.

Why should I wish to surrender modernism's hard-won victories, including those of the Romantics and Surrealists, victories over classicism's rearguard ecclesiastical and statist theories? Despite its "post-ness," postmodernism, with its privileging of mind over body and culture over nature, sometimes feels like a return to the one-dimensionality of the classic moment. That, more than any rapidity of contemporary sociocultural change and fragmentation, may be why its products are so quickly desiccated.

Because I am concerned with the reclamation of black female subjectivity, I am obliged to leave open the question of modernism's demise. For one thing, there seems no way around the fact that the method of reclaiming subjectivity precisely mirrors modernism's description of the artistic process. Whatever else it may require, it needs an act of will to project the inside onto the outside long enough to see and take possession of it. But, though this process may appear superficially *retardataire* to some, repossessing black female subjectivity will have unforeseen results both for action and for inquiry.

I am not suggesting an abandonment of theory: whether we like it or not, we are in an era, postmodern or otherwise, in which no practitioner can afford to overlook the openings of deconstruction and other poststructural theories. But as Spivak has said with respect to politics, practice will inevitably norm the theory instead of being an example of indirect theoretical application: "Politics is asymmetrical," Spivak says; "it is provisional, you have broken the theory, and that's the burden you carry when you become political."[44]

Art is, if anything, more asymmetrical than politics, and since artistic practice not only norms but, in many cases, self-consciously produces theory, the relation between art and critical theory is often problematic. Artists who are theoretically aware, in particular, have to guard against be-

coming too porous, too available to theory. When a well-intentioned critic like bell hooks says, "I believe much is going to come from the world of theory-making, as more black cultural critics enter the dialogue. As theory and criticism call for artists and audiences to shift their paradigms of how they see, we'll see the freeing up of possibilities,"[45] my response must be: Thanks but no thanks, bell. I have to follow my own call.

Gayatri Spivak calls postmodernism "the new proper name of the West," and I agree. That is why for me, for now, the postmodern concept of *fragmentation*, which evokes the mirror of Western illusion shattered into inert shards, is less generative than the more "primitive" and active *multiplicity*. This is not, of course, the cynical *multi* of "multiculturalism," where the Others are multicultural and the Same is still the samo. Rather, paradoxically, it is the *multi* implied in the best of modernism's primitivist borrowings, for example in Surrealism, and figured in Éluard's poem: "Entre en moi toi ma multitude" (Enter into me you my multitude).[46] This *multi* produces tension, as in the continuous equilibration of a *multiplicity of centers*, for which dance may be a brilliant form of training.

Stuart Hall has described the tensions that arise from the slippages between theory development and political practice and has spoken of the need to live with these disjunctions without making an effort to resolve them. He adds the further caveat that in one's dedication to the search for "truth" and "a final stage," one invariably learns that meaning never arrives, being never arrives, we are always only becoming.[47]

Artists must operate under even more stringent limitations than political theorists in negotiating disjunctive centers. Flannery O'Connor, who in her essays on being a Catholic novelist in the Protestant South may have said most of what can be said about being a strange artist in an even stranger land, soon discovered that though an oppositional artist like herself could choose what to write, she could not choose what she could make live. "What the Southern Catholic writer is apt to find, when he descends within his imagination," she wrote, "is not Catholic life but the life of this region in which he is both native and alien. He discovers that the imagination is not free, but bound."[48] You must not give up, of course, but you may have to go belowground. It takes a strong and flexible will to work both with the script and against it at the same time.

Every artist is limited by what concrete circumstances have given her to see and think, and by what her psyche makes it possible to initiate. Not even abstract art can be made in a social or psychic vacuum. But the artist concerned with subjectivity is particularly constrained to stay alert to the ten-

sion of differences between the psychic and the social. It is her job to make possible that dynamism Jacqueline Rose has designated as "medium subjectivity" and to avert the perils of both the excessively personal and the overly theoretical.

The choice of *what* to work on sometimes feels to the artist like a walk through a minefield. With no failproof technology, you try to mince along with your psychic and social antennae swiveling. Given the ideas I have outlined here, on subjectivity and psychoanalysis, modernism and multiplicity, this is a situation in which the following modest words of Rose's could prove helpful: "I'm not posing what an ideal form of medium subjectivity might be; rather, I want to ask where are the flashpoints of the social and the psychic that are operating most forcefully at the moment."[49]

I would add to Rose's directive the following: the most interesting social flashpoint is always the one that triggers the most unexpected and suggestive psychic responses. This is because winning back the position of the questioning subject for the black female is a two-pronged goal. First, there must be provocations intense enough to lure aspects of her image from the depths to the surface of the mirror. And then, synchronously, there must be a probe for pressure points (which may or may not be the same as flashpoints). These are places where, when enough stress is applied, the black female's aspects can be reinserted into the social domain.

I have only shadowy premonitions of the images I will find in the mirror, and my perception of how successfully I can locate generalizable moments of social agency is necessarily vague. I have entered on this double path knowing in advance that as another African American woman said in a different context, it is more work than all of us together can accomplish in the boundaries of our collective lifetimes.[50] With so much to do in so little time, only the task's urgency is forcing me to stop long enough to try and clear a theoretical way for it.

See also "Body Is the Ground of My Experience, *1991: Image Descriptions*"; "*On Creating a Counter-confessional Poetry*"; "*Black Dreams*"; "*Some Thoughts on Diaspora and Hybridity: An Unpublished Slide Lecture*"; "*Two Exhibits: The Diptych vs. the Triptych and Notes on the Diptych*"; "*SWM: On Sean Landers*"

Mlle Bourgeoise Noire and Feminism
(2007)

This statement was written for the audio tour of *WACK! Art and the Feminist Revolution*, a groundbreaking show of feminist art organized by curator Connie Butler at the Museum of Contemporary Art in Los Angeles. In it, O'Grady discusses her search for a feminist model that would allow for "tripartite" critique: of patriarchy, of the limitations of white feminism, and of the class specificity of black feminism. Note here a theme running through much of O'Grady's discussion of race: the importance of class as an inflecting factor.

Q How does the work *Mlle Bourgeoise Noire* relate to art and the feminist revolution?

A "Mlle Bourgeoise Noire" is French for "Miss Black Bourgeoise." The backstory I created for her was that she'd won the title in a worldwide event held in Cayenne, the capital of French Guiana. Cayenne may have been a backwater, but the black bourgeois condition was international! In 1955, the year she won her crown, all around the world, in London, Paris, Amsterdam, and Washington, DC, there were young women just like her.

Mlle Bourgeoise Noire was a critical piece, located at the nexus of race, class, and gender. In 1980, when I created it, there were no role models in white feminist art for a tri-partite critique, or at least none that I was aware of.

That era's feminism seemed concerned exclusively with gender. Second-wave feminism was basically a white bourgeois construction that seemed to operate as though unconscious either that it was white or that it was middle-class. It was a time when white feminists could still believe that their definitions of sexual liberation and professional advancement applied identically to all women . . . and that they could speak for all women. In that era, even though black feminists may have admired the energy, even the delirium, of white feminist rhetoric, not to mention the bravery of many of its actions, they still felt alienated by and even a bit derisive toward it.

Still, the fact is, black feminism was itself a middle-class construction. But the middle class it derived from was one in which women, however well-educated, did not have the luxury of a Betty Friedan–style *feminine mystique*. Even black Ivy League women married to doctors had to, or chose to, work. Since the end of slavery—given that blacks for the most part earned half of what whites did—middle-class lifestyles had been supported by families with two jobs. Black women were post-modernist *avant la lettre*.

It's true that black bourgeois women worldwide were sexually repressed in this era. What else could they be when they were defined by their surrounding cultures as the universal prostitute? They were desperate for respect. In 1980, black avant-garde art, another middle-class construction, was equally repressed. *That's* why Mlle Bourgeoise Noire covered herself in white gloves, a symbol of internal repression. *That's* why she took up the whip-that-made-plantations-move, the sign of external oppression, and beat herself with it. Drop that lady-like mask! Forget all that self-controlled abstract art! Stop trying to be acceptable so you'll get an invitation to the party!

The key moment of Mlle Bourgeoise Noire's guerrilla invasions of art galleries was when she would throw down the whip and shout out her poems. They had punch lines like, on the one hand, "BLACK ART MUST TAKE MORE RISKS!" And on the other, "NOW IS THE TIME FOR AN INVASION!"

But *Mlle Bourgeoise Noire* was a kamikaze performance, really. In 1980–81, no one was listening. It wouldn't be until 1988–89 that black artists were finally invited to the party . . . when Adrian Piper and David Hammons received their first mainstream exhibits. And a few years after that, second-wave feminism would start becoming third-wave. Oh, well.

See also "Mlle Bourgeoise Noire 1955"; "*Dada Meets Mama: Lorraine O'Grady on* WAC"; "*Olympia's Maid: Reclaiming Black Female Subjectivity*"; "*My 1980s*"; "*Job History (from a Feminist 'Retrospective')*"

4 Hybridity, Diaspora, and Thinking Both/And

On Being the Presence That
Signals an Absence (1993)

Written for the unpublished, photocopied catalogue of *Coming to Power: 25 Years of Sexually X-plicit Art by Women*, curated by Ellen Cantor and presented by David Zwirner Gallery and Simon Watson/The Contemporary, NYC, this essay examines O'Grady's inclusion in the show and responses to her diptych *The Clearing*. In it, we see O'Grady's willingness to offer critique in "real time," as it were—visitors to the exhibition could presumably see her work in concert with her analysis of the limitations of its curatorial presentation, and make connections to larger issues about the discomforts that her presentation of "miscegenation" and of desire conditioned by questions of race, gender, and colonial history provoked in viewers. This text was written one year after O'Grady had published the first iteration of "Olympia's Maid" in the journal *Afterimage* (1992); the account of the genesis of that essay contained here would go on to influence the second iteration of "Olympia's Maid"—published in 1994 in the anthology *New Feminist Criticism: Art, Identity, Action*—and including an extended theoretical postscript.

"I DON'T LIKE IT," he says. "That's not the way sex is supposed to be."

He points at "Love in Black and White," the right panel of a photo-diptych I call *The Clearing*.

But it is, I think. And it has been, often, for 500 years. I follow his finger and look at the white chevalier in tattered chainmail with a skull instead of a head. The knight's hand proprietarily grasps the breast of an almost jet-black nude woman whose eyes look out beyond the frame and reflect centuries of knowing blankness and boredom.

"It doesn't feel like that to *me*," he says. This southern white curator is not going to take my diptych for his show. But his presence in my studio is proof of how far he and we have come.

Then he asks, "Are the two panels Before and After?"

He catches me off-guard, and my response is oddly diffident. Now I look at "Green Love," the left panel, the one he's said he likes. A nude white male and black female are floating on air, coupling ecstatically above the trees. Below them, on the grass, two mixed-raced children are playing tag while a gun, camouflaged on the lovers' discarded clothes, silently threatens the scene.

"No," I say. "They're Both/And."

The curator gazes at me with an uncomprehending expression. Uncertainty is making me feel stupid. I know that when he leaves I will be able to construct an explanation. This is what I get for wanting images to take me someplace I cannot arrive with words. And yet the wordsmith in me wants to be defeated.

Later, when the curator leaves the studio, I look again at *The Clearing*. It has collapsed many of my love affairs, which I have only recently begun to view in historic and cultural terms, and has combined them into a single event in which beginning and end, ecstasy and exploitation are simultaneous. As I examine this couple, this death of "courtly love," I see a historical palimpsest that goes beyond _____, and _____, and me. Perhaps it is Thomas Jefferson and Sally Hemings. Or even Cortés and La Malinche.

The Clearing was to have been a triptych whose third panel, "Blue Love," would have contained a middle-aged black couple. But when I couldn't find a middle-aged black man willing to pose nude, I had to discard the idea. That's when I should have begun to suspect something. Perhaps I had confused nudity and nakedness. For me, nudity is less about sex than about removing layers of culture; the bare head-and-shoulder portraits I have made feel as nude to me as do these lovers. Perhaps I made these montages too innocently.

When I am asked to be on a College Art Association panel on the nude, I accept. It scarcely bothers me that it will be another of those "fly in the buttermilk" situations. I am hoping that, in some way I can't yet foresee, my

presence, my divergence from the panel's premises, will not just add to, but alter the debate's basic nature.

Another sign. I ask other artists and critics if they know of black women with bodies of work on the nude (I need more slides for my talk) and am taken aback. The only name I come up with is that of my friend Sandra Payne. Now I have to research in earnest.

As I work on "Olympia's Maid," my paper for the panel, I learn that during the two centuries of black fine art dating back to before 1960, the nude, Western art's favored category, was avoided even by male black artists, with Eldzier Cortor's Sea Island series of the 1940s a rule-proving exception. Since then, there have been individual pieces and a few series, but no *oeuvres*; and female black artists are vastly underrepresented. I try to account for this absence by referring to the stereotypes of Mammy and Jezebel, to the synchronous debasement and excision of black female sexuality through slavery and the cult of "true womanhood." When even the black woman's ability to survive being raped "proved" she was less than human (a *true* woman would have committed suicide rather than submit), was it any wonder that black artists wanted, not to take her clothes off, but to keep them on?[1] But all of my answers to this absence seem to be questions.

In the '90s, I think, surely things have changed. When I learn that a young white woman artist named Ellen Cantor is curating a show called *Coming to Power: 25 Years of Sexually X-plicit Art by Women*, I want to know if her research will have results different from mine.

"There isn't much fine art, but there is video and film, most of it by younger black lesbians," she says, and adds more issues to my list of answer-questions.

I begin to look forward to her show. Perhaps the cross-gendered, cross-generational dialogues Cantor plans will begin the process of unpacking a more elaborate and more interesting set of differences than we have been used to. The shifting glance of art may yet uncover new answer-questions and pierce through outdated binaries: not just black/white, young/old, and heterosexual/lesbian, but even sex/sexuality, consequences/pleasures, self-expression/seduction, and identification/desire may eventually stop seeming to cancel each other out. But those are tasks for the long haul.

As I write I have not learned anything to make me stop being concerned and curious about the status of the black female body. It seems as beleaguered today as it has ever been. After a recent remark in *Women's Wear Daily* that haute couture shows had begun to look like 125th Street, the black woman has almost disappeared from the fashion runway. And on rap videos, the few

girl rappers are still heavily outnumbered by the girls shaking their booties, who are abused equally by the gangsta lyrics and the camera.

I have been writing this essay before *Coming to Power* opens. My diptych *The Clearing* is down at the gallery, the only piece by a black fine artist, and I am nervous. How will it work, I wonder? It is hardly a "representative" piece: its oblique historic references are simply to one way sex *can* be. But I am hoping the show's context will stretch the definitions of nudity and sex in more than one direction, nudge them past the way sex is *supposed* to be.

At the opening, only "Green Love," the left panel with the nude white male and black female coupling above the trees, is on the wall. The right panel, "Love in Black and White," the one with the white male in tatty chain-mail and the black female looking bored as her breast is grabbed, is returned to me. There just wasn't room for it with so many pieces in the show, Cantor explains. At least she doesn't say, "*That*'s not the way sex is supposed to be."

See also "Body Is the Ground of My Experience, *1991: Image Descriptions*"; "*Black Dreams*"; "*Olympia's Maid: Reclaiming Black Female Subjectivity*"; "*Two Exhibits: The Diptych vs. the Triptych and Notes on the Diptych*"

Some Thoughts on Diaspora
and Hybridity
An Unpublished Slide Lecture (1994)

Written shortly after the postscript to "Olympia's Maid," this lecture was delivered to the Wellesley Round Table, a faculty symposium on *Miscegenated Family Album*, which was being shown at O'Grady's alma mater. It takes a retrospective look at O'Grady's earlier life and work through the prism of cultural theory. She elaborates her understanding of the productive ambiguity or disorienting quality of the diasporic experience, one that is organized around hybridity and cultural multiplicity. O'Grady emphasizes that these ideas—the product of diaspora—did not offer "resolution" (e.g., a resolution of racial difference in biracial offspring of mixed-race couplings). Rather, they forced a coexistence and reckoning of difference as that which is impossible to explain away.

PERHAPS I SHOULD BEGIN by giving you some background on how the topic of "Diaspora and Hybridity" relates to me personally.

My parents both came from Jamaica in the 1920s. They met each other in Boston at the tea table during a cricket match in which one of my uncles was bowling. It was the post–World War I period of the great West Indian migration, and most of their compatriots had settled in Brooklyn. In Boston, the tiny West Indian community could barely establish and fill one Episcopal church, St. Cyprian's.

Growing up I understood that, as a first-generation African American, I

was culturally "mixed." But I had no language to describe and analyze my experience. It's hard to believe, but it's been just two or three years since words like "diaspora" and "hybridity" have gained wide currency for the movement of peoples and the blending of two or more cultures. The lack of language, plus pressure to fit in with my peers, combined to keep me from thinking about my situation consciously, from understanding how I might both resemble and differ from my white ethnic classmates and my black friends.

As a teenager with few signposts and role models, I was trying to negotiate between: (1) my family's tropical middle- and upper-class British colonial values; (2) the cooler style to which they vainly aspired of Boston's black brahmins, some of whose ancestors dated to before the Revolution; (3) the odd marriage of Yankee and Irish ethics taught at the public girls prep school where, after six backbreaking years that marked me forever, I was the ranking student in ancient history and Latin grammar; and (4) the vital urgency of the nearby black working-class culture, constantly erupting into my non-study life despite all my parents' efforts to keep it at bay.

I had a wildly unproductive young adulthood, spent rebelling against the conflicting values instilled in me. But though it may have been easy to say "a pox on all your houses," eventually I realized that I had to inhabit each of them. Looking back, I can see that the diaspora experience, however arduous, has been critical for my life and work. Not so much in the mixed details of my background as in the constant process of reconciling them. Wherever I stand, I find I have to build a bridge to some other place.

For me, art is part of a project of finding equilibrium, of becoming whole. Like many bi- or tri-cultural artists, I have been drawn to the diptych or multiple, where much of the information happens in the space between, and like many, I have done performance and installation work where traces of the process are left behind.

The new prism of diaspora-hybridity helped me see that the hybridized form and content of *Miscegenated Family Album* was symptomatic of larger forces just coming into focus in the culture as a whole. Though I had been operating primarily out of personal compulsion (to resolve a conflicted relationship with my dead sister) and the aesthetic necessities of the work, it contained what Edward Said in *Imperialism and Culture* (1993) called "overlapping territories and intertwined histories."

Miscegenated Family Album, the installation which is premiering now, is in fact extracted from an earlier performance, *Nefertiti/Devonia Evangeline*, which I did in 1980. Both pieces have benefited from the fact that, since 1980, the work of post-colonialist thinkers such as Said, Homi Bhabha, Paul

Gilroy, Gayatri Spivak, and Trinh Minh-ha has shown that our old idea of ethnicities and national cultures as self-contained units has become obsolete in an era when "there is a Third World in every First World, and vice versa."[1] In fact, we were never, even in situations of the most extreme brutality, hermetically sealed off from each other. This realization, marked out in cultural studies, has been paralleled in contemporary art with an additional understanding: that the intellectual, emotional, and political factors from which art is made have themselves not been segregated. We do not look at or produce art with aesthetics and philosophy over here, and politics and economics over there.

In fact, as these false barriers fall, we find ourselves in a space where more and more the entrenched academic disciplines appear inadequate to deal with the experience of racially and imperially marginalized peoples. Perhaps the only vantage point from which the center and the peripheries might be seen in something approaching their totality may be that of exile, or diaspora. As the 21st century approaches, we could be facing a prolonged period of intellectual revisionism. Perhaps all of us, the newly de-centered as well as the already marginal, will have to adopt (in the spirit of Du Bois's old theory of "double consciousness") what Gilroy has called "the bifocal, bilingual, stereophonic habits of hybridity."[2]

It's true, diaspora inevitably involves sexual and genetic commingling. But this aspect of hybridity, though fascinating in itself, is not essential to the argument I am making. "Diaspora," a Greek word for the dispersion or scattering of peoples, includes by extension the lessons that displaced peoples learn as they adapt to their hosts or captors. It is diaspora peoples' straddling of origin and destination, their internal negotiation between apparently irreconcilable fields, that can offer paradigms for survival and growth in the next century. Well, I should say that the caveat is if, and always if, they choose to remember the process of straddling and negotiation and to analyze the resulting differences. A simplistic merging with the host or captor always beckons. But I do think that in a future of cultural crowding, the lessons of diaspora and hybridity can help us move beyond outdated originary tropes, teach us to extend our sensitivities from the inside to the outside, perhaps even help us maintain a sense of psychological and civic equilibrium.

As an artist I like to be concrete. Perhaps this example from my own practice will show what I mean by hybridity, how a process and an object can be more than one thing at a time.

Nefertiti/Devonia Evangeline was the 1980 performance from which I later developed *Miscegenated Family Album*. It was an early attempt to treat these

ideas in terms of my personal background. Of course, the performance wasn't created in an emotional and intellectual vacuum: it was a working through of a troubled, complex relationship with my dead sister, Devonia, a relationship that ran the gamut from sibling rivalry to hero worship and was itself a sort of hybrid.

The performance functioned on a lot of levels. On one level, that of a certain emotional distance, it dealt with the continuity of species experience—the old *plus ça change, plus c'est la même chose*, or the more things change, the more they stay the same. While this idea might appear essentialist on the surface, I don't feel there is any necessary conflict between permanence and change. To me, the continuity reflected in the piece's dual images was a kind of geological substratum underlying what was in fact a drastic structural diversity caused by two very different histories. The similarities in the two women's physical and social attitudes didn't negate the fact that Nefertiti had been born a queen and Devonia's past included slavery. The performance was not "universalist" in the current sense of the term.

My ability to think the two women, ancient and modern, in the same space came most immediately out of an experience I had in Egypt in the early '60s. On the streets of Cairo, I'd been stunned to find myself surrounded by people who looked like me, and who thought I looked like them. That had never before happened to me, either in Boston, where I was raised, or in Harlem, where I used to visit my godparents. All my life I had noted a resemblance between Devonia and Nefertiti. But in Cairo, I'd been jolted into an intuition of what that resemblance might be based on.

When I returned to the States, I began an amateur study of Egyptology. Of course, without the benefit of Martin Bernal's *Black Athena*, not published until 1987,[3] I was really reinventing the wheel. I soon came to feel that many of Ancient Egypt's primary structures—the dual soul, its king who was both god and man, the magic power invested in the Word, a particular concept of justice or *maat*, as well as its seemingly unique forms of representation— were, in fact, refractions of typically African systems. I could detect a ghostly image . . . a common trunk, off which different African cultures, north and south, east and west, had branched. It was significant that the heroic period of Egyptian culture, the one that created the Egypt of our minds—that of the pyramids and hieroglyphic writing—came during the first four dynasties at Thebes in the southern, "African," part of Egypt. And yet traditional Egyptology, with few exceptions, such as the works of Henri Frankfort and E. A. Wallis Budge, had voluntarily impoverished itself by not exploring the possibility of an African origin for these taxonomically "difficult" structures,

whose forms may have further hybridized with intercultural contact. Instead, the discipline in the '60s and '70s continued trying to fit Egyptian culture into the "round hole" of the Near East. There seemed, on the part of most, to be an almost magical insistence that the cataracts of the Nile were somehow a more impassable barrier than the Alps or the Pyrenees.

I should also say that there is no need, on the opposite side of the debate, for the unscholarly claim that Cleopatra was black. Like all the Ptolemies, the line of pharaohs imposed by Alexander the Great in Egypt's waning years, Cleopatra was Greek. But 300 years of Greek Ptolemies could have little effect on the "African-ness" of three millennia of Ancient Egyptian culture, including the dynasty of Akhenaton and Nefertiti a thousand years before Alexander's death blow. One of the concepts that enabled my use of historic imagery in *Nefertiti/Devonia Evangeline* and the later *Miscegenated Family Album* was my suspicion that, like some ancient Cuba, Egypt had been hybrid racially . . . but, culturally, had been aboriginally black. Given the abysmal state of mainstream scholarship, the Africanist intuition was as good as any other. Stating that, though, seemed more a matter of intellectual necessity than simple nostalgia. European scholarship had converted Egypt into a kind of *sui generis* limbo, a rose blooming in the desert, severed both from its later "cuttings" in Greece and from its roots in Africa. The more primitive version of this had been in geography class, when our third-grade teacher had pulled the map of Africa down over the blackboard and said, "Children, this is Africa, except," pointer poised on Egypt, "except Egypt, which is part of the Middle East." For me, locating a sense of continuity by forcing the matter visually was a matter of intellectual sanity. The performance was not "Afrocentrist." It had a political pedagogy that I could use in other ways.

I do think every good artwork is overdetermined, with multiple composing elements. One of the primary conscious elements in *Nefertiti/Devonia Evangeline* was something I would call, for lack of a better term, "subjective postmodernism." Of course, to refer to the mix of ongoing personal, cultural, and aesthetic preoccupations in my work as "subjective postmodernism" is to deliberately ignore that it is an oxymoron. For subjectivity is the baby that got thrown out with the bathwater in the binarism of postmodern theory. When Western modernist philosophy's "universal subject" finally became relativized (we know which race, we know which gender), rather than face life as merely one of multiple local subjects, it took refuge in denying subjectivity altogether. In addition, contemporary theory stoutly denies its enduring binarism. But through its almost Manichean inability to contain nature and culture in a common solution, it tends to rigidly oppose nature and

the "personal" on the one side, and culture and the "historic" on the other. All my work, including *Nefertiti/Devonia Evangeline* and *Miscegenated Family Album*, is devoted to breaking down this artificial division between emotion and intellect, enshrined in the Enlightenment and continued by its postmodern avatars. It makes the historic personal and the personal historic.

In my performances and photo installations, I focus on the black female, not as an object of history, but as a questioning subject. In attempting to establish black female agency, I try to focus on that complex point where the personal *intersects* with the historic and cultural. Because I am working at a nexus of things, my pieces necessarily contain hybrid effects. In *Nefertiti/Devonia Evangeline*, the aesthetic choice to combine personal and appropriated imagery worked, I think, in both traditional and postmodern ways. Using images with so uncanny a resemblance to my late sister and her family helped objectify my relationship to her and to them and may have given viewers a traditional narrative catharsis. On the other hand, because personal images were compared to images that were historic and politically contested, a space was created in which to make visible a previously invisible class. They were also able to open out to other cultural, i.e., impersonal questions. The piece was not "individualist."

Nefertiti/Devonia Evangeline and the later *Miscegenated Family Album* attempted to overcome artificial psychological and cultural separations through the strategies of hybridism. The work I am doing now in my studio continues these preoccupations but locates them in the more recent 19th century.

For those of you who have just seen the *Miscegenated Family Album* installation here at the Davis Museum, or who may have seen images from it in your classes, I have tried to examine my practice in words that hopefully cut a crevice between the magic of the installation and my overdetermined creation of it. I wanted to set up a situation where the movement back and forth between the experience of the piece and the process of hearing me talk about it might be disorienting, might create the feeling of anxiously watching your feet as you do an unfamiliar dance. Because it's what happens when you get past that, when you can listen to the music without thinking, that is most of what I mean by hybridism and diaspora.

See also "Rivers, First Draft, *1982: Working Script, Cast List, Production Credits*"; "Body Is the Ground of My Experience, *1991: Image Descriptions*"; "*Studies for a Sixteen-Diptych Installation to Be Called* Flowers of Evil and Good, *1995–Present*";

"Nefertiti/Devonia Evangeline, *1980*"; "*Interview with Cecilia Alemani: Living Symbols of New Epochs*"; "*On Creating a Counter-confessional Poetry*"; "*Black Dreams*"; "*Interview with Linda Montano*"; "*Olympia's Maid: Reclaiming Black Female Subjectivity*"; "*On Being the Presence That Signals an Absence*"; "*Two Exhibits: The Diptych vs. the Triptych and Notes on the Diptych*"; "*Introducing: Lorraine O'Grady and Juliana Huxtable*"; "*My 1980s*"; "*Interview with Laura Cottingham*"

Flannery and Other Regions (1999)

While performing at Georgia State College and University in Mill-edgeville in her role as the Guerrilla Girl Alma Thomas, O'Grady was asked by Sarah Gordon, a member of the English department faculty, to contribute to a festschrift to honor the seventy-fifth birth anniversary of the writer Flannery O'Connor. O'Connor had graduated from the college when it was still the Georgia State College for Women. Writing as a Catholic in the Protestant South, O'Connor had long been an important figure in O'Grady's intellectual formation, and the essay discusses the author's usefulness for today's "minority" artists living in a pluralized world. Because she had been invited to contribute while in her role as a Guerrilla Girl, she wrote the essay anonymously. However, in a 2016 interview with Jarrett Earnest (reprinted in this volume) she referred to the piece as one of her most important essays, thus explaining her decision to end the anonymity of authorship.

IT'S FRUSTRATING TO write about O'Connor in an anonymous voice: she was such a master at digging from the particular to reach the universal that it's disconcerting to have to approach her from the opposite direction, from the outside in, and respond to a specific life and work in global terms. Fiction is a considered gift from one sensibility that shapes to another that actively receives. So who speaks here?

To say that I am a black woman artist using the name of Alma Thomas—a black woman artist who is dead—so as to "fight sexism and racism in the art world" (the official line of the Guerrilla Girls) is to tell you almost nothing, either about the me who makes art or the me who reads Flannery. It reduces me to the very thing I am fighting, a stereotype.

Flannery understood that no one is a cipher, the mere "representative" of a category. She more than most would have realized how limiting it is not to reveal the date and place of my birth, the accent in which my parents spoke (different from mine), the style of their manners (more refined), the peculiar psychic and social history they passed on to me (if only they hadn't); or, to peel the onion further, not to be able to tell you who I married, how I've earned a living, my education . . . I'm convinced Flannery would have sympathized and would read these global statements remembering their missing nuance, and that gives me the courage to proceed. However, I'll have to restrict myself to her nonfiction; responding with less than my whole self to her fiction, even if it were possible, would be too disheartening.

The thirty-five years since Flannery died have been so critical for the culture, a period in which the magnitude of change in society has seemed even greater than that for individuals. It's hard to avoid a "presentist" project with respect to her. Five years before she died, I had my first encounter with Flannery, in a yellow cloth book with *Wise Blood* in big letters on the cover that a friend had bought me from a remainder bin—a first edition I no longer have and wish I did. Looking back, I think that in most ways, I haven't changed much since then, and perhaps in the basics not at all. Yet the culture has changed so greatly that backwardly interrogating Flannery about this or that new perspective is like asking one of those historical impersonators, "What would Mr. Jefferson think?" There is always the danger of either giving her the benefit of every doubt, based on the love one had at first sight, or dismissing her as irrelevant.

For years after my first encounter, I read Flannery "bi-optically," interpolating my reality into hers. How could it have been otherwise when I did not feel I was part of the audiences she anticipated? Peeking through a keyhole, "overhearing" the work, seeing but not being seen, turned the work into a secret all the more delicious. But two decades later, having consumed most of her fiction, I confess that picking up her essays and lectures came as a relief. Here was an explicit statement of authorial intentions that provided me a firm handle; instead of evanescent images, there were concrete ideas with which I could agree or disagree, and best of all, an explanation of the love I continued to feel.

For me, *Mystery and Manners* came at a crucial moment; I found it shortly after I'd "come out" as a visual artist. I felt I was standing inside a room we shared—not engaging with Flannery as an equal, of course, but getting there. Still, two decades had passed since my first reading of her fiction, and now the room looked different; it had been rearranged by shifts in the culture— not the least of which had been the black women's writing that had created a new audience for literature. I wondered: would Flannery's work and ideas survive the changes I could now see? The answer was an unequivocal yes, but with massive ironies I hoped she was enjoying.

To get the negative out of the way first, in a 1959 letter to Maryat Lee, Flannery wrote something that at this distance feels frankly embarrassing. Responding to a proposed meeting with James Baldwin, she said: "No I can't see James Baldwin in Georgia. It would cause the greatest trouble and disturbance and disunion. In New York it would be nice to meet him; here it would not. I observe the traditions of the society I feed on—it's only fair. Might as well expect a mule to fly as me to see James Baldwin in Georgia."

When you imagine the plane of intellectual camaraderie on which the out gay and black Baldwin wanted to meet the virginal O'Connor, it's hard not to be sad that she couldn't rise to his level. She was sick, of course, and conserving her energy, not just choosing her battles but no doubt trying to avoid them. Still, it makes me cringe.

For all Flannery's interest in the eternal, the transcendent, the universal, she understood the need for distinctions; she tried to see through them, not overcome them. She said to an interviewer: "I have a talk I sometimes give called 'The Catholic Novelist in the Protestant South' and I find that the title makes a lot of people . . . nervous. Why bring up the distinction? Particularly when the word Christian ought to settle both. . . . The distinctions between Catholic and Protestant are distinctions within the same family, but every distinction is important to the novelist. Distinctions of belief create distinctions of habit, distinctions of habit make for distinctions of feeling. You don't believe on one side of your head and feel on the other."[1]

Times would change, "distinctions" would become "differences." But between distinctions of belief and differences in experience there is a short distance, one it's clear that Flannery was large enough to encompass.

She once said, "The best American writing has always been regional." But since she wrote this, the concept of "region" has itself been redefined; it now includes not only geographic but cultural borders. It's hard for some of us to lament television's flattening of the old Southern and Midwestern literatures

when so many new regions of black, gay, and immigrant writing have since vibrantly entered the space. I believe the writer who made even black readers love "The Artificial Nigger" could have become reconciled to this change.

There's no need to rewrite the past. Flannery could never have predicted that those who would need her more than air would be readers and writers so marginalized she couldn't imagine them as part of her audience. It is her embattlement as a believing writer in a secular world and the morality of her aesthetic standards that have instructed generations of artists who have been "othered." Whenever I reread *Mystery and Manners*, I picture dozens of artists underlining, writing in the margins, changing the word "Catholic" to "Asian," "lesbian," "Latino." This is an irony I feel Flannery would relish in time.

In addition, political similarities have resonated in aesthetic solutions. From the Southern grotesque that Flannery's work embodied and described to the postcolonial magic realism of García Márquez and Rushdie seems a hop, skip, and a jump. She wrote: "When you can assume that your audience holds the same beliefs you do, you can relax a little and use more normal means of talking to it; when you have to assume that it does not, then you have to make your vision apparent by shock—*to the hard of hearing you shout, and for the almost-blind you draw large and startling figures*" (emphasis mine).[2] This could be sisterly advice to Toni Morrison.

I grant that many aspects of O'Connor's thought (perhaps even her fiction, though I think not) may appear superficially dated. Though I believe she deserves infinite reading generosity, others may find their patience tried. What remains that is irreducible? As a nation, we have become aware that competing narratives broaden and deepen our understanding, that inflecting the story of Thomas Jefferson with that of Sally Hemings (and vice versa) helps us see both more clearly. And we realize that O'Connor's art and thought have been strengthened by—but can never be replaced by—Morrison's.

Although Flannery valued regional writing, she also noted that "to be regional in the best sense you have to see beyond the region." This *beyond* did not mean *outside*: neither Sophocles, Murasaki, Chaucer, nor Tolstoy saw *outside* their region, or had to.

"The Southern writer is forced from all sides to make his gaze extend beyond the surface, beyond mere problems, until it touches that realm which is the concern of prophets and poets," she wrote in *Mystery and Manners*. The *beyond* that is a *beneath*, the openness to the unexpected and availability to

mystery, which she practiced in her art and preached in her essays, stands, I believe, as her warning beacon to the regional artists who continue to come after her. It's one we will always be guided and daunted by.

See also "Rivers, First Draft, *1982: Working Script, Cast List, Production Credits*"; "*Performance Statement #1: Thoughts about Myself, When Seen as a Political Performance Artist*"; "*Performance Statement #3: Thinking Out Loud: About Performance Art and My Place in It*"; "*Some Thoughts on Diaspora and Hybridity: An Unpublished Slide Lecture*"; "*Responding Politically to William Kentridge*"; "*Interview with Jarrett Earnest*"; "*First There Is a Mountain, Then There Is No Mountain, Then . . . ?*"

Responding Politically to
William Kentridge (2002)

A version of this article was originally read as a paper for "Animating Insights: A Conversation on the Work of William Kentridge," a panel moderated by David Theo Goldberg at the Los Angeles County Museum of Art on September 14, 2002. Other panelists included Rosalind Krauss, Yvette Christianse, and Fred Moten; William Kentridge was a respondent to the panel. The essay analyses a number of Kentridge's animated films, including *Sleeping on Glass*, admiring the doggedness with which Kentridge's work bores down deeper into what he knows and does not make false attempts to describe what he does not, and its willingness to name whiteness as such—qualities which O'Grady implies may be necessary steps in the exploration of black subjectivity.

TO RESPOND POLITICALLY to William Kentridge's very political work, I have to begin by going back to a "South African" story of my own, which may shed light on my encounter with it.

In 1959, when Kentridge was 4 years old, I was closer to 24 and still on my first job out of college. It was at the U.S. Department of Labor, as one of two people monitoring labor conditions in Africa. The highlight of my third year at the USDL was being made Vice Chair of the African Study Group, which consisted of all of the 250 people in the government working on Africa (Africa was never high on anybody's list). There were two blacks in the Afri-

can Study Group (the other was a middle-aged male from the Army Map Service). The only activity of the group was to meet once a month for lunch-and-a-speaker at the downtown YWCA.

The ASG's Chair was the Assistant Secretary of State for African Affairs, who got to sit to the speaker's left during lunch and introduce him after-wards. As Vice Chair, I got to do all the work, sit to the speaker's right, and moderate the question period. The first speaker of my tenure was the Ambassador of South Africa.

I'd been terrified, but the Ambassador had proved perfectly delightful. An English-speaker, not an Afrikaaner, he and I chatted amiably—about our families, about life in D.C. Soon feeling at ease, I'd set aside my luncheon plate, its rubbery chicken and limp salad mostly untouched, and attacked the more promising dessert. The Ambassador noticed and, placing his hand on my arm in an avuncular gesture, said, "But my dear, you can't live on pumpkin pie alone!"

Then it was time for the Q-and-A. Three years earlier, in *Brown vs. Board of Education*, the U.S. had been forced to begin the process of dismantling the legal structures separating its 15 percent black population. South Africa, with an 80 percent black population, was beginning to solidify them. The first question related to the recent decision to convert the bantustans into inde-pendent countries. No, the Ambassador did not question his government's policy on the bantustans.

The Vice Chair traditionally followed up. I tried to be gentle. Was there not something inherently contradictory about separate and equal? Was his government not concerned about South Africa's ability to compete eco-nomically? The Ambassador's eyes passed over the top of my head to the audience as he answered.

No, the moral, physical, and intellectual gaps between the two races are too extreme ever to be bridged, he said. So we were off, round and round again on the old loop.

I was young, and, after 10 years of excessively sheltered all-female educa-tion, recently entering the world, still trying to figure out how it worked. The Ambassador had confirmed something I earlier only suspected: once racism has taken up its seat in the soul, it is protected and nurtured by a madness beyond appeal, not just beyond that of reason, but perhaps more terrifying, beyond the appeal of love. I wondered what would happen to the Ambassa-dor's children when they understood this.

I wondered too about white radicals and white liberals in South Africa, and what might be the differences between them. For white radicals, I imag-

ined ultimately suicidal gestures—like living with a black mate, joining the Communist Party, or even training at a terrorist camp in Zimbabwe.

For white liberals, I imagined less dramatic gestures—like speaking up at dinner parties, voting as far left as the ballot box allowed, offering one's services as a doctor, lawyer, or writer, but, sadly, always, always returning to those clean streets, those clean houses, the books on those neat shelves, and the ability and time to read them.

Guilt. It felt like strangulation. The throat so constricted that nothing could go down or come up. It was all those severed heads that were my first point of entry into Kentridge's work. Another was the repetitiveness, the over-and-overness, the obsessive, futile determination to understand what can never be understood since it lives in a place not just beyond appeal but beyond comprehension.

I do understand that doggedness, but perhaps I don't really *like* the work until it gets beyond that, until, as they say, it "gives it up." The works I liked best in Kentridge's retrospective are among the most recent, the 1999 *Shadow Procession* and *Sleeping on Glass*.

His animation film *Shadow Procession* seems a summum of much of what has gone before, a statement of the understandings gained from the earlier animated series *Drawings for Projection* (1989–99), and from *Ubu Tells the Truth* (1997). The shift in method from rendered drawings, reworked and filmed, to animated cutouts seems summary too, the kind of didactic simplicity that makes one wonder if there will be a new complication in the work.

The blank screen that opens *Shadow Procession* fills first with sound—the familiar strains of "What a Friend We Have in Jesus," now translated into an African language, reminding us of the colonizing, subjugating tasks on which Christianity has so often been employed. A line of shadows appears from the left and trudges across the screen, heads down, some reading Bibles it seems, others newspapers, but all equally pacified. Next come, in single file, a line of halt and maimed being pushed from behind, a line of forced prison labor, blind men in hats holding each other's shoulders, people carrying heavy possessions, workers, hanged men, megaphones.

It's hard to tell if these dispossessed are fleeing or being forced to move. Now Ubu comes out of the swamp to the sound of terrorizing martial music and dripping water, cracking a whip, laughing, his fat jiggling like masturbation, and we recognize him. His name could be Hendrik Verwoerd or Idi Amin. The orchestrator.

When they resume, the lines of the dispossessed have become revelers at Carnival, and Ubu is among them. Victims and victimizers have become

one, and nihilism and optimism seem both beside the point: the megaphones have won. It's impossible to watch *Shadow Procession* without being reminded of the dance of the damned that closes Ingmar Bergman's *Seventh Seal*. We are post-plague and living in the mind of Revelation.

Watching these latest films, one begins to feel that Kentridge was able to slog his way through the particulars of his South African situation to reach a larger understanding of it only by staying true to himself. He seems to have avoided getting caught in the saccharine quicksand of the criticism coming his way, the kind of treacle that uses words like "universal" and "human condition" too often for his or anyone else's good.

Kentridge seems to have fought for the understanding that can only come from the work. Now, hopefully, he can move on. As for the word "universal," one of the most politicized and contested in the language, now might be a good time to retire it from serious discourse. In experiencing Kentridge's work, there is never a moment when I am not aware of watching a white liberal eye dissecting a white liberal dilemma, and I am grateful to him for presenting that process with such rigor.

Yes, there are lacks. There always are. In *Drawings for Projection*, there are only two characters, Soho Eckstein and Felix Teitelbaum. Because there are no black characters (the figure of the black woman, Nandi, is not yet a character), what happens to black bodies in the films is not drama but melodrama, not emotion but propaganda. I don't fault Kentridge for this. On the contrary, I admire his artistic integrity in not being tempted to speak about what he doesn't know.

I was more troubled by his failure to make *Mrs.* Eckstein other than the usual empty vessel (why *did* she go back to her husband? what was she getting out of his world?). For this reason, I found *Sleeping on Glass* (1999) an advance on the earlier films. By assigning the dream to the white woman, Kentridge begins to tackle some of the most difficult issues in his world. And he is fearless. In this more recent work, combining animation with live film, he examines the complicated complicity of the white woman in apartheid and even hints at clues to the character of Nandi. His approach is not as tortured as in the earlier films, and the move from Dada to Surrealism, from absurdity to the irrational, serves him well. In gazing at the unfamiliar "other" and allowing himself the luxury of unconscious freefall, Kentridge brings back nuggets of cautious truth that might serve as grist for a later political mill. *Sleeping Glass*'s use of language is his smartest to date, as well as both his most allusive and explicit. When a screen containing a tree labeled "THIS IS HOW THE TREE BREAKS" splits into two halves labeled "TERMI-

NAL HURT" and "TERMINAL LONGING," when the screen of the Semaphore Woman divides her signals into "ADAPTABILITY" and "COMPLIANCE," then resolves them in a screen labeled "SILENCE," the effect seems less dream-like and metaphoric than straightforwardly descriptive of the white woman's situation under apartheid.

In maintaining his integrity and pressuring his gifts, forcing them to ex-pand, Kentridge has benefited himself and others. If I might resuscitate that despised word "universal" for a bit, I am grateful to William Kentridge for bringing me his portion of the "universal" situation that is South Africa. He has whetted my appetite for more.

Now I would like to see images of Nandi, comparably extensive to those of Felix and Soho, made by Nandi herself. And as a person of long-term mixed race, I find that I am less fascinated by Johannesburg, Kentridge's *mise-en-scène*, than by Cape Town, with its mixed-race near-majority. The fact that South Africa's 10 percent white population produced a population 8 percent mixed raises interesting questions on the meaning and history of "apart-hood." I long for images by a Coloured artist the equal of the Cape Coloured activist-poet Dennis Brutus, who broke rocks on Robben Island with Nelson Mandela and wrote poems on the survival of the spirit in prison and political exile, and I hope the art market will permit me to see him or her.

Of course, I don't expect the art market to indulge me in what I know is a fantasy, which is to see a South African equivalent to such fascist talents as Louis-Ferdinand Céline, Curzio Malaparte, and Ezra Pound. But while it may be important to have what one already knows confirmed in unexpected ways, as Kentridge does so ably, our culture now seems to need other infor-mation—not just to "sophisticate up" its understanding of distant, so-called victims, but to acquire a handle on forces which never quite go away and may be closer to home. I am still haunted by a question many of whose answers I will not be able to imagine without artistic help.

Who *are* you, Mr. Ambassador?

See also *"Performance Statement #1: Thoughts about Myself, When Seen as a Political Per-formance Artist"; "Interview with Cecilia Alemani: Living Symbols of New Epochs"; "Some Thoughts on Diaspora and Hybridity: An Unpublished Slide Lecture"; "Flannery and Other Regions"; "SWM: On Sean Landers"; "Job History (from a Feminist 'Retrospective')"*

Sketchy Thoughts on My Attraction to the Surrealists (2013)

In 2013, the artist Simone Leigh made a presentation at a conference titled "Get Ready for the Marvelous: Black Surrealism in Dakar, Fort-de-France, Havana, Johannesburg, New York City, Paris, Port-au-Prince, 1932–2013," organized by curator Adrienne Edwards for the Performa Institute. O'Grady, who had taught a course on futurism, Dada, and surrealism for two decades at the School for Visual Arts starting in the late 1970s, composed these informal notes to assist Leigh in the preparation of her talk; it was the first time O'Grady had written about her relationship to the movement. O'Grady addresses both the possibilities surrealism offered and its limitations, and speaks about figures usually associated with the movement but closer to home in other ways—Aimé Césaire and Wifredo Lam—as well as the filmmaker Maya Deren, to whom she was even more drawn.

WELL, I TAUGHT the European Dadas and Surrealists at SVA for several years before making my own work. I loved the artists in those groups—especially Tzara and Duchamp, Ernst and Breton. Perhaps I was looking for a deeper understanding of my experience than the rational language of Western culture could give. But later I felt those artists were after something different than other Surrealists I loved more . . . like Aimé Césaire, the Martinican

poet . . . like the Cuban painter Wifredo Lam . . . and like the New York film-maker Maya Deren.

It seemed as if the Europeans missed the boat by leaving the project at "play," albeit serious. As if they'd been content just to flip the bird at their parents, at the repressive and false rationality of the West. But if, instead of merely picturing rationality's opposite, they had pushed on to image a truer composite of both rationality and irrationality, perhaps they could have created that "changed life" they yearned for. Of course this is probably impossible. No one's ever done it or possibly ever will. But failure can produce great goals.

As I look back, Maya Deren was the most important for me.[1] Her move from Surrealist filmmaker to Vodoun initiate could not have been more perfect and inevitable . . . from *Meshes of the Afternoon* to *Divine Horsemen* (the book, not the film) . . . I read it so many times. In the end, after teaching Surrealism and studying Deren, my own interests in Surrealism and Vodoun had totally overlapped. For me both would now be centrally pegged to "The Crossroad," that topos where above and below, rational and irrational, and all other opposites merge and emerge again.[2]

The European Surrealists weren't really *there*. I loved those guys (they were mostly guys), they were great fun. Still, I could see that I loved their methodologies more than their work. They rejoiced in the random and the middle finger they could use it for. But as I already lived in the random of Western culture, I hoped to bend the random to my will, make it yield a truer rationality than the one on view. I wanted to use their techniques to take me somewhere I couldn't go on my own, to help me get something new out of something old. I wanted a new vocabulary for a new situation.

I've always been a devotee of Jamaican proverbs, Greek myths, and Grimm fairy tales—those repositories of understanding greater than the sum of human limitations. Of course they aren't the only way. I know that physics can be like that too—at the outer limits, where the greatest theories often arrive in poetic leaps on ground that's been properly prepared. And I love the demands Césaire and Lam made of European Surrealism, as they transformed themselves into perfect crossroads, stretching that idea and those techniques from the ludic to the spiritual and political, and then back again.

We haven't yet seen a fully-blown, non-European Surrealism. Let's hope we will . . . or at least an art as beautiful, as deranged and unstable as the other, but more complete and true. That would be marvelous!

(To be returned to . . .)

February 5, 2013

See also "Cutting Out the New York Times (CONYT), *1977*"; "*Performance State-ment #2: Why Judson Memorial? or, Thoughts about the Spiritual Attitudes of My Work*"; "*On Creating a Counter-confessional Poetry*"; "*Black Dreams*"; "*Dada Meets Mama: Lorraine O'Grady on WAC*"

Two Exhibits
The Diptych vs. the Triptych (1998)
and Notes on the Diptych (2018)

Written twenty years apart, these two short pieces address what O'Grady has come to recognize as the most consistent formal and conceptual element of her work: the diptych. The first is an excerpt from an unpublished conversation between the artist and a studio visitor that took place on September 12, 1998; in it she discusses the hidden "third term" that is always present in the Western "either/or" binary. The second text is composed of selections from emails, notes, and interviews that took place in the wake of her dual shows of *Cutting Out CONYT*, at the Savannah College of Art and Design Museum of Art in Savannah, Georgia, from September 2018 to January 2019, and at Alexander Gray Gallery in New York City from October to December 2018, both of which prompted a deep reconsideration of her involvement with the diptych from the earliest moments of her forty-odd-year career.

Exhibit A: The Diptych vs. the Triptych

The following is an excerpt from an unpublished conversation between Lorraine O'Grady and a studio visitor that took place on September 12, 1998.

VISITOR You've said your work is an argument against Western dualism. But if that's the case, why do you use two panels? Doesn't that just reinforce the basic idea? Why not the triptych instead?

O'GRADY I know it seems odd, but this is one case where reality does not support common sense. You'd think that dualism would be reproduced in two panels, but it can't be. Two does not equal two here, no matter how it might appear at first. It took me a while to figure out that, in Western dualism, there's a kicker, and it's hierarchy.

VISITOR Which means?

O'GRADY Since Western dualism is hierarchical, there can't be balance or equation: as good is not the obverse of evil, full acknowledgement of both isn't needed to achieve balance in the world. For harmony, good must simply rule evil. And the corollaries to that are endless. White doesn't equal black, male doesn't equal female, culture doesn't equal nature . . . something is always better than. Despite its name, the binary contains a hidden third term that accounts for the superiority of one side of the binary over the other. It's the thing that has been "passed through," the thing that has been experienced or received, that makes it higher in value, like the blessing of Abel over Cain, or of Jacob over Esau. The Western binary isn't really a two, it's a three, with an implied beginning, middle, and end. It's a narrative that goes from Fallen to Saved.

VISITOR You mean the binary is a triptych, not a diptych . . .

O'GRADY Yes, I think you could say so . . . The diptych may have two panels, but it's nothing like the binary in that it isn't either/or. There's no implied before and after, no being saved. The diptych is always both/and, at the same time. And with no resolution, you just have to stand there and deal.

Exhibit B: Notes on the Diptych

November 19, 2018: If you had told me when I started forty years ago that the form of my work would prove to me more important than the content, I would probably have laughed. But the diptych whether expressed or implied has always been my primary form, even in the performances and video where there is always more than one idea, more than one emotion at a time. For me, the diptych can only be both/and. When you put two things that are related yet dissimilar in a position of equality on the wall, they set up a ceaseless and unresolvable conversation. The diptych, appearance to the contrary, is anti-dualistic. That's why it's been my weapon of choice to oppose the West's "either/or" binary, which is always exclusive and hierarchical. I feel that the

"both/and" lack of resolution, an acceptance and embrace of it, is what needs to become the cultural goal.

July 28, 2018: The "haiku diptychs" of *Cutting Out CONYT* allowed me to maintain the tensions between my more explicit and my less explicit voices.

Whether "narrative/political," "expressive/argumentative," "inner-directed/outer-directed," or "post-black/black," these two voices form the parameters of my work in order to describe and circumscribe diaspora mind, diaspora experience.

Ultimately, there was no extrication of the personal from the political, the narrative from the argumentative, because these qualities were not opposites but obverse and reverse of the same coin. The diptych structure and the surrealist tone both express and argue the dichotomy. Even categorizing or referring to the divisions and splits feels like a regression back into hierarchies, a submitting to the binaries, not overcoming them.

October 26, 2018: In the end, I may just have lucked out. The newspaper poem's Surrealist language is constantly exploding at the edges of the mind. You understand it for a moment. Then no sooner than you fall in love, it disappears. And you have to start over again. It was like some crazy objective correlative to the diptych's endless, elliptical movement. But it was beautiful. And it was the best, firmest example of "both/and thinking" I'd had.

See also *"On Creating a Counter-confessional Poetry"; "Olympia's Maid: Reclaiming Black Female Subjectivity"; "On Being the Presence That Signals an Absence"*

Introducing
Lorraine O'Grady and Juliana Huxtable (2016)

In this two-part conversation, organized by Aria Dean for the Museum of Contemporary Art in Los Angeles, O'Grady speaks with the artist, writer, and DJ Juliana Huxtable. The two artists—one in her eighties, the other just thirty at the time of their conversation—had never met, and spoke on the telephone from their respective studios in New York City. The two discuss, among other things, the difficulties in tackling questions of hybridity—whether related to race or to queerness, intersexuality, intertextuality, and other forms of both/and-ness—in the current cultural moment.

Part 1

LORRAINE O'GRADY Juliana, I have to tell you something, Jarrett Earnest interviewed me and said he hoped you and I could meet, but you know, I didn't ask him why he thought it would be a good idea. [*Both laugh.*] To be honest, I have to confess that because I didn't know much about you or about your work before this, I'd succumbed to the stereotype; I was captivated by your image and didn't look at your mind at first. But now I totally understand why people want to put us together—it's almost like talking to myself. [*Huxtable laughs.*] Do you know what I mean?!

JULIANA HUXTABLE Definitely.

O'GRADY I often try to imagine what I would be like if I had been born about the time you were born, and now I realize what I would be like. I'd be like you! I see so much of our attitudes as being similar that it's kind of scary. But then I wondered why you thought it was going to be a good idea?

HUXTABLE Well, I didn't study art; at one point I had the intent, but I was really turned off by my school's program and generally distanced myself from studying studio art. So I studied literature and gender studies and found myself in my practice as an artist, not necessarily unexpectedly, but without a really concrete knowledge of an art history. I remember actively seeking out an art history relevant to me. I saw a piece of *Miscegenated Family Album* at the Brooklyn Museum. When I found your work, I was so excited and so happy— really fascinated by the idea that you were able to navigate the practice that you have. Initially, I was fascinated by the idea of taking a conceptual approach to Egyptology, how your work dealt with ideas of racial violence related to perceptions of Egypt, and the right of someone of the African diaspora to engage or identify with Egyptian history. On a larger level, I was excited by your floating between text and a sort of personal and documentary imagery. You were also using performance as a way of approaching text. It seems—and I don't know if you perceive your work in this way—that performance has been a way of animating text and taking text out of the referential structures that it's easy for them to get trapped in otherwise. It's similar to the way artists see a necessary relationship to Western art history in some ways. So I guess that's a starting point.

O'GRADY Well, I totally agree with that because I did come to art as a writer, and I still think of myself as, I don't know what really, I use the phrase "writing in space." In fact, I constructed *Miscegenated Family Album* as a novel in space. Sometimes I wonder if what I do is visual art. It's like some strange hybrid between the two [art and writing]. Some of my most important influences are literary. I came into art so late, after doing so many other things. I was further out from the history of art when I began than you were, I think. [*Both laugh.*] You'd studied art history seriously for at least a moment before you gave it up. But I hadn't done that. I had been teaching a kind of art history at the School of Visual Arts—the Surrealists, Dadaists, and the Futurists, but as part of a course on the literature of those movements . . . you know, the manifestoes of [Filippo Tommaso] Marinetti, Tristan Tzara, André Breton, and those guys, and the writings of Marcel Duchamp. Duchamp's ideas seriously influenced me. But at that time I didn't have a systematic integration

of the field as a whole. For example, I knew the situation that we as black artists were in at that moment, but not all that had led up to the extreme segregation of the 1980s. When I look back, I think I understood the moment itself and had a narrowly focused idea of how the current ideas in art could be appropriated by myself and others like me. Perhaps that led to more originality, I don't know.

One thing that I wanted to talk to you about was—how to put it? Besides making critiques, without intending to, I seemed to be constructing myths. Even *Art Is...* turned out that way. It was accidental, because it was done the last year before crack hit Harlem. That was the last moment you could do a performance like that, collect photographs in that way. But even an accidental myth is still a myth. Now I wonder if I was making art in a way that you might find boring or irrelevant to making art today. For me, it's been about making a body of work. Well, maybe not a body of work so much as individual works that are complete and self-sufficient. I've had this kind of traditional relationship to myth and form. I knew about mythology, first from the images at the Boston Public Library, which I visited several times a week from the time I was five, and then from going to a classical middle and upper school. I also grew up High Episcopalian, with all those rituals and the language of the Book of Common Prayer, which hadn't changed since the days of Shakespeare and King James. I feel like whatever I do goes toward myth whether I want it to or not and ends up private and layered. But I think what you're doing may be the opposite of mythology.

HUXTABLE Mhm.

O'GRADY Maybe it's my age, but I'm private enough that I can't imagine putting so many photographs of myself on the Internet and still living my life. [*Both laugh.*] I think I'd be too worried, or perhaps too curious. I don't know whether there's a question in all of that or not. Was there a question?

HUXTABLE I think there are threads of different and related questions. In terms of mythology and how it relates to my work, my mother—and my father to the degree that he was present and had any influence on me—held on to this idea that they were projecting this sort of mythological status onto their performance of upward mobility, onto their education . . . it's actually where I got the name Huxtable. So both of them had this crossover between their own sort of "biographical" (for lack of a better term) existence as people in the world and their ties to this almost overwhelming symbolic— and for my mother heavily religious in a Southern Baptist type of way—idea

of themselves. Growing up, certain iconographies were very important. At my mother's command, we had no white Santa Claus. Santa Claus was black, all the elves were black, any biblical representation was black or perhaps multicultural. The Jesus in my multicultural Bible "for children of color" had a Jheri curl.

In terms of how my work became visible, I started out writing online. I had a blog and people followed it. It was this weird space in which I was just sharing a lot of things, but also establishing a trail of how I was thinking. Then it started to coalesce into images and texts of my own making. I didn't think of them as art necessarily; I wasn't so conscious of exactly what was happening. They were just exercises in thinking through the ideas that I was excited by.

O'GRADY But you were thinking them through online?

HUXTABLE Yeah, I was thinking them through online, and it happened as I was on the cusp of becoming highly visible on social media in a larger public sense. By the time that my visual work—especially the work involving the images of myself—started to circulate, I was also aware of myself—at like twenty-four, twenty-five years old—as already being sort of . . . fantastical. Mythical feels like an intense word for me to use in reference to myself, but I became very cognizant of my work as an extension of myself and as a vehicle for other people to see themselves and their own possibility, and this is amplified by social media. That began to inform my work. I became obsessed with the Nuwaubian Nation and how they were taking these weird strains of science fiction and Egyptology, merging them together with a liberation theology and creating a mythological system of references . . . ideas dealing with a kind of racial crisis, perhaps even if they didn't know what the crisis was. I also wasn't sure of exactly what I was dealing with or whether it was a crisis. I did feel, nonetheless, that I was creating these images that allowed me to perform the role of the mythological figure in different ways.

O'GRADY I think that you're being seen in your own time in this way that is similar to the way I'm being seen after my own time, and I wonder how that affects your process?

HUXTABLE At one point it felt less about me singularly, back when I was primarily producing things online and doing smaller group shows in the context of the different communities that I was part of on the Internet. At that point, the potentials and ramifications of the online didn't really affect my

work. If anything we were all mutually projecting these ideas of each other, simply reflecting what's always happening. But especially after the [2015] New Museum Triennial's inclusion of Frank Benson's sculpture [of me] and my own work and what it signified in terms of visibility, I had a growing sense of anxiety. It was in that moment that performance became a really clear, powerful, and necessary way for me to work through all of that. I think there is a prevailing idea of performance, a kind of romantic notion of performance being about putting your body in a public or social context to create a provocation, which isn't what I do. This is partially why I look up to so many of the performances that you've done. Performance offered a powerful way to deal with questions of self-erasure or presence, tempting an audience with the idea that I am performing to enable their consumption of my image or my body—and then to ultimately refuse that. Text and video and all of this media become modes of abstracting presence or abstracting myself in the present. And so right now performance feels like a way of dealing with the sort of aftermath of a cultural moment.

O'GRADY Kimberly Drew says some really interesting things. She speaks about how the Internet provides a space for non-majority artists to make our work known on its own terms. In my case, I had actually done all of this work, but [I did so] when it wasn't part of the extremely limited recuperation of black artists that happened in the late '80s, it had to exist in the limbo of my imagination for the next twenty years. The Internet gave me the opportunity to put it out there and have it live again in this archival way—the first website went up in 2008. But you know, even though I put the work up as something dead, it's turned out to live in a more active way than I could have imagined. While for me, it's very distant because the making was so long ago, it's alive for others. I'm too concerned with what I'm doing now.

Last year I got a grant from Creative Capital for a new performance. It's *Mlle Bourgeoise Noire 35 Years Later*, what she's turned into. The character is an avatar of that previous avatar if you know what I mean. It relates to the way I used to do performance, I think, but in an off-kilter way. It's a kind of drag. The costume is kind of hiding me. But the main problem I face is that it's being done in a totally new moment, an Internet, smartphone moment. And a moment when I'm a known artist, not the unknown that I once was. When I did *Mlle Bourgeoise Noire*, no one knew she was coming—I could do it as a totally guerrilla performance. Now everyone wants to know about her avatar in advance. But if anybody had known *Mlle Bourgeoise Noire* was coming, there wouldn't have been any surprise and neither she nor I would still be

here, right? So I feel I can't talk about it, that I have to be withholding, at least for now. Right now, we're developing the new persona in the studio, to see how it looks, moves.

But, I don't know, the current cultural moment feels more—if not narrative—perhaps more serial than the earlier single actions that I did. Maybe after the character appears for a while, it will have another life where I develop it further on the Internet. Not that I live there myself; I have no social media presence at all, you know? I have a highly developed website—I even did the information architecture myself—but I'm not on Facebook or Instagram or any of the others. So, I don't really know how successfully those platforms can be used as an exercise in creativity for something that isn't life-based, just fictional work. Maybe I should just try and see what happens.

HUXTABLE In my ideal world, I would be able to control and decide how and when to document performances that I've done or work that I've made online. The way that it currently exists kind of puts artists—at least for me—in this crisis where I don't really have a choice in the matter. If I don't participate in the construction of my own presence online, it's totally in the hands of others.

O'GRADY Are you a gallery artist, by the way? Do you have a gallery?

HUXTABLE I do not. Everything that I've done has been me up to this point. I have my first gallery show soon, but I work on my own, which has also been kind of a crazy experience because of presumptions about protection that artists have. But I've produced on my own, and with the gracious assistance of friends and curators that have helped me out.

O'GRADY [Laughs.] I became a gallery artist about the same time that I put the website up. One of the things the gallery thought was smart was that I'd controlled the existence and availability of my images. But I hadn't tried to do that! What happened was I didn't have any videotapes of my performances, just a limited number of photos. So I was accidentally lucky! In the end, the reduced amount of material meant nobody could do to my work what you've indicated you fear: no one could control my existence or distort my existence online. I'm not sure, but I suspect even negative critiques couldn't do that. Bad or faulty interpretations may enter the work's history, but I don't think they undermine the work. At least, because of the initial shaping I did, I'm hoping that the work can just sit there and wait for another interpretation.

HUXTABLE Right.

O'GRADY Some things about your situation seem so different from mine that I have to struggle to translate. But then there are all the underlying things that don't seem to change. For example, I found it difficult to watch that panel ["Transgender in the Mainstream"] at Art Basel Miami.[1]

HUXTABLE Oh my God, they totally messed up that panel . . .

O'GRADY To me, it was just so much the same old story. It was a three-to-two ratio, which is certainly better than the old three-to-one or three-to-zero ratio. But the framework . . . Some of the panelists at Art Basel used the phrase "multiple methods" multiple times, and yet I still felt a subtle undertow of privileging abstraction over representation. It reminded me a bit of what I'd written about in "Olympia's Maid." [*Laughs.*] Just when we were beginning to be able to examine our own subjectivity, others were declaring subjectivity dead, of no interest because it was socially constructed. But how could we declare it dead until we'd had a chance, or taken the time to examine it live? Another thing that bothered me was that doing the panel at a commercial art fair seemed like a chew-it-up, spit-it-out use of trans. Nothing could be properly interrogated, either "trans" or "mainstream."

HUXTABLE Right, and I felt like the violence of that panel was absurd. The term "mainstream" has a way of announcing something as dead, at least in the context of an Art Basel panel. It dealt with none of the dynamics that we should actually be talking about, which have yet to be worked through. I'm so angry at that panel.

O'GRADY I think what you said to Jarrett [Earnest] was right on target, you know, that there's still so much unexplored work to be done on bodies, that wanting to move from representation to abstraction really is a way of avoiding dealing with bodies, and especially a way to avoid dealing with bodies that are discomforting.[2] Your statement seemed to directly parallel what I was saying in "Olympia's Maid." There, I couldn't help feeling that two concerns might be connected, that the discomfort caused by black people's exploration of their subjectivity might somehow be connected to postmodern thought's declaration of subjectivity as a dead construct. As I watched the panel, I wondered if trans bodies were not discomforting, there might not be the need to go into abstraction to protect mainstream sensibilities, to provide a path to safety. As if safety should be a motif in art, either for the maker or the viewer!

HUXTABLE Right, right. There's a rush to push it to abstraction when it's not a white dude creating his own interpretation.

O'GRADY Exactly.

HUXTABLE In terms of why you turned to images of Egypt, was that intended as a dismissal of or an alternative to prevailing models of cultural history? Perhaps even fashioning an idea of representation or history of representation that doesn't rely on a Western history of visual culture?

O'GRADY Well, I can still remember the day my third-grade teacher pulled down the map of Africa over the chalkboard for a geography lesson. She waved her long wooden pointer and said, "Children, this is Africa! All except this . . . which is Egypt and part of the Middle East." Even then, I felt something was being taken from me. And that feeling stayed until two years after my sister died, and I went on a trip to Cairo. I found myself surrounded by people who looked like me. It was the first time in my life that had happened, you know? I always thought that [my sister] Devonia looked a bit like Nefertiti, but that was the moment I began to think about hybridity as a concept. I saw Egypt as a hybrid culture.

For sure, some people see Afrocentrism in the performance *Nefertiti/ Devonia Evangeline* and the wall installation I made from it later, *Miscegenated Family Album*—but it wasn't that. If anything, it was a kind of hybrid-centrism. I felt in the coming together of Lower and Upper Egypt, northern and southern Egypt, that two distinct regions and cultures, the Middle East and Africa, had come together. And that they had been joined the way so much else is joined, by an act of violence. One conquered the other. In this case, the conquerors were from the South. The Nubian dynasties conquered the Northern ones. I think most students agree that contemporary-style racism never took hold in ancient Egypt. It was sort of preempted. Looked at from that point of view, I saw ancient Egypt as a sort of utopian society compared to current cultures. There are other ways of looking at Egypt that may not be so utopian, but certainly from that perspective, I thought it was. But the genesis of the work itself was much more personal. I'd had a rather troubled relation with my sister. In the end, I used what I could imagine as Nefertiti's troubled relation to her younger sister to work out my relationship with my sister Devonia. You could say that the piece was overdetermined, like everything I do. It was political and personal, about sisters but also about mothers and daughters, about cultural theory and beauty.

HUXTABLE That makes sense. You mentioned in another interview, *Black Athena* . . .³

O'GRADY Right, the Martin Bernal opus . . .

HUXTABLE . . . that what you were doing predated that. I was obsessed with Chancellor Williams' *The Destruction of Black Civilization* and Bernal's *Black Athena* growing up.⁴ I found them in high school.

O'GRADY You actually found the Bernal books and you read them?

HUXTABLE There's a PDF site online that had excerpts. It wasn't the whole book, but I had *The Destruction of Black Civilization*, which pulls heavily on similar ideas and similar histories.

O'GRADY Did you read Cheikh Anta Diop?

HUXTABLE No.

O'GRADY He was a Senegalese scholar who wrote about the connections of Ancient Egyptian civilization to southern African civilization in a way that made a big impact. It really clarified certain things for me. He was the first to say that everything we think of as Egyptian—the structure of kingship, the nature of religion, not to mention hieroglyphics and pyramids—all of that was basically the product of the Southern dynasties, and since they were coming out of Nubia and perhaps points further south than that, it's impossible to comprehend ancient Egypt without understanding its foundation in southern African culture. But Cheikh Anta Diop's book was what I would call the Afrocentric argument. That wasn't what interested me the most about Egypt. What interested me was the meeting of the Middle East and Africa in that one place . . . I mean, I admire the accomplishments of southern Egypt, but I don't think Egypt became "Egypt"—the glorious Egypt—until the two halves were united.

HUXTABLE Right.

O'GRADY It may be romantic of me, but I saw it as an example of what true hybridism could accomplish. I have a similar romantic response to al-Andalus, Moorish-occupied Spain.

HUXTABLE Right.

O'GRADY I also think Egypt was just the most beautiful culture, don't you think so?

HUXTABLE Yeah, it's gorgeous.

O'GRADY I want to wear that clothing forever! [*Laughs.*] It looks like it must feel incredible. And I love that they had hair problems, and they just solved them by shaving it all off and wearing wigs and headdresses.

HUXTABLE I really like the idea of thinking of or appreciating Egypt as a hybrid culture because for a long time I had a hard time feeling like I could identify with or find pride in Egypt. It felt like it had to be about Afrocentrism, you know, totally loaded with derogatory ideas of revisionism and all of the attacks that were launched on this scholarship coming from a non-European and specifically diasporic angle. It was as if it was dangling in front of me and to go for it, to fully engage it, was something I refused myself as a masochistic gesture.

O'GRADY Well, I don't know that I've really tried to make coherent, convincing arguments for Egypt's hybridism. People still look at that work and dismiss it as Afrocentric without understanding that it was not that at all. But you can't do everything. Sometimes, it's all I can do to do the work. You just hope that if you drop breadcrumbs, someone will pick up the trail. I believe Nefertiti and her family, like my sister Devonia and her family, were formed by generations of miscegenation. But I do recognize the difference between royal marriage politics and slavery in the Western Hemisphere. Still, what interests me is that, in both cases, ancient Egypt and the Americas, this lived hybridization or miscegenation created new cultures. I really do think we live in a new culture here. And with the continued pressures of diaspora, it's a culture that is still evolving, being reproduced by a hybridization that is now way beyond that weirdly matched world of slaves and masters in the "old" Western Hemisphere.

HUXTABLE Yeah.

O'GRADY We're living in some strange world that's . . .

HUXTABLE . . . a really insane in-between.

O'GRADY Yeah. I feel that way, too. In my case, it gets complicated because people think I'm advocating for interracial sex or they think I'm in favor of colorism, which is something I've actually been fighting against my whole life. I feel that the complexities and the dangers of the arguments in my work make it more interesting. I think because my work contains so much ambi-

guity, it's always going to be the subject of approval or disapproval, if you know what I mean.

HUXTABLE Right.

O'GRADY But I have to leave the complexity and the ambiguity in there because that's a part of it. I have to make the arguments that I have to make, you know.

HUXTABLE Right. It can be difficult for people to engage with this, at least when I've done performances or texts that have dealt with this taboo. Growing up in the South, a lot of my early interactions had a particular curiosity to them; there was something that stimulated me visually and symbolically about the exchange of desire between myself and these "country," presumably off-limits, white boys that I had romances with. When I deal with what that means or how that imagination was charged with ideas that aren't just about desiring to overcome some sort of slave-master dichotomy, it's a conversation that can get shockingly conservative.

O'GRADY Yeah, well . . . I think John Waters has called it "the last taboo."

HUXTABLE Right.

O'GRADY His movies kept trying to deal with it, but it is the last taboo even though people don't say so.

HUXTABLE Yeah.

O'GRADY It's hard to find ways to deal with it suggestively in a way that's generative and doesn't close it down. The response is always to try to close it down, but if there's something in the work that is still generative that can fight back, that's what you want.

HUXTABLE Right. How do you see—thinking in terms of hybridity—the way that the Internet has amplified discussions around cultural appropriation? Sometimes there are these acts that I think are totally egregious, and other times I think it's less a question of appropriation than emblematic of the culture that we're in, which has been accelerated by image production and distribution. This acceleration has perhaps created generations of people whose only notions of culture come from what they're feeding themselves and generating online. It's something alien and foreign to them, and so when it crosses over into real interactions between different and othered bodies, it

becomes complicated in a different way. How do you see those sort of questions of being amplified or not amplified or being mutated by the net?

O'GRADY Doesn't it depend on who's doing the appropriation in some ways? I mean, we have this whole history of colonialist appropriation. And, to me, one of the things that black artists are engaged in is their own appropriation of white culture. I don't know if it effectively answers the other form of appropriation, but it certainly complicates one's view of appropriation, when the appropriated begins to appropriate.

HUXTABLE Right, right.

O'GRADY And you know, I'm not sure that moment is being given the freedom it requires to grow and to have its fullest impact. It's amazing to me how quickly discussions can be shut down. The discussion of the subjects we've been engaging, all these things can be shut down if you don't fight, if you don't have the weapons with which to fight. I mean, for example, the accusations against Ta-Nehisi Coates of pessimism . . . I have to confess that I'm a bit on his side myself.

HUXTABLE In what sense?

O'GRADY That, basically, the struggle may never be finally won, or at least not in our lifetimes.

HUXTABLE Oh, yeah.

O'GRADY So as Coates says, the struggle itself has to become the source of pleasure.

HUXTABLE Mhm.

O'GRADY One of the things Edward Said wrote in *Orientalism* is that, even in academia, you find that you are always having to go back to the beginning because the drag of resistance is so great, things have to be repeated over and over and over again. They're not proven, transmitted as truth once and for all. Because power has the infinite capacity to resist, you find yourself making the same arguments over and over and over. You're in this loop. I think that's where many black artists are now. We're in this repetition loop. How to get out of it is the question. We still don't seem to be saying much that hasn't been said before by other black artists. Is what we say "sticking" better than before? That's harder to see.

HUXTABLE Taking that as a context, one of the quotes that really stuck with me from reading through your interviews and essays is: "I will always be grateful to performance for providing me the freedom and safety to work through my ideas; I had the advantage of being able to look forward, instead of glancing over my shoulder at the audience, the critics, or even art history." I think you were talking about the *Nefertiti/Devonia Evangeline* performance. That registered with me, with my own relationship to performance. I really feel a freedom to not have to deal in the conversations that painters have to have. So many painters that are dealing in questions of representation have to deal with the burden of the art historical reference. They have to deal with the fact that the work itself exists and the work itself has to carry the responsibility for its own historical presence in some way. I was curious what you meant in terms of the freedom of performance, or performance as a space of possibility specifically in the context of what you were just sort of saying about sort of the cycle.

O'GRADY Performance was not overburdened with history and that itself was freeing. I'm wondering if the presence of my work has already become a drag? [*Both laugh.*] Do you feel you have to fight me off? [*Laughs.*]

HUXTABLE I don't!

O'GRADY That's good, but feel free, feel free to fight! [*Laughs.*]

Part 2

O'GRADY I have a feeling that you'll think it sounds strange, but the biggest compliment I can give you and some other young artists is that you make me feel afraid. [*Both laugh.*] Like when I come out with this new performance, "Oh my God, Juliana's there"—I mean, I realize you are capable of seeing it as *retardataire*, right? As totally backward, out-of-it thinking. Even in the short time I've become familiar with your ideas and your work in more depth, I feel they are already forcing me to become sharper at my game, and that's a thrill. It's scary to have young artists capable of judging you, but it's also a thrill.

HUXTABLE Well, that's a compliment. [*Laughs.*] I feel a burden of new proofs on my end constantly.

O'GRADY Well, we're not in easy positions, either of us, it seems. I think that has to do with representing positions that are so new. It's interesting that, even though we may have come from different theoretical and aes-

thetic places, from different historical and cultural times, we've had similar attitudes in response to the difficult work we knew we had to make. I think one aspect of that position was a desire to make work that is beautiful.

HUXTABLE Mhm.

O'GRADY To help make my case, I've often quoted the statement by Toni Morrison—I may be paraphrasing here—where she says she believes that art can be "resolutely political and irrevocably beautiful at the same time."

HUXTABLE Right.

O'GRADY When I was making political work in the early '80s, there was such pressure to make it ugly, I mean mostly from white people. [*Huxtable laughs.*] They seemed to feel that what announced the presence of political intention was ugliness, or at least a refusal of beauty. I don't know if that was because in the United States certainly—and the '60s were a very thin and short-lived exception—most white artists and critics had been raised in a culture of acceptance, not of refusal. They seemed new to protest in serious art, felt uncomfortable with it, or maybe they just didn't understand political art's nuances. I think it also had to do with a misunderstanding of black culture. For instance, I was at the March on Washington in 1963, and the thing about the march and the event later on the Mall is that it was family time, it was picnic time; it was have-fun-with-your-friends time. People marched with smiles on their faces and then picnicked on the grass with old and new friends. It was Sunday in the country. That night, watching the scene reflected on TV via an all-white commentariat, then discussing it at work the next day with my virtually all-white colleagues and friends in the Federal Government, it was as if they'd been watching a different event from me. The consensus was that the black people and their white allies at the march could not be serious, can you believe? They all thought, if the marchers were having so much fun, they couldn't be serious. I kept saying, "You don't get it, you don't get it. Don't you realize that people can laugh and smile and be implacable at the same time?" I think the same thing is true of beauty. I don't see why black political artists would refuse one of the greatest arms we have, which is black style.

HUXTABLE Right.

O'GRADY Twenty years later, in the early '80s, I found that a similar sort of uninformed and un-nuanced theorization would become a way of refusing the work—the aspersion that it was too beautiful.

HUXTABLE Right now, the idea that a work that distances itself or maybe even squanders an opportunity to deal in beauty is having a moment among younger, self-postured-as-critical and largely white artists. There seems to be a crisis of representation where they're so in a hole or at least so backed into this corner of questions around commodification and representation that the only art that can announce itself as having merit intellectually must deal in conceptualism. And so I feel, as an artist of color right now, that I have to actively fight against this inclination to see my work—which has some romantic inclinations aesthetically, or in my writing—as commodifiable, consumable—you know, aspiring to a Jeff Koons sort of position. It's been really frustrating to have to work against that but in a different context now. But maybe the same context actually, I'm not sure.

O'GRADY I don't know. It could be the fact that you are so beautiful physically and that your work is made with romantic imagery, uses the imagery of romance, which accounts for the fact that, as you sense, you've been perhaps stuck in this location of the imagistic rather than the conceptual. What can one say? If they can, they will. [*Laughs.*] So that sort of bracketing is a way of not taking you seriously as a contributor and a critic of culture. For sure, the playfulness will always be there, in many different valences, sometimes pure, sometimes instrumental, and often occupying points in between. But there is a need for others to learn that the playfulness is not a contradiction of the seriousness, to see that political moments are multi-faceted, composed of interdependent elements.

HUXTABLE Right, right. I'm really fascinated by your role as a writer because I've found that sometimes people encounter my work solely through its visual manifestations and then they find out about my writing, and there's this realization like, "Oh, whoa, now I can enter into the work."

O'GRADY Well, that's obviously been the case with me, too. You know, there have been so many woefully inadequate responses to the visuals. I think, in some ways, people are still pretty far behind being able to understand the writing as well. But at least the writing gives a ballast, weight to the visuals so that people do get the sense that maybe they don't understand, and that sense of not understanding allows the work a bit of room to at least—I'm not going to say grow—but at least persist. I can't imagine what the ideal moment for growth in perception of the work would look like. But for now, at least, the work is able to hold on, to find its moment because of the writing. I do believe that's the function my writing has performed. It always seemed

that nobody else was thinking like me. But I always believed I was thinking in a way others would eventually have to think, I just didn't know how long it would take. [*Both laugh.*] You know? Wrongfully, I now realize, I always thought I was the first. But other artists and intellectuals before me and during my time—few in number, to be sure—were saying similar things. But I thought I was the first, and being the first is an advantageous position, you're at least encountering things for the first time, not to mention that your audience is even newer to those ideas than you. You're on that edge where the culture hasn't quite figured out how to deal with you, and so its responses are a little less pat.

You feel like the responses, even those of pure refusal, have not been rehearsed but are actually alive, you feel like you are at the live barrier, that you see where the actual limits are. I mean, I grew up like everybody else did, thinking that if only you work hard enough, if only you are good enough, if only you whatever, whatever . . . but in this situation, you realize that oh no, that is not what it's going to take. You see that the limit is real, it's not a figment of your imagination.

HUXTABLE [*Laughs.*] Yeah.

O'GRADY You encounter these limit moments and then you try to pass on that understanding, but it takes a while for people to get it. So you start circling around, making the argument from different positions, using different methods. I think every bit of armor that you have, including writing, can and should be used. I think that's one of the things that's drawn both of us so much to interdisciplinary work—knowing that we have to attack the arguments from many points of view.

HUXTABLE Right, and be able to subsume someone in it.

O'GRADY That's right. I mean the more you can surround the argument, the more you strengthen it. Even so, it's never going to be so strong that it can't be attacked. But I do think one of the things that's been wonderful to me about seeing people like Kimberly Drew and Aria Dean is that I—well, I should confess that to sustain myself as an artist, I've often had to take ideas from people who may be fascistic in certain areas of their work but nevertheless give me concepts I can use, right, like [Carl] Jung, like [Martin] Heidegger. [*Laughs.*] I've read a lot of Heidegger. And Heidegger has said that work being made from a certain kind of truth would not necessarily be made for its immediate moment but rather for its "coming preservers," those who had

acquired the tools to comprehend it. And so as I worked, I had to hold on to this idea—I mean this was something I had to hold on to for like thirty years—the concept that at some point in time, the preservers would come. So I have to say, I'm glad I've lived long enough to see some of them coming. When I see the way in which the work is able to echo with young women like Kimberly and Aria, you know, I feel, maybe they are the coming preservers. [*Laughs.*] Maybe they and others will be the next step forward, you know what I mean? For so long, I've felt like I've been walking in deep sand—I guess treading water is the right metaphor—but I finally feel that perhaps a step forward can be taken. Or, rather, that the work will be permitted to step forward.

HUXTABLE What did people say to you when you first did the *Mlle Bourgeoise Noire* performance?

O'GRADY I have to tell you: some of the hardest comments came from black people who thought the work was too confrontational, too harsh. They may not have wanted attention drawn to them in that way, I think. They may have been outside, but they didn't want attention to the fact that they were outside. I think they felt that only their work could get them inside. But I had already observed that no matter how good the work was, it couldn't get you inside. Later, what would open the doors in the end was only partially the work of the likes of Adrian [Piper] and David [Hammons]. In actuality, inclusion came primarily from the needs of a moment that had been created by Euro-American theory—both the perception and the reception of work by "others" were created and trapped in Euro-American theory.

HUXTABLE Right.

O'GRADY So that's really not about being good enough. It's about being needed enough. And the art world and the academy needed—not changes to the theory or the rule—but exceptions to the rule. They needed isolated instances and artists that would show they were being inclusive, but not numerous or varied enough to challenge the validity of the theory itself. That may account for the totally illegitimate and untenable response of anointing two foreparents, Adrian and David—a foremother and a forefather—period. While at the same time, all knowledge of African American fine art history seemed to remain erased, and even other black fine artists, working contemporaneously, were left almost invisible for another two decades.

HUXTABLE Right.

O'GRADY I mean, think of what other black avant-garde artists like Senga Nengudi, Jack Whitten, Melvin Edwards, and even Sam Gilliam went through.

HUXTABLE Mhm.

O'GRADY So many were left invisible for decades after the first two were let in. Because it wasn't about our work, it was about their need. So the answer to your question—"What was the response to *Mlle Bourgeoise Noire* by white people?"—would be that she was immediately ignored. Even the inclusion of Piper and Hammons in 1988 and 1989, I felt, only proved that the argument *Mlle Bourgeoise Noire* had made seven or eight years earlier was still valid.

HUXTABLE And it's still valid in a lot of ways. I feel like I'm still dealing with something similar—this need for an exception that can be championed in a moment, but using that window of opportunity to inundate people with an idea. I was so paranoid because I've seen so many people have these moments of entry—whether it's into a biennial or a large group show that gets a lot of attention or whatever the circumstance is, and there's an entryway that happens—but the people who are structuring that entryway are not actually thinking about the artists necessarily in the full breadth of their work, they're kind of just doing it so they can perform the idea that there are [marginalized artists] included.

O'GRADY Oh, yeah.

HUXTABLE It becomes about strategizing, you have to strategize a way to ensure that it's about you. I feel this way, at least. I have to consciously strategize to make sure that it's about me.

O'GRADY You have to constantly strategize. But then again, there's a similarity at some level to the situation of black actors and actresses, the problem of "Where does the next role come from?" There always are minority actors and actresses that break out in these wonderful, isolated movies or plays. And then they don't get the follow-up movies, the follow-up roles. As a result, they're not able to have the kind of careers where they can develop because there are always economic issues, concerns.

HUXTABLE Right, right.

O'GRADY And then, those economic issues usually stem from psychological and sociological cultural fears: oh, we can't spend too much money on movies with black people because only black people want to see them. Up to

now, that's really been just an excuse, a rationalization for what they don't want to do in the first place: they don't want to continue writing roles, producing movies and plays with black people in the round, with black people who are complete, when all they know, all they feel comfortable with is the stereotypes.

HUXTABLE Right, which is all they see.

O'GRADY Yeah, so in other words for the black actor or actress or even screenwriter or director, you know, to get the next one, to be able to build on whatever they did previously, has been nearly impossible. Sometimes I think that's the situation in the art world as well. Over the decades, there have been a lot of black artists in biennials, and then nobody remembered who they were. They didn't get the next biennial, the next group show, and so on. A fundamental change would mean taking the artists seriously, letting their objects and their concepts enter and affect the dialogue. The situation may be changing with the breakthrough of certain artists of color into the biennial circuit, which has become its own sort of art world.

HUXTABLE Its own ridiculous world, yeah.

O'GRADY I haven't examined it very carefully, so I'm still not exactly sure what the true presence of these artists in the world of the biennial and the art fair is. I'm not sure what that role is and how it is changing anything.

HUXTABLE Right. Well, neither am I. [*Both laugh.*]

O'GRADY You know what I mean?! It's just so hard to know. That's a long, long discussion. The effect has to be observed over longer periods of time. Then you could retroactively analyze what that role was.

But when I was making notes of what I would like to speak with you about, my notes didn't have any of this theoretical stuff, nothing about the nature of oppositional art, the role of black artists, the erasure of black art history. You know what I was thinking? I had notes that were so silly, like, "What does the sound of tolling bells mean to you?" [*Both laugh.*] The first thing you hear in that piece [*There Are Certain Facts That Cannot Be Disputed*], right?

HUXTABLE Yeah.

O'GRADY Does it mean anything in particular?

HUXTABLE I don't even really know how to answer that right now.

O'GRADY Well, that didn't stop me from interpreting it on my own. [*Laughs.*] I thought that in some ways the sound of the bell tolling is a sound of universality. Historically, it's sound that says, "This applies to everyone," no matter who they are or what their station in life may be. I thought you were saying, "This may be about me, but it actually is about everyone." The sound made me think of—do you know John Donne, the English poet from the seventeenth century?

HUXTABLE I don't, no.

O'GRADY Well, I can't say I know his work well, but I've read his Meditation XVII, the one they call "For Whom the Bell Tolls." It seems that at that time—when people were dying—their family and friends would have the church bells tolled, so people would pray for them. So he's lying in bed, and he's sick, and when he hears the bells tolling outside his window, he wonders to himself, "Who are those for?" And then he gets this awful thought: "Oh my God, maybe my friends, maybe my family thinks I'm sicker than I think I am." [*Laughs.*] So they're having the bells tolled. [*Both laugh.*] But while he's lying there, he gets this second moment and he writes this meditation, the main line of which is, "Do not send to ask for whom the bell tolls, it tolls for thee." In other words, even if the tolling is not for him, it is for him.

HUXTABLE Right, right.

O'GRADY It's calling him to live a new life, a conscious life. As recently as my own childhood, the tolling of the bells was a reminder of when to pray, of time passing. It's like a warning. That's how I read the tolling of your bells. I thought it fit in with the title of your piece in the Triennial, *The Self Canonized Saints of Becoming*, which I loved.

HUXTABLE Oh, yeah.

O'GRADY I thought it was so great because that's what we are.

HUXTABLE That was sort of a moment where I felt, maybe in a similar vein, that the diaspora and people of the diaspora and the questions of identity and movement kind of creates and predates postmodernism in a lot of ways. Self-representation or the fantasies surrounding self-representation are a part of a nexus of ideas or ways of producing ideas of oneself. The way that black people have figured themselves, and have been forced to be their own saints—and partially thinking about and embracing theology—prefigured what everyone else has more recently thought of as novel and radical about

visual culture on the Internet. I was thinking about Tumblr, for instance, because I was an avid user. I was frustrated because I felt like the way that net art as an active category of contemporary art was really brief and shallow and only about just the most uninteresting formal gestures from a really limited group of white artists. And so that piece came from a feeling of "I need to take this back." [*Both laugh.*]

O'GRADY I love that title. Also, I wanted to ask you how you connected the dots between [Raquel Welch's] *One Million Years B.C.* and Octavia Butler's book covers.

HUXTABLE The inspiration for that series of images was writing that was produced in conversation with, you know, the type of household art that maybe for lack of a better word, you might think of it as kind of kitschy. Black household art, where it's the black Jesus that looks like Tupac or the persecution of Christ as kind of a diasporic metaphor.

O'GRADY Right, yeah.

HUXTABLE Or like a black woman with leopard pelt tattered clothing in a shallow body of water and there are black panthers behind her. I've always been obsessed with those images, but I started studying them for the heavy subjects they navigated, and I think in a way they mirrored some of the ways that I try to approach my practice. It was an abstraction of really, really dense, really necessary sometimes political impulses. It was an effort to take them and abstract them towards something a bit more symbolic than it is necessarily directly representational, but in a way that I felt was really poetic and beautiful. I also felt like it was coded and kind of subversive in a lot of ways, like the presence of literal black panthers in those images, and the linking of black women and weaponry with the panthers. I'm just thinking about the different levels and ways that black politics have been pursued since the introduction of crack in the 1980s and everything. So, Octavia Butler's book covers are a reflection of how her writing links the legacy of sci-fi culture to liberation theology, or even liberating sci-fi culture itself.

O'GRADY That was what my next question was going to be—what is the connection between science fiction and theology that you're referring to?

HUXTABLE I think that, for me, science fiction is an alternative to theology. I think a more crass, maybe less interesting way to see it is as similar to the way that some people supplement or replace religion with astrology. Sci-

ence fiction and its ability to construct these narrative worlds or myths—especially with Octavia Butler, something like *Earthseed*—is so religious to me. It's less in terms of the description of the world, but more in how it aspires to something similar to a liberation theology. It aspires to do the same thing, to take an aspirational canon or set of ideas and images and inject them with alternative potentials. The link between the content of Butler's books but also the covers as a reflection reminded me of TLC and the weird Hype Williams music video culture Afrofuturism that was happening in the late '90s and early 2000s. I really do feel like those images are directly a sublimation of a political desire—like you know, black women wearing men's cargo pants and military boots with these large hoop earrings. It's all a way of sublimating or abstracting an impulse that is truly about a really radical sense of black liberation while existing in the confines of a culture wherein expressing these desires directly is not tolerated or has actively been erased by really violent legacies.

O'GRADY It's so fascinating. I'm just really glad I'm asking you these questions.

I have another question. I have to confess that I had never heard the word "cute" used theoretically before. [*Both laugh.*] I want you to know that's how far out of it I am, so my question is: are you cute and in what ways?

HUXTABLE Um, well, I don't necessarily think not hearing "cute" as a theoretical term is a sign of you being out of touch. At one point, I was originally planning on getting a PhD in literature. That was my plan when I moved to New York, and I sort of fell into art. So academia's theoretical paradigms and esoteric language at a certain point began to feel a bit unnecessary, or at least for what I was working through at the time. I felt incapable of doing what I wanted to do on those terms. In the same way that I imagine a lot of theorists create their own terms, whether it's piecing together these three hyphenated words together, taking "anarcho-" and "testo-" to use slang or terms that I would hear just being out in New York and in bar culture, club culture, whatever. These spaces and online Tumblr communities felt really rich to me culturally but weren't necessarily translated into a sort of theoretical context. I started to use and just insist on them. I insisted on them being the same way; so "cute" was a term that I started to use a lot, and I really liked the term "cute" because I think it describes how I'm posturing myself in relation to the way people perceive me. In my performances and in parts of my personal life, I know that when people look at me, they see a certain idea—there's a

certain aesthetic, a beauty or a cuteness or a put-togetherness. I kind of use that as an entryway to almost bait and switch or deceive people. It's sort of a methodology for my performances.

O'GRADY Is it like a way of making yourself palatable?

HUXTABLE I don't think it is, actually. I think it's offering the illusion at one point that perhaps you're going to get something more palatable, and then refusing to follow through with that. I think the ambiguity of the ways that one can use the word "cute" are also reflective of that. "Cute" can be a really shady term; it can be a really nasty, loaded, shady way of suggesting, "Oh that's . . ."

O'GRADY "That's cute . . ." Yeah.

HUXTABLE "Oh, that's cute." It carries with it all of the ways that "cute" can be used as a disguise for really sharp or caustic intents, meanings or significations. The idea of cuteness, almost like a ploy, is kind of interesting.

O'GRADY I love it! It's all wonderful! It's all new. I'm having to think about it a lot, what can I tell you. But I have to say something else—I watched a DJ set that you did on YouTube, I didn't watch it all the way through, but I thought, "Oh my God, this is so funny." I mean, to me, it was funny. You had just got to this point where you just felt so free to do whatever you damn well pleased. [Huxtable laughs.] You started off with your spoken word. Here we are in the club, and you see—it's shot from behind the crowd, so you can see the people who are waiting to go on the floor and dance—and you're doing this spoken word bit, and then you go from that into classical music?! [Both laugh.] The crowd is just like, what kind of club mix is this?! And you don't care! Then they would hear a beat, and they would start to move and as soon as they did, then you would take it away from them quickly. Oh, I loved it. [Laughs.]

HUXTABLE I really love the idea of refusal as a sort of way to approach mixing.

O'GRADY [Laughs.] When I saw that I thought this is all very interesting, the way the mix moves all said something about who you were and how you do things and I liked that.

It was, wow . . . I have to tell you, I'm amazed I've been able to carry on a conversation with you. [Laughs.] I was so woefully unprepared, and I also feel really tired—I was on a deadline and got about three hours' sleep last night—

and still it's been a wonderful conversation. But I can't be smart for another second, I mean, I can't. I don't have one more thing that I can say or do that could possibly make sense. But, wow . . . I hope that we'll be able to continue this in some way.

HUXTABLE Yeah, that would be awesome.

See also "Performance Statement #3: Thinking Out Loud: About Performance Art and My Place in It"; "On Creating a Counter-confessional Poetry"; "Olympia's Maid: Reclaiming Black Female Subjectivity"; "Some Thoughts on Diaspora and Hybridity: An Unpublished Slide Lecture"; "My 1980s"

5 Other Art Worlds

A Day at the Races
Lorraine O'Grady on Jean-Michel Basquiat and the Black Art World (1993)

O'Grady's article on the occasion of Basquiat's first retrospective, held at the Whitney Museum in 1993, weaves together an analysis of the market's insatiability and the "primitivist" responses to his work by critics and fans. O'Grady discusses her attempts to include Basquiat in her 1983 *Black and White Show* and the lost opportunity of connecting the younger artist to an active black avant-garde working in New York. In analyzing the terms of Basquiat's success in the white art world, O'Grady drills down into the reasons that black artists would always—structurally—be treated as "peripheral" by existing art world institutions, including the market, museums and galleries, and art criticism.

PROJECTING AN endearing combination of self-effacement and plantation cynicism, Shaquille O'Neal, the #1 NBA draft pick, said in a recent TV profile, "I've got three different smiles: the $1 million smile, the $2 million smile, and the $3 million smile." It went beyond playing the game: with a $40 million contract and limitless prospects for endorsement, O'Neal was a winner. His situation seemed to shed light on the art world's own black-player-of-the-moment. For there is no doubt that the most bizarre aspect of the recent Jean-Michel Basquiat retrospective at New York's Whitney Museum of American Art was its aura of sport. Analysis of the work was put on hold, pending results of two different horse races.

First: could Basquiat's prices hold with this much exposure? Answer: yes. The match race between Basquiat and Julian Schnabel continues. At the big New York and London auctions following the opening, Schnabel's best was $165,000; a Basquiat made $228,000. His prices are at 50 or 60 percent of the earlier bull market and steadily rising. His work has become more, rather than less, financially interesting now that its obsessions with colonialism, creolism, and history can be plugged into the market's three-year-old concern with multiculturalism.

Second: would jamming 100 pieces together help or hurt his critical reputation? Answer: maybe; the air still hasn't cleared. But he certainly wasn't done in. Initially, the gushing catalogue may have been checked by the vitriol of a Robert Hughes. But getting the contending views out, like piercing a boil, seems to have eased the way for tougher thinking. In the end, the gradually changing perceptions of a Roberta Smith, from "savvy imitation" and "illustrational stylishness" (1982) to "roiling, encompassing energy" (1989) and on to "a distinct form of visual speech" and "one of the singular achievements of the 80s" (1992), stand to gain credibility.[1]

Still, there was something embarrassing about all the hysteria, including my own. It was an uncomfortable reminder that more was at stake than a game. (At some point between the Greeks and the free-agent clause, sport gave up its pretense to a cultural meaning beyond narco-catharsis.) The barely submerged violence for and against Basquiat was a sign that even the '80s couldn't turn art into basketball. Whatever the postmodern condition, art was more than a decorative anodyne; it was a locus of values for which we were willing to kill.

Luis Camnitzer has argued that although, in the capitalist context, whatever can be sold as art is art, the market itself knows there's more to it than that. For work to come into existence in the first place requires a communication between artist and viewer. This exchange can be quite disjunct from the art's final consumption; for example, in both film and literature, the preponderance of readers and viewers of *The Color Purple* may have been white, but most would have sensed that the enabling audience, the one addressed by the work, was black.

Nevertheless, Camnitzer continues, control of the art's final context is what determines its destiny and function. Who buys, wins; and the destiny of crossover visual artists is an auction house that will be ruled by white money into eternity. This is a market of stripped-down, absolute values. The secondary market may, at a spiritual level, realize that art is the link between what is known and what needs to become known, but it will not permit divergent

values to confuse or upset it. To retain its power to judge the work, it will remain willfully ignorant of nonhegemonic original contexts.

The result is that "peripheral" art can only be absorbed into the market when the politics of that market's values allow for its recognition. Hegemonic artists and critics have first to create appropriate references and spaces for it. As Camnitzer says, this condemns our work to being derivative *avant la lettre*. Whenever "peripheral" art is allowed to exist in a hegemonic context, it is derivative by definition, because it "enters as a consequence, not as an originator." If its originality can't be reduced, the work is too discomfiting and must be ignored.[2]

The hysteria generated by the Basquiat show, the extremes of ideology and emotion, even among those who said it was a yawn (on boredom, see Freud), came from a sense that this was one of those raw moments when the final context sat in judgment of the original. But the moment proved ineffectual. Faced with naively unresolved comments on graffiti, the '80s, and race, the work held on, if only tenuously.

It was disconcerting: Basquiat's habit of painting canvases that shatter at the edge of the mind appeared to defeat all but the most adventurous of critics. And "neutral" comments on discourse about the show often illustrated Camnitzer's argument. There were heated objections to referencing jazz by writers who seemed not to realize that jazz was not only an art form but a style of black intellectual life, and even well-intentioned calls to substitute formalist analysis for overworked ad hominem arguments were based in Eurocentric assumptions. In dealing with Basquiat's art, there is a fine line between rehearsing the legend and examining the art impulse itself. With precedents still undetermined, it's not just biography to analyze the intersections of the life with art history. But which art history/ies do we mean?

Under the compulsion to find hegemonic origins for him, such as Jean Dubuffet and Cy Twombly, analysis is being strangled. The debate needs air. If Basquiat did copy the painters so often mentioned, why them? What echoes made their styles appropriate to the experience of a late-20th-century black man? And has the black painter Raymond Saunders, whose work resonates with Basquiat's, heard them as well? Quotation in isolation is hardly interesting. Everybody quotes—vide Picasso.

Basquiat's biography is fascinating, but discussion of it is so uncomprehending that not even his legend has room to breathe. His romantic notion of the jazz life was a quarter-century out of date. Forget his internal resources—what does it mean that he didn't have access to the kind of information that might have saved him? Would knowing the lessons of Bob Thomp-

son, the '60s black painter with eerie parallels to him, have helped him move on? One effect of Basquiat's isolation is not speculation: the thinnest aspect of his art was not lack of training, which is irrelevant, but his separation from the audience that could have enabled and challenged him.

When I saw Jean-Michel's pieces in Annina Nosei's 1981 group show, I was stunned. I knew what I was looking at; and what I didn't know, I sensed. I never had to translate Jean-Michel, perhaps because I too came from a Caribbean-American family of a certain class—the dysfunctional kind, where bourgeois proprieties are viciously enforced and the paternal role model of choice is Kaiser Wilhelm. It was the sort of background that in the first generation of rebellious adolescents, kids no longer Caribbean and not yet American, faced with the inability of whites and blacks alike to perceive their cultural difference but convinced they were smarter than both combined, often produced a style of in-your-face arrogance and suicidal honesty. At their best, these traits sometimes ascended from mere attitude to the subversive and revolutionary.

It was the next-to-last day of the show, a Friday. Out on the street, I made calls from a pay phone. To Linda Bryant, founder of Just Above Midtown, the black not-for-profit where I showed with David Hammons, Fred Wilson, and others. I could tell Linda thought I was crazy: Haitian? From Brooklyn? Only 21? It was too weird; she'd catch up with him later. I hadn't even mentioned graffiti. With the artists I spoke to, disbelief hardened further: on Prince Street? When there are guys out here who've been working 30 years?

It took over a year to find a way. The *Black and White Show* I was curating in the spring of '83, at the Kenkeleba Gallery, was to feature black-and-white work by black and white artists. It would star Jean-Michel, not David Hammons: David was already overexposed in the black art world, though he wasn't to be discovered by the white one for another six years. Of course, I didn't know if Jean-Michel would agree.

He had split with Nosei and was without a gallery. I'd heard the stories about exploitation (the studio in her basement, etc.), but these were less frightening to me than a white friend's tale of late-night calls from a Jean-Michel in despair after white patrons had physically recoiled from him. The simplest handshake was a landmine. I knew the art world was about to eat him up and before it did, I hoped to connect him to black artists who, picked up in the '60s and then dropped, could give him perspective on its mores in a way his graffiti friends could not. I also wanted to connect them to his hunger, his lack of fear. There were some who had stopped reading art magazines because they knew they would not see themselves there.

Keith Haring, a former student of mine, introduced us. I think Jean-Michel agreed to be in the show both because of Keith and because I'd sent him documentation of my performance persona, Mlle Bourgeoise Noire, and he'd thought she was great. But when I talked to him about the black art world, he was perplexed; he'd never heard of it. If he came to the opening, he asked, could he meet Amiri Baraka? I thought it could be arranged. He had confirmed that, like others, we learn about ourselves from white media.

In anticipation of the pieces he said he would make for me, I visited his loft on Crosby Street several times. We talked about art, performance, and the places he'd been, especially Rome, and about the need to hold on to his best work, and as we talked, he sat in the middle of a canvas writing with oil-stick. "I'm not making paintings," he said, "I'm making tablets." I ransacked my library for books for him. His line, the way he arrayed figures in space, made me settle on Burchard Brentjes' *African Rock Art* and, for an overview, *Prehistoric Art*, by P. M. Grand. But there was an aura in the loft that I'd identified as cocaine paranoia (later I heard the heroin started that summer). I understood my pieces were not forthcoming. Someone told me Basquiat had already mounted his campaign on Mary Boone, that exhibiting in the East Village would not be cool. I replaced him in the show with Richard Hambleton, whose black, spray-painted figures exacerbated urban fear.

The Black and White Show came either too late or too soon. The press release spoke of "black-and-white art for a black-and-white time," "a time when cadmium red costs $32 a quart wholesale"—which shows how out of it I was. This was the '80s; only black people were getting poorer, only black artists seemed to worry about the price of paint. And the white art media remained the same. For all my exertions, the show got a three-line notice in the *East Village Eye* and a review in the *Woodstock Times*. I had to admit, there were things Jean-Michel knew more about than I.

For Basquiat, of course, it was just another no-show. He couldn't realize a chance had been lost. Except for pieces in *Since the Harlem Renaissance* at Bucknell University in 1984, his work was not shown in an African-American context while he lived; nor did it have to be. Whatever the degree of exploitation, he had been validated by the white gallery system, and in 1983 was included in a Whitney Biennial for which none of Just Above Midtown's artists received studio visits.

By 1986, Just Above Midtown would close, and Linda Bryant would drop out of the art world, leaving much of the black avant-garde in limbo. Looking back, it's easy to see irony and heartbreak in all that's happened since. At the time of *The Black and White Show*, the black avant-garde was about to reach

critical mass. But unlike black literature, it couldn't consolidate. Whereas every black writer seemed to have half-a-dozen PhDs to support them, the numbers of black artists appeared to have grown faster than those of teachers, curators, and critics. Advanced black art, while aesthetically vibrant, was institutionally fragile. It would shortly enter the mainstream, but in a fragmented way, and with limited means to frame its reception and contest its positioning by hegemony.

We are in a transitional moment, hoping our increased visibility will translate into increased effectiveness. But municipal politics show us that's not how it works. Given a Basquiat retrospective, there's always a horse race, and when black art-historian Judith Wilson says "only black people will monumentalize him," it's less germane than Judd Tully's comment: "The interest of international collectors in protecting their investment in Basquiat's work will help his viability long-term."

The 1993 Whitney Biennial will go down as the Multicultural Biennial, but what will have changed? A white curator at a major out-of-town museum told me,

> The kinds of things I hear from patrons you wouldn't believe. The attention span at that level of the art world doesn't permit looking at the whole fabric of multicultural art. For many of them, every black artist is a black artist by definition. There aren't artists who are black and bring this in varying degrees to their work. And since they are interested in what's new, they think of the issues black artists raise as something they can only spend so much time on, then they want to go on to the next thing. They're looking for the one typical, quintessential black artist, so then they can say, "I've done it," and not do any more.

In an odd reversal, Hammons, in less than three years, has become the quintessential black artist for today. Hammons tries to make art in which white people can't see themselves, but may not have reckoned on their seeing themselves in the power to name the trend. He keeps trying not to play the game, but they keep letting him win.

In 1983, when Basquiat was in the Biennial, David had already done some of his best work. That year, he made the first and most magical of his *Higher Goals*, a 55-foot basketball pole erected across from his studio, warning passersby on 121st Street not to dribble away their dreams. But ten years later, an accidental Shaquille, he is attempting to restore his equilibrium by instituting changes in the rules. Through absence, he has made himself the sharpest presence of the last two Biennials.

For the Basquiat retrospective, Hammons provided an answer to the unspoken question: was the event a priority for the hegemonic market or for black culture? One thousand people a day went to the show, including two hundred of color, grateful to see themselves. At the opening, Hammons stood outside, watching, occasionally chatting, refusing to go in.

See also *"The Cave: Lorraine O'Grady on Black Women Film Directors"; "Some Thoughts on Diaspora and Hybridity: An Unpublished Slide Lecture"; "Introducing: Lorraine O'Grady and Juliana Huxtable"; "SWM: On Sean Landers"; "Poison Ivy"; "The Black and White Show, 1982"; "Email Q&A with* Artforum *Editor"; "Rivers and Just Above Midtown"; "The* Mlle Bourgeoise Noire *Project, 1980–1983"*

SWM

On Sean Landers (1994)

This article, O'Grady's last for *Artforum* ("by mutual consent," she notes), was one of three cover stories devoted to the artist Sean Landers in the April 1994 issue of the magazine; the title, "SWM"— an acronym used in personals ads of the 1970s and 1980s to indicate "Single White Male," and, later, "Straight White Male"—nods to her understanding the work as a performance of a particular flavor of white masculinity. At the time, in shows at Andrea Rosen in New York City in late 1993 and Regan Projects in Los Angeles in early 1994, Landers had turned his attention from sculpture to a bad-boy confessional mode, which took the form of monumental text paintings, monologic videos, installations of stream-of-consciousness writing on notepapers hung on the wall in a grid, and other interventions. O'Grady's was an early—and trenchant—race-conscious critique of an emerging notion of "the abject" in art discourse, which centered on all that was disavowed within modernism, but, as O'Grady points out, did not, still, admit artists of color (or their concerns) into the fold.

EVER SINCE THAT bloody Monday in October 1987 when the stock market dampened Euro-American certainty, young white artists, like young, upwardly expectant whites in general, often seem not to know what's hit them. It's this confusion that gives their work expressive drive. The new crop of

artists has a free-floating intensity, set harshly adrift from the confident sub-jectivities of that brief shining moment when it was possible to believe in an information-age millennium.

Julia Kristeva's term "abjection" has been appropriated to describe these artists and their mood.[1] But without a full theorizing of the differences be-tween "abjection" and "subjection," "abject art" can sound suspiciously like another last-ditch attempt to keep European subjectivity centered (self-abasement as the twisted obverse of self-glorification). And the need to take endemic mental states and extend their sphere through universalization seems out of synch with this art's desperate particularities. The *Abject Art* exhibit at New York's Whitney Museum of American Art last summer, for example, dragged in the quite different work of David Hammons and Adrian Piper to validate its nomenclature; the desire for the clean comfort of the universal not only illustrated the downside of multiculturalism, it deprived even the white artists of their messy, sadly deflated, but still vibrant beauty.[2] Another epithet for this work, borrowed from the title of Richard Linklater's movie *Slacker*, seems both more modest and more apt: this is "slack" art, art that has had the wind knocked out of its sails.

Slackers, as one commentator put it, "are beatniks without a beat—a lost generation minus a sustaining poetics of loss."[3] In a group that defines itself by its weakness, the conceptual artist Sean Landers seems one of the stronger: by putting words to the loss, he makes it clearly visible, if not neces-sarily bearable. Pictures alone won't do here: they are too coded, and a more defined self-awareness is called for. No matter that the loss may be only one of unreasonable expectations (i.e., that the market would continue provid-ing rewards without limit and that, as white artists, they would never have competition), it is a bafflingly real one, and is shared by an entire culture.

Landers is a fast-babbling Irish-American whose words can snake over the walls of several museums and whose charismatic physical presence is able to hold up against dozens of hours of real-time video. That he is articu-late, though, does not mean he is always in control of the implications of his speech. Blissfully tone-deaf, he writes as if unconscious of how a phrase like "Surely pity for a whiner of my magnitude must be impossible" echoes dif-ferently in the corridors of power than when it is overheard by someone who really has something to whine about.

Landers may not have "a convenient trust fund," but his lack of power is relative, cushioned by forms of earned and unearned luck. Unlike the Latin American would-be artist who in the early '80s rented wall space and graf-fitied "Rene: I Am the Best Artist" all over SoHo, Landers is neither with-

out talent nor unchic. And, closer to home, he is unlike my friend George Mingo: a child art prodigy whose third-grade teachers paid him to make their Christmas cards. George didn't take art seriously until late high school, when he saw a picture of Salvador Dali wearing a top hat and cape and carrying a gold-knobbed cane. With dreams of limousines and good-looking broads, he went off to Cooper Union and discovered he was black a few years before multiculturalism. That was the end of that. How sorry can you feel for Landers when, with two group shows and a one-person exhibit covered in a single 1990 issue of the *New York Times*, and with the *New Yorker* taking note of his every move from the beginning, he has reaped the benefits of his perfect placement in time?

This doesn't mean he's not entitled to a sense of thwarted ambition. The contradiction between subjective feelings of powerlessness and the real power inherent in being at the center of a trendy discourse is the heart of ambiguity in the work of Landers and others of the abject/pathetic/slack group and, as much as anything, is this art's motor of fascination. That others declared culturally, nationally, or racially out of it may feel this group already has most of what it's entitled to certainly doesn't lessen the pain, and may, in fact, add to it. But for these artists, empathy is not the point; their positioning is.

What sets Landers above many of his peers is his healthy degree of self-loathing. Self-aware, he seems to have a sense of the historical moment, though he cannot see it or make it seen. The shtick he has adopted—and with Landers the decision-making seams invariably show, often intentionally—allows for the illegitimacy of his own situation, both psychological and cultural. This straddling of the chasms between need and the reality of privilege is the true referent of what reviewers call his "sincere insincerity," his "manufactured schizophrenic personality," and his "inspired transformation of infantile demands into art." Whether or not he'd agree with what I'm saying, there's no law that says he can't be better than he thinks.

When Landers moans "Oh God, I only wish that there was some content in what I say and do," or "I don't want a life of mediocrity, I've been born into the middle, of the middle, of the middle and I'm clastrophobic [*sic*]," he knows he's not alone. But does he realize that to those outside the charmed circle these stifling monologues of the self, superficially chaotic and decentered, sound like the orderly discourses of the bourgeois subject, still holding the upper hand? (But then, how many of us know how we look from the outside?) There is a good bit of *art politique* in Landers' "sincere insincerity." His constant positioning and repositioning in relation to the current argument

may often seem dogged, the products of a subsistence diet of alcohol and too many issues of *Artforum*, but they're also unapologetic and at times deft. And how much can you edit a stream of consciousness engaged in at such length? Something is bound to slip through. His bravery feels real.

The level of reflecting-pool intimacy reaches its highest decibel on the videos, featuring physical as well as verbal masturbation. Landers, blessed with "Black Irish" good looks, with a tendency toward beef and bad skin (sorry, when you keep your face six inches from the camera hours at a time, you get what you get), has a shambling grace that renders his manic story-telling and solipsism surprisingly easy to take. The most fascinating of the videos, though, star not Landers but his father. For one thing, the tapes offer an eerie glimpse of how Sean will look when he grows old. For another, they show how honestly he comes by his logorrhea: Landers *père* talks nonstop, without prompting and with seeming unawareness of the camera, about nothing. On, and on, and on he goes. And his way of shaping his ramblings is identical to his son's. After hours of watching Sean and finding him eccentric but diabolically clever, we discover that he has taken a family trait and, by pointing it in the direction of the "right" subject matter, elevated it to art. So what else is new?

White male adolescence is hardly my favorite vintage, and at thirty-one, Landers is approaching the outer limits of his ability to work it. In a few short years, the "single" he happily announces to the ladies on his invitation card will turn into "unmarriageable." There's no judging unconscious contents, of course; they simply are. But we can address the choice to reveal them. For me, Landers' decision to let it hang out, outdated macho and all, is performing a vital service.

In defense of Robert Mapplethorpe, the black gay British critic Kobena Mercer stated, "One might say that what is staged in Mapplethorpe's black male nudes is the return of the repressed in the ethnocentric imaginary. . . . His work begins to reveal the political unconscious of white ethnicity."[4]

The invisibility of the white political unconscious to which Mercer alludes, its opacity even to itself, may be this moment's most pressing obstruction for white and nonwhite artists alike. Besides forging a bond between conceptualism and expressionism, Landers' compulsive self-revelations, that hammering away through writings and videos *ad nauseam* and drawings and sculptures (such as they are), have an unintentional side-effect: they are helping to unmask whiteness, beginning to take its lid off.

Even so, certain distinctions continue; and it pays to maintain their subtleties. There remains a difference between the endless smooth talking of

having nothing to say and the stuttering that may be heard in a minoritized art's excess of accumulated, unexpressed meaning, which, having exceeded the space allotted to it by the history of expression, can now only explode or be repressed in a display of dark-glasses cool. Mercer and others have spoken of the "burden of representation": when only one or two voices at a time are allowed to be heard, there is a tremendous pressure to try and say everything in a single mouthful. And when your experience is more complex than the language, which was created for another purpose, has words for . . .

I find a difference between Landers' logorrhea and the way my own work is driven from medium to medium and from style to style by the compulsion to get it all in. This lack and this over-abundance are dialectically related, and I don't want to choose between them. Hal Foster, in a repudiation of his own, earlier post-modern theories under the pressure of what he calls "multi-culturalism at its non-identitarian best," now asks: "Whose 'postmodern' . . . whose 'today?'"[5] Even the dullest of us should by now be able to sense that the cultural projects of the West and the non-West are each implicated in a larger history. And if we don't all keep getting it said, how will we find out what that is?

See also *"Olympia's Maid: Reclaiming Black Female Subjectivity"; "Responding Politically to William Kentridge"; "A Day at the Races: Lorraine O'Grady on Jean-Michel Basquiat and the Black Art World"; "The Wailers and Bruce Springsteen at Max's Kansas City, July 18, 1973"*

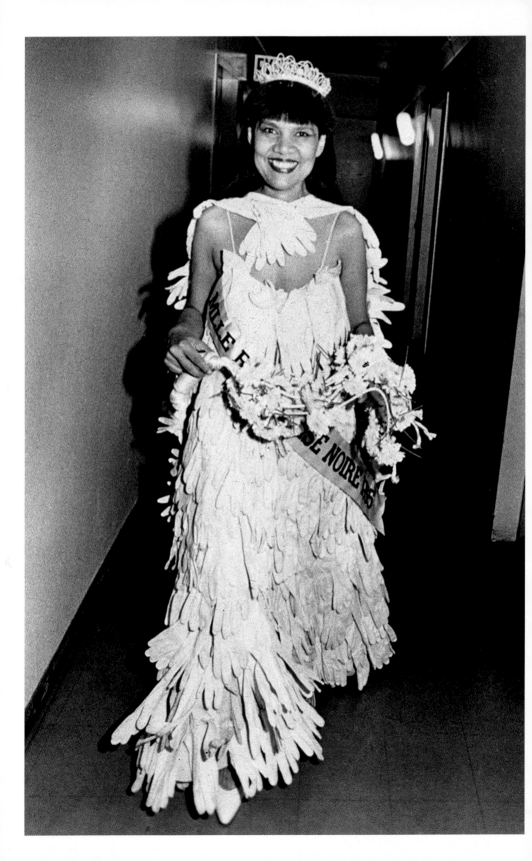

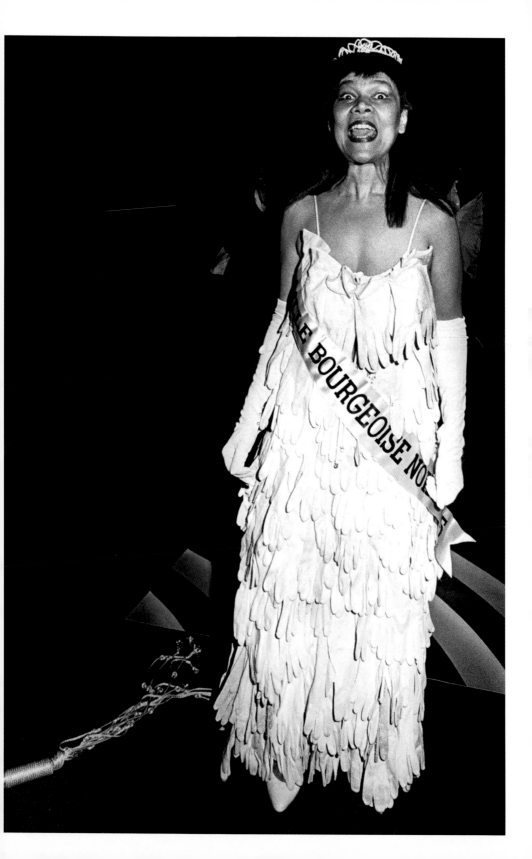

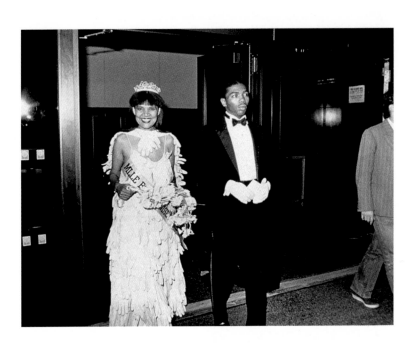

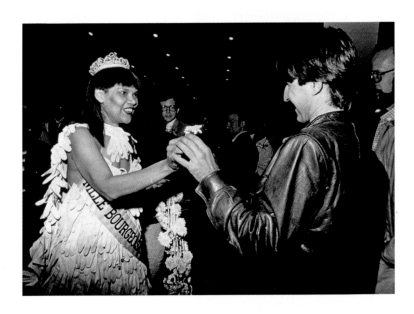

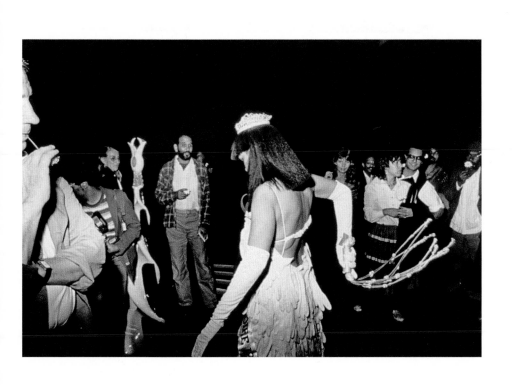

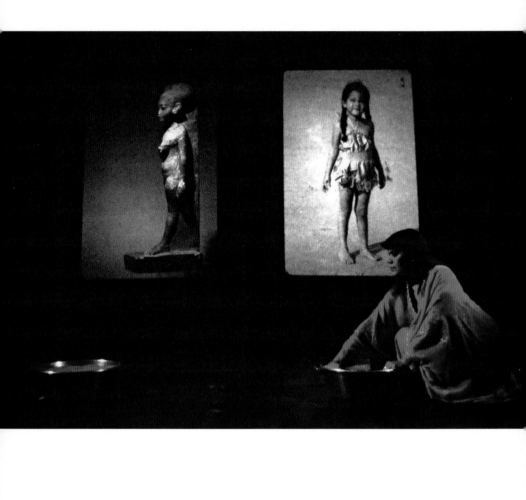

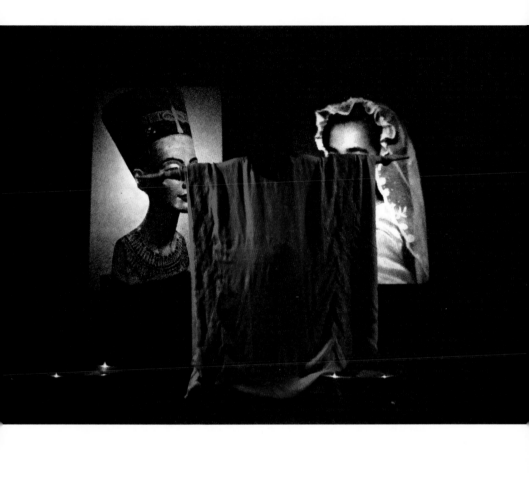

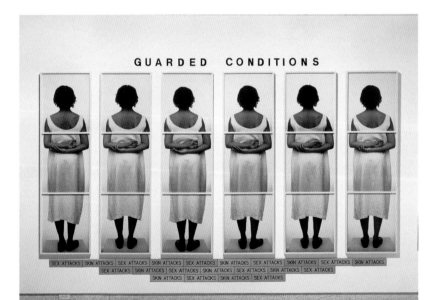

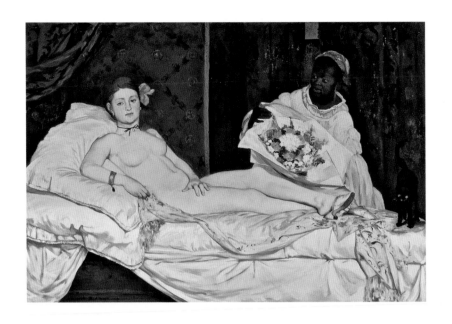

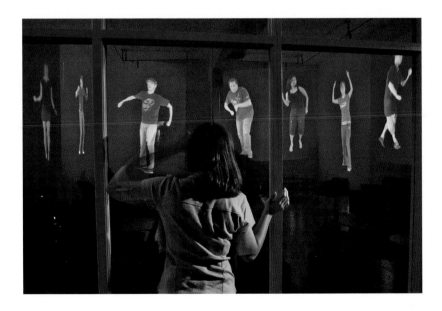

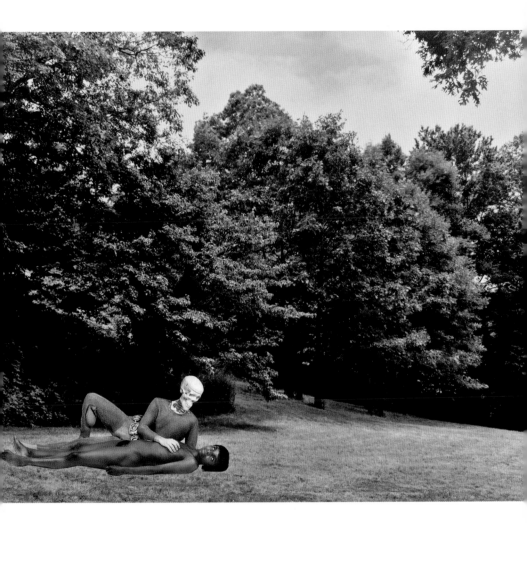

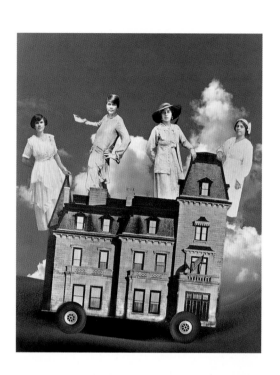

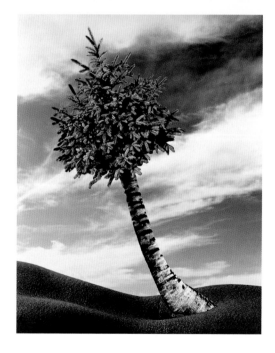

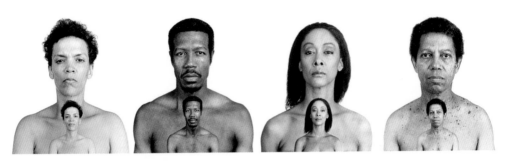

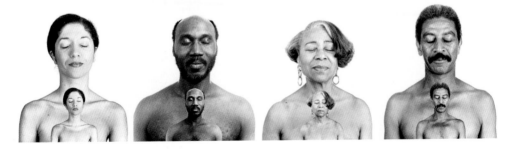

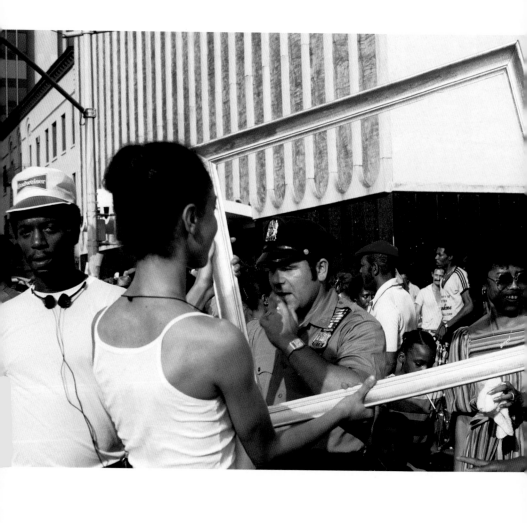

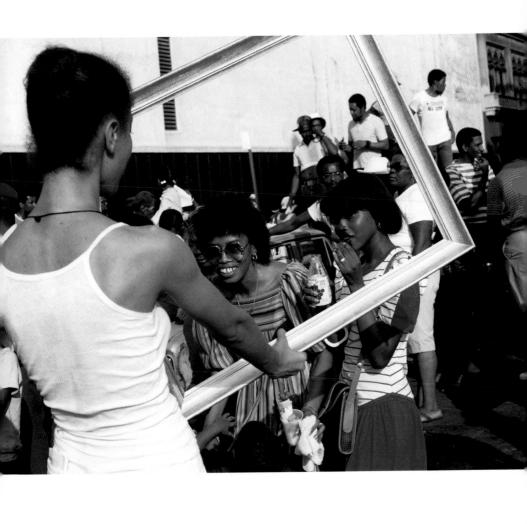

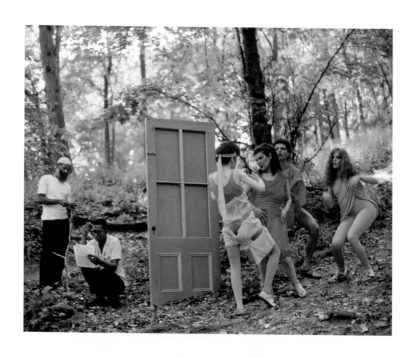

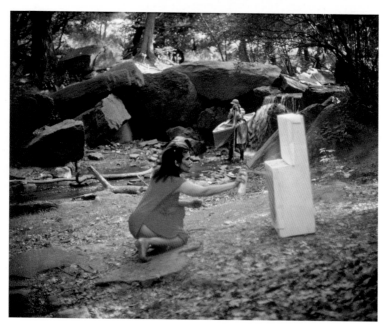

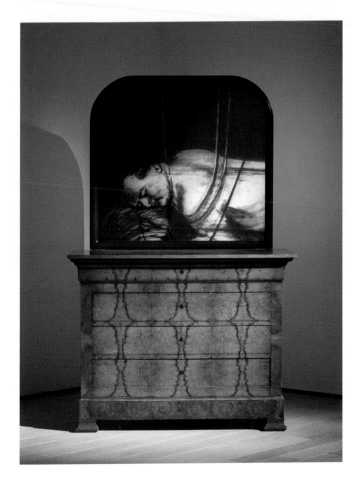

It's been said that gold isn't

But in fact it often is.

The Best of All Gifts: Common Things That Move the Imagination

A FEELING
AS WELL AS
A LOOK

'The modern artist, finding himself with no shared foundation, has begun to build on

Reckless Storytelling

STAR WORDS

and

The Deluxe Almost-Everything-Included

WORK OF ART

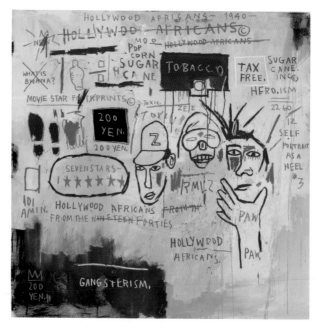

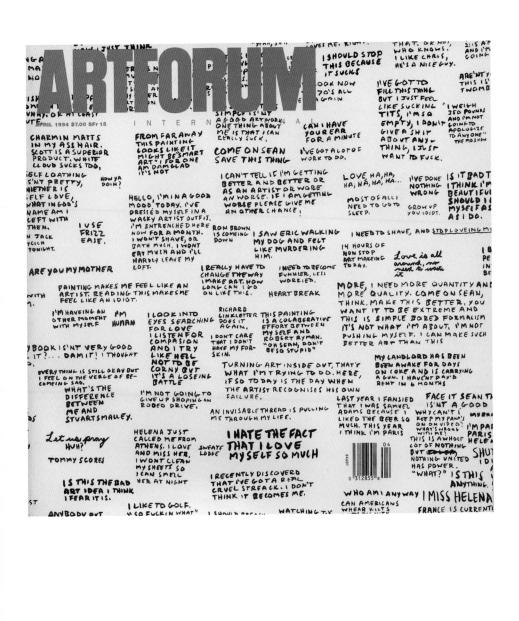

ARTFORUM

INTERNATIONAL

APRIL 1994 $7.00 SFr 15

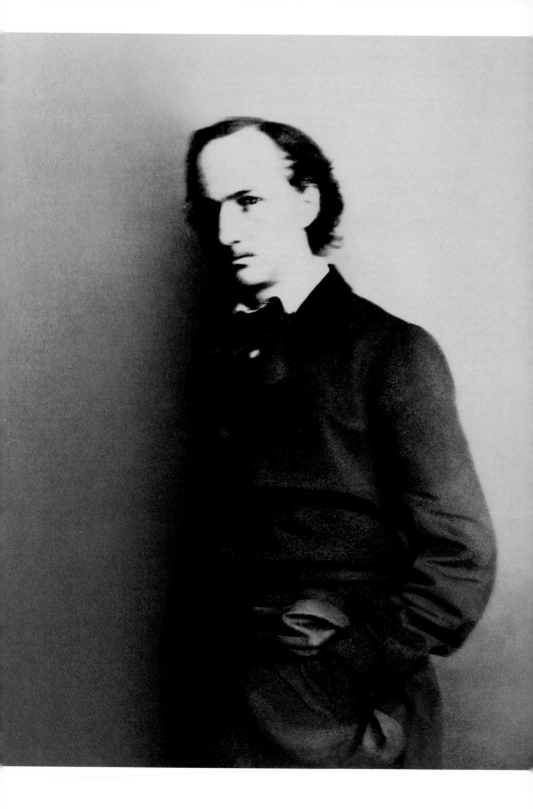

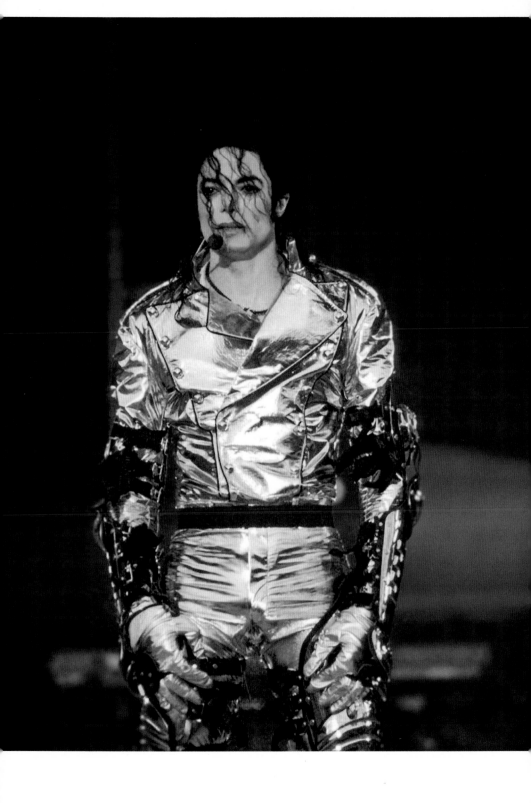

Poison Ivy (1998)

In 1998, in response to the debates surrounding the work of the artist Kara Walker, which had been denounced by some in the black art world for its play with racist imagery, Harvard University hosted a panel on stereotypes in contemporary art. Ronald Jones, the artist and critic, wrote about the event in the summer issue of *Artforum*. O'Grady's response appeared in the next issue. In it, she offers a terse but subtle analysis of the ways in which the controversy served the needs of the white gaze and the art market.

TO THE EDITOR:

After the initial shock of seeing "our dirty linen" washed in public (by an outsider, no less), I found Ronald Jones' "Crimson Herring" in the Summer issue (on "Black Like Who?," the Harvard symposium on stereotypes in contemporary art) quite brave. At the same time it was a bit confused—how could it not be?

Before going further, let me confess: I'm of the pox-on-both-your-houses school myself. The Kara Walker attackers and defenders have so occupied the floor that mere *examiners* of the work have no room.

One reason the audience was so "snow-packed," as Jones put it, is that beyond the brutal demographics of the art world, many black arts professionals were not informed of the symposium, or if they were, they decided not to

attend: they feared they might get angry (not at white people, but at the conference organizers) and lose their cool.

The warning signs were there, in the choice of panelists and the framing of issues—all crimson flags that this was one symposium that would not have the intellectual weight one expects from Harvard. When so many who have pondered long and hard on the issues as they affect the art world (bell hooks, Michele Wallace, and Judith Wilson, e.g.) are conspicuously absent, while so many with axes to grind are there, even the pretense of reasonable discussion seems abandoned. Not to mention the shameless imbalance in the opposing sides: three lonely "attackers," most out of their depth (Florence Ladd is an academic dean recently turned novelist, and Betye Saar, while a good artist and nice person, is not an academic heavyweight)—against the combined market power of the most currently certified names?[1] I ask you. Even the symposium's sponsorship by two of Walker's biggest collectors hinted at agendas unnamed. However serious the intentions of the organizers may have been, they could only be undone by suspicion that this was a market maneuver in masquerade.

Jones was right to point out the unfortunate timing of the debate "at a moment marked by the withering life of affirmative action on certain upscale campuses"—or, for that matter, in the mainstream art world. And his use of Anselm Kiefer's example was apt, I feel (though I'm not sure it's an exact equivalent). But it was disappointing to see someone so perceptive adopt the simplistic casting of the disagreement as a generational dispute: i.e., between younger and older black artists. This furnished one more example of what Jones himself rightly identifies as the ignorance that verifies "the real effect of multiculturalism in the academy as hovering a few degrees above zero." Part of the problem, of course, is the lingering truth of the folk wisdom of the black art world, that there is only room for one or two blacks of either gender to be successful at a given time. Add to that the further restriction of age, and the odds become astronomical. But while there is a "market" reality to the generational war (so that it is not too difficult to see who is sponsoring it, and why), its intellectual reality is almost nil. Outside the questionable parameters of the Harvard symposium, it comes as no surprise that many older black artists are thrilled both by the aesthetic bravura and by the sheer personal gumption of Walker's work, and that, equally, many younger black artists are appalled by its seeming lack of psycho-political reflection—nor is it any surprise that most black artists, of whatever age, are thrilled and appalled at once.

I agree that we need "refined beliefs in racial and cultural equality," but

we need lots of variety in the refinement. What we don't need is the kind of unitary vocalization—one right point of view, one hip generation—that white culture seems to demand of us, so that it doesn't have to think about us so much, so that we're not too *complicated*.

See also *"A Day at the Races: Lorraine O'Grady on Jean-Michel Basquiat and the Black Art World"; "Email Q&A with* Artforum *Editor"; "My 1980s"*

The Black and White Show, 1982 (2009)

In 2009, O'Grady created this artist portfolio to document one of her important early works: *The Black and White Show*, which O'Grady curated in the guise of Mlle Bourgeoise Noire at Kenkeleba Gallery in 1983. The exhibition, which included twenty-eight artists, half of them black and half of them white, opened on the heels of that year's Whitney Biennial, which featured Jean-Michel Basquiat's work. (She had tried to convince Basquiat to take part in *The Black and White Show*, to no avail.) O'Grady conceived the curatorial gambit as part of the larger *Mlle Bourgeoise Noire* project, along with her parade performance *Art Is...* Taken together, the three interventions functioned as both an implicit critique of the segregation of the art world and a positive declaration about who and what was being left out of current mainstream conversations.

OUTSIDE, East Second Street between Avenues B and C in 1983 was Manhattan's biggest open-air drug supermarket. It was always deathly quiet except for the continual cries of vendors hawking competing brands of heroin, "3-5-7, 3-5-7," and "Toilet, Toilet." From the steps of Kenkeleba, looking across at the shooting galleries, you saw unreflecting windows and bricked-up façades, like doorless entrances to Hades. How did the junkies get inside? There was almost no traffic. Behind the two columns flanking Kenkeleba's doorway unexpectedly was a former Polish wedding palace in

elegant decay owned by a black bohemian couple, Corrine Jennings and Joe Overstreet.

The gallery, invisible from the street, had five rooms—one, a cavern—plus a corridor, and dared you to use the whole of it. It was perfect for an impossibly ambitious *Mlle Bourgeoise Noire* event, thirty artists, half white, half black, with all the work in black-and-white. Achromaticity would heighten similarities and flatten differences. And it would be the first exhibit I'd seen in the still virtually segregated art world with enough black presence to create dialogue. A sudden opening meant only three weeks to do it.

And of course, no money. But the Whitney Biennial's inclusion of Jean-Michel Basquiat as a mascot was salt in the wound. That, and the daily bravado needed to walk on that block where even the air was strange—dawn felt like twilight here—kept me going. Race would not be on the labels. Would it be on the wall? In what way? I wanted to see for myself.

Keith Haring had audited my "Futurism, Dada and Surrealism" course at the School of Visual Arts. I called him first. Then contacted Jean-Michel, who could be reached only by telegram. Give that boy another chance! But after promising two new canvases for the show, Basquiat pulled out. Obligations to Bruno Bischofberger came first. Walking down East Second Street was like passing stacks of dreams in mounds. I asked muralist John Fekner to connect the inside with the outside. Downtown had a multitude of talents and trends, some being bypassed by the stampede to cash in. The show ended with twenty-eight artists, many still worried that cadmium red cost $32 a quart wholesale. Each day as I approached the block, I wondered, "Where is my mural?" On the day before the opening, it was there. John had done it at 4 a.m., when even junkies sleep.

Inside the gallery, it pleased me that, even across so many styles, the images gave off language. But who would come? Compared with Kenkeleba, Gracie Mansion and Fun Gallery were like SoHo. The chasm between East Second and East Tenth streets might be too great to bridge. The answer was, friends and East Villagers who understood that people "in the game" leave "citizens" alone. Getting reviewers to the gallery was like beating your head against air. The show received a single paragraph in the *East Village Eye*, nothing more. Looking back, it's clear the artists have had differing careers. A few became household names; more disappeared without a trace. Of some I've wondered, what might their work have become had money and critical attention been paid? There are so many coexisting tendencies in any given time. What is lost when the present reduces the past, ties it up with a ribbon so it can move on to the future? Is that result necessary? Is it real?

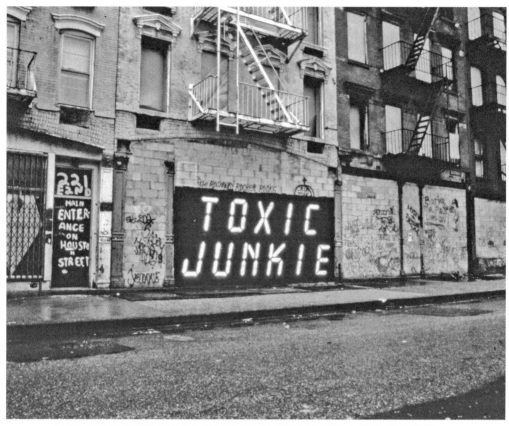

1 JOHN FEKNER, *TOXIC JUNKIE*, 1983, SPRAY PAINT ON CONCRETE WALL. INSTALLATION VIEW, 219 EAST SECOND STREET, NEW YORK, APRIL 1983. PHOTO: JOHN FEKNER.

In this photograph taken just after John Fekner's mural was finished, dawn is rising, the street is empty, the dealers and junkies have not yet come. The mural later became the emblematic image of the East Village art scene, but few connected it to Kenkeleba or to *The Black and White Show*.

Just Above Midtown, where David Hammons, Fred Wilson, and others exhibited, received slightly more press than Kenkeleba. But a black friend active in the East Village scene later said that at the time, he hadn't heard of JAM. A month before the show, an announcement came from Adrian Piper in California. It was black with gold print. I asked her to do it in black and white, and she did. This photocopy was destroyed later.

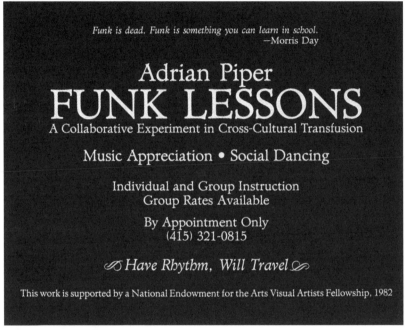

Funk is dead. Funk is something you can learn in school.
—Morris Day

Adrian Piper
FUNK LESSONS
A Collaborative Experiment in Cross-Cultural Transfusion

Music Appreciation • Social Dancing

Individual and Group Instruction
Group Rates Available

By Appointment Only
(415) 321-0815

✍ Have Rhythm, Will Travel ✍

This work is supported by a National Endowment for the Arts Visual Artists Fellowship, 1982

2 ADRIAN PIPER, *FUNK LESSONS DIRECT MAIL ADVERTISEMENT*, 1983, 130 INVITATION CARDS WITH EMBOSSED GOLD-LEAF LETTERING, 6″ × 8″. SINGLE BLACK-AND-WHITE PHOTOCOPY VARIANT, HORS SÉRIE, LATER DESTROYED.

The breakthrough year of Nancy Spero's career, 1983–84, was marked by U.S. interventions in such countries as Grenada and Nicaragua. This sketch would become her 1984 *El Salvador.*

3 NANCY SPERO, SKETCH FOR *EL SALVADOR, 1984–85*, 1983, HAND-PRINTING ON PAPER, 20″ × 110″.

The Card Players, by Gerald Jackson, is a large painting on canvas from the mid-'70s. Gerald had a studio on the Bowery in the '70s and '80s. He was a friend of Keith's. I wonder if the figure in the lower right may have influenced the "radiant child."

4 GERALD JACKSON, *THE CARD PLAYERS*, CA. 1975, ACRYLIC ON CANVAS, APPROX. 60″ × 72″.

Keith Haring's cooperation when called on helped the show come together. He had been my student at SVA and I'd been following his work since the earliest white-on-black graffiti done in the subways.

5 KEITH HARING, *UNTITLED*, 1982, SUMI INK ON PAPER, 40″ × 52″.

6 JUDY BLUM, *SMALL SONGS* (DETAIL), 1981, INK ON CANVAS, FORTY-EIGHT PARTS, EACH 6″ × 6″.

These small paintings on canvas by Judy Blum, a detail from the forty-eight-part arrangement *Small Songs,* could be read as either poems or sentences, depending on the viewer.

A piece about perception and artmaking by Fluxus artist Jean Dupuy. The tiny periscope in the center magnifies the image in the mirror, so you see the top of your head. And it's projected that the accumulated sweat of five thousand foreheads and noses will turn the paper into the desired golden print. That couldn't happen here.

7 JEAN DUPUY, *THE PRINTING TABLE*, 1974, WOODEN TABLE, PAPER, LAMP, PERISCOPE, MIRROR. INSTALLATION VIEW, KENKELEBA GALLERY, NEW YORK, 1983.

Randy Williams, a Just Above Midtown sculptor, did a new piece for the show about the black and white toilets of his southern childhood. The quote on the floor (BETWEEN THE WHITE MAN AND THE LAND THERE WAS THUS INTERPOSED THE SHADOW OF THE BLACK MAN), by William Faulkner, lay in a field of razor blades. It was eerie. From the doorway of the room where they were both placed, the Williams and the Dupuy looked as if they were made by the same artist.

8 RANDY WILLIAMS, *BETWEEN THE WHITE MAN AND THE LAND THERE WAS THUS INTERPOSED THE SHADOW OF THE BLACK MAN*, 1983, TOILET SEATS, WOOD, RAZOR BLADES, STADIUM LIGHT. INSTALLATION VIEW, KENKELEBA GALLERY, NEW YORK, 1983.

9 WILLIE BIRCH, *UNTITLED*, 1979, DIPTYCH, GRAPHITE, AND ACRYLIC ON CARDBOARD, EACH PART APPROX. 36" × 36". FROM THE SERIES *NEW YORK CITY JAZZ*, 1979.

As a painter, Willie Birch moved through several styles, from Color Field to faux naïveté. This gridded cardboard diptych from the *New York City Jazz* series, notations made while listening to experimental music such as John Coltrane's, is from a period when simultaneously his work was at its most "folk" documentary.

10 JACK WHITTEN, *OMIKRON I*, 1977, ACRYLIC ON CANVAS, 52″ × 64″.

In a call-and-response counterpoint to abstract or free jazz by musicians such as Coltrane, Ornette Coleman, and Cecil Taylor, many painters of the '70s and '80s, Jack Whitten among them, profoundly mined a kind of jazz abstraction. I saw this painting again just recently in the viewing room at Alexander Gray.

11 TYRONE MITCHELL, SCULPTURE, 1983.

Besides jazz, the abstract sculptors were often influenced by African attitudes to form and materials. One of the sculptors who showed at Just Above Midtown, Tyrone Mitchell, actually spent time living with the Dogon people.

12 LYNNE AUGERI, *TORSO NUMBER 38*, 1982, BLACK-AND-WHITE PHOTOGRAPH, 24″ × 20″.

Lynne Augeri, a former student of mine, was a self-portrait photographer. She used costumes and extreme poses to explore child and sex abuse with adroit technique. It came as a shock to have to defend such serious work from accusations of pornography.

13 LOUIS RENZONI, *MARGIN*, 1983, OIL AND WAX ON LINEN, 88″ × 70″.

In *noir* paintings that were both voyeuristic and vulnerable, Louis Renzoni iterated a threatening quality of the early '80s. This was his first group show in New York. He went with Piezo Electric, an East Village gallery, shortly after.

14 STEPHEN LACK, DRAWING (JEAN-MICHEL BASQUIAT AND HIS FRIENDS BEING STOPPED BY THE POLICE), 1983.

Stephen Lack had promised to do a painting for the exhibit. Instead, he did a drawing of an upsetting incident that happened to Jean-Michel Basquiat and his graffiti friends shortly before the show opened.

Some of the artists were a revelation. A wall of small collages and drawings by Marc Eisenberg, most done in the '70s, anticipated many things that were happening. This 1975 *Self-Portrait* seemed to contain elements of Jean-Michel. The show had been built around Basquiat, and even after he pulled out, he remained present.

15 MARC S. EISENBERG, *SELF-PORTRAIT*, 1975, PENCIL AND CRAYON ON PAPER, APPROX. 14″ × 11″.

George Mingo, a graduate of Cooper Union, was a faux *primitif*. He painted this expressly for the show and told me I HAD to put it in. I did. Its black-and-white-in-living-color made the perfect coda. It was in the last room.

16 GEORGE MINGO, UNTITLED PAINTED SKETCH, 1983.

See also *"The Cave: Lorraine O'Grady on Black Women Film Directors"; "Two Exhibits: The Diptych vs. the Triptych and Notes on the Diptych"; "Introducing: Lorraine O'Grady and Juliana Huxtable"; "A Day at the Races: Lorraine O'Grady on Jean-Michel Basquiat and the Black Art World"; "Email Q&A with* Artforum *Editor"; "My 1980s"; "Interview with Laura Cottingham"; "The* Mlle Bourgeoise Noire *Project, 1980–1983"*

Email Q&A with *Artforum* Editor (2009)

While preparing her portfolio on *The Black and White Show* for publication in *Artforum*, O'Grady approached the queries by her editor, Elizabeth Schambelan, in part as an opportunity to provide background on the situation of race in the 1980s art world.

Part 1

Text Reference: "'*Mlle Bourgeoise Noire*' Event"

ELIZABETH SCHAMBELAN When did you come up with the concept for *The Black and White Show*, and do you remember what the specific impetus was, if there was one? Or was it a more generalized response, as you suggest below, to the virtually segregated art world?

O'GRADY It was part of an invasive strategy I'd employed from the beginning. All black artists probably thought about this "virtual segregation" all the time. But I may have responded more aggressively.

I sometimes joke that I was "post-racial" *before* I was "racial." I'd graduated from Wellesley in the mid-'50s, way before the civil rights battles, landed one of the most prestigious entry-level jobs in the federal government based squarely on merit, had married interracially, and in general avoided the most egregious forms of discrimination—perhaps due to how I looked (I was fair-

skinned and still straightened my hair). The art world was the first place I'd felt "cornered" that way.

The segregation wasn't absolute but the occasional exception, such as an incidental solo at the Whitney in a ground floor gallery off to the side, felt meaningless. *Mlle Bourgeoise Noire* began shouting in 1980. Then in 1985, the Guerrilla Girls put up posters counting the numbers of women in commercial art galleries. But to have counted the numbers of blacks and other non-whites in those same galleries would have been an ironic gesture.

The Black and White Show was in 1983. In 1988, Lowery Stokes Sims and Leslie King-Hammond curated *Art as a Verb*, featuring 13 black avant-garde artists, to show that side of black art making. The exhibit at the Studio Museum and the Met Life Gallery got a review in the *New York Times*, but didn't make a strong dent. *The Decade Show* of 1990 was more impactful. It was co-produced by three institutions—the Studio Museum in Harlem, the New Museum of Contemporary Art, and the Museum of Contemporary Hispanic Art—and featured 200 works by 94 artists of Hispanic, Asian, African-American, Native American, and European heritage. But even this show seemed safely "bracketed," as would be evident in the response to the 1993 Whitney Biennial (more later). However, *The Decade Show* benefited from its institutional backing, sheer size, and a more welcoming media environment following the David Hammons show in 1989.

It may be a function of how the art world is structured that the breakthrough shows for black art were of *individual* artists: Adrian Piper's retrospective at the Alternative Museum in 1987 and especially Hammons' 1989 show at Exit Art. Both exhibits were in not-for-profit artist spaces, but the political and theoretical requirements of the moment—and, in David's case, the creation of a context for his work—catapulted the two artists into the mainstream art world, making a space for others to follow.

Text Reference: "A sudden opening meant only three weeks to do it."

SCHAMBELAN How did it come about that you only had three weeks to put it together?

O'GRADY Kenkeleba, like Just Above Midtown, Artists Space, the Alternative Museum, etc., was part of a network of not-for-profits in the '70s and '80s funded by entities like the New York State Council for the Arts and others. (Kenkeleba probably received less funding than JAM as it wasn't as

prominent.) Contractually, any hole in the schedule would have to be filled. The opportunity fell to me.

Text Reference: "Note on ANECDOTAL CAPTIONS: Without answering the analytic and theoretical questions myself, I tried to enable readers to begin the process of answering them for themselves."

SCHAMBELAN I can't help but wonder . . . was race on the wall? What kind of dialogue or kinds of dialogues did you see amongst the works?

O'GRADY It's difficult to remember how I responded at the time. But in assembling the portfolio, which is essentially a new piece, I was struck by both the differences and similarities. In some cases, the conceptual vocabularies obviously differed—with black artists, jazz was more operative, with white artists, the languages of film and dream—while literature and theory were more evenly divided. But I was surprised to see how many artists shared an underlying anxiety, even a dread. The Nancy Spero sketch was untitled at the time, but it's appropriate that it later became "El Salvador." These were Reagan years, and alienating . . . imagine sending Marines in to an island with less than 100,000 people. New York may have been easier for artists to survive in then than now, but it was a poorer and more unpleasant place to live.

Text Reference: "Note on THE LAYOUT: The design attempts to maximize formal comparisons but not necessarily on a racial basis."

O'GRADY One place where many of the questions come into focus is the duo Randy Williams–Jean Dupuy. Employing uncannily similar formal means, the two artists deliver radically differing content, marked on the one hand by political and philosophical urgency, and on the other by disinterested playfulness. Will readers automatically make judgments on which is the more "important" piece and which the more important attitude? If so, on what factors will those judgments be based? (For me, the Williams is the more successful and compelling piece, but I know that for some readers "compelling" will be beside the point. I find a comparison of the two pieces more interesting than contemplating either individually. Hopefully, others will also).

Another duo, John Fekner–Adrian Piper, might raise the question of the links between intellectual and financial investment. Though by some standards not a financially "successful" artist, Piper has been recuperated art historically, whereas Fekner, a public artist whose most important pieces were

in the 1980s Bronx and East Village, has been less so. As a result, though Fekner's piece could be the richer, more complete of the two, Adrian's may hold more meaning for today's viewer due to the critical space made for it.

Part 2

Text Reference: "Doing the portfolio raised questions for me about, not just the fate of many black and women artists of the period, but also about East Village art and its historical and market assessment."

SCHAMBELAN Do you think it would be different now? That is, do you think that reception conditions have changed meaningfully, or only superficially?

O'GRADY Before answering, I should say something I forgot to mention. I tried hard in the portfolio not to argue for *The Black and White Show*'s importance. But I did want to make it as interesting as I thought it had been. That the 1990 *Decade Show* (see above) made an institutional presentation of similar ideas and produced a major splash didn't make my 1983 show less interesting or less prescient. The fact is, artist-curated shows, even in strong institutional settings (and Kenkeleba was not that), can be "raw." They can have a handmade quality—sort of like the difference between an *Art Is . . .* float and other, commercially produced floats in the Afro-American Day Parade. I do feel *The Black and White Show* had more intellectual density and quirkiness than the later show. And because it was a conceptual art work using curating as a medium, it could raise more complex questions.

But to get back to your question, the "reception conditions" you refer to changed in several waves. *The Decade Show* made a PR splash, but due to the nature of the sponsoring institutions, i.e., the Studio Museum, MOCHA, the New Museum, the show remained safely "bracketed." Three years later, in 1993, nearly the same proportion of "others" would be repeated (I don't have exact figures)—this time inside a powerful institution, in the Whitney Biennial. The numbers were stunning compared to the biennial of 1983, coincidentally the year of *The Black and White Show*, when the only African-American besides Basquiat that I can remember was the painter Oliver Jackson from Oakland (I did a Google search but couldn't find a participant list online), and none of the Just Above Midtown artists had visits to their studio. The 1993 edition of the biennial would help make several careers, but it became pejoratively labeled as "the multicultural biennial," and two of its cura-

tors, Elizabeth Sussman and Thelma Golden, left the Whitney shortly after. Biennials have not gone that way again.[1]

Beyond the simplistic measure of the Biennials, even determining what the other measures should be is difficult. And for the individual minority artist earning a comfortable living, perhaps a fortune, it may be irrelevant. But thinking culturally, as I always try to . . .

Well, to be honest, it's hard for me to think along those lines now . . . not just because I'm tired (I am), but because this is such a culturally confusing moment. I'm not being disingenuous if I say that I am more interested in your answers to your questions than in my own.

Although I may believe that an ongoing, actively dialogical engagement on the wall between minority and majority art of the sort attempted in *The Black and White Show* is a long way off, a combination of the recession and the electorate's response to the Obama administration could bring unforeseeable change.

To give just two examples: I'm leery of the kind of discourse I recently read on David Hammons that foregrounds terms like "magical" and "reclusive"—rather than, say, making an analytical comparison to Damien Hirst's stage-managing of his career (many may not be aware that if a Hammons piece is at Phillips de Pury, chances are it came from David's studio and has for the last eight years). . . . I also feel that even a positive collection like the Rubells' *30 Artists* remains a form of bracketing. . . . But I recognize that there have been changes—even in my own career—in the last two or three years that can't be parsed so easily.

I'm having to face new questions:

What does it mean to discover a small yet growing audience among artists, across the racial spectrum, who are mostly under 30 years of age?

What mixture of romanticism and dispassionate perception may be involved here?

See also *"Performance Statement #1: Thoughts about Myself, When Seen as a Political Performance Artist"; "The Cave: Lorraine O'Grady on Black Women Film Directors"; "A Day at the Races: Lorraine O'Grady on Jean-Michel Basquiat and the Black Art World"; "The* Black and White Show, *1982"; "My 1980s"; "Rivers* and Just Above Midtown*"; "Interview with Laura Cottingham"; "The* Mlle Bourgeoise Noire *Project, 1980–1983"*

My 1980s (2012)

The following text is based on a lecture O'Grady delivered at the Museum of Contemporary Art in Chicago in conjunction with the 2012 exhibition *This Will Have Been: Art, Love, and Politics in the 1980s*, curated by Helen Molesworth. Her article gently critiques the framing premises of the show, suggesting that while the 1980s might have seemed like an expansive period for others thanks to the introduction of postmodern ideas, for black artists—and black women artists especially—it was experienced more often as a last-ditch effort for whiteness to reclaim its hold on artistic and cultural discourse via a variety of postmodern theoretical mechanisms.

This crucial essay is also significant for explaining O'Grady's "reverse trajectory," as she terms it, from "postblack" to "black." Thelma Golden defined the postblack moment as one "characterized by artists who were adamant about not being labeled as 'black' artists, though their work was steeped, in fact deeply interested, in redefining complex notions of blackness";[1] she locates that moment primarily in the 1990s and later. The artists Golden identified as postblack (including Glenn Ligon, Kara Walker, Hank Willis Thomas, and others) could be said to be defining themselves not as "black artists" but as "artists who were black," in part by moving beyond the didactic imperatives of the black arts movement into a more conceptual terrain for effecting their critique.[2]

Golden saw "postblack" artists as addressing themselves to questioning the idea of a singular, monolithic black experience while simultaneously envisioning their own very particular experiences as part of a larger, even global, idea of "multiculturalism," one in which their individual subjectivities could be universalized, and understood not as black experience but as human experience.

In O'Grady's work, the trajectory from postblack to black was spurred by her growing recognition of the unrelenting segregation of the art world, a segregation from which her relatively privileged background, her education, and her ability to meet and exceed white standards of excellence outside the art world had insulated her. In concrete terms, it is represented in the difference between her first artwork—*Cutting Out the New York Times (CONYT)* (1977), which was an attempt to find a private poetry in public language—and the *Mlle Bourgeoise Noire* project, which unpacked the racism of the art world both by challenging its terms (as she did in the guerrilla performance of *Mlle Bourgeois Noire* itself) and by making clear who was being excluded (as she did in *Art Is . . .* and *The Black and White Show*). From the 1990s forward, with explorations of black feminine subjectivity in works such as *Miscegenated Family Album*, *Body Is the Ground of My Experience*, and *Flowers of Evil and Good*, and then, beginning in 2010, with examinations of the "both/and"-ness of diasporic experience such as *Landscape Western Hemisphere* and *The First and Last of the Modernists*, O'Grady developed what she refers to as a "post-post-black" approach. This approach was premised on the idea that subjective experience cannot be disconnected from larger institutional, psychic, and cultural interpenetrations of blackness and "whiteness" or "nonblackness." This trajectory from postblack to black to post-post-black prompted her to revisit her 1977 collage poems; the new work that resulted from this reexamination, *Cutting Out CONYT* (2017), highlights the way in which her original attempt to mine her inner life from the language of mass media was always determined and delimited by her belief, during that earlier period, that she had already escaped from the limitations of blackness into the universal or human—a belief she later recognized as ingenuous. Entering the rigidly segregated art world in 1980 had abruptly changed that perception. But now, by returning the lived "black experience" of forty years to her earlier "postblackness" and taking both "blackness" and "postblackness" for granted, she felt that this time she could bend that public language, steeped as it was in value-laden binary think-

ing around race and gender, and transform it anew into a private idiom of "post-post-blackness," one capable of simultaneously expressing both the particular and the universal. "My 1980s" was written, in part, to consolidate the argument for this shift in the trajectory of her work and as its opening salvo.

FIRST, I must thank Helen Molesworth for curating such a brilliant and brave show and for allowing me to be part of it. *This Will Have Been: Art, Love, and Politics in the 1980s* is an unusual exhibition. It attempts to deal historically with a period that has not yet disappeared, one that is still vexed in present memory. Its admirable qualities leap out at once—a refusal of the curatorial temptation to evaluate and re-categorize, its willingness to let the period "live free," Molesworth's exemplary admission of her own biases in shaping it.

I won't be responding to the show on the walls, but more to the catalogue—whose richness I can't recommend highly enough—and to what a quiet reading of it in New York made me think and feel.

Molesworth's own extraordinary essay helped me get to a place it would have taken me years to reach otherwise. I am especially grateful to the invitation extended in its final paragraph to others' alternate visions of the period, its recognition that even those of us with similar goals can never be fully in synch but that, if we can express our differences "without losing time," we may get there in the end.[3]

None of the differences between my perception of the 1980s and Molesworth's should be taken as a criticism of *This Will Have Been*, of course. If I saw the 1980s differently than Molesworth—and I did—my responses are more an attitudinal selection, my differences a case of the glass half-empty and half-full.

Molesworth sees the 1980s as a moment of nascent ideas, as the incubator of an expanded "understanding of identity and subjectivity" which would arrive more fully in the 1990s—in effect, as the beginning of the postmodernist period.

On the other hand, I see the 1980s as the last gasp of modernism, a modernism newly under pressure, un-self-confident, making a desperate last effort to control the narrative.

Molesworth refers to feminism and the AIDS crisis as "stakes in the ground" shaping the contours of the vision of the 1980s that she explores in her show.

For me, the theorizing of white feminism was one last cruel obstacle to be overcome.[4] And AIDS was a source of private loss without outer acknowl-

edgement. Though gay artists made some of the best art of the period, their work was not valued as it should have been, nor is it still. It sometimes feels as if the very centrality of homosexuality to the period may be the biggest reason the 1980s are seen, to use Molesworth's phrase, as "just too much."[5]

However, I do agree with Molesworth that the 1980s may have been the "last movement," the last to believe that art based in individual desire could be socially and culturally transformative.[6] Sadly, individual desire is one of the human qualities most easily and effectively structured by political economy, which is to say, power.

For me, it was at times infuriating to watch modernism's end and postmodernism's arrival being celebrated prematurely in the 1980s.[7] Modernism was indeed coming to an end. But in the three decades since the start of the 1980s, some of us have had to live with flailing attempts by the usual suspects to hold on to the old methodologies and "truths," all the while proclaiming their departure a welcome farewell.

Johanna Burton writes in her catalogue essay that the editors of *October* have at last thrown up their hands and declared that, to paraphrase, they can no longer analyze and predict.[8] What a relief! The effort to control the narrative was a mandarin project like any other and was bound to fail in any truly postmodern era defined by splintered consensus.

The master narratives that characterized the we-they, top-down modernism typical of colonialist empire seem aberrant interruptions between, on the one hand, the totalizing narrative regimes of premodern, homogeneous cultures and, on the other, a newly postmodern globalized world in which all stories are becoming dangerously equal.

The economic dispersal and ensuing fracture of the art field of postmodernism that seems finally to have arrived in about 2008, with the worldwide economic bailout and the election in this country of Obama, are quite terrifying. And yet, the current moment feels safer for *me*. I am so glad I made it here, even though there's no way to predict where this sundering of narrative unity is going. I spent all of the 1980s and the 1990s feeling, "God, will it never end? Will they never stop taking up all the room, stop speaking for themselves as though speaking for everyone?" The death of the author? The total construction of subjectivity? Sexual liberation as a prime victory of feminism? For you, perhaps. But for others, there was more.

History as the single-minded story of the winners is something premodern and modern cultures have in common. But history has, in reality, always been just one story among many—and not always the most interesting, not always the most useful to the present. It was just the story that was needed

to survive, to justify power, or the one capable of being understood with the mindset then available. I'd like to see the lost stories recuperated: stories to use, to amuse.

I grew up in the 1940s and 1950s, when you could take a course called "World Literature" in almost any university in the country and not encounter a single writer who was not either European or Euro-American. But you know, that was the story they were telling about the world then. Still, it was beautiful and edifying and exhausting, all that identification with exotic characters, all that reading one's self into their stories with nothing to compare.

But sometimes you have to tell your own stories, not just to understand yourself but to understand the world, to find the space between their stories and yours, to learn what's really going on.

I often say that I was "post-black" before I was "black." For a long time, I felt that I had escaped the limitations imposed by blackness. In those days, in the years well before 1968, living in my insular worlds of elite education and government employment, in a seeming meritocracy, I didn't feel I had difficulty being noticed or being taken seriously.

Then in 1977, when I was still post-black and experiencing the kind of personal crisis that now seems routine, I did a series of newspaper poems. But not like the Dadas and Surrealists—the former draft dodgers from World War I whom I'd been teaching—had done. World War I had been one of the stupidest and most devastating wars ever waged—more combatants were killed or wounded, or rather a greater percentage, than in World War II,[9] and all for mysterious economic power reasons that nobody understood. Those artist sons of Europe, with their rigorous, old-fashioned educations, had been shocked to learn that beneath the rationalism drilled into them as Europe's foundation was a blind irrationality that only occasionally saw the light of day.[10]

One of the best pieces of public performance art I've ever heard tell of was performed by a regiment of five thousand French soldiers being marched to fight in the trenches during that war. Each village the soldiers passed through, as they marched down the main street, they would baa (baaaa, baaaa) like sheep being led to the slaughter. As they left the town, they would fall silent again.

The newspaper poems of the young Dadas and Surrealists were a self-conscious surrender to the random in order to expose it, to bring the irrationality out from where it lay hidden and create a *surrealité*, an "above" reality, they could benefit from. My newspaper poems were almost the oppo-

site of that. My last job with the government had been at the Department of State, in the Bureau of Intelligence Research (INR), the American Republics branch. It was during the Cuban crisis of the Kennedy years, and I had to read five to ten newspapers a day and plow through transcripts of three different Cuban radio stations. At a certain point in the day, you could watch language melt away. More than a dozen years later, in 1977, in my own little crisis, I started cutting headlines out of the Sunday *New York Times*. I would smoosh the cut scraps around on the floor until a poem appeared. My newspaper poems were more of a *sous-realité*, an "under" reality. They were an effort to construct out of that random public language a private self, to rescue a kind of rational madness from the irrational Western culture I felt inundated by, in order to keep sane.

In 1977, I was still post-black, and the poems were all about universal stuff, the meaning of life and art and all that. I did a poem a week for twenty-six weeks, and they averaged about ten pages each. But in 1979 I had an epiphanic experience at 80 Langton Street, an alternative space in San Francisco. I'd gone to see Eleanor Antin, whose *100 Boots* I adored. I had no idea what to expect. As it turned out, she was doing a performance of Eleanora Antinova, her black ballerina character who had danced with Diaghilev in Paris after World War I. I liked the concept, it made me think of my mother Lena, of what might have happened had she emigrated from Jamaica to Paris as an eighteen-year-old instead of to Boston at exactly that time. But my mother was tall and willowy, the black ballerina type. And neither this short, plump white woman in blackface nor her out-of-kilter vision of the black character's experience could compute for me. That was the moment I decided I had to speak for myself.

In 1980 I volunteered at Just Above Midtown, the black avant-garde gallery founded by Linda Goode Bryant that had lost its space on Fifty-seventh Street and now had to create a new space in Tribeca. I became a sort of in-house gallery PR agent. One day, I called the *New Yorker* and spoke to the editor of "Goings On About Town." I wanted her to list the gallery's opening show, with pieces by David Hammons and others. JAM had never had a listing there, of course, nor had any of the other black galleries. I told her that the name of the show was *Outlaw Aesthetics*. When I heard her reply, my blood froze. "Oh, they always put titles on shows there, don't they." That was the moment I was transformed from post-black into black.

Ah, recuperation. It's so boring, especially if you don't have anything to recuperate, if all your stories are already known by you and by all those who need to know them in order to survive. But if I must get my stories told so as

to visualize the space between my stories and theirs and gauge where truth might lie, then they need me to tell my stories so as to do the same, to measure the distance between their stories and mine and find a corrective truth for them.

We must try to be analytic with our recuperation. But even so, it may be difficult for some to realize that they need our stories both to understand themselves and to learn the selves they present us to deal with, to see accurately the world in which they increasingly must live.

Since one of my projects in art is to make the invisible visible, I'd like to discuss a few pictures of a kind I imagine most have not seen before. These are photos taken seventy-two years ago, in November 1939. The party is for my sister Devonia's sixteenth birthday, and the young people range in age from fifteen to nineteen. The girls are dressed in floor-length formal gowns, the boys are wearing suits and ties. An unusually attractive group as teenagers go, relaxed and jovial but still well-mannered, intelligent, and poised. But if you look more closely, it can be unnerving. The group is so uniform, so carefully selected. These are not new friends; they have grown up together, been carefully vetted by complicit parents, groomed to compete successfully in every way. It's the world of prewar Black Brahmin Boston, the world I came from and was in perpetual rebellion against. I was five years old at the time and not at the party. The chaperone, in whose home it was held, was my godmother Ruth Silvera, my mother's best friend.

Later, these young people would achieve great things. Catherine McCree's brother Wade became Solicitor General of the United States, appointed by Jimmy Carter. Devonia herself would help to set up the country's first school social work program, in Stamford, Connecticut. But neither they nor memory of their accomplishments entered public consciousness. They were obliterated by glazed eyes programmed to eternally render them invisible.

When the Obamas arrived unexpectedly seventy years later, those same eyes, with cauls suddenly removed, saw them as having dropped from Mars. Bless her heart, Michelle has always insisted, I'm not unique, I'm just one of thousands. She is, and not the most beautiful or the most brilliant. But she *is* one of the most self-confident. That woman has been well-loved.

In 1980, after being transformed from post-black to black, I did my first public art work, *Mlle Bourgeoise Noire*, for the opening of *Outlaw Aesthetics* at Just Above Midtown/Downtown. She was a persona who wore a gown and a cape made of 180 pairs of white gloves, gave away thirty-six white flowers, beat herself with a white cat-o-nine-tails, and shouted poems that criticized the mindsets of the white and the black art worlds. It was a hard perfor-

mance, perhaps the most difficult I've done. I had to strip away everything that had been instilled in me at home and at school. Mlle Bourgeoise Noire wore a crown and a sash announcing the title she'd won in Cayenne, French Guiana, the other side of nowhere. (Black bourgeoise-ness was an international condition!) Her sash read "Mlle Bourgeoise Noire 1955." That had been the year her class graduated from Wellesley.

The performance was done in 1980, so it was a jubilee year, a year in which she would enact a new consciousness. Well, not entirely. At Wellesley, I'd worn white gloves myself and still had them in a drawer. But I didn't include them in the gown. I couldn't go that far.

After invading openings where she shouted poems against black caution in the face of an absolutely segregated art world, with punch lines like "Black art must take more risks!" and "Now is the time for an invasion!," Mlle Bourgeoise Noire became a sort of impresario. She presented events like *The Black and White Show*, which she curated at Kenkeleba, a black gallery in the East Village, in May 1983. The exhibition featured twenty-eight artists, fourteen black and fourteen white, and all the work was in black-and-white. The curating and the work were subtle, but the intention was perhaps not. To a blindingly obvious situation, sometimes you make an obvious reply.

Another Mlle Bourgeoise Noire event was *Art Is . . .* , a September 1983 performance in the Afro-American Day Parade in Harlem. A quarter-century later she would convert photo-documents of the performance into an installation, a selection of which is on view in *This Will Have Been*.

When she presented these events, Mlle Bourgeoise Noire would pin her own gloves—the gloves she'd lacked resolve enough to put into the gown—onto her chest as accessories. Perhaps she was getting stronger.

People often ask me to compare the live performance of *Art Is . . .* and the installation, but I can't. They were incommensurate events. The day of the parade was hot, one of the hottest of the summer. There were a huge number of floats and marching bands, and they each had to wait on a side street before they could get en route. We shared the block with the Colt 45 group for almost four hours before our turn came. While we waited, the young actors and dancers I'd hired, none of whom may have known each other previously, began to bond. And some did more than that, I'm sure. It was that kind of day. We got onto the parade route about 1:00 p.m., and by the time we finished it was almost 6:00.

I've never had a more exhilarating and completely undigested experience in my life. The float was stop-and-stall, sometimes for fifteen minutes at a time. At other times, it would be moving so fast that in order to stay in line,

you had to run like crazy, or just jump on and ride. I wasn't from Harlem, so half the time I didn't know what I was looking at. But I had deliberately not put the float into the West Indian Day parade in Brooklyn, where I would have felt at home, because I didn't think avant-garde art could compete with real carnival art. I felt it might do better with the oompah-oompah marching bands and the beer company floats. The fact that I didn't know what to expect is what made the performance a personal challenge and may have made it ultimately successful.

It was scary because I had no idea if it would work. But in the end, I think it met the challenge of the black social worker who'd told me in our *Heresies* issue collective, "Avant-garde art doesn't have anything to do with black people!" There were more than a million people on the parade route, and time and time again we had confirmation that the majority of them understood that the piece, and their participation in it, was art. "Frame me! frame me! make me art!" we heard. And "That's right! That's what art is. We're the art!"

I was on a bigger high at the end of the parade than I can tell you. But at the same time, I couldn't describe what my full experience had been.

There were hundreds of slides taken that day. In 2008, I took the images out of their storage box and made a time-based slideshow for my website using forty-three of them. But the sequentiality of the slideshow didn't do it for me. A year later, for Art Basel Miami Beach, I reduced the slides to forty and made a wall installation, totally rearranging and mapping them. When I saw them like that—spatially, all over and at once—I felt I could finally intuit what the experience had been. But only what it had been for *me*.

Although it had been a joyous occasion, it wasn't the joy that attracted me. It was the complexity, the mystery, the images that no matter how hard I looked would never become clear, would always remain out of reach.

The guy in the photo I call "Caught in the Art" . . . I could never have imagined him there. I made him the center of the installation.

And the place in the next photograph! I could write a novel about what I can see and can't see here.

The ambiguous gesture of a girl pointing. The girl is delightful, but is her response one of ironic complicity or is it dismissive?

By the mid-1980s, Linda Bryant and Just Above Midtown had fallen on hard times. In the same way she'd been the first to put titles on her shows—something later done routinely—Linda was the first to see the need to move from Tribeca to lower Broadway, the first to understand the role of cafés and office space rentals in supporting alternative art spaces. I'm not sure the

funding agencies got her. In any case, it became impossible for JAM to support its artists' careers. I think it closed in 1985. Most of the artists drifted to academia or to other straight jobs. As for me, I found myself having to care for my mother, who had been diagnosed with Alzheimer's. The photo here is from the good days of Lena, otherwise known as "she who must be obeyed" and, lately, "the will-have-been black ballerina."

In 1988, I did my first tentative wall piece, the Sisters quadriptych that would later evolve into *Miscegenated Family Album*. In 1989, I made a decision to perform *Nefertiti/Devonia Evangeline* for the last time. While looking with a desultory glance over my shoulder, I couldn't believe what I saw happening. Adrian Piper, after the imposing retrospective at Geno Rodriguez's Alternative Museum, and David Hammons, after a great show at Jeanette Ingberman and Papo Colo's Exit Art, were being recuperated!

My exultation was short-lived. Oh God, they're doing it again! Remedying the situation so nothing will change. Fostering a few successful careers but staying in control of the narrative.

In 1988–89, I was at my mother's place in Brookline, Massachusetts, living in the madness there. And that was the end of my 1980s.

You know, I'm still hopeful. But I have to acknowledge that change can be glacial. I may feel that 2008 was a turning point, but it's so recent that I can't see its outline. Your guess is as good as mine. Will the arrival of the real postmodernism bring a moment when we are all finally just an "other" of someone else's other? I can't imagine how long that will take. I mean, for me the 1980s took forever to end.

See also *"Two Biographical Statements"*; "Cutting Out the New York Times (CONYT), *1977*"; "Rivers, First Draft, *1982: Working Script, Cast List, Production Credits"*; "Performance Statement #1: Thoughts about Myself, When Seen as a Political Performance Artist"; "Performance Statement #3: Thinking Out Loud: About Performance Art and My Place in It"; "On Creating a Counter-confessional Poetry"; "Olympia's Maid: Reclaiming Black Female Subjectivity"; "Some Thoughts on Diaspora and Hybridity: An Unpublished Slide Lecture"; "Sketchy Thoughts on My Attraction to the Surrealists"; "Two Exhibits: The Diptych vs. the Triptych and Notes on the Diptych"; "Introducing: Lorraine O'Grady and Juliana Huxtable"; "Email Q&A with* Artforum *Editor"; "Rivers and Just Above Midtown"; "First There Is a Mountain, Then There Is No Mountain, Then . . . ?"*

Rivers and Just Above Midtown
(2013, 2015)

This text, discussing the importance of Just Above Midtown gallery's role in O'Grady's artistic formation, is actually two pieces combined; both connect her 1982 Central Park performance *Rivers, First Draft* to the experience of being an artist at JAM. The artist read the first text (now titled "Intro") while standing in front of a slideshow with images of *Rivers, First Draft* during a symposium held in conjunction with the exhibition *Now Dig This! Art and Black Los Angeles 1960–1980* curated by art historian Kellie Jones at MoMA PS1. In recognition of the disjunctive experience of viewing and listening at the same time, O'Grady immediately repeated the slides and the reading. The second text, a paean to the ways in which JAM enabled her work, is simply titled "Text"; it uses *Rivers, First Draft* as an example of the gallery's generative atmosphere. This "textual diptych" was printed in the catalogue for her 2015 show at Alexander Gray Gallery in New York, when she showed the *Rivers, First Draft* photo installation for the first time.

Intro (2013)

[As captioned slides of the Rivers, First Draft *installation were projected on the screen behind her, O'Grady read the following text.]*

The *Rivers, First Draft* installation consists of photos from a performance done in Central Park as part of "Art Across the Park" in summer 1982. Together, the curator and I made an exhausting tour of the Park to look at suitable locations.

When she and I reached The Loch, a little-known section at the Park's northern edge, it captured me. This wasn't the Frederick Law Olmsted I thought I knew. It was wild and frighteningly unkempt, like something out of literature, not the city. And it was perfect for the piece I needed to create.

Rivers would be a one-time only event with a cast and crew of 20, several of whom, including a young Fred Wilson and the late George Mingo, were part of Just Above Midtown, the black avant-garde gallery I was associated with then.[1] The piece would be performed for an invited audience barely twice as large as the cast, no more than 40 people, nearly all with JAM or part of its environment. And there was an uninvited audience of about 5 passers-by who'd come on the scene accidentally and stayed. One, a young Puerto Rican taking a short cut from the pool where he worked as a lifeguard, said afterward it was like walking into one of his dreams.

The piece was a narrative three-ring circus, about a woman trying to become an artist. In it, her present and past happen simultaneously.

It was called *Rivers, First Draft* because it was done quickly and I knew I would have to go back to it. It was always meant to be the first of a three-part piece called *Indivisible Landscapes: Rivers, Caves, Deserts.* But perhaps when I revisit it, it will be unrecognizable. For me now, the making of *Rivers* and what it uncovered was one of the most important moments of my artistic and personal life and could not have happened without Just Above Midtown, a nurturing space when others would not have us.

For me, doing *Rivers* in the context of Just Above Midtown was a unique art-making moment, one when the enabling audience—the audience which allows the work to come into existence and to which the work speaks—and the audience that consumes the work were one and the same.

The installation being projected here is silent when on the wall or on pages in a catalogue, titles newly added. Imagine my voice now reading a text which bears on it only tangentially. Of course, you may not be able to follow the installation and the spoken text simultaneously. But whether you

wander in and out of the installation and the text in alternation, or attend to them sequentially, it's OK. Cognitive dissonance can be overcome when you slow down and repeat.

[*After a seven-second pause, the slideshow and reading are repeated.*]

Text (2015)

She'd been invited to speak, asked to address the differences between East Coast and West Coast artists at Just Above Midtown. But she hadn't experienced it that way. She'd come late to the party, late to art. By 1980, when 57th Street was gone, when the gallery was re-opening in Tribeca, they had long forgotten their resentments. It was a family now, dysfunctional perhaps, but one where everyone felt free. On one wall, an installation of *Artforum* covers. On another, an altar to Santería gods. And in the basement, directors who were often better artists than some of those they showed.

JAM was a complete world. Between the business model of the gallery and the clubhouse model, JAM was definitely the clubhouse where people gathered. It was sometimes hard to know who was a JAM artist and who was not. David definitely, and Senga and Maren, and Houston and Randy. But what about Tyrone? He was nominally with Cinqué, but was he ever not at JAM? Did George ever have an exhibition there? Did it matter? Everyone knew how good his work was. Then there were young artists finding their voices, like Sandra and Cynthia.

But artists were just one part of the whole. There were art historians *in potentia*, like Judith Wilson and a young Kellie Jones. Photographers documenting others' work and doing their own, like Coreen, like Dawoud. There were intellectuals like Danny and pure spirits like Charles. And there were curators. Lowery was always there. Kynaston never was, but his presence hung like a shadow on the wall. His was one way to be, she thought. She could have made that her goal. It was easy when whiteness was part of what you were. But instead she had come HERE.

JAM was an *esprit* formed in exclusion. A kind of isolation that brings strength, brings weakness, brings freedom to explore and to fail, to find the steel hardened within. David did his originary work there, as did others. Refinements would come later, of course, but if they were lucky, the rough edges would remain. Integrity, originality, adventurousness, those were Linda's ideals. In truth, she was inspired by Linda, the founder-director, more than by the artists there. But mostly she felt at home. JAM was a place as much as a world, a place where people ate together, discussed and argued,

drank and smoked together, collaborated on work, slept together, pushed each other to go further, and partied 'til the cows came home. There was even space for those who didn't quite fit, like Dan, like her. She was embarrassed by her age. She was becoming aware of it. It was now or never.

The new space on Franklin Street took longer to finish than expected. The sun beat down outside the Riverrun Café, on tables laden with large glasses of ice-cold white wine.

Arguments inspired by articles in *Artforum* sometimes went nowhere. For each person peering out at the art world of Castelli and Sonnabend, there was another for whom THIS was the art world that mattered, the one where the art was most advanced, and where the artists were most cosmopolitan. It was hard to argue with that. Whereas for white artists, traveling between European capitals was still considered urbane, by 1980 Senga had lived in Japan, Tyrone had lived with the Dogon in Africa. The mid-day discussions were sharp, funny, sarcastic. In the evening, they got even more so as the scene switched to outdoor tables in the East Village where the arguments were complicated by the circles around Steve Cannon, Quincy Troupe, and Ishmael Reed.

It's hard to remember what happened where, but JAM's energy seemed always the focus. An endless progression of the toughest jazz she'd ever heard, dance performances alone and as part of the art work. It seemed Pina Bausch's influence was God. And always, JAM was a place to hook up with friends. Dawoud and Candida had their wedding there.

These, finally, were her people. When she did *Rivers, First Draft*, she wanted them to understand . . . what route she'd taken to becoming an artist, what being West Indian was like, the mapping of the world of a Black Bohemian. And then she wondered if it were not already too late, if the Black Bohemian were not long enough gone as to be almost inscrutable. But she felt herself gain in incremental respect as the audience of JAM watched her struggle and grow. That was enough.

See also "Rivers, First Draft, 1982: *Working Script, Cast List, Production Credits*"; "Performance Statement #1: Thoughts about Myself, When Seen as a Political Performance Artist"; "Performance Statement #2: Why Judson Memorial? or, Thoughts about the Spiritual Attitudes of My Work"; "Performance Statement #3: Thinking Out Loud: About Performance Art and My Place in It"; "On Creating a Counter-confessional Poetry"; "Sketchy Thoughts on My Attraction to the Surrealists"; "A Day at the Races: Lorraine O'Grady on Jean-Michel Basquiat and the Black Art World"; "My 1980s"

6 Retrospectives

Interview with Laura Cottingham (1995)

The following is the transcript of a wide-raging interview con-
ducted by the art critic and curator Laura Cottingham for *Art-
ist and Influence*, a series produced by Camille Billops and James
Hatch for their archive of African American visual and theater
arts. O'Grady discusses her early life and path toward becoming
an artist, her move from performance to conceptual photography
and installation, the relationship between her art and her writ-
ing, the specificity of Afro-Caribbean experience, and audiences'
continuing discomfort with her propensity to name and picture
blackness and whiteness in her work.

LORRAINE O'GRADY This is my good friend Laura Cottingham. We've been
having conversations like this for some time now.

LAURA COTTINGHAM I want to start by asking you how you came to
understand yourself as an artist, how did you adopt that identity, what in
your own life led you to this understanding of yourself?

O'GRADY I understood that I was an artist almost by accident. I was pushed
into it at about age twenty-five. You have to understand, I came from the
kind of family where the arts would never have been encouraged. They were
West Indian immigrants, and immigrants of color are de-classed when they
come here. They may have been middle class and upper class in Jamaica, but

here they were de-classed into the working class. They didn't have time or energy to devote to what we might think of as life-affirming activities. They really had to focus on survival. They understood a lot about taste, like what kind of silverware and china to put on the table, but in terms of what books to read—I don't think that was what they were able to give me. They were not really culture-oriented. And I don't think they were unique in that way. The black middle class has not been involved with wealth accumulation long enough nor is it financially and socially secure enough that bohemianism and encouraging children to be artists is an option for them.

I had that driven home to me when I did a residency at Wellesley College on the occasion of the premiere of *Miscegenated Family Album*. Here I was, going back to my old school having fantasized that the work I was doing was for them, for the new generation of girls of color who would be an audience like me, but it was sad and disappointing. When I got there I found myself addressing audiences with the same Euro demographics of the New York art world, in spite of the fact that one out of three Wellesley students is now of color. Not only could young African American women, young Latino American women, young Asian American women not conceive of themselves as being artists, they couldn't even conceive of art appreciation as something to which they could devote much of their time. When I asked the professors at Wellesley why this was the case, they told me students of color seemed focused on preparing for the professions. It was the same dynamic I had experienced in my own family so many years ago, when nobody could imagine anything but that I would prepare for a profession.

My mother's idea was that I should major in history, go to Harvard Law School, and become the first black congresswoman. But I was always a rebel, and I rebelled against my background. I got pregnant and married in that order. I was still at Wellesley, so of course I couldn't go to law school. I did manage to finish, but with a child to support, I had to get practical. I changed my major to economics—not exactly a straight line to the arts, but in an odd way I was heading in that direction. I was the first girl from Wellesley to pass the Management Intern exam, an elite entrance exam for the federal government. I went to work for the Bureau of Labor Statistics and then the Department of State. And then one day in the early '60s, I suddenly realized that nobody in that entire elite government world knew who I was. It was a world where people did not have any comprehension of what it meant to be a black intellectual, let alone what it meant to be a black female intellectual. It was still a time when there was no context to understand my social experience: the people around me had no idea what the problems of dating and mar-

riage would be like for me. To tell you the truth, I didn't have any idea myself.[1] I just know that I felt this tremendous alienation from the world I was surrounded by. Wherever I went during those years of my intellectual formation and my early professional life, I was always "the only black woman." That was my identity.

At a certain point I felt a real drive to change my status in the sense of making a statement about who I was. My first idea was that I would write a novel. You have to understand, I was not a great novel reader. I don't know why I thought that I could say something about myself in a novel that I couldn't say in an essay, but something told me I needed to do that. I quit my job at age twenty-five, took out my retirement fund, and went to Denmark. Somebody had told me I could live there and get some work done, but when I got there I was soon having too good a time to settle down to work. One day I was in a bar and asked a man (his name was Jorgen Peter Schjerbaek, and he turned out to be very wealthy) where I could go that I would have no choice but to work. He said, "Norway." Then he offered me the use of his ski lodge in a place called Espedalen. So I went off to Norway to spend the winter by myself in the high mountains, seven hours north of Oslo, and I actually pulled together fifty pages of a manuscript. That's what I went to the Iowa Writers' Workshop with.

Still, it was not about art for me—not about writing an artistic novel; it was about making a statement. So when I got to Iowa I was still not functioning as an artist. I think that's why I got so easily sidetracked into translating my writing instructor, José Donoso's, second novel. I wasn't focused on my own creative production. I was still too involved in trying to explain myself to the world.

COTTINGHAM So how did you end up deciding that you wanted something artistic—either literary or visual?

O'GRADY It's strange. Although I was always getting sidetracked, I think that, deep down, being an artist was something that was lying in wait for me. I have to tell you a funny story. I had actually written a novel when I was in the fourth grade. It starred all my girlfriends in the homeroom, and I made the mistake of showing it to them. My parents had just moved into a mostly white area, and in this area the majority of kids went to one elementary school. The white kids living in the houses on either side of ours were assigned to the William Lloyd Garrison School, which was all white. But I was gerrymandered out to the Henry L. Higginson School where the population was 50 percent black. I didn't notice this at the time, of course. I

made friends with mostly little black girls, and then the novel starred these little black girls. But when I let them read it, one of them didn't like the way she was portrayed. After school she accosted me, and soon we ended up in a huge fistfight and accidentally one of my long nails gashed her face. She went home, and her mother, who was a really tough woman from the South, took her directly to the police station without even dressing the wound. Before we knew it, I was in juvenile court. My mother took off from work, my sister took off from college, and there we were sitting on a bench in the juvenile courtroom. The judge sided with my antagonist: he reprimanded me and paid no attention to the fact that here was this little black girl who had written a novel. All he saw was a little savage who had torn another girl's face. As far as my mother was concerned we had gotten out of this by the skin of our teeth. On the way home, she said, "If I *ever* catch you writing another word . . ." And it would be fifteen years before I tried to write another novel.

Anyway, after the translation detour, I went through an odd sequence of things that convinced me I could be a visual artist.

COTTINGHAM How did that happen?

O'GRADY Clearly, my continuing ability to "know who I was" had familial as well as cultural causes. I don't think my parents became "black" until they came here, and they didn't take to it too well. It exaggerated their personalities along their fault lines, all the distortions and paranoias they already had in them. Without going into the details of my particular dysfunctional family, it's fair to say that like many immigrant parents, they began to live through their children, and in a not very pretty way. At some level I realized I could never please them and so I started trying to please men; I began to seek salvation in sexual relationships. I went from being a wild child at home to being the ventriloquist dummy of various men. The extreme of this was when I became a rock critic in order to fit into the world of a boyfriend who was managing rock bands. But you know, strangely enough I was quite successful as a rock critic. My opening salvo in rock criticism was a 3,000-word article on the cover of the *Village Voice* on the Allman Brothers Band plus, inside the issue, I also had a TV review on *Soul Train*. After that, I went on to write for *Rolling Stone* and other trendy magazines.

But this began to feel ridiculous. At some point I woke up in the midst of this bizarre dream where I was living in a fifth-floor walk-up in Chelsea and every day a chauffeured limo would come to take me to some party or concert—this was in the early '70s. I woke up and said, "This is still not me. I am still not making my statement. If I am ever going to make my statement—

and I am hitting forty—I better start doing it." A friend of mine who had been with me at Iowa offered me a job teaching at the School of Visual Arts, and that's when I came into the visual art world. It was just after that critical moment in the visual arts when writing and visual art had come together in the conceptual art movement, and I realized this was something I could do. I had ideas like that all the time but I didn't know where to put them. I have always had a good visual sense, which I got from my mother, whose art form was interior decorating and dress designing.

COTTINGHAM I remember a story you once told me about when you saw Eleanor Antin's "Black Ballerina." Could you talk about that?

O'GRADY I had read Lucy Lippard's book *Six Years, or the De-materialization of the Object*, and I had been very struck by Sol Lewitt's *Thirty Sentences* and by Adrian Piper's *Catalysis* performances,[2] and I thought, "I can do this."

I didn't pull myself together to do anything until I was in San Francisco and went to a performance of Eleanor Antin's in which she was giving a lecture as Antinova the Black Ballerina. I watched this performance in which Antin takes on the persona of a black ballerina in the early '20s who has somehow ended up in a Diaghilev-type company. It was good, but it was completely out of sync with what I imagined a black woman in the early '20s thinking and feeling. Watching it, the problem I had was that, as I was looking at Eleanor Antin in blackface with a tutu, I kept thinking of my mother: what was she like as a young woman in the early '20s and what would have happened to her had she gone to audition for Diaghilev. Antin didn't have the answers, and neither did I, but the show I was seeing in my head was more interesting than the one Antin was presenting. I thought, "I can speak for this black ballerina better than she can. It's time to speak for my own black self."

COTTINGHAM I think Antin had done other ballerinas. She used the same material but did it as a black ballerina. I think it was in 1976.

O'GRADY I think I saw this in 1979. My first piece was in 1980, when I came out as Mlle Bourgeoise Noire. The piece, in which I was wearing a gown and a cape made of 180 pairs of white gloves, came to me as I was walking across a still-scuzzy Union Square, on the way home from teaching. It was a writerly statement in visual form, a critical statement, which is what most of my work became—or art as art criticism. The piece was a critique of the 1979 *Afro-American Abstraction* show at PS1. The work in the show was by black artists, but though it was quite tastefully done, it all had white gloves

on. I did the performance at Just Above Midtown, where most of the artists showed, and the punch line of the poem I shouted was "BLACK ART MUST TAKE MORE RISKS!!!" I did it again in 1981 at the New Museum, for the *Persona* show. I actually appeared in the costume a couple of other times, but I soon realized that Mlle Bourgeoise Noire was not a character who could appear in costume at just any event. She had to come out for a reason, and so I stopped performing that.

COTTINGHAM Could you explain the cat o' nine tails?

O'GRADY The cat o' nine tails was the whip that made plantations move. It was a sign of external oppression, and the gloves were a symbol of internal repression, internalization of those oppressive values.

COTTINGHAM What did you mean by bringing the whip out in public as you are dressed in these all-white gloves?

O'GRADY I was combining the external oppression and the internal repression, in the same way they reinforce each other and keep each other locked in place. For me, the most significant moment in the performance was when, after beating myself with the whip, I threw it down on the floor and then shouted out the poem.[3]

COTTINGHAM Do you remember the punch line of the poem at the New Museum?

O'GRADY "NOW IS THE TIME FOR AN INVASION!!!"

COTTINGHAM Then you did the parade piece with the frames.

O'GRADY First I did *Nefertiti/Devonia Evangeline*. These were all critical pieces. But not just that, of course. In the case of *Nefertiti/Devonia Evangeline*, I was using the similarity in the faces of the two families to work out the relationship with my sister, which had been very troubled and couldn't be worked out in person because she had by this point died. I was using the piece to get to a different place in my relationship with her and with my parents.

There was another component to the piece, which was that in the early '80s, as a kind of tail end of the "Black Is Beautiful" movement, there was an elaboration of the so-called Black Aesthetic in the visual arts that produced a lot of false anthropologizing, a lot of pseudo-African religious ceremonies with nostalgic fake altars. I really couldn't connect to the stuff you used to see in some of the black art venues. I thought it was bad-conscience work. So

in *Nefertiti/Devonia Evangeline*, I used an ancient Egyptian ceremony called the "opening of the mouth" on the voice-over narration, but everything I performed live was totally out of sync with what was being read on the voice-over. The point was that I couldn't use this ancient Egyptian ceremony to bring my sister and Nefertiti back to life. No way. It would be a false hope to try to do that. I was bringing them alive through art, not through this fake ceremony.

COTTINGHAM At this time, given that you escaped office jobs and rock reviewing, how did you come into a sense of an artistic community? Were you in contact with the black community of artists that was organized and very vital in Los Angeles at the time in the late '70s? How did you find other people with whom to be an artist, talk art, and think art?

O'GRADY Some of the people from Los Angeles were showing on the east coast, like David Hammons and Senga Nengudi and Maren Hassinger. But I can't say that I really knew very much about the West Coast community. Basically, I discovered my community through the show *Afro-American Abstraction*, which I went to when I saw it advertised in the *Village Voice*. It was as a result of that that I discovered Just Above Midtown. Most of the artists in the show came from there. A few months later, I learned that Linda Bryant, who was the proprietor and director of JAM, had lost her lease on 57th Street and was creating a new space on Franklin Street in Tribeca. This was in 1980. It triggered something in me. I had seen the work at PS1, I had been to the opening where, for the first time, I had seen great numbers of black people who looked like people I could talk to, and I knew I wanted to be within this environment. But I didn't know what I could do there, how I could present myself. Then something out of my social background just appeared: I volunteered. I said I could do anything, like lick envelopes, and literally that's what they had me doing. I think they thought I was this strange bougie black person who wanted to help out. I don't think they had a clue that I had any artistic ideas on my mind, just that I wanted to do something for art.

COTTINGHAM Does that mean you were still hiding out?

O'GRADY No, not from myself. I knew that I wanted to become part of the environment, but I didn't really know how I was going to do it. It wasn't until three months later that *Mlle Bourgeoise Noire* came out. When she appeared at the grand opening on Franklin Street, people were shocked out of their minds. The strange lady licking envelopes was an artist!

David Hammons had been there the day I had first come to volunteer. After that, whenever I saw him, I would question him about what he thought about this or that, and David would give me his opinions on art. Later, about two years after *Mlle Bourgeoise Noire*, I developed the proposal for the parade float. One day, David came over to me: he had read the proposal, because I had used JAM as the sponsor. He said to everybody in the room, "She is always asking me things, and in the meantime her work is going like this!" and he made this motion like an airplane going off into the horizon. It was almost like he was annoyed that I had actually been growing as a result of what he had been saying to me.[4]

I was at JAM as a performance artist. I don't know how many people there besides David and Linda understood performance art. No, that's not what I mean. People may have understood it, but I don't know how much they valued it. In the black art world, at that time, people were very object-oriented. They had to be. People didn't have money just to play without any hope of a financial return.

COTTINGHAM Why did you move out of performance art in the mid '80s toward objects, photographs, and installations and away from the literary?

O'GRADY I don't think I answered your earlier question, about the parade piece. All of my performance was still in the mode of art criticism, and putting that float in the parade was a way of saying that art could be made relevant to "the community."

COTTINGHAM Did people see it that way? Did anyone notice your parade piece?

O'GRADY Besides the people on the parade route? No. I did it in a very purist way and didn't advertise it to the art world. As you can see, I've changed that stance rather dramatically [*laughs*]. Just before the parade piece, I curated my show at Kenkeleba Gallery, *The Black and White Show*, because I wanted to say something about the position of black people in the art world. Nobody was ready to hear that they were equal. I thought that if you put fourteen black artists and fourteen white artists in the same place, all with work in black and white, you would get the point that they were equal.

COTTINGHAM What was the response?

O'GRADY There was no response. The comment that I remember the most was from Leon Golub (whose wife, Nancy Spero, was in the show), that it was better than the Whitney Biennial that year. That was the only critical

response that it got outside the family, except for a three-line notice in the *East Village Eye*.

COTTINGHAM What year was this?

O'GRADY 1983. It was too soon. It was like a lot of other things that I did; it was too soon. That was my biggest problem in the art world. I got pretty discouraged after *The Black and White Show*, wondering about the lack of reception to my ideas. Coincidentally, my mother got Alzheimer's, so I had to spend a lot of time running back and forth between New York and Boston, and I just withdrew.

When I came back to art, the question was how to do performance. In that five-year period, performance had moved into a much more theater-based mode. I was not theater trained nor did I have any theatrical ambitions. And I didn't have any desire to critique theater through performance. What I wanted to do was to stay in the visual art world. It seemed to me that it was time now to take ideas that had been both too complex and too soon for people to get and slow them down a bit. One way to slow them down would be to put them on the wall so people could get hold of them. And there were many other reasons for stopping performance. One reason was I felt I was getting too old for it physically.

Mlle Bourgeoise Noire was the last moment when I could pull off the "pretty girl" number, and it is very hard with an aging female body to not have that be part of the subject matter of the work. But aging didn't interest me as a subject. Unfortunately, any woman who continues in performance while she's aging has got to deal with aging per se, and I had other arguments I preferred to make. Dealing with aging would interfere with the clarity with which I could present other things. Besides, I thought people like Rachel Rosenthal were doing it quite well enough, thank you.

So my body was aging, and I thought that the work was too complex to continue in that time-based format, and also performance costs a lot of money, at least the way I was doing it.

In the early '80s there was a big gathering at Franklin Furnace of Los Angeles women and London women in performance art, and I went to every one of the sessions and was usually the only black. They asked me why there weren't more black women in performance. In those years, even though Faith Ringgold did a performance occasionally, she wasn't identified as a performance artist. The only other person who was sort of identified as a performance artist was Adrian Piper. Kaylyn Sullivan was really primarily a theater person, but in the visual art world it was primarily Adrian and myself. I an-

swered them frankly. I told them performance has no prestige, makes no money, and it costs a small fortune. Really, how many black women artists could do it? I put out a lot of money in the beginning, but I couldn't afford to keep spending money that I wasn't going to get back sales from. That was part of the motivation for going to the wall.

COTTINGHAM Once you went to the wall you really went to photography.

O'GRADY I can't draw, I can't paint. The alliance between photography and conceptual art has always been there from the beginning. First in documentation, and then in the exploitation of found photography, etc.

COTTINGHAM What was the first photographic piece that you put together?

O'GRADY The first piece was actually my performance *Nefertiti/Devonia Evangeline*, because there had been sixty-five sets of double images projected behind the live action. After that, there was the photodocumentation of *Mlle Bourgeoise Noire* that I used in several sets of distortions behind the live action in a piece called *Fly By Night*, which I did at Franklin Furnace but which I prefer to forget because it wasn't very good.

COTTINGHAM Did you ever print the slides from the Nefertiti performance?

O'GRADY The first time I printed them was when four sets of double images became the *Sisters* quadriptych in 1988. I mounted them in the show that Leslie King Hammond and Lowery Sims curated at the Maryland Institute in Baltimore, called *Art as a Verb*. It was in that show that I did the last performance of *Nefertiti/Devonia Evangeline*, and at the same time that I announced myself as a wall artist, so I did both: I was in the performance section as well as in the installation part of the exhibition.

COTTINGHAM How do you understand your work from the last few years compared to your first entrance into the visual community with performance? Are there thematic influences other than this formal transition? Do you feel that you are still dealing with the same material in a different way?

O'GRADY I think that I'm still making statements and that I'm still formally making art. The media may have changed, but the statements are similar. When I look at my portfolios I see a line of development that is getting more and more clear. Now I can see the role the diptych has played in the work, the way in which it makes a statement about the dualism of Western thought. The anti-dualism of the diptych has always been at the heart of the work in some way. What has been happening is that the work has been focus-

ing down, purifying itself into what is the most important argument I think I can make in art, which is against the dualism of Western culture.

COTTINGHAM For me your recent work, like *Miscegenated Family Album* as well as *The Clearing*, deals directly with heterosexual relationships, which means black and white, especially between the black woman and the white man. Could you talk about that and how that subject and content comes to you and how you feel it's perceived?

O'GRADY I don't know if it's been because of my own personal experience, because of the times in which I grew up, always finding myself the only black woman surrounded by a sea of white people and thus almost of necessity dating white men, but I have always understood racism not in economic terms, but in sexual terms. I don't think racism could have the kind of intensity it has if it were simply, as the Marxists say, "an economic problem." It is certainly an economic problem, precisely because it is a psychological problem, but the psychological precedes and makes the economic exploitation possible. Interracial sex, and the fear surrounding it, seems to me to be at the nexus of the country's social forces. Within the various permutations, of course, the black male/white female is the most symbolically potent. It represents the fear of the loss of power; it is a negative symbol, if you will, embodying the very structure of white fear.

The white male/black female (or the female of color all over the world) on the other hand, is the positive symbol of domination, an expression of what the power is FOR, rather than a reaction to the potential loss of power. And since it is the expression of power, I feel that is nearer the crux of the situation. If you can examine that, bring it to light and make it objectively viewable, then you can perhaps create an interesting discussion. I'm not sure that you can change the world, but at some level I believe in the psychoanalytic theory which states that problems can be made manageable through the handling of images and words. The more familiar an image becomes, the more it can be discussed, and perhaps then the more it can be psychologically manipulated in a social context.

COTTINGHAM You have said before that you consider that particular context to be the most controversial in the images that you have produced so far. Do you still feel that?

O'GRADY I read an interview in *Artforum* with John Waters, who said, "Black and white is the last taboo, although nobody talks about it." I think that in fact it is. And although the white male/black female is more underground as

a taboo than the black male/white female, its very hidden quality makes it the most difficult to come to grips with. All I know is that I have been having some real difficulty in getting people to focus on the imagery. A few months ago when I showed *The Clearing* at the Bunting Institute at Harvard, it made people uncomfortable. One white male professor of history confessed that he found it very difficult to look at. When I asked him why, he said because it talked about how erotic domination is.

COTTINGHAM For those not familiar with your work, could you please give a description of the content of that work?

O'GRADY *The Clearing* is a diptych that I did for my INTAR show in 1991. On the left side, a white male and a black female nude are making love in the trees. The couple is very obviously happy. Below them on the ground you see a pile of discarded clothing and two mixed-race children running after a ball. On the pile of clothing is a gun silently threatening the scene. On the right side it's the same background, the same clearing of trees, only now the black woman is lying on the ground looking off into the distance with a very bored expression; the white male is now dressed in tattered chain mail, and his head has been replaced by a skull. His attitude is clearly proprietary, as he absentmindedly grasps her breast. I put him in chain mail because I felt that this relationship, and the duplicities it implied for white women, was the death of courtly love.

Something else that seemed to bother people was that I changed the title in order to make it more explicit. In 1991 it was called simply *The Clearing*, but now it is *The Clearing: or Cortés and La Malinche, Thomas Jefferson and Sally Hemings, N. and Me*. So the piece has been historicized in that way. And it isn't a "before/after" piece; it's a "both/and" piece. This couple is on the wall in the simultaneous extremes of ecstasy and exploitation. I think the piece is saying something interesting and complex about relationships. Not just about this particular relationship, but about all sexual relationships.

What do I think about the subject matter? The subject matter of miscegenation and interracial sex? I certainly don't think it is an evil in itself or at all. But to the degree it is still a symbol of the "other's" exploitation culturally, sexually, and in every way, I think it's what we've got to come to grips with worldwide before we can move on. Every time I think that the subject matter is old-fashioned, I get brought up short by how contemporary it is.

COTTINGHAM It is a fascinating admission of black angst in Marlon Riggs's film *Black Is, Black Ain't*, which is concerned specifically with boundaries and

how they are constituted in terms of blackness in the U.S., that the relationship of black and white is not directly dealt with at all.

O'GRADY I think it was omitted because it's still a taboo, believe it or not. It's a taboo for even black people to deal with directly. The problem for me is that I am dealing with it directly, that I have the actual bodies there. There is so much denial that goes around this subject. The very first conversation I had at Harvard with an undergraduate student after starting my Bunting Fellowship was at dinner in the Quad, where I've taken a faculty suite at Cabot House, an undergraduate dormitory. The Quad used to be the old Radcliffe dorms; it has no real Harvard history, and it's located very far from Harvard Square. Almost by default it seems to have become the "Third World" residence. White students are in the minority. There is a preponderance of Asian students, a large number of black students, and some Latinos. First I have to set the scene: it's my first evening in the dining room, and I begin looking for a place to sit. I see the black table and it is all filled up. I don't want to force myself on them, so I keep looking around. Dormitory drama: you know, it's like high diplomacy. And if you try as a person of color to approach certain tables, you can sense people's faces becoming still and their backs becoming stiffened. You don't just go and sit down with them. It's a fallacy to think that it's just black people who are always self-segregating. I was looking for a place where I would feel comfortable sitting, and I saw a young black woman sitting by herself. I took the seat across from her and we introduced ourselves. She was from New Orleans. She had gone first to an integrated junior high school, then to an all-black high school and now she was a junior at Harvard majoring in English. For some reason, I talked about my experience teaching Catullus at SVA,[5] and she listened without saying anything. When I finished my story, she rejoined with comments very much more sophisticated than I had made; she knew her Augustinian literature. Soon I started asking her questions about herself. She told me she had not come to Cambridge to live the same kind of life that she had lived in her all-black high school; she wanted to branch out. She had spent the last two years reaching out to Asians, Latinos, Middle-Easterners, and she found that these relationships would invariably end in the same way: after six months the Asian or the Latino would find some need to explain that their parents were racist, but they were not. She said they didn't even realize that this was the same thing that she had been hearing all her life. Then there would come another point where they would confess that they could marry anyone *except* a black person.

Interview with Laura Cottingham 231

Then she glanced around the room, finally focusing on the black table, and said, "You know, it's as if we are a pariah race and no one is talking about it."

When I left the dining hall, I was shaking. This was my first twenty-minute conversation at Harvard, and it had dovetailed with these things I'd been thinking, feeling, and dealing with. Nobody talks about it, but very little has changed since I was growing up. And I don't know how it can change unless you start talking about it.

COTTINGHAM Do you think one reason what you are talking about in terms of your investigation, specifically of black female/white male, has such a difficult reception is actually because of the double hegemony?

O'GRADY Yes, exactly. It's not just white, it's white male, and it's not just black, it's black female.

COTTINGHAM What other effect does this difficulty have?

O'GRADY It seems that this subject matter is so powerful, so electric that it tends to eliminate aesthetic considerations. If I talk about the aesthetics of my work for an hour but spend five minutes on this topic, it's the only thing most people will hear. One of the biggest difficulties I have as an artist is how to present this explosive subject matter and still have the art paid attention to. I think *Miscegenated Family Album* succeeded in doing this because it was so coded.

COTTINGHAM *Miscegenated Family Album* is about the people who are the product of heterosexual sex, whereas what you are getting to seems to be more like Piper's work. Not about the sexual act, but about black and white, and about racialization through genealogies in three generations. But I think the explosive element is the inceptual act itself, because of the issues that it raises about sex and race from all sides. I was really struck by the fact that it wasn't at all in *Black Is, Black Ain't*. Especially because Riggs had a white boyfriend, and this would have been an issue for him. I think that how that would have to have been introduced into the film would be in the aspect that deals with the biological/heterosexual aftermath in terms of the discussion about skin color changes, skin color value, hair texture changes. That whole discussion could not exist were there not such a thing as miscegenation. The fact that the sexual act itself, that these are actual white people and black people, that this isn't something that you are just born with, but that you do, that is the immediacy you are confronting that is otherwise generally absent.

The immediacy and the responsibility of your individual actions as opposed to being born with a certain skin color.

O'GRADY That may be why one of the most disturbing things about *The Clearing* for most people is in the left panel, where the mixed-blooded children are playing on the ground beneath the black-and-white couple in the air: the cause and the effect were shown simultaneously.

Judith Wilson did a study of nineteenth-century images of miscegenation, and many of the paintings were of white slave owners who had a certain relationship with their children, images of white slave owners with their black sons. One is selling the son, another is working with the son in different situations, but in these paintings of widely varied relationships, between one father who is selling his son and another who is adopting his son, the one figure in all of these images who is missing is the black mother. It is the sexual and personal relationship that cannot be represented, that is denied.

COTTINGHAM Can you elaborate on your statement that your work is against Western dualism?

O'GRADY I think that the biggest problem that those of us have who are bi- or even tri-cultural and are trying to interpolate our positions with those of the West (a group that includes nearly all non-Afrocentric artists) is the way in which, both philosophically and practically, the West divides its ability to comprehend good/evil and black/white, the way it makes oppositions of everything. Not just simple oppositions, but hierarchical, superior/inferior oppositions, so that male/female, black/white, good/evil, body/mind, nature/culture are not just different, one is always better than. I feel this is a disease peculiar to Judeo-Christianity. It is certainly not the only way in which the world can be philosophically conceived. Many Eastern religions have structured it differently. African religions structure it differently. And as part of their survival process, blacks in this country have both been able to and been forced to maintain a position of "neutral monism," which has permitted them to keep their image of themselves as valuable, as equal. They have benefited from the "dual consciousness" of their situation, as Du Bois put it, and from holding onto a conceptualization that is more African, and more Eastern, than it is Western—a conceptualization of both/and rather than either/or. It's clear that blacks have had to be more philosophically sophisticated than whites. If there is anything I really want to put forward in my work, it's that degree of sophistication.

COTTINGHAM Can you describe Mlle Bourgeoise Noire's gown and how you made it?

O'GRADY The first thing I did was I shopped. I shopped New York out in 1980 of just about every pair of previously worn white gloves south of 125th Street. I used 180 pairs, but I actually had close to 350 pairs of them.[6] Then I found a white gown. It was a backless polyester gown made in Miami: perfect! The front tied around the breasts, and I sewed the gloves onto that structure, and then the cape was made up by sewing the gloves together. This sewing took three weeks. The gloves in the cape were all leather, and I didn't have the right needles for leather. By the end of this my hands were so swollen I couldn't hold a pen.

COTTINGHAM You mentioned Afrocentrism and African Americans' relation to Africa. Can you talk more about that?

O'GRADY First of all, about African Americans' relationship to Africa, I think it's been changing over time, becoming more and more nuanced and complex. Like everything in life, it doesn't stay the same. In some ways, it was at its least sophisticated in the early '60s when Africa was becoming independent at the same time that we were having our civil rights movement here, so there was this desire to look at Africa and say, "How wonderful it is. This is our role model." I think that now Africa has become much less of a myth; it is much more realistically perceived. By the late '70s, I think we were having the tail end of the mythologizing of Africa.

There seems to be a greater understanding, now that Africa is Africa and African America is African America, that we have unique problems and unique destinies. I'm not sure where the Caribbean situation intersects here, and the differences between African Americans and African Caribbeans. Since the Caribbean islands were plantation islands, they were overwhelmingly black. Those islands were held by mere handfuls of white people, so slavery on them was a different kind of slavery than it was here. Black religion was able to be maintained more fully. As a result, I think the African Caribbean's relationship to Africa is much closer, much more natural and real. During the "Black Aesthetic" period in the United States, Africa was fetishized in a very unrealistic and unsatisfying way.

COTTINGHAM Where would you place yourself in this?

O'GRADY Well, I am a Caribbean African American, so already I am in this strange halfway point between. Part of what one always has to deal with

psychically is one's parents, and even though I was born and raised here, my parents were from the Caribbean and had lots of problems revolving around British colonialism. The difficulty was, my parents were no longer there, their situation was no longer there. In a sense, everything about them was anomalous. They came from the mulatto class that was employed by the British to help rule those islands: the British couldn't rule those islands themselves; they had to have help, and they had this ready-made caste of mixed-bloods who could be used to control the blacks of the island. To use this class effectively they had to make allies of them, let them feel they were superior to the blacks.[7] My parents brought that feeling of social superiority inherent in light skin coloring with them to this country. That is what I have been rebelling against all of my life. But in the meanwhile, with the passage of time on the islands, the mulatto caste itself has changed. Michael Manley, who is the off-again, on-again prime minister of Jamaica, is the son of Norman Manley, who was the prime minister in my parent's day. Norman had a white wife, but his son Michael could not be prime minister if he did not have a "black" black wife. Clearly, the world of Michael Manley, who is a socialist with an obviously black wife, is no longer that of Norman Manley, but in my life, I am still stuck dealing with the attitudes of that previous world. In this and countless other ways, some of which I may not even be aware of, I find the people with whom I have the most in common are not necessarily African Americans, whose formation is basically southern, but diaspora Caribbeans, people who have moved to London or are living in Brooklyn.

COTTINGHAM I know for myself that every time I go to Europe, which is quite frequently, there is barely one trip, no matter to which country, where someone doesn't somehow find a way to remind me that all of the Europeans in the U.S. were Europe's garbage. It's not necessarily related to any sense that they are talking directly about me. And in different countries, they will do it differently. So in France they don't think I am French, but someone will have to introduce this recurring theme that all of us who are European American are Europe's garbage. One of the things that I saw for the first time, when you spoke at Cooper Union, was one of the students from Kenya making an issue out of East Africa versus West Africa, where most of the slaves came from. It's not stated directly, but for me, I see for the first time this parallel situation of "those in Africa are better than those from Africa now in the U.S."

Could you speak about the relation between your work as a writer and as a visual artist?

O'GRADY My writing and my visual art have a very symbiotic connection. Because I always seem to be working at the edge of acceptability and/or comprehensibility, I often feel that I have to defend my work. Since 1992 I've been employing the writing as a way of creating the theoretical context for the work. Right now, for my new series *The Secret History*, whose program is to insert black female subjectivity into certain founding documents of contemporary Western culture, I am extending the issues I raised in *The Clearing* by starting with Baudelaire and focusing on his relationship to his black mistress, Jeanne Duval.

I still don't feel that I will have the luxury to just put work up on the wall. I will have to explain the work, and having taught Baudelaire for fifteen years now, there are things I know I will be able to use. But at the same time, I feel I need to know much more than is inside my head, so one of the first things that I've done this year at the Bunting Institute with my research assistant is put together a casebook of three to four hundred pages of journal articles. So as I am doing the visual work, I'm also looking at this casebook and thinking about arguments I can make to explain this work which I suspect might have a difficult reception. It will need to be buttressed by other work currently being done in the field, and in the past five to ten years there has been a new interest in the phenomenon of nineteenth-century literature and its intimate connection to the exploitation of the other. There is some really good argumentation. What I have been telling my assistant is that I will probably be writing an article sometime after the work is done, in the same way that "Olympia's Maid" was done a year after *The Clearing*. That was an article I did to explain the absence of the black nude in black fine art, and to theorize the situation in which I found myself as one of the very few black artists employing the black nude. I had not realized how small a minority it was until I undertook that search. Obviously, there is always an occasional black nude by an artist, but bodies of work on the black nude are hard to come by.

In general, the black nude was not addressed during the first two hundred years of black art production in this country. I tried to understand why that was the case and what my own use of the black nude meant. How did my use of the black nude intersect with the whole of black fine arts history? And just as interesting, how was it different from the nude employed by white feminists? For black women, freedom may be the ability to keep our clothes on if we want; historically, we've been forced to take our clothes off. But for white feminists, the situation is opposite. For them, the freedom to take their clothes off is critical, and that fact is reflected in the difference in

the art that they produce. *The Clearing* had to be placed with respect to both black art history and white feminist art history; I used "Olympia's Maid" as a way of doing that. I'm afraid I may have to make that kind of effort again for the new work. I would like to be able not to have to write for a while, but I may not be able to get out of it.

COTTINGHAM What was "Olympia's Maid"?

O'GRADY The title "Olympia's Maid" was not so much about Manet's painting as referring to it. In the article I wrote, first for the College Art Association, then for *Afterimage*, and then later expanded for the anthology *New Feminist Criticism: Art/Identity/Action* edited by Joanna Frueh, et al., I concentrated on the reasons why the maid accompanying the white nude had been blended into the background drapery with all of her clothes on.

COTTINGHAM Who do you see as the audience you are making the work for?

O'GRADY There are two different answers: the first audience for the work is the work itself. The work has to proceed on its own terms and has to be satisfied in itself. Afterwards, when it is done, who is it for? Well, even before you do the work there is an audience that you may have in mind to send it to after it's finished. For most black artists the question of "Who is the audience?" is a tremendous problem, one that's not getting any easier, even though some black artists are becoming successful. I did a studio visit in the early '80s with the black abstract artist William T. Williams, and he said to me that until the black community valued its culture enough to put its resources into collecting black art in the same way that the Jewish community did, we were not going to be able to have a viable art world. When I premiered *Miscegenated Family Album* at Wellesley, I thought the work was for the girls who had followed me there. But to find that these girls could not even free themselves enough to look at art, let alone make it, was very frightening. I've had to pull back to a position of "wait and see." Still, I'm surprised at how, for *Miscegenated Family Album*, the audience was very much more general than I would have anticipated, going across race, gender, and age lines as it has been more widely shown. The most unalloyed response it has received has been from women of all kinds who have had intense relationships with their sisters. The work is the primary audience and, secondarily, the mainstream art world. At least that's the fantasy. Why not? It will be an adventure to see what will happen when and if it finally gets there.

See also "Mlle Bourgeoise Noire 1955"; "Body Is the Ground of My Experience, *1991: Image Descriptions*"; "*On Creating a Counter-confessional Poetry*"; "*Some Thoughts on Diaspora and Hybridity: An Unpublished Slide Lecture*"; "The Black and White Show, *1982*"; "*Email Q&A with* Artforum *Editor*"

Interview with Jarrett Earnest (2016)

The following interview was the cover story of the February 3, 2016, issue of the *Brooklyn Rail*. In her conversation with the artist and writer Jarrett Earnest, O'Grady discusses her notion of Flannery O'Connor as a philosopher of the margins, her project of creating an archival website to make her work available for future study, her research into Egyptian sculpture in relation to *Nefertiti/Devonia Evangeline*, Michael Jackson's genius, and the need to think of feminism as a plural noun.

JARRETT EARNEST (RAIL) A lot of your work relates to archives, both in content and form. When you started putting together your own website, were you thinking about it in terms of framing it as an archive?

LORRAINE O'GRADY I did it because I thought I'd disappeared in many people's minds—Connie Butler's being one exception. Connie had been at WAC (Women's Action Coalition) as a young woman, and I was one of the very few women of color who were active in that group. When she later curated the exhibition *WACK! Art and the Feminist Revolution* (2007) and put me in it, I knew it would be important, I felt I had to be ready. That's when I put the website up; I wanted to make it possible for anyone that was interested to become more engaged. Everything had disappeared from public view, it was all just sitting in the drawers of my file cabinets. I realized that for any of

it to be understood I had to include everything: the images, the texts—it had to be a mini-archive. It's designed to shape my work for the public and to be a teaching tool. But it's also meant as a staging for serious research, a start for access to my physical archives at Wellesley. I also deliberately built the site to emphasize the connections between text and image—I didn't want people to just look at pictures. You can't get to the images without going through text; every link lands you back into text. During my exhibit at the Carpenter Center, I met with art historian Carrie Lambert-Beatty's PhD seminar. I think I shocked the grad students when I said, "I would not be here now were it not for my website." But you know, to have just appeared in *WACK!* with Mlle Bourgeoise Noire's gown, I would have been a one-hit wonder. I thought having the website up with my other artwork and my writings available would make it more possible for me to be recuperated by a new generation of artists, writers, and curators.

RAIL One of the reasons your body of writing is so vital is that it really feels like it has a job to do, creating a context that wasn't otherwise there.

O'GRADY Speaking was a demand that the work made on me, and that increasing interactions with others made on me. I learned so much each time I had to find a way to talk about the work.

RAIL One thing you've said about the gloves that made up Mlle Bourgeoise Noire's gown was that they were worn by "women who believed in them." I bring this up because of something Flannery O'Connor wrote that has been on my mind: "Distinctions of belief create distinctions of habit. Distinctions of habit make distinctions of feeling. You don't believe on one side of your head and feel on the other."

O'GRADY You noticed the piece on my website about Flannery O'Connor by Guerrilla Girl Alma Thomas? Flannery O'Connor is someone I've read for years—I had a first edition of *Wise Blood* (1952)—

RAIL I did! And it made me wonder if Mlle Bourgeoise Noire were a *Wise Blood* type character? I think of Motes roving around the South proclaiming the gospel of anti-religion, with his fervor and disillusionment—

O'GRADY Mlle Bourgeoise Noire does speak her mind. Is she a *Wise Blood* character? I don't know, to me she's so much a creature of my own mind—although I do think the reason that I like Flannery is that her mind is similar to mine. I even had a period of religiosity—

RAIL When was that?

O'GRADY When I was a kid. My family, especially my mother's sister Gladys Norman, were Jamaican émigrés who helped build the first West Indian Episcopal church in Boston, St. Cyprian's, so all our family traditions were around St. Cyprian's. But it was a very middle-of-the-road Episcopalian church and I preferred a form of worship that was much more "High-Church." So I took myself out of St. Cyprian's and went to Saint John the Evangelist's of Roxbury Crossing, which was staffed by people at the Harvard Divinity School because they couldn't get anyone else—it was this tiny little church. St. Cyp's is still there but St. John's is gone now, destroyed by a fire in the '60s. It was brilliantly formal—the formality of the High Episcopal, or Anglo-Catholic, ritual always appealed to me more than the belief system. The thing about being Episcopalian is that it's a way of being Christian without worrying too much about what you believe. But I was permanently formed by the aesthetics of that experience, of the rituals, which are a more stately and elegant version of Roman Catholicism. I believed until my mid-twenties, until my sister died, then I stopped believing.

RAIL To this day?

O'GRADY Well, I don't believe in the Bible or Michelangelo's God, that's for sure. But belief in terms of how things are connected? That's something I'm not sure I've got away from. I've found that if you are attentive, sometimes there are hints of interconnections that, if you follow them, can unconsciously help you get to where you need to go—and perhaps this put me in a place where Flannery O'Connor never felt alien to me. But I don't know that I appreciated her as a minority philosopher until I read an article about her by Alice Walker in *In Search of Our Mother's Gardens*, "Beyond the Peacock: The Reconstruction of Flannery O'Connor" (1975), which alerted me to O'Connor's collection of essays *Mystery and Manners*. I was struck by how much *Mystery and Manners* applied wholesale to those of us who are representing our own experience, and the experience of others, from a point of view that is distinctly different than the majority's. Flannery wrote brilliantly and definitively of the responsibilities and opportunities of that position. I think I underlined every word in that book.

I was one of what the Guerrilla Girls called "gig girls" who did lectures around the country. I ended up doing a gig in Milledgeville, at the College that used to be the old Georgia State College for Women, which Flannery attended. And while I was there I got into a conversation about Flannery

with the woman who was chair of the English Department. Before I left, she asked me to write about Flannery for a Festschrift she was editing and I did, as Guerrilla Girl Alma Thomas, the person she was inviting, but years later I had to put it on my website because I thought it was one of the most important pieces I'd done.

RAIL I was grateful you put it up where I could find it, even if it meant it was quietly outing yourself as a Guerrilla Girl. I guess this interview makes it official?

O'GRADY What studying Flannery did was make me understand that the work of the minority artist is the same wherever they are in the world: fighting to make their work understood. Flannery had to defend what she was doing, and thank god she understood that she had to defend it. I mean, she was tough! She was not apologetic about any aspect of herself, including her lack of traditional femininity, her position as a Southerner when she went North, or her position as a Catholic down South—she defended those positions completely, and I learned a lot from that.

RAIL I found the pieces from *Miscegenated Family Album* at the Carpenter Center very moving. There is a reference that it was made as a memorial for your sister who you had a complicated relationship with—could you give me more of the context? Egyptian funerary sculpture is not exactly sentimental—it's not warm and fuzzy—but I think through cropping and pairing you coax out something extremely touching.

O'GRADY Not too long after my sister Devonia died, I found myself in Egypt. I was there three or four weeks. It was 1963 and I'd been working for the United States government so I'd made a stop at the Embassy almost as soon as I got off the plane, after several months in Ethiopia. I parked my suitcases there and went to cash my travelers checks at the American Express in the basement of the Nile Hilton. As I was walking from the Embassy to the Hilton across the square, I looked around and I could not believe it—there were so many people who looked like me. I had never been anywhere like that before—it had not happened in Boston certainly, and it had not happened in Harlem. Downstairs in the American Express, behind the counter there were three agents, two Egyptian men and a young Egyptian woman, and I got into one of the three lines.

The lines were filled with Danes and Germans. And there was me. When I got to the counter the young man who'd been speaking perfect English to the

person ahead of me immediately started speaking Arabic. I said, "I'm sorry, but I don't speak Arabic." He looked surprised and then from the other end of the counter I heard this voice, the young Egyptian woman, say "Oh, she's such a snob!—she doesn't speak Arabic!" At that point I knew the resemblance was not in my head, and I began to think more deeply about my general attraction to Egyptian aesthetics and what I'd always felt was a strong resemblance between my sister and Nefertiti.

RAIL It is an extremely simple idea: pairing images of Ancient Egyptian sculptures of Nefertiti with photographs of your sister—but the total effect is very complex, emotionally. It's also interesting that that specific moment of Egyptian art, from the reign of Akhenaten, is the only instance you can really say: that looks like a specific, idiosyncratic individual.

O'GRADY I essentially became an amateur Egyptologist of the Amarna Period. Akhenaten, with his monotheistic religion, was a total aberration and a threat to the established powers, including the Theban priesthood. After he died, they destroyed all traces of that place. They erased Akhenaten and Nefertiti's names from cartouches throughout the Two Lands. Everything was buried—which is why the Germans could unearth Amarna's sculpture workshops almost intact in the 1890s. The person the priesthood put in charge of destroying Amarna was General Horemheb, the husband of Mutnedjmet—Nefertiti's younger sister. I'd been thinking of the relationship of Mutnedjmet to Nefertiti because the usual images you saw of her were in processions of Nefertiti followed by her six daughters, and then following them at the end would be Mutnedjmet accompanied by two dwarfs. When I realized that it was her husband that destroyed Nefertiti's city and memory, I could imagine how Mutnedjmet might be feeling, and I knew that I wanted to get past that feeling in relation to Devonia. So, my imagined relationship between Nefertiti and Mutnedjmet enabled me to resolve these issues between my sister's memory and myself. Actually, I had good luck with my creative timing because, after 1980 when I put together the *Nefertiti/Devonia Evangeline* performance, Egyptology continued to evolve. It discovered that the figure at the end of the processions was probably not Mutnedjmet, the wife of Horemheb. But I'd already used her for my own purposes. So there you go!

RAIL Given the depth of your meditations on history, how have you noticed the narrative of feminist performance art evolve—how has it been constructed?

O'GRADY Well, you know, there were a lot of people doing feminist performance that were not connected to Womanhouse.[1] Black women, Chicanas, women around the globe. To many, much of the early history of feminist performance art—as well as of the feminist movement itself—seemed constructed to foreground the concerns of white, middle-class women. At the time, white women dominated the movement, which seemed driven by two goals: the right to a career outside the home and the right to sexual freedom. But while those goals were valid for them and no doubt benefited other women, they were not universal. If you asked what those goals might mean to black women who'd never had the right not to work, never had the right not to be considered sexual objects, you could see the goals might need calibrating. That same calibration was also required for the art that was made or that needed to be made.

The attitude to the physical body in performance art that's accumulated the largest concentration of scholarship and the most definitive modes of teaching has seemed defined by the white woman's revolt to take off her excessive clothing. That wasn't really most black women's rebellion. When Adrian Piper took her clothes off in *Food for the Spirit* (1971), it seemed a spiritual and psycho-intellectual act—not one about the sexualized body so central to white feminist performance of the time. That's not to say there may not be different ways to talk about the same thing—nudity and dressing up both have to do with sex and self-love. But feminism is a plural noun, and we need all the feminisms and feminist scholarship we can get. The fact is, in some ways the right to dress up was closer to the needs of many early black performance artists. The situation is changing a bit now. I think feminism itself, both inside and outside of the academy, has been changing since the early '90s, especially in response to theory around intersectionality, cultural studies, globalization, and so on. I find younger scholars much more aware of these issues than those trained earlier. But it's slow going. It can still take twenty years for a new idea to take hold and transform the thought patterns of feminists and scholars.

RAIL Your famous essay "Olympia's Maid" was partly about your engagement with the black female nude in your art, attempting to reclaim it as a site of subjectivity—

O'GRADY You're right. I'm so aware that there are things about my work that may seem contradictory. On the one hand, I've not been interested in performing nude; on the other, at that time I was one of the few women using the black female nude in my two-dimensional work. What looks like

inconsistency on the surface is something I've had to come to grips with: when you are the object of irrational contradictions, then you are in a position of having to struggle in contradictory ways. If you are simultaneously being seen as the universal prostitute, and at the same time as the sexless matriarch—the Jezebel and the Mammy—neither of which have anything to do with what you are, then sometimes you have to fight for the right not to be either, and sometimes for the right to be both at once. I kept my clothes on while performing, and sometimes I took them off while making art. That contradiction is all over "Olympia's Maid," where the language can shift mid-sentence and take the opposite stand. But the two arguments don't negate each other, they keep the line of struggle flexible, supple.

RAIL "Both/and" instead of "either/or"—it makes me think of your continued use of the diptych as a formal device: they are not alternatives, this or that, but this and that. You wrote "Olympia's Maid" in 1992 and then a post-script in '94—which is twenty years ago now. How have you seen the questions posed in that essay evolve today?

O'GRADY To be honest, "Olympia's Maid" is something I don't know if I've given a serious re-reading over the years. I've been afraid I might have to rewrite it! I can sense that everything has changed, and at the same time, basically nothing has changed. Or rather, I should say that the changes and lack of change have become so much more subtle, so much more difficult to describe and to battle, that it's simultaneously hopeful and frustrating. The obverse and the reverse of the coin have become much better defended now. Those you used to be able to call the victims have become more powerful in taking control of their own lives to the extent the situation allows, and those you used to be able to call victimizers have become more skilled at declaring nothing is wrong and avoiding the responsibility to change anything, including themselves, so "Olympia's Maid" would be hard to go back to. I can tell that the piece is still alive, people still refer to it and teach it, and it seems not much has replaced it. Every year, or every other year, there's a brouhaha about the situation of black models in the fashion world, an important nodal point for judging the acceptance of black beauty, and someone will cite "Olympia's Maid." And I do observe changes in the status of blacks in the art world—Mlle Bourgeoise Noire herself has been welcomed into the museum. (Of course, this might be seen as the co-opting of black artists and black artwork by the white art world, the usual form of neutralization.) At the same time, it does seem to me that we are still not past the situation where the exception proves the rule. But I am noticing things now

that I didn't a few years ago. Up until five years ago I could confidently say that the entry of black artists into the mainstream art world had been safely bracketed: it didn't actually affect any of the theorizing, marketing, or role modeling that was going on; it was safe. I'm not sure when I would say things changed or if they have, or by how much, but I do think the average white student in an MFA program has begun looking over his or her shoulder, is feeling less in control of the discourse, a bit more relativized. I myself won't be fully convinced until the average white male artist is looking as much at David Hammons, and in the same way, as at Jeff Koons for his image of success in the art world. It's really a question of who do you think is important? Who do you want to make yourself like? I think that is what determines change.

RAIL *Mlle Bourgeoise Noire* is very beautiful.

O'GRADY That's so funny. During Carrie Lambert-Beatty's seminar there were all these pictures of *Mlle Bourgeoise Noire*, and Carrie said "I just can't believe you were forty-five when you did this!" And then, "Art historians always say the women who did this kind of work were so beautiful—from Carolee Schneemann and you in the '70s and '80s to Andrea Fraser now." I don't know, I suppose that to do this, to put yourself on display this way, you have to have a certain kind of confidence. Would I have been able to become a performance artist if I didn't think I was attractive enough to receive the gaze? For sure, this is part of some kinds of performance work, though not all. And in some ways I stopped doing performance because I thought I was becoming less attractive. Well, perhaps not less attractive, but beginning to look different. I'd started performance in 1980, when I was forty-five. By 1983 I was forty-eight and aging was becoming a subtext of my performances whether I liked it or not. I didn't want to have to deal with "aging" when, for me, there were so many more pressing issues to examine. Just by chance, I stopped performing in 1983 because my mother got sick. When I came back in 1988, I was asked by Lowery Sims and Leslie King-Hammond to be in *Art as a Verb*, a landmark exhibit of avant-garde black art. That's when I decided to go to the wall. I also did the last performance of *Nefertiti/Devonia Evangeline* for that show. It was a relief to not be looked at.

RAIL What do you believe art is supposed to do?

O'GRADY I'm old-fashioned. I think art's first goal is to remind us that we are human, whatever that is. I suppose the politics in my art could be to remind us that we are all human. Art doesn't change that much, actually. I've

read lots of poetry from Ancient Egypt and Ancient Rome and they talk about the same things poets do today. Is anyone more down and dirty and at the same time more introspective than Catullus? At one point I was a rock critic, and I did an interview with Gregg Allman. To me, Gregg is one of rock's few truly tragic figures. A lot of people are pretending to be tragic, and they are able to make work out of that, but Gregg actually was tragic and to me, he was the best white blues man ever, he really cared about his lyrics. He showed me the black-and-white composition book where he did his writing. He said, "My brother always told me there is nothing new to be said in this world—just different ways of saying the same old thing." This is what it is. Gregg gets it. I don't think the average person who becomes an artist starts off thinking of it as anything other than self-expression. I taught in art schools for thirty years, and if you ask students how old they were when they knew they were artists, most will tell you—"five." Which means they went through adolescence in a totally different way because they were doing everything self-consciously. By the time they get to college they still want to express themselves. That gets educated out of them gradually. "Self-expression" is something that gets tamped down in graduate school in particular—teaching at UC Irvine, I watched people struggling against that, against having to learn how to fit into the market. I don't know that the nature of art itself has changed; I do think the idea of an "art career" has changed.

RAIL Do you feel there have been any persistent misunderstandings about you or your work?

O'GRADY There may be a failure to see that, no matter how varied in form or content, all my work is surrounding aspects of the same issues and takes a unified approach to them. All of it is connected. The only thing that changes is the medium, each of which imposes its own rules and perhaps implies different audiences toward which the approach might shift, but the issues remain the same. The inability of people to see the connections between the bodies of work, perhaps due to unfamiliarity with the issues, has been one of the most difficult parts of being an artist for me. One thing that keeps me going is to try and lasso all of this into a single, unique body of work that people will be able to see as that.

RAIL Could you describe your piece *The First and the Last of the Modernists* (2010), a sequence pairing images of Charles Baudelaire with Michael Jackson?

O'GRADY You know I taught a course on Baudelaire and Rimbaud for twenty years at SVA. There are many things about Charles that Michael shared, an overpowering father being just one. But if I had to say which of the two was the better in his own art form, I would say Michael was. What shocks people when they see them side-by-side is they think: how can you compare a pop star with an avant-garde poet? When I look at them, I see Michael as the greater genius.

RAIL When I looked at those photos of Michael Jackson I can't help but think of him as "suicided by society."

O'GRADY The reason for doing the piece was to try and understand why I loved Michael so much. I knew why I loved Charles—that was clear to me. I loved him for his aesthetic courage, for his openness to a changed historic reality, his eccentricity, his relationship to Jeanne Duval. Michael was a very sad and lonely figure; he'd always been sad and always been lonely, but he did the best he could. He's one of the few child prodigies who ever fulfilled his talent so completely as an adult. But on an interpersonal level, he was severely limited. I myself don't believe he actually had sex with any of those boys—I was relieved of that attitude. But I think he was a fool in many ways. He thought children came to him with no agenda, but he didn't seem to realize their parents had multiple agendas. I feel he played out his childhood with those kids in a way that only someone who can do whatever they want, might. He was self-indulgent, a limited person in the way child prodigies often are. You look through history and see that most are not exactly the greatest people.

RAIL Through making this piece, what did you ultimately understand about loving Michael Jackson?

O'GRADY I've learned a lot about Michael, as a flawed object still worthy of my love. But I'm not sure I understand what caused my tears when he died. I suspect there are a lot of people out there like me. I know when Michael died there were a billion people crying, and there were probably half a billion who didn't know why they were crying. They think he's beautiful, they think he's talented, an incredible musician—but that doesn't account for the love. How did he manage to reach so many different people? And they don't know why. I think there's something ultimately about Michael's vulnerability—that vulnerability he always displayed, even as a small child, and the unhappiness he had even as a child, and at the same time the resignation with which he lived with that in order to achieve glamor—that made you identify something of

yourself with him. Seeing or hearing him reconnected us to that sad, resigned, but determined part of our selves, even if we fail. What I learned was I was just like all the others who cried.

See also "*Performance Statement #2: Why Judson Memorial? or, Thoughts about the Spiritual Attitudes of My Work*"; "Nefertiti/Devonia Evangeline, *1980*"; "*Interview with Cecilia Alemani: Living Symbols of New Epochs*"; "*On Creating a Counter-confessional Poetry*"; "*Dada Meets Mama: Lorraine O'Grady on WAC*"; "*Olympia's Maid: Reclaiming Black Female Subjectivity*"; "Mlle Bourgeoise Noire *and Feminism*"; "*Flannery and Other Regions*"; "*Introducing: Lorraine O'Grady and Juliana Huxtable*"; "*Two Exhibits: The Diptych vs. the Triptych and Notes on the Diptych*"

The *Mlle Bourgeoise Noire* Project, 1980–1983 (2018)

To mark the opening at the Crystal Bridges Museum of American Art of *Soul of a Nation: Art in the Age of Black Power,* an exhibition organized by Tate Modern curators Zoe Whitley and Mark Godfrey, O'Grady delivered the following remarks about *Mlle Bourgeoise Noire.* The text is a clear articulation of the serial nature of *Mlle Bourgeoise Noire*—the fact that the performance was conceived as part of an ongoing investigation into the segregation of the art world along lines of race and its inflections by gender and class. O'Grady discusses *Art Is . . .* and *The Black and White Show* as projects realized under the auspices of *Mlle Bourgeoise Noire*; the series would have continued, she says, had she not interrupted her performance career after 1983 to care for her ailing mother.

IF YOU THINK that you've never seen this image before, it's because you haven't—it's the first time I'm showing it. I did not include it in the *Art Is . . .* installation because I felt that it would be self-promotional [figure 17]. It was just a pretty picture of me and one of my assistants, and I felt it didn't advance the themes or the purposes of the *Art Is . . .* performance. But, if you'll notice, Mlle Bourgeoise Noire did not always wear a gown and a cape made of 180 pairs of white gloves, 360 in all. Sometimes she rolled her sleeves up and just wore one pair of gloves pinned to her karate outfit.

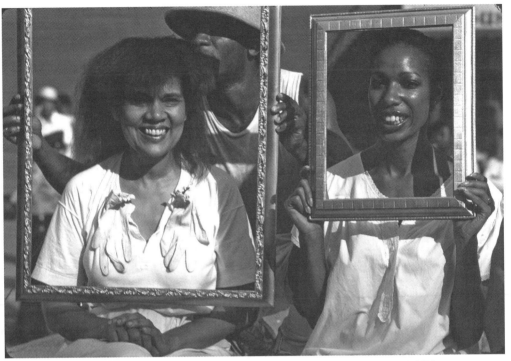

17 LORRAINE O'GRADY, "MLLE BOURGEOISE NOIRE IN KARATE OUTFIT, WITH WHITE GLOVES PINNED TO HER CHEST." PHOTO-DOCUMENT FROM *ART IS . . .* PERFORMANCE, AFRICAN AMERICAN DAY PARADE, HARLEM, 1983. NOT INCLUDED IN *ART IS . . .* INSTALLATION, 2009.

It's odd, you know. I've been asked how was I able to assume the agency to come out as Mlle Bourgeoise Noire, where had that come from?

Well, of course, a desperate situation can sometimes provoke and enable desperate actions. But I think that for everybody, agency isn't something that you're born with. It's something that you learn and accept, and then act on. And it's something you have to keep learning. At 45, I may have already internalized enough agency to go out as Mlle Bourgeoise Noire the first time, but I had to keep learning, forcing myself to grow so I could go on with it. I also had to get rid of a lot in order to gain added agency.

At the beginning, *Mlle Bourgeoise Noire* was a performance in which my persona spoke against "bourgeois-ness" as if she were not part of it. Here I had collected all these gloves from thrift shops around the city, gloves that had been worn by women who'd accepted those values, but I hadn't put my own gloves into the costume. Because, of course, I had been a nice middle-class girl and had worn gloves, too. In this image, three years after that first

performance at Just Above Midtown Gallery, I am now 48 and am wearing gloves as Mlle Bourgeoise Noire that I wore my senior year at college, when I was 21. These are the gloves I'd gone job-hunting in. For some reason, and I don't know why, I'd carried them around with me for 27 years. They're leather and they're dirty and out of shape. But when I put those gloves on, pinned them to my chest, it signaled my acceptance and acknowledgement that *Mlle Bourgeoise Noire* was not just about them, it was also about me.

But the fact that I didn't include this image in the *Art Is . . .* installation has meant that most people don't know about that part of my trajectory. It has also made people less aware that *Art Is . . .* was not just a feel-good performance in Harlem. It was part of a larger conceptual art project of institutional critique, which I called the *Mlle Bourgeoise Noire* project. It lasted for three years and ultimately included three different works.

The first was the *Mlle Bourgeoise Noire* performance itself. The second was an exhibit curated by Mlle Bourgeoise Noire called *The Black and White Show*. And the third work in the project was the *Art Is . . .* performance. The project's first piece, the *Mlle Bourgeoise Noire* performance itself, had been basically shouting out what the situation was. The persona had encountered a situation that she'd never experienced before. She was 45 when she first emerged, had had many other lives and lived in many other worlds, but she had never encountered a world as absolutely segregated as the art world—where the segregation wasn't simply social, it was also an intellectual and cultural form of segregation justified under the rubric of "quality."

But this justification was concealing a lethal combination of condescension toward blacks, toward black relevance and black capacity. To her, the real problem, even beyond the absolute segregation, seemed that most people on both sides appeared to have settled into an attitude of "This is the way it is. We just have to do the best we can." But Mlle Bourgeoise Noire was not about settling, she was about breaking down doors. Attempting to do so was perhaps premature. But she/I had been in many other worlds where there'd been more impersonal standards of quality than any she'd found in the art world. If you could score high on the SATs and the GREs and the Federal Service Exams, if you could do translations accurately, and so on, you at least stood a chance. But here, you were arbitrarily told you were not relevant, you were not capable of making this work, and that just annoyed me.

I did have to change to do the work—which was not the work assigned to me. I had to strip myself of most of the social conditioning I had acquired from the various finishing schools I had been to, starting at home, then Girls Latin School in Boston, then Wellesley. Those schools were great in their

way, but they had not given me the tools I needed to deal with the situations I was encountering. So I'd had to get them myself somehow. I had to get rid of nearly all that false conditioning, I adopted a form of aggression that I thought I could use to promote my ideas. Perhaps I made mistakes. In retrospect, I think I made many mistakes. But I did what I felt I had to do at that moment. I think that for me, gaining agency was mostly about accepting the best and the worst in myself, joining to my natural strengths the added strength of giving up pretenses of various (bourgeois and other) sorts.

The *Mlle Bourgeoise Noire* Project lasted from 1980 to 1983, and it didn't stop because I ran out of things to say. It stopped because in the fall of '83, I had to leave the art world to become the sole caregiver for my mother, who had been diagnosed with Alzheimer's.

When I say I made mistakes, the reasons for them weren't solely personal. Institutional critique began with the minimalists and the argument about "What is painting?" It continued with the site-specific artists like Robert Smithson and others who asked, "What is art?" But in all the time I had been looking and thinking, I had not seen any institutional critique that was about racism—that was anti-racist, and pro-feminist. Yes, there were slight hints of it in the work of Adrian Piper, but what I wanted to say was not *that*. And the same with Martha Rosler, who did a type of feminist institutional critique, but I knew that mine was not *that*. So I started thinking for myself because I didn't feel that there were role models for me. I made a lot of mistakes but partly because the discourse I needed was not there.

Before I show some slides, let me go back and just briefly clarify the project's sequence. The *Mlle Bourgeoise Noire* performance had been to say, "Look, this is what the situation is, segregation is intolerable." But by 1982, I was thinking, "She's not going to do another one of *those*, shouting out poems is not the way." So I turned to something I call "direct presentation." The next piece Mlle Bourgeoise Noire did, *The Black and White Show*, a conceptually curated exhibit, was to show who the artists should be. And MBN's third piece, the *Art Is...* performance in Harlem's Afro-American Day Parade, was about who should be in the audience. So, there were three different questions being asked: What is the situation? Who are the artists? Who is the audience?

When Mlle Bourgeoise Noire first did the performance at Just Above Midtown, she shouted a poem that concluded with the line "BLACK ART MUST TAKE MORE RISKS!" because she had decided that much of the black art she'd seen, especially at the PS1 *Afro-American Abstraction* show, was very well groomed—a little *too* well groomed. Some people thought the perfor-

mance was against abstract art. But it was not. It was against *careful* art. She hoped *The Black and White Show* would demonstrate that point clearly. Then there was the *Art Is . . .* performance, which absolutely terrified her. I mean, she could have done it in the parade and nobody got it. What would happen then? Right?

The first slides I will show you are from when *Mlle Bourgeoise Noire* performed at the New Museum in 1981 [plates 1–5]. The museum was doing an exhibit called *Personae*, but I called it the "Nine White Personae" show. The education department had called me and asked me to do the outreach program for the school children, and I had said, "Let's talk about it after the opening."

So, here she is. She is dressed in her gown and cape made of 180 pairs or 360 white gloves, and she's also carrying a bouquet. And the bouquet is white chrysanthemums studded into the knots of a white cat-o-nine-tails made of sailing rope. For her, the whip was the sign of external oppression, the gloves were a sign of internal repression—how we internalize our oppression. So, she embodies both.

Here she's entering the New Museum in its old venue on 14th Street, when it was part of the New School. This is 1981. She's entered with her Master of Ceremonies. Now she begins to give away flowers from her bouquet and she's smiling. She smiles, she smiles, she smiles, and she says, "Won't you help me lighten my heavy bouquet?"

After a while, all of the flowers are gone, and she gets serious. Now she puts on a different pair of gloves, handed to her by her Master of Ceremonies, a pair of elbow-length white gloves. The bouquet has now become unmistakably a whip. The cat-o-nine-tails is what she calls "the whip that made plantations move."

And she begins to beat herself with it. She beats herself and she beats herself. I got a little over enthusiastic and so I beat myself for about five to ten minutes and there were practically welts on my back. This was sailing rope—people have sometimes thought it was macramé, but it was actually sailing rope, which was tough, almost as tough as leather.

But as documentation would have it, the most important moment didn't get captured, the moment when she throws down the whip. After she throws the whip down because she has had enough and all eyes are on her, she shouts out the poem. She's tired of doing both things, externalizing the oppression and internalizing the repression, so she shouts out the poem. It's the New Museum, and the punchline of the poem is, "NOW IS THE TIME FOR AN INVASION!" Of course, nobody was going to invade; this was 1981.

Unfortunately for the *Mlle Bourgeoise Noire* performance and for me, for 25

years the performance would remain captured or rather imprisoned by the empty signifier of the image of me shouting and another of me beating myself with the whip. Both images were in isolation, with no indication of an audience. This was before the internet, and these two images were the only ones that had ever been published. An oddly distilled anger had been the only quality of the performance the art world would know. It wasn't until WACK! Art and the Feminist Revolution, the groundbreaking exhibit curated by Connie Butler, that the full photo installation as well as the costume were shown. Then a few months later I put up my website—it wasn't until the full set of images including me smiling and laughing and having a good time with my friends were available that you could see the complexity of the performance.

Here she's finished shouting. Now she's leaving. And now she's in a restaurant with her friends. So, that's George Mingo and Richard DeGussi, and there is David Hammons and Jorge Rodriguez.

Next is *The Black and White Show*. Mlle Bourgeoise Noire had been looking for an opportunity to make her next move when Kenkeleba House in New York suddenly had an unexpected opening. She took it and curated *The Black and White Show*. The concept of the show was rather simple: 28 artists, 14 black, 14 white, and all of the work in black and white.

The first thing she did was commission a text piece from John Fekner, a mural [figure 1]. John was known at that time for outdoor text murals in the Bronx, which were always political and always very place-oriented. She didn't know what he would want to say. But Kenkeleba House was on East 2nd Street between Avenues B and C, which at the time was the largest open-air heroin market in New York City. So he put up this mural: *Toxic Junkie*.

Adrian Piper had just done *Funk Lessons* and had made a beautiful advertisement card for it in black and gold [figure 2]. But Mlle Bourgeoise Noire needed it in black and white. She got Adrian to do her a favor. Adrian didn't really want to. But she pleaded, "It's got to be in black and white." And Adrian did.

Here is an installation shot of the front room and as you can see, there's a mixture here of both abstract and figurative work [figure 18]. Mlle Bourgeoise Noire wasn't advocating for any particular form of art making, just a certain attitude toward art.

One thing I would like to point out is that even though the art world itself, or the institutional aspects of the art world, were rigorously segregated, the artists themselves were not so segregated. There were many conversations between artists of different races that were taking place, sotto voce, underneath the radar of the official art world.

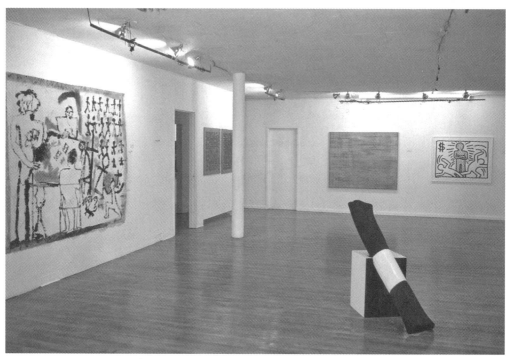

18 INSTALLATION VIEW SHOWING THE WORKS OF KEITH HARING, GERALD JACKSON, JACK WHITTEN, AND WILLIE BIRCH, *THE BLACK AND WHITE SHOW*, 1983, KENKELEBA GALLERY, NEW YORK.

This is Gerald Jackson, *The Card Players* [figure 4]. Gerald Jackson, if anybody knows him, is a real character. But he and Keith Haring became friends, and they exchanged many studio visits. You may disagree with me, but I feel there might have been a direct influence of Gerald Jackson on Keith Haring here. Let me show you what I mean. The figure of the Radiant Child that Keith was famous for, sometimes more abstract, sometimes less so, sometimes with rays, sometimes without, if you look back at Gerald's painting, you'll notice the figure in the lower right of *The Card Players*. Gerald was older than Keith, and this painting was at least five years before Keith's work.

But everybody has influences, and Keith did something completely different with that figure [figure 5]. I have to say that Keith Haring was a dear person for me. I knew him from when he audited my Surrealist Lit class at SVA. He made *The Black and White Show* by being the first person to sign on for it.

Now I'm rushing to get through the slides quickly. Here is the shot that shows the point I was making most clearly [figure 19]. When people looked into this room from the doorway, they thought the two pieces were made

19 INSTALLATION VIEW SHOWING THE WORKS OF JEAN DUPUY AND RANDY WILLIAMS, *THE BLACK AND WHITE SHOW*, 1983, KENKELEBA GALLERY, NEW YORK.

by the same artist. But while the forms and materials are almost identical, the content couldn't be more different. This is Jean Dupuy, a French Fluxus artist, whose piece about perception and artmaking involved a periscope set into sheets of paper on a high table with a mirror [figure 7]. When viewers looked into the periscope, they saw the tops of their heads reflected in the mirror while the oils from their foreheads, deposited on the paper, helped to make the final piece.

And this is Randy Williams [figure 8]. My goodness. Thank you, Randy. I felt this was the piece of the show. Randy, as you may know, was also a JAM artist, and this is about his memories of growing up in the South, looking at segregated bathroom facilities, You can see the white toilet seat on top, the black toilet seat beneath it, and below that a field of razor blades on the floor. But the piece also contains Randy's later education involving reading William Faulkner. The small white paper sitting on the razor blades con-

tains a quote from Faulkner, which reads, "Between the white man and the land, is interposed the figure of the black man." I thought that piece was spectacular.

My friend Stephen Lack, who was white, had been out with Jean-Michel Basquiat and some of Jean-Michel's friends one evening [figure 14]. Steven was from Canada, and this was the first time that he had experienced what could happen to black men on the street, when they were stopped by police and had to put their hands up against the wall so they could be frisked. It made a deep impression on him. And this was the piece he made for the show.

That's, of course, Jack Whitten, *Omikron* [figure 10]. This is a piece by Willie Birch who had been an abstract expressionist originally. Here he's using the grid [figure 9]. Each of the small squares in the grid holds thoughts he had while listening to jazz music.

This is my student Lynne Augeri, who did work about sexual and other forms of abuse [figure 12]. The owners of Kenkeleba thought it might be pornographic, but I was able to explain it to them. Louis Renzoni also, I thought, did interesting work in terms of using faux film noir stills to make dread palpable in his black-and-white paintings [figure 13].

And this is Nancy Spero [figure 3]. Even though the message is very serious, the painting seems at the same time playful to me. It seemed to go well with my friend George Mingo [figure 16], who'd said to me, "I can't make a piece in black and white." So, instead, he did black-and-white in color. There is a black man, his white wife, and their zebra-striped child.

Now back to *Art Is . . .* [plates 18–20]. The basic elements are the float with the 9 by 15 foot frame, and the troupe of actors and dancers carrying gold frames. The two elements captured more than I could describe here. Every time I look, I see something different. From the very old, like the Renaissance Ballroom, which is now shuttered and decayed, to the very young, like this adorable child. And this wonderfully stark image that, to me, is about the opacity and mystery of the life behind these doors and windows that you can never fully understand no matter how hard you try to imagine it.

So many contrasts, obviously. Different kinds of masculinity. The loving father with his child, and then the guy that looks like he just got off of Rikers Island and doesn't know he's in Harlem, even. The woman who knows who she is and is flaunting it. I love her. Then there's another woman who's just as glamorous, but introverted, and I love her too.

And there is the never-ending policing and its implications. For all the complexity that was captured, there was no avoiding that.

This is another of my favorites, the girl pointing her finger. I never know whether she's with me or against me. But she's always pointing. So I always say, "What are you pointing at?" And she's pointing at me.

See also "Mlle Bourgeoise Noire 1955"; "Statement for Moira Roth re: Art Is ..., 1983"; "Performance Statement #1: Thoughts about Myself, When Seen as a Political Performance Artist"; "Performance Statement #3: Thinking Out Loud: About Performance Art and My Place in It"; "Interview with Amanda Hunt on Art Is ..., 1983"; "A Day at the Races: Lorraine O'Grady on Jean-Michel Basquiat and the Black Art World"; "The Black and White Show, 1982"; "Email Q&A with Artforum Editor"; "My 1980s"

Job History (from a Feminist "Retrospective") (2004)

In 2004, one of O'Grady's granddaughters, Ciara Mendes, interviewed her for a school project on women and work. O'Grady's charming and affectionate responses provide a great deal of insight into her early career, including her work in the Department of Labor and as an intelligence analyst and translator, the challenges she faced as a black woman and a single mother navigating the professional world, and her slow path to becoming an artist.

THURSDAY, SEPTEMBER 23, 2004, 16:42

Hey Grama Rain,

For my Labor study: Women and Work, I have to interview 3–5 of my female family members and write a report on each, and I would like you to be one of them. These are the questions:

—What kinds of paid jobs have you held, approximately how old were you when you held them and what work did they entail? (in school and as an adult)
—What concerns if any, did you have in any of these jobs about working conditions, wages, benefits, hours, relationship to family responsibilities, sexual harassment, etc.?

—Was there any resistance within your family to you holding any of the jobs?
—Why did you choose these jobs?

Thanks so much. If you don't have the time to answer the questions its ok I know you're a busy lady, but I would be so grateful if you did. My paper is due the 30th next week so I need it before then.

Thanks again,

C.

Wow, C., that's a tall order. You have no idea how many jobs I've had! I'll do my best to get it to you by late Monday.

Grama Rain

Hey, C.,

I finished it a little early. It's almost 9 single-spaced pages and only takes me up to 1972 (with a couple of flash-forwards to about 1990). I enjoyed writing it, and I even learned a few things. I didn't specifically answer your questions, I had to ground them in the overall picture. But somewhere in there, I'm sure you'll find stuff you can use for your paper. Hope you get a good grade!

Grama Rain

Thank you soooooo much! Wow that's a lot of info. I better get started. I'll let you know how I do.

C.

In the end, C. forgot to tell me her grade. I only recently learned that she'd received an A.

As for me, at about 1972 in my reply I ran out of time and energy. I tried to do a few flash-forwards but didn't mention being a rock critic, and hardly discussed being an artist. One of these days, I'll put down the whole story . . .

My First Job

When I started college in 1951, I was going to major in history. But after a course in Central European history, I knew I'd never be able to read fast enough. I couldn't stop sub-vocalizing! So I decided to major in Spanish literature. But after I got married and had a baby, I realized I would have to get practical. So I switched to economics because I thought that would give me better job prospects. In my senior year, I went on a few interviews through the Career Center at Wellesley. But they weren't too interesting. In those days, it seemed like the majority of recruiters, even at a high prestige women's college like Wellesley, were fashion retailers. I went through the motions. I got dressed up, took the train to New York and talked with the people at Bergdorf's and Alexander's (opposite ends of the fashion scale). But it was clear, women retail buyers could only go so high. You would spend most of your life in dreary back rooms on the store floors, talking to low-level vendors with carpet fleas biting your legs.

That's when I decided my training and interests were best suited for work in the government. It was the only "equal opportunity" employer at the time and, amazingly, it paid better than any of the other jobs. You took an exam and if you passed, you were in, even if you were a black female. This was 1956, and at that time, the federal government had an elite entry program called the Management Intern Program. You had to take a special exam in addition to the regular entry exam. I decided to try my luck even though everyone said it was almost impossible to pass. About 20,000 people sat for the MIP test around the country, and 500 passed. I was one of them. But then there was the second part, a one-hour oral interview where each candidate was grilled individually by five professionals. Of the 500 who'd passed the written, 200 made it through the oral, and I was still in. So that made me the first girl from Wellesley ever to pass the MIP, and I felt hot!

Now came the next stage, you had to bid for the jobs on offer at different government departments and agencies. In retrospect, I can see that this was the early-warning sign. Out of the final 200 people who'd passed the exam, just 6 of us were girls (we still called ourselves "girls" then!). And of these six,

three of us ended up together at the Department of Labor. To put it mildly, Labor and Agriculture were the two least "sexy" departments in all of Washington. State, Treasury, Defense, any of the intelligence services, those were the sexy ones. Not one of us had put Labor as one of our top three. It seems the Department of Labor was the only one willing to take us in . . . and we were all "Ivies," the best of the best. So I went to work as a research economist at the Bureau of Labor Statistics. Well, another early-warning sign came just a year later. There was an evaluation of the 200 management interns that told them their future career prospects. Nearly all the guys we knew in the program were told they could reach Deputy Assistant Secretary, the highest possible career post. But the biggest cap any of the women got was GS-13, or division chief, which was five steps below Deputy Assistant. Me, I got GS-12. I think the Department of Labor knew before I did that I wasn't cut out for government service! Still, though it was the most welcoming to women, even at Labor there were limits. You could look around and see that division chief was as high as any woman would get.

Another aspect of the work that affected me as a woman was that—and again, I only understood this in retrospect—at the time, I was still trying to be a single mother (ultimately I wouldn't succeed). Nowadays, nurseries in federal buildings are routine. But at that time, there was no support at all, you were lucky to get maternity leave. I had moved as a young woman in my early 20s to a strange town and had no family nearby to help. And the peer group I was working with consisted only of young single people, so there was nobody to call on or exchange with. It's hard to remember, but in the 1950s, most mothers didn't work, and there were no support groups or childcare cooperatives for those that had to—in fact, such concepts were seemingly invented in the late '60s. Even though my starting salary was relatively generous, I still couldn't afford a nanny. So I had to find a nursery school, then rush home after work before it closed to pick him up. God forbid my child should ever be sick! In the summer, I had a two-week vacation, but the nursery school shut down for five weeks. I had no choice but to send him to a sleep-away camp. He never forgave me for this.

My Next Job (Interview)

In 1961, after five years, I decided to leave the government. I'd sent my son to live with his father, who was living with his parents. It was clear they could provide him a more stable home. And before leaving Washington, I tried to line up a more interesting, better-paying job than being a researcher and

intelligence analyst. My sister Devonia and her husband, who were living in Connecticut, had a neighbor and close friend who was the head of CBS Television News, so I asked them to arrange an interview. It was all very informal. He took me to lunch in one of those busy, high-powered Manhattan restaurants that you see in films. I thought he was enjoying the attention I was paying him, we weren't really talking business, the conversation was just wandering. As the lunch was coming to an end, he brought us abruptly back to the point and said, "So, what would you like to do?" I told him, "I'd really love to be a writer for CBS News." For sure, I knew better than to say I wanted to be an on-camera reporter; at that time, I don't think I'd ever seen a woman reporter, let alone a black one. But from today's perspective, what he said next was truly astonishing. He answered in the most off-handed voice you can imagine: "Lorraine, I can tell you that no woman will ever write for CBS News. But we can see about a job for you as a researcher." Oh. My. God. . . . a researcher again! I felt totally done for. Of course, had the lunch taken place eight years later, in 1969, though he may have thought it, he wouldn't dare say as much. Someone could get the law after him.

Going into Business for Myself

It was a while before I would have what you would call a "normal" job. When I look back on what happened after that, I can see that I was beginning to drift. I was trying to find something to do in which I could make a mark. By 1967, I'd already spent a year in Europe trying to write a novel and learning that I couldn't, going back to graduate school (the Iowa Writers' Workshop, where I translated the novel of my instructor, a Chilean writer, which was published by Knopf), then getting married again to a fellow grad student and moving to Chicago. My new husband was making enough money in the film production company he worked for that I didn't have to work, and for a few weeks I didn't. But I soon got bored. Those were turbulent times in Chicago.

I didn't want to do job applications cold, I was still afraid of a racist response. So I answered an ad on the radio for substitutes to teach in the inner city (can you believe they advertised?). The schools and the kids were so troubled, they couldn't get anyone to go there. I lasted exactly three weeks—and then I broke down and cried in front of my fourth-grade class. There was one little girl who could only come to class on days she could borrow shoes to wear! And every day, since there were not enough pencils and copybooks to go around, the kids who didn't have would grab them from those who did when they weren't looking. Then they'd break out into fistfights because

they would accuse each other of stealing. One day, two boys ended up rolling on the floor between their desks and I couldn't break them up, and I just cried. I knew it was the end. The next day I called the principal and told him I couldn't come in again.

I took a job as a cocktail waitress in a blues club owned by a friend of my husband's. He told me I could make a lot of money, and I did. Three times as much as I'd made at the Department of Labor. It was amazing. But every guy who gave me a tip thought it gave him the right to pinch my ass. So I stayed there for three months, and then one afternoon, I went down to the Illinois State Employment Office to see if they might have a *real* job to refer me to. I was in luck. That very morning a call had come in for someone to be a translator and help manage a translation agency. I said I could translate. Boy, could I translate! I could do Spanish and French, and with the help of my six years of Latin, make out Portuguese and Italian. And after living in Denmark for a year, I could even take a stab at Danish, Swedish, and Norwegian. I went on the interview. The lady who owned the translation agency, Mary Baldwin, was 90 years old. She told me that she had been the first woman graduate of the University of Chicago and had been an official interpreter at the 1893 World's Columbian Exposition! By now, she had clung on to her translation business and just wanted someone to turn it over to. Its furniture, and most of its clients, seemed to date from the 1890s, too. But by some miracle, Hugh Hefner and *Playboy*, who in 1968 were still based in Chicago, had picked Miss Baldwin's Academy Translation Bureau out of the phone book, probably because it began with "A." If they only knew! The *Playboy* account was keeping her afloat. It's a funny thing about translation . . . if you can do it, no one cares if you're male or female, white or black, young or old. But you have to get that foot in the door.

I worked for Miss Baldwin two days a week, and for three days a week I continued the volunteer work I'd begun while I was at the blues club . . . for Jesse Jackson and his organization Operation Breadbasket, the precursor to PUSH [People United to Save Humanity]. I don't remember now how I'd found out about Jesse. Perhaps I'd read an article. He and his friend David Wallace had just graduated from U of C Theological Seminary but were still squatting in married student housing with their families. They were too poor and too busy to move, running Breadbasket alone. They were beginning to make news. I was the first volunteer, but after Dr. King's assassination, many more came on board. A few months after I arrived, Calvin Morris and Willie Barrow were appointed. But for a while, the brain trust was David and me. The most important thing I did while I was there was write a long memoran-

dum to Jesse titled "The Difference between Power and Influence." After my five years working for the government, I suspected he didn't have a handle on the difference. He was so impressed that he made my memo the topic of the SCLC's national training week for ministers that year. But I soon had to stop being a volunteer.

The translation business was starting to take off. When Miss Baldwin died, I dropped all but her *Playboy* account. I had learned that the *Encyclopaedia Britannica*, also based in Chicago, was having trouble finding someone to properly do their work. In preparation for what would be only the third basic revision to the encyclopaedia in its history, "Britannica 3," the publishers had done a survey. They had learned that they now sold more copies of the *Encyclopaedia* in foreign-speaking countries than in countries that spoke English and so had decided to change their long-standing policy. Instead of the old-style monument to English-speaking scholarship, they would open up the contributorship: articles would now be written by the world's expert, no matter what language they wrote in. But they hadn't found translators who could match the *Encyclopaedia*'s style. I felt confident, so I went for it. I proposed doing two articles on spec, one from Spanish and one from French. If my translations were good enough, I would get the contract. I did, but the flood of articles was so great, I soon had to stop translating and become an editor for the translators I had to hire. The business was run out of my home. There were four electric typewriters (it was before computers!) going all day long. I would go over the translations to make sure they were letter-perfect before turning them in to the *Encyclopaedia*.

And this was when I discovered a talent I hadn't known I had or even that such a talent existed. I had a natural aptitude for language and with my Girls Latin School education, somehow I could invariably spot when something illogical had crept into the vocabulary or syntax of the English translation. This meant that all I had to do was focus on the clarity of the English, and I could edit translations from languages I didn't know . . . about subjects I was completely unfamiliar with. Well, the day I edited the 50-page article on quantum physics . . . when my last math had been algebra . . . that had been translated from Russian, of which I knew not a single word, was the day I made my decision. Either I stayed in Chicago and used this skill to build a business, or I had to leave to keep searching for what I was put into this world to do.

It's funny. This peculiar skill came in handy about two decades later, by which time I was living in New York. A friend of a friend, a guy I'd met at dinner parties over the years, was working at Citibank, which had pio-

neered the ATM machines. In the late 1980s, Citi was just starting to translate its ATM screens for machines worldwide. But like the *Britannica*, they'd found it wasn't so easy. They had tried three different agencies, and none had worked. This acquaintance remembered that I had done something like this a while back and asked if I could help. I agreed but I was a bit scared because, this time, I had to do it in reverse. Now I couldn't monitor the logic of the English translation, because all the translations were going the other way—from English into the European and Asian languages. I would have to set up a company, select teams of translators, then supervise the translation sessions to guarantee my final product to the bank. In the end, I think it was my visual acuity that saved me. It shocked me. I could compare translations by three different translators into Japanese and tell where and when each one was wrong . . . just by focusing on inconsistencies in kanji characters that I didn't know at all! This was different than language ability. To be honest, I still don't understand the skill I have. I just knew I could count on it. And I wasn't going to argue with something that could make that much money.

So why am I not still in the translation biz? Well, some of it was timing. I'd come to Chicago because of my husband's job and never felt at home there. And as the *Britannica* revision was coming to an end, so was my second marriage. In my mind I was already moving back east to New York. Several years later, with Citibank, as the project was winding down, I was already busy with my art career.

But the deeper reasons tie in with your paper on women's issues. All three of my big clients, *Playboy*, the *Encyclopaedia*, and Citibank, had more or less fallen into my lap. I hadn't gone out looking for them. And they were so grateful for my help, I hadn't had to acquire any of the normal accoutrements of a business other than a phone and a bank account. I didn't even have stationery or business cards. But it's a law of business that to make it work, you have to keep adding clients. Sooner or later, the job is finished and the old client doesn't need you anymore, or not as much. To maintain a business and make it grow, you have to commit yourself to the task of PR. Maybe I was afraid. Or perhaps I just didn't have access to advice. My competitors in the translation business wouldn't give me information, that's for sure. And there weren't any business people in my social circle. Or perhaps I didn't know how to ask, or where to go for input.

But beyond the usual problems women had in that era of lacking know-how, I had the additional impediment of being black. With my foot already in the door, I knew that I could always prove myself. But faced with growing a business, I feared the moment of the "first encounter." Translation is

a peculiar business; people have to trust deep down in your absolute knowledge of the language. I knew, for instance, that blacks could not get jobs teaching English in Asia, because Asians didn't trust that they would speak English properly enough to teach them. Eventually the quality of the work would speak for me, but I wasn't sure I could get the business off the ground and to that point. I may have been wrong.

Still, I don't regret not having gone that route. The fact is, I didn't want to live my life as a translator. Translation is a service profession that no one really values. It requires enormous talent and intelligence to do it well. And if I had those qualities, I didn't want to use them in the service of someone else's work, to be the "invisible contributor" that helps an author's novel live in another language, for example. I wanted to use those qualities for myself and for my own work. The only desire I can remember having almost from the beginning was to express myself and make a mark. I had to take the plunge and commit to art.

Being an Artist

C., I've run out of time. Suffice to say, becoming and being an artist is the only challenge I've never tired of. I'm still here. But as for women's issues, it's the samo samo. When I started thinking about art in the '70s, there were basically no blacks in the mainstream art world, and only a handful of women. Later I was in feminist organizations that fought successfully to help change the art world's awareness of this situation. But even though there are now a few blacks and many more women than there once were, contemporary art is still primarily a white male world. *"La lutte continue!"* as they say in French. The struggle goes on and on.

See also *"Two Biographical Statements"; "Dada Meets Mama: Lorraine O'Grady on* WAC*"; "Mlle Bourgeoise Noire and Feminism"; "Responding Politically to William Kentridge"*

First There Is a Mountain, Then There Is No Mountain, Then . . . ? (1973)

This article on the Allman Brothers Band was O'Grady's first piece as a rock journalist. An unsolicited personal essay on how listening to the band's music had helped her get over a breakup, the article was published by the *Village Voice* as a three-page cover story on August 2, 1973, and coincided with breakthrough gigs by the band at Madison Square Garden and at Watkins Glen the previous week.[1] The narrative describes events that took place in Chicago in January 1973, just three months before O'Grady would close her translation business and move to New York City, committed to developing her own artistic potential. The article, now lightly edited to correct errors in her original transcription of the band's lyrics and to clarify details of her recently ended relationship, offers a brief glimpse into O'Grady's pre-art life; in the present context it also effectively demonstrates the continuity in her conceptual concerns. The ease and freedom of the Allman Brothers' multigenre and racially fluid approaches to their music can be seen as an idealized version of the "never-ending and circular conversation" among "dissimilars but equals" that she would soon present in her own approaches to the diptych as form.

IT ISN'T JUST THAT the Allman Brothers have the baffling simplicity of true artists. That they stand alone in fully bridging the gap between black and

white music. You've got to be *grateful* to a rock band that can bring you from depression to catharsis in less than two weeks.

Even before I became a fan, from the first time I heard the Allmans I could tell something special was happening. They were the first white band I'd enjoyed dancing to. I always fall into the "black is better" syndrome when it comes to music. For someone like me, it's been a long, hard road learning to like rock music after growing up in the late '40s and early '50s, the golden years of rhythm and blues. I've had to give up trying to convey to my white friends, most of whom are knowledgeable in all things pop, what a personal affront it was for me to hear Bill Haley and his Comets spastically blasting through "Rock Around the Clock" as though they'd invented it. When years before I had stayed up all night (on a school night no less, since they only played black music after midnight in Boston), waiting to hear Wynonie Harris's original, jelly-roll version of that song. But when my white friends have never heard of Wynonie Harris until I mention him, it's too depressing. I've had to stop.

What can I say? White radio in the late '50s was a teeth-grinding experience for me, a daily dose or masochism I subjected myself to as I listened to them steal and distort some of my best memories. But along came the '60s, and I had to grudgingly admit that there might be something to this music. Being so new to whites, some of it might be originally derivative at least. Who would have had the heart not to be swayed by the enthusiasm and sheer melodic talent of the Beatles? Then came the Stones with their lyric pungency. But in pop music, lyrics and melody are still secondary values for me. I haven't been able to get away from the primary importance of rhythm, no matter how hard I try intellectually. And, to be honest, whenever I've liked white rock, I've had to do it intellectually, in my head. Because I've almost never felt it in my body and my feet. Dancing to the Stones has always been a dull experience for me (heresy of heresies). The Stones may be good consistently and that certainly counts for something. But they're never *great*, if you know what I mean.

At this point someone might look up and call me a black chauvinist. But this distinction isn't as racist as it might seem. I have a friend who's an Olympic equestrian and, though I feel put down by her, I can't argue with the fact that she's had a definite cultural (and financial) advantage over me. Because her father was a horse-trader, she was riding horses before she could walk on her own two feet. By the time she started jumping, there was no separation between her body and the horse's. But she can't dance worth a lick.

I try to reassure her that if *her* 11-year-old sister had bounced her up and

down in her crib to the beat—and danced with *her* every day until she was seven or eight—then maybe she, too, could feel the difference between good and great. The maddening thing is that some white rock music comes so close. It has such an insistent beat that it makes you get up out of your seat. It isn't until you're on your feet and trying to move that you discover the beat has no connection with your body. It reminds me of the pastry in Latin bakeries dotted about Chelsea. It looks like pastry in the window, but when you bite into it, you wonder if they were copying pastry from photographs. Or could they actually have had a recipe?

When I heard *Eat a Peach,* for the first time I was listening to a white band with whom I didn't have to make an intellectual leap. Their rhythms were quickening every nerve ending in my body.

But after breaking up with Ben, I don't feel much like dancing. The Allman Brothers had been a part of our last week. Background music against which we'd talked, balled, fought. They had been a wall of sound I hadn't bothered penetrating. But right now, all I want is to get stoned and let their music wash over me. I start playing the records narcotically. Praise the Lord, Flora's dope is old-fashioned, space-out-to-the-music dope. God knows, there's no band better than the Allmans for that. Is it blues, jazz, rock, country? It's none of those things, and all of them too. They are a playing band who have listened to their influences with respect and perceptivity and combined them into a synthesis that is personal and unique. And though I hadn't really planned on it, I find them drawing me into their world. The state of rock musicianship is still so low compared to jazz, or even rhythm and blues, that it's still a shock when you find musical instruments not just being held as stage props but actually being used.

I discover that they are two bands really, or rather they have two different repertoires that are distinct. First, they are the incredibly tight band that backs up and extends the strong blues lyrics written and sung by Gregg Allman, plus an occasional Dicky Betts country tune. And then they are the free-jamming, purely instrumental group which, however much it bobs and weaves around its individual talents, seems always to be playing like one man. Or rather like some strange 12-armed Shiva balancing one Hammond organ, a bass, two lead guitars, and two drum sets.

Initially, I fasten on the pulsating vocal blues. They are so immediately catching. And Gregg Allman is the first white blues singer I've ever believed was telling me the truth. There have been so many weird white "blues" voices breaking over the air waves the last ten years. Voices that have been caricatures in four directions at once. Not just out of color, but out of time and

place as well, imitating the old, country blues instead of the more modern, urban blues. And strangely lacking in one of the blues' most important elements, since in their rush to imitate the guts of the blues, the white singers seem to have almost completely missed its intelligence. And, after the umpteenth well-intentioned or not so well-intentioned attempt by singers to appropriate and warm themselves at these roots, you can't help groaning: Why do they all have to take the coarsest voices as their models? Why can't any of them imitate the bell-like tones of the last bluesmen I was personally able to relate to, singers like Jimmy Rushing, B. B. King, or even Albert King? It's as if truly imitating these would require too subtle an understanding of the blues.

It's not the raw power of Gregg Allman's guttural voice that is convincing me. It is its complexity. His voice is the full expression of a complete and contradictory personality. It is rooted in the kind of self-confident, self-conscious sexuality you most often hear connected with black voices. And like them, it gives the impression that it hasn't been separated from the act of life by any false morality (Gregg Allman has definitely not been fucked up by the fundamentalist sense of sin). But yet reflected against this hard-baked, earthy clay, his voice contains an almost translucent intelligence, a calm, mystical, oddly interiorized turn of mind that is both working against and supporting its life-affirming qualities. It's this very ambiguity that can't be imitated because it is the paradox of life itself. You can't grab it by putting on the intonations of the Deep South. It can only be achieved by an artist working from the depths of his experience. I know that Gregg is from the Deep South, that the intonations aren't being forced, that they are coming naturally. But I can judge this from the words he has written as well.

Lyrics that are always thoughtful, yet unpretentious. For example, these from one of the best of his songs on the album, "Ain't Wastin' Time No More," written, it appears from the album's chronology, in the period immediately following the death of his brother Duane: *"You don't need no gypsy to tell you why, you can't let one precious day slip by / Look inside yourself and if you don't see what you want, maybe then you don't—But leave your mind alone and just get high."* And filled with odd urban-rural images. From the same song: *"'Cause time goes by / Like hurricanes runnin' after subway trains."* Thoughts of black or white often become irrelevant. His feeling for the blues and for rhythm-and-blues is so oddly true that renderings of his own songs, those he's written himself, can sometimes feel as good or better to me than the older, black pieces he also sings. Because his are today's blues.

But Gregg is too decided a personality. I can't follow him to the bottom of his experience because I'm too concerned with my own at the moment.

I feel restless. Confused. Unhappy. And detailed lyrics are too restrictive. I need something more malleable. Ben didn't just leave me, he left the bands he was managing, left Chicago—for New York and a record company. Now I'm here with my three thousand books, four IBM Selectrics, the cats, plus all the paintings we'd been caretaking, the abstracts Rudy pulled from his head two decades ago because, with frosted windows, you can't see out from here. There are 6,000 open square feet with no walls and no doors to help you keep it together.

I stop listening to Gregg and turn to the instrumentals, first to "Mountain Jam," a brilliant 35-minute riff on "First There Is a Mountain," the old Donovan tune. It's what I need. Every night about midnight, in this basement loft where the outer walls are a foot thick and no one cares how late or how loud I play my stereo, I turn off all the lights except the two above the abstract purple tree still standing on its old seven-foot wood easel. I lie down on my couch in the midst of all the stuffed pillows and as I smoke Flora's dope, I try to fix an image of the pitch-black lake lapping only half a block from my street here on the north side. "Mountain Jam" becomes a whole world for me. I'm hoping there will be enough complexity in this world to keep my mind busy. I'm not disappointed.

At first, I'm just remembering, still speaking to him with the usual effort of trying to make sense in the haze. "I'm usually dancing to the bass, but the rhythm is everywhere here." I wonder when it will stop mattering that there is nobody here to answer me. Then I finally give in. The Allman Brothers don't play music in the abstract, they play it in the real. When I try to put a name to their music, it doesn't work. They're never mathematically conceptualizing, they're always playing what they feel. And they seem to have absorbed all the elements, synthesized the entirety of American music: hard and soft rock, country, gospel, blues, jazz, rhythm-and-blues, even tin-pan alley. It's such a total accomplishment that I wonder if it could have been achieved by anyone else. What makes them so unique? How did they integrate their influences so naturally? Because there's no question about it. These white boys from the South aren't affecting blackness. They've made it their own without giving up any part of themselves.

And how could they have forged so much symbiotic unity out of six separate personalities? In fact, if there's anything I *don't* like about the Allmans it's that, for an improvisational band, they don't get all the benefits of tension and humor that come from exploring disparateness fully. From an incredible empathy for each other's style of playing they have created such a tight music-machine that it's sometimes hard to separate out the players.

The two drummers play almost as one—a thick, rich, sound full of color and metronomic accuracy inseparably combined. But sometimes you can't help but wish they would stop being a duet and become a duel. The two guitarists, amazingly worthy of each other's talent, play like two halves of one mind and body. All this unity is a double-edged sword. What the band loses in complexness, it gains in intensity. They have more real power than any band in the country, and although they may not have the tension of conflict, there is tension in the fact that their power is never fully unleashed. Not paradoxically, it's their sure musicianship, the ability to hold back, that is keeping them from disintegrating musically.

But I want to go beyond the unity. As I lie here alone in this cavernous basement room, I want to find out who I am talking to. I want to separate the personalities from the group. After isolating the playing styles, I want to associate them with faces, names. But it's not easy. *Eat a Peach* doesn't have a picture of the band, and the Dutch-master photo on the cover of *Idlewild South*, the only other album I have, has no caption info. I know one of the drummers is black because Ben has mentioned that, but even if I could separate their playing, I wouldn't know which drummer had played which part of the duet. On the back cover, names are listed in the musician credits: the drummers are Butch Trucks and Jai Johanny Johanson (I've lived in Scandinavia, so I know that's Swedish). I flip back and look at the Dutch-master photo again, at the black guy whom I assume is Trucks.[2] *Idlewild South* is from 1970 and he's wearing an earring, not that common, which usually means one thing. Maybe that's how he's been able to survive as the only black in a Southern white band?

Berry Oakley is the bassist. He died in a motorcycle crash a few weeks ago, Ben said when he gave me their albums.

I wish I could decide which face went with his name. I have no problem characterizing his playing—he's a melodic bassist who leans more toward the guitars and sometimes even triples with them. While at times functioning like a lead and at other times standing halfway between the guitars and the drums, liberating both by anchoring the sound, Oakley seems the pivot, the reason why this group can achieve rhythmic freedom to an extraordinary degree. Gregg Allman's work on Hammond organ is also variable. Lighter, more strictly time-keeping on the instrumentals yet, on the blues, covering a wild gamut, from harsh sensuosity to ethereal mystery. But Oakley and Gregg are easy, single instruments that are simple to isolate and to hear. The lead guitars, like the drums, are another duet. Between them, Duane Allman

and Dicky Betts are the expressive soul of the instrumental group. But which is the prose, and which the poetry? For a change, there's a way to find out.

Duane Allman, too, is dead, killed in a motorcycle wreck a year ago, before *Eat a Peach* was finished, Ben said. Death is stalking this group, I think, but put that thought quickly away and re-cue the album. There's one whole side on this two-record set where Dicky Betts is playing alone after the band was reduced to five men. I listen to that side until his guitar style becomes a map inside my head, and when I turn back to "Mountain Jam" on the other side, I realize it's Betts who carries the main solo load. Betts is one of the most perfect poetic vehicles I've ever encountered. He's like some blank page on which every musical and human experience has been recorded in its purest impression. A simple man with apparently unimpeded access to his own emotions, he seems to play either at midnight or at noon. When he plays country it's pure country, when he plays blues it's pure blues. Gliding, melting, soaring notes that sing of sorrow, joy, and a thousand other feelings I can't give a name to. There are times, lying here, when I think Dicky Betts is going to fly off the record's surface, that it is only Duane Allman, the perfect counterpart to his playing, who is keeping him attached to the vinyl grooves. It's not that I don't think Duane's a great guitarist. He is. Strong, direct, and at the same time, sinuous and sensitive. But in the scheme of things, Duane Allman was a prose rather than a poetic personality. From these albums at least, I can't help feeling that his fate ultimately was to be the catalyst and balance for more imaginative talents than his own. The *animateur*, as the French call it, the man who provides the creative energy but not the creativity.

Duane Allman is far and away the most professional, most musicianly musician in this group and, like some universal donor, his declarative statements never conflict with the lyric poetry of Dicky Betts or the metaphysical poetry of his brother Gregg. His empathy for Gregg may have been of the blood, but his empathy for Dicky Betts must be one of the great musical accidents. And though Duane is the one who reframes, restates, suggests, he's not without his own feeling of urgency.

There are so many reasons this music provides me with a world I find complete. With Dicky Betts I feel I'm getting the distilled emotion, intensified, even *relived* in the body and soul. When I listen to Gregg Allman I often find myself standing back from the emotion, not analyzing or reflecting on it exactly, but rather having it *re-created* for me in the eyes of the mind. Hearing Duane Allman, I feel him translating the emotion into terms that are pure

music. But all this faceting of emotion, though satisfying, is not in itself what makes the Allman Brothers' music complete for me. It's the beat, carried and differently inflected across all six instruments simultaneously, that gives me the rhythmic complexity without which my body can't really live.

By the second week, they've become good enough friends so I can take them for granted. I've stopped thinking about them almost completely. Now I'm just lying here, stoned limp, my head vibrating to the music. It may be just my imagination, but "Mountain Jam" sounds like all of the black and white musical experience rolled into one piece. I feel myself going down, down, down, immersed at first, then totally submerged, the notes washing me back to myself. God, Dicky Betts, you play just the way I feel. But why can't I *write* the way you play music?

There I go, starting to feel restless and full of envy.

On Friday night, I don't get stoned, because I feel like dancing. Sometimes I think I only get stoned to slow the music down, so my mind can hear it as well as my body can feel it naturally. Tonight, I turn away from the instrumentals and go back to the blues. And when I do, I realize that I'd almost forgotten this part of their music. Sweet Jesus of Nazareth, as Aunt Gladys would twang in West Indian. I'll tell anybody, Gregg Allman knows what good is. Cut after cut, I can feel the spirit building. So many rhythms from which to choose. And the lyrics! *"Thirty minutes after my ship set sail, / She put up a sign and my house began to wail."*

Wail? I can't believe it. I have never heard anybody who wasn't black use that one! Has he been in some interesting places, or has he been doing deep research? I go over to the record player. I've got to hear that one again. And when he gets to *"She put up a sign and my house began to wail,"* I start to crack up. It's too much! I can't stand up, let alone dance. I have to drop down on the couch, I'm so doubled up. It's just so funny, the thought of all those little kiddies out in rock land spelling it *wale*, or even *whale*! And while I'm pressing my face into the pillow to stop from laughing. Gregg Allman just keeps on going, singing his ass off on the stereo:

> *Just when all began to fade,*
> *I reached down, drew the Ace of spades.*

CHRIST, this white boy won't quit!

> *Now that it's all over and gone,*
> *Somehow, I just don't feel so all alone.*
> *But lie, lie, lie, it seemed like such a waste of time.*

She did not ever seem to know me.
And now it's much too late to show me.
But if I ever see that woman walkin' down the street,
I'll just stand back
And try to move away sl-o-o-w.

Gregg baby, you *do* know how it is! It's time to STAND BACK, and try to move away sl-o-o-w.

I have to struggle to get up from the couch, my body is so stretched out with the anger and laughter. The Allmans are coming to the Amphitheatre on Monday, Ben honey, and I'm getting OUT of this basement. I'm getting over you, and I'm going to do something for them and for me, too. I'm going to write this article. Then . . .

See also *"Performance Statement #3: Thinking Out Loud: About Performance Art and My Place in It"; "On Creating a Counter-confessional Poetry"; "Some Thoughts on Diaspora and Hybridity: An Unpublished Slide Lecture"; "Flannery and Other Regions"; Two Exhibits: The Diptych vs. the Triptych and Notes on the Diptych"; "My 1980s"*

The Wailers and Bruce Springsteen at Max's Kansas City, July 18, 1973 (1973)

This prescient review of the night the Wailers with Bob Marley opened for Bruce Springsteen and the E-Street Band was written by O'Grady in 1973 for the *Village Voice* but was rejected by her editor because it was "too soon for these two." The essay was eventually published in 2010.

UPSTAIRS AT Max's Kansas City is packed. Tonight the tiny showcase room that seats 40 is crammed with 50 record execs and press wanting to hear for themselves the buzz from *Asbury Park*, Bruce Springsteen's first album. The smoky air is electric when the lead-in act begins: they are the Wailers, a Jamaican reggae group being seen for the first time in the States. Though the audience may be curious about this new island music, the charge here is for Bruce.

Springsteen is getting famous. "At least," he says, "that's what my manager tells me."

And why not? He's the real thing. An authentic talent, with a rushing stream-of-conscious imagery that is banked by a solid rock-and-roll-rhythm-and-blues beat. At times the imagery becomes less of a stream and more of a torrent. It's enough to make a Freudian analyst rub his hands in glee.

In lyrics that are among the most beautiful and complex in rock today, Springsteen takes his audience on a tender odyssey through the landscapes

of a decaying city with side trips to a boardwalk's circus-carnival, fitting enough for an artist from Asbury Park, New Jersey.

But star-making is a gruelling process. When the band came on, Springsteen looked as if he hadn't slept in weeks. The first set was tired and listless. Still, no one in this audience was about to leave. By the second set, the band's mood had changed to tired but happy, with playing so loose and easy I felt as if I'd wandered into a practice room accidentally.

Springsteen and his band are in transition and, like so many groups about to make it big, the sound is being temporarily affected. Their small, inexpensive equipment has been turned in for larger amps, more suited to the concert hall than to the intimacy of the small club. Eventually it won't matter. This is probably one of their last trips to Max's Kansas City.

Last night, the acoustic songs worked best. The carefully orchestrated, line to line mood-changes in "Circus Song," from pathos to gaiety, were amazing. If you can picture Todd Browning's *Freaks* laced with gentleness, then you have an idea of what I mean. By the time Bruce introduced a new number, "Zero and Terry," as being "sort of a *West Side Story*," the band was on electric and I had to take his word for it. I couldn't hear a thing.

The people at his record company, Columbia, are pretty excited. "Another Dylan," they keep saying. But they may be speaking more commercially than artistically. It's hard to imagine Bruce spawning a host of imitators. Hard even to imagine anyone else singing his songs, they're such an intimate reflection of his psyche. Not that this is an adverse criticism, or even a prediction of future popularity. But in the dialogue started by Dylan, Springsteen feels more like a closing statement than a new opening. I can't see pop music becoming pure poetry.

The Wailers, who record for Island Records, would have made a better lead-in to Dylan's message-oriented fantasies than to the free associations of Springsteen. Reggae is rooted in the calypso tradition of political commentary. But in reggae we have rounded a bend, from innuendo to polemic. Too bad. The sly ingenuousness of calypsonians like the Duke of Iron and Lord Kitchener may be gone forever, replaced by today's thing: black power.

But it's complicated. When the Wailers sing, "We're burning and looting tonight . . . We're burning all illusion," it's hard to connect the message to the monotonous beat. Reggae is ganja as much as politics; you can get high just dancing to it. Moving slowly and repetitiously, you feel your head leave your body. But Americans may be too keyed up to sway like somnambulists. And Upstairs at Max's Kansas City, there's scarcely an inch between tables.

Whether the quaalude set latches on or not, the Wailers are a tight group, and their lead singer Bob Marley, a small denim-clad man holding a big acoustic guitar, looks like a half-crazed Rastafarian out of the hills. He sings in the Afro-Caribbean's haunting semi-falsetto. Marley wrote "Stir It Up" and "Guava Jelly" for Johnny Nash, for those who need further introduction.

See also "Rivers, First Draft, *1982: Working Script, Cast List, Production Credits*"; "*Interview with Cecilia Alemani: Living Symbols of New Epochs*"; "*Some Thoughts on Diaspora and Hybridity: An Unpublished Slide Lecture*"

Lorraine O'Grady, *Portfolio*
Art, Affinities, and Interests, 2019

PLATES 1 AND 2 Lorraine O'Grady, *The Faces of Mlle Bourgeoise Noire*, 1981/2019. Diptych artist sketch, composed of digital images of cropped and adjusted performance documents. Dimensions variable. © 2019 Lorraine O'Grady/ Artists Rights Society (ARS), New York.

PLATE 3 Lorraine O'Grady, "Mlle Bourgeoise Noire and Her Master of Ceremonies Enter the New Museum." Image #2 of *Mlle Bourgeoise Noire Goes to the New Museum*, 1981, a fourteen-piece photo-document performance installation, 1981/2007. Variously sized digital prints, each matted and framed at 14″ × 14″ (35.56 × 35.56 cm). © 2019 Lorraine O'Grady/Artists Rights Society (ARS), New York.

PLATE 4 Lorraine O'Grady, "Mlle Bourgeoise Noire asks, Won't you help me lighten my heavy bouquet?" Image #3 of *Mlle Bourgeoise Noire Goes to the New Museum*, 1981, a fourteen-piece photo-document performance installation, 1981/2007. Matted and framed at 14″ × 14″ (35.56 × 35.56 cm). © 2019 Lorraine O'Grady/Artists Rights Society (ARS), New York.

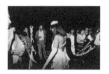

PLATE 5 Lorraine O'Grady, "Crowd watches Mlle Bour-
geoise Noire whipping herself." Image #9 of *Mlle Bourgeoise
Noire Goes to the New Museum*, 1981, a fourteen-piece photo-
document performance installation, 1981/2007. Matted
and framed at 14″ × 14″ (35.56 × 35.56 cm). © 2019 Lorraine
O'Grady/Artists Rights Society (ARS), New York.

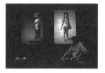

PLATE 6 Lorraine O'Grady, "Told to swing an incense cen-
ser, she stirs sand instead." Image #1 of six photo-documents
from *Nefertiti/Devonia Evangeline*, 1981/2019 (version per-
formed in *Act Up*, curated by Lucy Lippard). Digital C-print
from Kodachrome slide, 20″ × 13.25″ (50.8 × 33.66 cm). © 2019
Lorraine O'Grady/Artists Rights Society (ARS), New York.

PLATE 7 Lorraine O'Grady, "The voice on tape says: 'Mount
and straddle tubs of sand, which are now touching . . . face
audience.'" Image #6 of six photo-documents from *Nefer-
titi/Devonia Evangeline*, 1981/2019 (version performed in *Act
Up*, curated by Lucy Lippard). Digital C-print from Koda-
chrome slide, 20″ × 13.25″ (50.8 × 33.66 cm). © 2019 Lorraine
O'Grady/Artists Rights Society (ARS), New York.

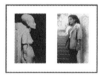

PLATE 8 Lorraine O'Grady, "Cross-Generational." Dip-
tych #15 of *Miscegenated Family Album*, 1980/1994, photo-
installation of sixteen matted and framed digital Ciba-
chrome diptychs, each 26″ × 37″ (66.04 × 93.98 cm). © 2019
Lorraine O'Grady/Artists Rights Society (ARS), New York.

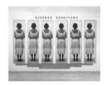

PLATE 9 Lorna Simpson, *Guarded Conditions*, 1989. Eigh-
teen color Polaroid prints, twenty-one engraved plastic
plaques, and plastic letters, overall dimensions 91″ × 131″
(231.1 × 332.7 cm). © Lorna Simpson. Courtesy the artist and
Hauser & Wirth.

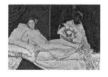

PLATE 10 Edouard Manet, *Olympia*, 1863. Oil on canvas,
75.2″ × 51.38″ (191 × 130.5 cm). Musée d'Orsay, Paris.

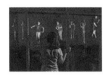

PLATE 11 Lorraine O'Grady, *Persistent*, ArtPace San Antonio, 2007. Eight-channel video wall installation, separate audio mix, furniture, built environment. Patrons of recently closed Davenport Lounge, San Antonio, dance to ambient mix by Davenport DJs on wall of a darkened space, above furniture lent by club proprietors behind the club's rebuilt closed and locked façade. Still from documentary video. © 2019 Lorraine O'Grady/Artists Rights Society (ARS), New York.

PLATES 12 AND 13 Lorraine O'Grady, *The Clearing: or, Cortés and La Malinche, Thomas Jefferson and Sally Hemings, N. and Me*, 1991/2019. Left: "Green Love"; right: "Love in Black-and-White." Digital prints from analogue photomontages (diptych), 50″ × 40″ (127 × 101.6 cm) each. © 2019 Lorraine O'Grady/Artists Rights Society (ARS), New York.

PLATE 14 Lorraine O'Grady, *The Strange Taxi: From Africa to Jamaica to Boston in 200 Years*, 1991/2019. Digital print from analogue photomontage, 40″ × 50″ (101.6 × 127 cm). © 2019 Lorraine O'Grady/Artists Rights Society (ARS), New York.

PLATE 15 Lorraine O'Grady, *The Fir-Palm*, 1991/2019. Digital print from analogue photomontage, 40″ × 50″ (101.6 × 127 cm). © 2019 Lorraine O'Grady/Artists Rights Society (ARS), New York.

PLATE 16 Lorraine O'Grady, *Gaze*, 1991/2019. Quadriptych digital prints from analogue photomontages, each 20″ × 24″ (50.8 × 60.96 cm). © 2019 Lorraine O'Grady/Artists Rights Society (ARS), New York.

PLATE 17 Lorraine O'Grady, *Dream*, 1991/2019. Quadriptych digital prints from analogue photomontages, each 20″ × 24″ (50.8 × 60.96 cm). © 2019 Lorraine O'Grady/Artists Rights Society (ARS), New York.

 PLATE 18 Lorraine O'Grady, "Stone and Brick with Egyptian Motif." Image #12 of *Art Is...*, a forty-piece, nonchronological, photo-document performance installation, 1983/2009. Digital C-print, 20″ × 16″ (50.8 × 40.6 cm), from cropped and adjusted Kodachrome slide. © 2019 Lorraine O'Grady/Artists Rights Society (ARS), New York.

 PLATE 19 Lorraine O'Grady, "Caught in the Art." Image #18 of *Art Is...*, a forty-piece, nonchronological, photo-document performance installation, 1983/2009. Digital C-print, 20″ × 16″ (50.8 × 40.6 cm), from cropped and adjusted Kodachrome slide. © 2019 Lorraine O'Grady/Artists Rights Society (ARS), New York.

 PLATE 20 Lorraine O'Grady, "Girl Pointing," Image #40 of *Art Is...*, a forty-piece, nonchronological, photo-document performance installation, 1983/2009. Digital C-print, 16″ × 20″ (40.6 × 50.8 cm), from cropped and adjusted Kodachrome slide. © 2019 Lorraine O'Grady/Artists Rights Society (ARS), New York.

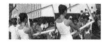 PLATES 21 AND 22 Lorraine O'Grady, *Night and Day*, 2010/2019. Diptych artist sketch composed of digital images of cropped and adjusted video stills from *Landscape (Western Hemisphere)*. Dimensions variable. © 2019 Lorraine O'Grady/Artists Rights Society (ARS), New York.

 PLATES 23 AND 24 Lorraine O'Grady, *Moments of Perception*, 1983/2019. Diptych artist sketch composed of digital images from *Art Is...* Dimensions variable. © 2019 Lorraine O'Grady/Artists Rights Society (ARS), New York.

 PLATE 25 Lorraine O'Grady, "The Debauchees intersect the Woman in Red, and the rape begins." Image #29 of *Rivers, First Draft*, a forty-eight-piece spatialized, narrative photo-document performance installation, 1982/2015. Digital C-print, 16″ × 20″ (40.6 × 50.8 cm), from cropped and adjusted Kodachrome slide. © Lorraine O'Grady/Artists Rights Society (ARS), New York.

PLATE 26 Lorraine O'Grady, "The stove becomes more and more red." Image #34 of *Rivers, First Draft*, a forty-eight-piece spatialized, narrative photo-document performance installation, 1982/2015. Digital C-print, 16″ × 20″ (40.6 × 50.8 cm), from cropped and adjusted Kodachrome slide. © Lorraine O'Grady/Artists Rights Society (ARS), New York.

PLATE 27 Maya Deren, *Meshes of the Afternoon*, 1943. 16mm film (black and white, silent). 14 min. Film still.

PLATE 28 William Kentridge, *Sleeping on Glass*, 1999. Mirror, chest of drawers, marble top for chest, 35mm film with sound transferred to video laser disc, charcoal and pastel on paper; edition of 3. Los Angeles: LACMA. © William Kentridge.

PLATE 29 Lorraine O'Grady, "Evening Sky Blue (Jeanne and Charles)." Color study for in-progress photo installation, *Flowers of Evil and Good*, 1999. Digital image, dimensions variable. © Lorraine O'Grady/Artists Rights Society (ARS), New York.

PLATE 30 Lorraine O'Grady, "Day Sky Grey (Jeanne and Charles)." Color study for in-progress photo installation, *Flowers of Evil and Good*, 1999. Digital image, dimensions variable. © Lorraine O'Grady/Artists Rights Society (ARS), New York.

PLATES 31 AND 32 Lorraine O'Grady, "Haiku Diptych 16." Artist sketch for *Cutting Out CONYT*, 1977/2017. Scans of original panels from *Cutting Out the New York Times (CONYT)*, 1977, composed of newsprint cutouts collaged on rag bond papers, each 8½″ × 11″ (21.6 × 27.9 cm). © Lorraine O'Grady/Artists Rights Society (ARS), New York.

PLATES 33 AND 34 Lorraine O'Grady, "Haiku Diptych 3." Artist sketch for *Cutting Out CONYT*, 1977/2017. Scans of original panels from *Cutting Out the New York Times (CONYT)*, 1977, composed of newsprint cutouts collaged on rag bond papers, each 8½" × 11" (21.6 × 27.9 cm). © Lorraine O'Grady/ Artists Rights Society (ARS), New York.

PLATE 35 Kara Walker, *The Emancipation Approximation: "Scene #6,"* 2000. Silkscreen, from a portfolio of twenty-six prints plus colophon, 44" × 34" (111.8 × 86.4 cm) each. © Kara Walker, courtesy of Sikkema Jenkins & Co., New York.

PLATE 36 Jean-Michel Basquiat, *Hollywood Africans*, 1983. Acrylic and oil stick on canvas, 84⅛" × 84" (213.5 × 213.4 cm). New York: Whitney Museum of American Art. © The Estate of Jean-Michel Basquiat/ADAGP, Paris/Artists Rights Society (ARS), New York 2019.

PLATE 37 Sean Landers, text painting detail. Cover of *Artforum International*, April 1994. © Artforum.

PLATES 38 AND 39 Lorraine O'Grady, "Diptych 3 BLUE (Charles and Michael)." From *The First and the Last of the Modernists*, 2010, a four-diptych photo installation. Diptychs composed of Fujiflex prints, 46.8" × 37.4" (118.8 × 95 cm) each. © Lorraine O'Grady/Artists Rights Society (ARS), New York.

Notes

Introduction

1 "Performance Statement #3: Thinking Out Loud: About Performance Art and My Place in It," letter to Tony Whitfield, January 2, 1983; reprinted in this volume. The present essay takes its title from this statement: "I'm concerned about the future audience of the work, about those who *will know*."

2 In "Performance Statement #3," O'Grady refers to *Mlle Bourgeoise Noire* as a "didactic essay written in space," says "the form of *Nefertiti/Devonia Evangeline* approximates that of a book," and describes *Rivers, First Draft* as a folktale. In a 2016 interview with Juliana Huxtable, she describes *Miscegenated Family Album* as a "novel in space." "Introducing: Lorraine O'Grady and Juliana Huxtable, Part 1," Museum of Contemporary Art (Los Angeles), accessed March 10, 2020, https://www.moca.org/stream/post/introducing-lorraine-ogrady-and -juliana-huxtable-part-1; and "Introducing: Lorraine O'Grady and Juliana Huxtable, Part 2," Museum of Contemporary Art (Los Angeles), accessed March 10, 2020, https://www.moca.org/stream/post/introducing-lorraine -ogrady-and-juliana-huxtable-part-2; both reprinted in this volume.

3 Between the time of preparing this manuscript and its publication, a number of style guides have changed their recommendations, suggesting that *Black* appear capitalized. However, I have chosen to respect the wishes of the artist in keeping the *b* lowercase, as it appears in the rest of the book.

4 Presentation at the *Now Dig This!* Symposium at the Museum of Modern Art in New York City on February 8, 2013; reprinted in this volume.

5 *WACK! Art and the Feminist Revolution* was curated by Cornelia Butler. It was on view at the Museum of Contemporary Art, Los Angeles, March 4–July 16, 2007, and later traveled to PS1 Contemporary Art Center, where it was on

view February 17–May 12, 2008. It also made stops at the National Museum for Women in the Arts in Washington, DC, and the Vancouver Art Gallery.

6 "Re: *Cutting Out the New York Times (CONYT)*," 1977, unpublished exhibition statement, 2006; reprinted in this volume.

7 Written for the *Village Voice* in 1973, the review was first published in 2010 as "A Review of Max's," in Steven Kasher, ed., *Max's Kansas City: Art, Glamour, Rock and Roll*, with contributions by Lou Reed, Lenny Kaye, Danny Fields, Lorraine O'Grady, and Steven Watson (New York: Abrams Image, 2010), 106; reprinted in this volume.

8 Interview with Theo Davis, *Sojourner: The Women's Forum*, November 1996, 25–28.

9 In a 2016 interview, O'Grady acknowledges the problematic position of Heidegger and other writers and thinkers she has mined in order to elaborate her ideas: "I've often had to take ideas from people who may be fascistic in certain areas of their work but nevertheless give me concepts I can use, right, like [Carl] Jung, like [Martin] Heidegger." She cites Vito Acconci too as an artist with "fascistic" tendencies. "Introducing: Lorraine O'Grady and Juliana Huxtable."

10 "Introducing: Lorraine O'Grady and Juliana Huxtable."

11 "Performance Statement #3."

12 "Performance Statement #3."

13 "Postscript" to "Olympia's Maid," originally published in *New Feminist Criticism: Art, Identity, Action*, ed. Joanna Frueh, Cassandra L. Langer, and Arlene Raven (New York: Icon, 1994); reprinted in this volume.

14 "From Me to Them to Me Again," unpublished statement from 2019. The rest of Toni Morrison's statement, which she made during her remarks at the Black Studies Center public dialogue at Portland State University on May 30, 1975, is as follows: "Somebody says you have no language and you spend twenty years proving that you do. Somebody says your head isn't shaped properly so you have scientists working on the fact that it is. Somebody says you have no art, so you dredge that up. Somebody says you have no kingdoms, so you dredge that up. None of this is necessary. There will always be one more thing."

In an edited conversation with the artist, writer, and DJ Juliana Huxtable from 2016, O'Grady cited another thinker who observed this same need for repetition and reiteration: "One of the things Edward Said wrote in *Orientalism* is that, even in academia, you find that you are always having to go back to the beginning because the drag of resistance is so great, things have to be repeated over and over again. They're not proven, transmitted as truth once and for all. Because power has the infinite capacity to resist, you find yourself making the same arguments over and over and over. You're in this loop. I think that's where many black artists are now." "Introducing: Lorraine O'Grady and Juliana Huxtable."

15 Interview with Theo Davis. In the interview, O'Grady says more specifically that she wanted to make art as a *black* art critic.

16 Email to the author, February 8, 2019.

17 "Dada Meets Mama," *Artforum International* 31, no. 2 (October 1992): 14–15; reprinted in this volume. "The Cave," *Artforum International* 30, no. 5 (January 1992): 22–24; reprinted in this volume. Connie Butler was a member of the Women's Action Coalition and used its abbreviation, WAC, to inspire her groundbreaking *WACK!* exhibition over two decades later.

18 "SWM," *Artforum International* 32, no. 8 (April 1994): 65; reprinted in this volume.

19 "SWM," 65.

20 "Olympia's Maid," published in *Afterimage* 20, no. 1 (Summer 1992); a revised version, including "Postscript," originally appeared in Frueh, Langer, and Raven, *New Feminist Criticism*; reprinted in this volume.

21 See, for example, Eunice Lipton, *Alias Olympia: A Woman's Search for Manet's Notorious Model and His Own Desire* (Ithaca, NY: Cornell University Press, 1992).

22 See, for example, the exhibition *Posing Modernity: The Black Model from Manet and Matisse to Today*, curated by Denise Murrell at the Wallach Art Gallery at Columbia University (October 24, 2018–February 10, 2019), which took as its starting point a search for Laure, Manet's model for Olympia's maid.

23 *Posing Modernity*.

24 "Some Thoughts on Diaspora and Hybridity," unpublished lecture from 1994; reprinted in this volume.

25 Spivak first used the term in a 1984 interview with Elizabeth Grosz, reprinted as "Criticism, Feminism, and Institution," in Gayatri Chakravorty Spivak, *The Post-colonial Critic: Interviews, Strategies, Dialogue*, ed. Sarah Harasym (London: Routledge, 1990), 1–16.

26 "Olympia's Maid."

27 "Olympia's Maid."

28 Around the same time, Paul Gilroy published his own take on Du Bois's notion in his book *The Black Atlantic: Modernity and Double Consciousness* (Cambridge, MA: Harvard University Press, 1993); O'Grady had read Gilroy's elaboration of these ideas in *Third Text* in the years before.

29 "Black Dreams," *Heresies #15: Racism Is the Issue* (1982): 42–43; reprinted in this volume.

30 Quoted in Andil Gosine, "Lorraine O'Grady's Landscapes," *ARC: Art, Recognition, Culture* 1 (January 2011): 26–27.

31 "Some Thoughts on Diaspora and Hybridity."

32 "On Creating a Counter-confessional Poetry," *Artforum*, November 19, 2018; reprinted in this volume.

33 O'Grady speaks extensively of the misunderstanding this work has generated over the years, including one viewer's insistence on seeing the images as "before" and "after," rather than simultaneous and internally contradictory aspects of mixed-race relationships. See, for example, "On Being the Presence

That Signals an Absence," a statement written for the unpublished, photo-copied catalogue of *Coming to Power: 25 Years of Sexually X-plicit Art by Women*, curated by Ellen Cantor and presented by David Zwirner Gallery and Simon Watson/The Contemporary, NYC, 1993; reprinted in this volume.

34 "The Diptych vs. the Triptych," unpublished conversation between Lorraine O'Grady and a studio visitor that took place on September 12, 1998; reprinted in this volume.

35 "Some Thoughts on Diaspora and Hybridity."

36 In a recent email, O'Grady notes of this period: "I decided at some point that I was not willing to lop off parts of myself in order to 'fit' a worldview that I felt was unrealistic. So then I had to think about what in the culture would have to change so that all parts of me could effectively function." Email to the author, May 1, 2019.

37 Email to the author, January 30, 2019.

38 Another indication of the belatedness of O'Grady's entry into the institutional space of the museum: though *Mlle Bourgeoise Noire* was performed starting in 1980—five years, say, before the Guerrilla Girls began their spectacular callouts of the lack of diversity in museums' collections and exhibition programming—the photo-installation based on the original piece was only acquired by the Museum of Modern Art in New York in 2015.

39 "A Day at the Races," *Artforum International* 31, no. 8 (April 1993): 10–12; reprinted in this volume.

40 "SWM."

41 "SWM."

42 Email to the author, February 8, 2019.

One. Statements and Performance Transcripts

Mlle Bourgeoise Noire 1955

Published in "Artists Chronicle," *High Performance #14* 4, no. 2 (Summer 1981): 56.

1 In a 2007 piece on *Mlle Bourgeoise Noire*, O'Grady speaks in the third person of the reaction to the New Museum iteration of the performance: "Her next invasion was of the New Museum, at the opening of the 'Persona' show in September 1981. The exhibit included nine artists using personas in their work. Mlle Bourgeoise Noire called it 'The Nine White Personae Show.' When invited to give the outreach lectures to school kids for the show, she'd replied, 'Let's talk after the opening.' . . . After the opening, she was dis-invited from giving the outreach lectures to school kids." [Ed.]

2 Bert Parks was best known as the legendary host (1955–79) of the annual Miss America Pageant telecast.

3 Born in French Guiana in 1912, and educated in Martinique and France, Léon Damas (1912–78) was one of the founders of the Négritude movement, along

with his lifelong friend Aimé Césaire and Leopold Senghor. His poetry was marked by a blunt, staccato rhythm, repetition, and alliteration—along with an impulse to enumerate his ideas. Among his poetry collections is *Pigments* (1937), which revolves around themes of the Caribbean diasporic subject, including that of the divided self. [Ed.]

4 When the piece was performed at the New Museum in 1981, the poem was a different one. Written by O'Grady, it again critiqued the well-behaved and self-contained responses of some black artists, but it also addressed the posturing art world bromides ("art is only for art's sake") that seemed to her designed to prevent questioning by "others." [Ed.]

> WAIT
> wait in your alternate/alternate spaces spitted on fish hooks of hope
> be polite wait to be discovered
> be proud be independent
> tongues cauterized at
> openings no one attends
> stay in your place
> after all, art is
> only for art's sake
> THAT'S ENOUGH don't you know sleeping beauty needs
> more than a kiss to awake
> now is the time for an INVASION!

Rivers, First Draft, *1982*

1 Brooklyn-based WLIB had appealed to Jewish and African American audiences since the 1940s; in the 1970s, in response to activists, it became black-owned, after which it focused on political and health-centered programming directed at the city's Afro-Caribbean population. [Ed.]

2 The Little Girl's recitation is a conflation of two poems that O'Grady had created in her 1977 collage series *Cutting Out the New York Times*. [Ed.]

Statement for Moira Roth re: Art Is . . . , *1983*

1 "Sniper's Nest," *Z Magazine*, July–August 1988, 102. [Ed.]

2 O'Grady's participation in the Heresies issue collective resulted in her essay "Black Dreams" (1982), reprinted in this volume. [Ed.]

Body Is the Ground of My Experience, *1991*

1 The model had been instructed to look "bored" but to most people appears dead, according to O'Grady. [Ed.]

Studies for a Sixteen-Diptych Installation

1 In the spring of 2019, the following exchange occurred between O'Grady and the poet Lisa Robertson, with me as the go-between, regarding O'Grady's statement that "none of Duval's words remain." Robertson, who was working on her novel *The Baudelaire Fractal* (Toronto: Coach House Books, 2020), writes:

> As it turns out I'd been reading Nadar's memoir of Baudelaire this week, after seeing the Nadar show at the Bibliothèque Nationale de France. (No portrait of Jeanne in that show, but a few portraits of black sitters, named and unnamed . . .). Nadar begins the memoir by talking about Jeanne at great length—her neighborhood, the theatre she acted in, her household, her blonde maid . . . also her lovers. There is part that is grotesquely disturbing, aggressively pornographic to read. Before Nadar knows Charles, he has another male friend who is also Jeanne's lover. This friend, who had done or was doing medical studies, described Jeanne's body to Nadar in clinical detail—her skin, nipples, breasts, etc. He particularly describes the colour of the skin of her naked body, and then the colour of her skin on the interior of her genitals. I had to stop reading the book for several days—the effect of this dissection left me reeling.
>
> When I did return to it, I found 2 instances of intimations of Jeanne's voice. She only ever, in those very early days, refers to Baudelaire as "monsieur." This is how Nadar describes her tone when naming Baudelaire "Monsieur": "le mot Monsieur etait proferé par la maitraisse et la suivante avec un meme accent de deferente et mysterieuse reserve."
>
> It could be interesting to ask various francophone women to attempt this pronunciation!
>
> A few pages later there is a transcription of a letter (un billet) written by Jeanne, not to Charles, but to the other, earlier lover: "On sonne un gros coup. J'étais couchée et Louise sortie. Ce ne pouvait être que toi. Je cours ouvrir en chemise. Personne! Mais à travers la cour, de mon rideau je vois ton étourneau de frère qui file comme un cerf-volant. Qu'est-ce que tu voulais? Viens me le dire."

On reading Robertson's letter, O'Grady wrote:

> I've just downloaded Nadar's memoire of Charles. I recall having deliberately avoided it. Because . . . I don't see Baudelaire as a virgin-poet, but rather as a male lesbian. I've read the poetry over many years and can't believe that he did not have sex with Jeanne. Complicated sex, but sex nonetheless.
>
> But I can't believe what my avoidance made me miss—a letter from Jeanne!

It never occurred to me that Nadar would have one when not one to Charles remained.

What an idiot I was!

Robertson responded as follows:

> I would agree with Lorraine about Baudelaire being a lesbian. I am opening my novel with a quote from one of his letters to his mother: "I have insupportable nervous troubles, exactly like women."
>
> None of Jeanne's letters to Charles survived because his mother burned them all after his death. But of course they had no access to any of Jeanne's other correspondence so couldn't burn that. It makes me wonder if there is more out there? She was very close to Privat D'Anglemont, for example, a Parisian mixed-race Guadelupian-born journalist. Could there be letters in his archive, wherever it may be? The reason they couldn't marry, had they wanted to, which we can't really fully know, is because Charles was transformed into a legal minor by court order when he was 24, so his family could control his money and spending. As a legal minor he had no adult rights, socially, economically or politically. He asked his mother to provide for Jeanne after his death, and she did not honor this request. [Ed.]

2 Joseph D. Bennett, *Baudelaire: A Criticism* (Princeton, NJ: Princeton University Press, 1944), 5. [Ed.]

3 Charles Baudelaire, "The Gallant Marksman," in *The Prose Poems and La Fanfarlo*, ed. and trans. Rosemary Lloyd (Oxford: Oxford University Press, 1991), 96. [Ed.]

Two. Writing in Space

Performance Statement #1

1 See "*Mlle Bourgeoise Noire 1955*," reproduced in this volume. [Ed.]

Performance Statement #2

1 In 1978–79, during her "voluntary residence" at Franklin Furnace, O'Grady wrote a film script in which the protagonist was a performance artist; *The Dual Soul* is the name for one of the character's performances. It was based on the Vodoun themes that most interested her: that of the Marrassa (or Divine Twins), and the Crossroad. She discarded the script, but nearly all of the ideas were used later in *Rivers, First Draft* (1982). *Rivers* was intended as the first part of a series, *Indivisible Landscapes: Rivers, Caves, Desert, City*, each featuring an autobiographical character going through an experience connected to a landscape; the series was interrupted because, as O'Grady explains, "Mlle Bour-

geoise Noire rushed in ahead of herself!" In the intersection of these projects, the Woman in Red from *Rivers, First Draft* can be considered a prequel—in O'Grady's words, "Mlle Bourgeoise Noire was who the Woman in Red might have become." Email to the editor, March 18, 2019. [Ed.]

Performance Statement #3

Letter to Tony Whitfield, in preparation for the interview for Just Above Midtown's *Afro-Pop* catalogue, dated January 2, 1983.

1 The Canadian-American sociologist Erving Goffman's 1959 book *The Presentation of Self in Everyday Life* posited the widely influential idea that an individual's self-presentation was a theatrical performance determined by one's framing in social space: "[The self] is a dramatic effect arising diffusely from a scene that is presented." Erving Goffman, *The Presentation of Self in Everyday Life* (New York: Anchor Books, 1959), 252. [Ed.]

2 Lucy Lippard, *Six Years: The Dematerialization of the Art Object from 1966 to 1972* (New York: Praeger, 1973; rpt., Berkeley: University of California Press, 1997).

3 Ping Chong's work in theater, choreography, video, and installation was just beginning to garner attention in New York City at the point that O'Grady mentions him. A foundational figure in the Asian American arts movement, he established Ping Chong & Company in 1975, with a "mission to create works of theater and art that explore the intersections of race, culture, history, art, media and technology in the modern world." "The Company," Ping Chong + Company, accessed July 9, 2019, https://www.pingchong.org/the -company/. [Ed.]

4 Martin Heidegger, "The Origin of the Work of Art," in *Basic Writings*, ed. David Farrell Krell (New York: HarperCollins, 2008), 143–212. [Ed.]

5 In an almost uncanny signal of the idea that O'Grady's work was out of sync, conceptually and temporally, with her time, the artist relates the following anecdote about the fate of the three Performance Statements included in this volume: "Shortly after writing 'Performance Statement #3,' I shared all three statements with a friend, who suggested I send them to *Artforum* magazine, since the editor there (Ingrid Sischy, I think) was a feminist and might be receptive to them. So I copied the pages, folded them in half and sent them off in a small manila envelope. After several weeks, I had not heard back and didn't follow up, assuming I had landed in the slush pile. A few months later, there was a small manila envelope in my mailbox. It was unopened. It had been returned to me as 'undelivered' by the post office. By then, I was already in Boston, taking care of my mother. It was not the right time." Email to the editor, March 18, 2019. [Ed.]

Nefertiti/Devonia Evangeline, *1980*

Published in "Performance Art: (Some) Theory and (Selected) Practice at the End of This Century," ed. Martha Wilson, special issue, *Art Journal* 56, no. 4 (Winter 1997): 64–65.

Interview with Cecilia Alemani

Published in *Mousse*, no. 24 (Summer 2010): 100–108.

Interview with Amanda Hunt on Art Is . . . , *1983*

Amanda Hunt, "*Art Is* . . . : Interview with Lorraine O'Grady," *Studio: The Studio Museum in Harlem Magazine*, Summer/Fall 2015, 21–24.

On Creating a Counter-confessional Poetry

"Interviews: Lorraine O'Grady: Lorraine O'Grady on creating a counter-confessional poetry," posted on Artforum.com, November 19, 2018, https://www.artforum.com/interviews/lorraine-o-8217-grady-on-creating-a-counter-confessional-poetry-77735.

Three. Reclaiming Black Female Subjectivity

Black Dreams

Published in "Racism Is the Issue," special issue, *Heresies*, no. 15 (1982): 42–43.

1 In a recent email correspondence, O'Grady writes: "Actually, her name was June Christmas. She was married to a member of the Spiral Group, and had recently returned to private practice after serving a political stint as the NYC Commissioner of Mental Health. She had been a great accidental find, but in the end, I left her happily as it was too close for comfort. After beginning therapy with her, I'd learned she was from Cambridge, had been a sorority sister of Devonia's, and her mother had belonged to one of my mother's bridge clubs. That's how small the Boston-Cambridge upper-middle-class black world was." [Ed.]

2 Hannah Arendt, "Introduction: Walter Benjamin, 1892–1940," in Walter Benjamin, *Illuminations: Essays and Reflections* (New York: Schocken Books, 2007), 17. [Ed.]

3 Per a recent email correspondence, O'Grady writes: "I was still straightening my hair and, in the Washington context, friends told me, looked very 'corps diplomatique.'" [Ed.]

4 *Erewhon* is the name of an 1872 novel by Samuel Butler (1835–1902), which describes an imaginary country—neither utopian nor dystopian, but rather

a satirical play on such fantasies, as well as on Victorian society as a whole. ("Erewhon" is the near-reverse transcription of "nowhere.") Butler's ideas were taken up by Gilles Deleuze and Félix Guattari starting in the late 1960s; the theorists found the nineteenth-century writer's concepts useful in describing their own notions of difference and the "desiring machine." [Ed.]

5 The imagery here—of the European country house on wheels ridden by Caribbean women—shows up in O'Grady's work *The Strange Taxi: From Africa to Jamaica to Boston in 200 Years*, an image from her series *Body Is the Ground of My Experience* (1991/2012). [Ed.]

Interview with Linda Montano

Later edited and published as "Lorraine O'Grady," in Linda M. Montano, *Performance Artists Talking in the Eighties* (Berkeley: University of California Press, 2001), 400–406.

Dada Meets Mama

Published in *Artforum International* 31, no. 2 (October 1992): 14–15.

1 Tristan Tzara, "Seven Dada Manifestoes," in *Dada Painters and Poets*, 2nd ed., ed. Robert Motherwell (Boston: G. K. Hall & Co., 1981), 95.

2 WHAM! (Women's Health Action and Mobilization) was established in 1989 in response to a U.S. Supreme Court ruling that states could bar the use of public money and facilities for abortions. NARAL Pro-Choice America is the oldest abortion rights advocacy group in the United States. [Ed.]

3 Sheila Radford-Hill, "Considering Feminism as a Model for Social Change," in *Feminist Studies/Critical Studies*, ed. Teresa de Lauretis (Bloomington: Indiana University Press, 1986), 170, makes the strongest and most succinct of the contemporary calls for a separate black feminist movement, one in which middle-class black women learn to unite with working-class black women to achieve their common goals.

4 Tzara, "Seven Dada Manifestoes," 75.

The Cave

Published in *Artforum International* 30, no. 5 (January 1992): 22–24.

1 Stacy L. Smith, Marc Choueiti, Angel Choi, and Dr. Katherine Pieper, "Inclusion in the Director's Chair: Gender, Race, and Age of Directors across 1200 Films from 2007 to 2018," USC Annenberg Inclusion Initiative, Los Angeles, January 2019. [Ed.]

2 These reflections, made at the 1992 College Art Association conference, became the basis of O'Grady's groundbreaking article "Olympia's Maid," reproduced in this volume. [Ed.]

3 See Judy Chicago, *The Dinner Party: A Symbol of Our Heritage* (Garden City, NY: Anchor/Doubleday, 1979); and Hortense J. Spillers, "Interstices: A Small Drama of Words," in *Pleasure and Danger: Exploring Female Sexuality*, ed. Carole S. Vance (Boston: Routledge & Kegan Paul, 1984), 77.

4 Karen Grigsby Bates, "They've Gotta Have Us: Hollywood's Black Directors," *New York Times Magazine*, July 14, 1991, 10 ff.

5 O'Grady refers here to a foundational text of mainstream feminist art history, Linda Nochlin's "Why Have There Been No Great Women Artists?," which enumerated the ways in which European women had been structurally excluded from participation in the institutions of "great art" by virtue of their gender. [Ed.]

6 Richard Schickel, "Hollywood's New Directions," *Time*, October 14, 1992, 68–78.

7 Euzhan Palcy, quoted in Nina J. Easton, "Calendar: The Invisible Woman," *Los Angeles Times*, September 29, 1991, 54.

8 Barbara Johnson, "Metaphor, Metonymy, and Voice in *Their Eyes Were Watching God*," in *Black Literature and Literary Theory*, ed. Henry Louis Gates Jr. (New York: Methuen, 1984), 216.

9 Sapphire refers to a stereotype of black women as rude, overbearing, emasculating, and loud—the caricature of the "angry black woman." The long-standing trope was personified in a character on the *Amos 'n' Andy* radio show, which aired from 1928 to 1960. [Ed.]

10 Hortense Spillers, "Mama's Baby, Papa's Maybe: An American Grammar Book," *Diacritics* 17, no. 2 (Summer 1987): 80.

11 When I asked O'Grady to confirm her use of the word "verb" in this sentence, she responded as such: "The word 'verb' is intentional here. I think it started as a borrowing from the title of Lowery Stokes Simms and Lesley King-Hammond's 1988 exhibit of African American avant-garde art called *Art as a Verb*. But here, to me, 'verb' is more like the Greek 'logos,' the word that summons from lifelessness to life, to a state of 'being.' I think most people see the Logos as a noun, a call to 'being' or 'essence,' having as its synonym 'truth.' But I see the Logos as a call to 'action,' as a verb. All the nouns are already there. Now we must ACT on them." [Ed.]

12 The studio assistant in question is the artist, designer, and educator Robert Ransick, now vice president of academic affairs at the Minneapolis College of Art and Design. [Ed.]

13 See the interview with Martina Attille in Coco Fusco, *Young, British and Black: The Work of Sankofa and Black Audio Film Collective* (Buffalo: Hallwalls/Contemporary Arts Center, 1988), 39; and Manthia Diawara, "The Nature of Mother in *Dreaming Rivers*," *Black American Literature Forum* 25, no. 2 (Summer 1991): 283–98, an issue on black film guest-edited by Valerie Smith, Camille Billops, and Ada Griffin.

14 Discussed in Nancy Hartsock, "Rethinking Modernism: Minority vs. Majority Theories," *Cultural Critique*, no. 7 (Fall 1987): 198.

The first part of this article was published in *Afterimage* 20, no. 1 (Summer 1992): 14–15. The revised version, including "Postscript," originally appeared in *New Feminist Criticism: Art, Identity, Action*, ed. Joanna Frueh, Cassandra L. Langer, and Arlene Raven (New York: Icon, 1994), 152–70. The article has subsequently been reprinted in *Art, Activism, and Oppositionality: Essays from Afterimage*, ed. Grant Kester (Durham, NC: Duke University Press, 1998), 268–86, and *The Feminism and Visual Culture Reader*, 2nd ed., ed. Amelia Jones (London: Routledge, 2010).

1 Hortense J. Spillers, "Interstices: A Small Drama of Words," in *Pleasure and Danger: Exploring Female Sexuality*, ed. Carole S. Vance (Boston: Routledge and Kegan Paul, 1984), 77.

2 Sylvia Ardyn Boone, *Radiance from the Waters: Ideals of Feminine Beauty in Mende Art* (New Haven, CT: Yale University Press, 1986), 102.

3 "African American Women in Defense of Ourselves" (advertisement), *New York Times*, November 17, 1991, 53.

4 Judith Wilson, "Getting Down to Get Over: Romare Bearden's Use of Pornography and the Problem of the Black Female Body in Afro-U.S. Art," in *Black Popular Culture*, ed. Gina Dent (Seattle: Bay Press, 1992), 114.

5 Toni Morrison, *Beloved* (New York: Knopf, 1987), 119.

6 George Nelson Preston, quoted in Wilson, "Getting Down," 114.

7 For an examination of the relationship of black women to the first white feminist movement, see Hazel V. Carby, *Reconstructing Womanhood: The Emergence of the Afro-American Woman Novelist* (New York: Oxford University Press, 1987), chaps. 1 and 5; and bell hooks, *Ain't I a Woman: Black Women and Feminism* (Boston: South End, 1981). For insights into the problems of black women in the second white feminist movement, see Audre Lorde, "Age, Race, Class, and Sex: Women Redefining Difference," in *Out There: Marginalization and Contemporary Cultures*, ed. Russell Ferguson, Martha Gever, Trinh T. Minh-ha, and Cornel West (New York: New Museum of Contemporary Art, 1990); and Bernice Johnson Reagon, "Coalition Politics: Turning the Century," in *Home Girls: A Black Feminist Anthology*, ed. Barbara Smith (New York: Kitchen Table: Women of Color Press, 1983). For problems of women of color in a white women's organization at the start of the third feminist movement, see Lorraine O'Grady on WAC, "Dada Meets Mama," *Artforum* 31, no. 2 (October 1992): 11–12.

8 See Judy Chicago, *The Dinner Party: A Symbol of Our Heritage* (New York: Anchor/Doubleday, 1979).

9 Spillers, "Interstices," 78.

10 Michelle Wallace, "Multiculturalism and Oppositionality," *Afterimage* 19, no. 3 (October 1991): 7.

11 Nancy Hartsock, "Rethinking Modernism: Minority vs. Majority Theories," in "The Nature and Context of Minority Discourse II," ed. Abdul R. Jan-Mohamed and David Lloyd, special issue, *Cultural Critique* 7 (Fall 1987): 204.

12 See the title story by Merle Hodge in *Her True-True Name*, ed. Pamela Morde-cai and Betty Wilson (London: Heinemann Caribbean Writers Series, 1989), 196–202. This anthology is a collection of short stories and novel extracts by women writers from the English-, French-, and Spanish-speaking Caribbean.

13 The understanding that analysis of the contemporary situation of African American women is dependent on the imaginative and intellectual retrieval of the black woman's experience under slavery is now so broadly shared that an impressive amount of writings has accumulated. In fiction, a small sampling might include, in addition to Morrison's *Beloved*, Margaret Walker, *Jubilee* (New York: Bantam, 1966); Octavia E. Butler, *Kindred* (1979; rpt., Boston: Beacon, 1988); Sherley A. Williams, *Dessa Rose* (New York: William Morrow, 1986); and Gloria Naylor, *Mama Day* (New York: Ticknor and Fields, 1988). For the testimony of slave women themselves, see Harriet A. Jacobs, *Incidents in the Life of a Slave Girl*, ed. Jean Fagan Yellin (Cambridge, MA: Harvard University Press, 1987); *Six Women's Slave Narratives*, Schomburg Library of Nineteenth-Century Black Women Writers (New York: Oxford University Press, 1988); and Gerda Lerner, ed., *Black Women in White America: A Documentary History* (New York: Vintage Books, 1972). For a historical and sociological overview, see Deborah Gray White, *Ar'n't I a Woman? Female Slaves in the Plantation South* (New York: Norton, 1985).

14 Wilson, "Getting Down," 121n13.

15 Wilson, "Getting Down," 114.

16 Wilson, "Getting Down," 114.

17 Wilson, "Getting Down," 114.

18 Judith Wilson, telephone conversation with the author, January 21, 1992.

19 Wilson, "Getting Down," 116–18.

20 Adrian Piper, "Food for the Spirit, July 1971," *High Performance* 13 (Spring 1981). This was the first chronicling of *Food* with accompanying images. The nude image from this performance first appeared in Piper's retrospective catalogue: Jane Farver, *Adrian Piper: Reflections 1967–87*, Alternative Museum, New York, April 18–May 30, 1987.

21 Hortense Spillers, "Mama's Baby, Papa's Maybe: An American Grammar Book," *Diacritics* 17, no. 2 (Summer 1987): 68.

22 Hartsock, "Rethinking Modernism," 196, 194.

23 Toni Morrison, quoted in Charles Ruas, "Toni Morrison's Triumph" (interview), *Soho News*, March 11–17, 1981, 12.

24 Gayatri Chakravorty Spivak, "Three Women's Texts and a Critique of Imperialism," in *"Race," Writing, and Difference*, ed. Henry Louis Gates Jr. (Chicago: University of Chicago Press, 1986), 272.

25 "Carnal Knowing: Sexuality and Subjectivity in Representing Women's Bodies," a panel of the College Art Association, Eightieth Annual Conference, Chicago, February 15, 1992, was chaired by Margaret R. Miles of Harvard Divinity School, and included Joyce Fernandes, Anne Naldrett, Lynn Randolph, and Sarah Schuster. The original title of O'Grady's panel presentation was "Olympia's Maid: She'll Take Subjectivity, Medium Rare." [Ed.]

26 A riff on Barbara Christian's title "But What Do We Think We're Doing Anyway: The State of Black Feminist Criticism(s)," in *Changing Our Own Words: Essays on Criticism, Theory, and Writing by Black Women*, ed. Cheryl A. Wall (New Brunswick, NJ: Rutgers University Press, 1989), which is itself a riff on Gloria T. Hull's title "What It Is I Think She's Doing Anyhow: A Reading of Toni Cade Bambara's *The Salt Eaters*," in Smith, *Home Girls*, which is in turn a riff on Toni Cade Bambara's autobiographical essay, "What It Is I Think I'm Doing Anyhow," in *The Writer on Her Work*, ed. Janet Sternberg (New York: Norton, 1980).

27 "But by thus remaking contact with the body, and with the world, we shall also discover ourselves, since, perceiving as we do with our body, the body is a natural self and, as it were, the subject of perception." Maurice Merleau-Ponty, quoted by Edward R. Levine, unpublished paper delivered at College Art Association, Eightieth Annual Conference, Chicago, February 13, 1992. (The original quotation appears in Maurice Merleau-Ponty, *Phenomenology of Perception*, trans. Colin Smith [London: Routledge, 2002], 239. [Ed.])

28 Gayatri Chakravorty Spivak, "Strategy, Identity, Writing," in *The Post-colonial Critic: Interviews, Strategies, Dialogues*, ed. Sarah Harasym (New York: Routledge, 1990), 42.

29 Kobena Mercer and Isaac Julien, "Race, Sexual Politics and Black Masculinity: A Dossier," in *Male Order: Unwrapping Masculinity*, ed. Rowena Chapman and Jonathan Rutherford (London: Lawrence & Wishart, 1987), 106–7.

30 Wallace, "Multiculturalism," 7.

31 Spivak, "Criticism, Feminism, and the Institution," in Harasym, ed., *The Post-colonial Critic*, 11.

32 See the oft-quoted phrase "for the master's tools will never dismantle the master's house," in Lorde, "Age, Race," 287.

33 Jacqueline Rose, "Sexuality and Vision: Some Questions," in *Vision and Visuality*, ed. Hal Foster, Dia Art Foundation, Discussions in Contemporary Culture, no. 2 (Seattle: Bay Press, 1988), 130.

34 Wallace, "Multiculturalism," 7.

35 bell hooks, *Black Looks: Race and Representation* (Boston: South End, 1992), 115–31.

36 Spivak, "Criticism, Feminism, and the Institution," 11.

37 Alfred Adler was a student of Sigmund Freud's; the two famously disputed over what Adler considered Freud's overemphasis on sexuality in his teacher's psychoanalytic approach, positing instead that the will to power drove individual psychology. [Ed.]

38 Spillers, "Interstices," 79.

39 See the famous description of African American "double-consciousness" in W. E. B. Du Bois, *The Souls of Black Folk* (New York: New American Library, 1982), 45.

40 Elizabeth Hess, "Black Teeth: Who Was Jean-Michel Basquiat and Why Did He Die?," *Village Voice*, November 3, 1992, 104.

41 "The expressionist quest for immediacy is taken up in the belief that there exists a content beyond convention, a reality beyond representation. Because this quest is spiritual, not social, it tends to project metaphysical oppositions (rather than articulate political positions); it tends, that is, to stay within the antagonistic realm of the Imaginary." Hal Foster, *Recodings: Art, Spectacle, Cultural Politics* (Seattle: Bay Press, 1985), 63.

42 Cited in Teresa de Lauretis, *Feminist Studies/Critical Studies* (Bloomington: Indiana University Press, 1986), 17.

43 Stuart Hall, "Theoretical Legacies," in *Cultural Studies*, ed. Lawrence Grossberg, Cary Nelson, and Paula Treichler (New York: Routledge, 1992), 291.

44 Spivak, "Criticism, Feminism, and the Institution," 47.

45 bell hooks, interviewed by Lisa Jones, "Rebel without a Pause," *Voice Literary Supplement*, October 1992, 10.

46 Paul Éluard, quoted in Mary Ann Caws, *The Poetry of Dada and Surrealism: Aragon, Breton, Tzara, Éluard, and Desnos* (Princeton, NJ: Princeton University Press, 1970), 167.

47 Hall, "Theoretical Legacies."

48 Flannery O'Connor, *Mystery and Manners: Occasional Prose*, selected and ed. Sally Fitzgerald and Robert Fitzgerald (New York: Farrar, Straus & Giroux, 1961), 197.

49 Rose, "Sexuality and Vision," 129.

50 Deborah E. McDowell, "Boundaries," in *Afro-American Literary Study in the 1990s*, ed. Houston A. Baker Jr. and Patricia Redmond (Chicago: University of Chicago Press, 1989), 70.

Mlle Bourgeoise Noire *and Feminism*

Statement recorded for the *WACK! Art and the Feminist Revolution* cell phone tour, February 2007; transcript later published in *Art Lies* 54 (Summer 2007).

Four. Hybridity, Diaspora, and Thinking Both/And

On Being the Presence That Signals an Absence

1 See Lorraine O'Grady, "Olympia's Maid: Reclaiming Black Female Subjectivity," reprinted in this volume. [Ed.]

Some Thoughts on Diaspora and Hybridity

Unpublished slide lecture, given at Wellesley College during the premiere of the *Miscegenated Family Album* installation, in the exhibition *The Body as Measure*, Davis Museum and Cultural Center, Wellesley, MA, 1994.

1 The formulation is that of Trinh T. Minh-ha, in the introduction to a special issue of the journal *Discourse*: Trinh T. Minh-ha, ed., "She: The Inappropriate/d Other," *Discourse*, no. 8 (Fall/Winter 1986–87). [Ed.]

2 This is a paraphrase of Paul Gilroy's statement, which appears in the introduction of *The Black Atlantic: Modernity and Double Consciousness* (Cambridge, MA: Harvard University Press, 1993), 3: he refers to "the stereophonic, bilingual, or bifocal cultural forms originated by, but no longer the exclusive property of, blacks dispersed within the structures of feeling, producing, communicating, and remembering what I have heuristically called the black Atlantic world." [Ed.]

3 Martin Bernal, *Black Athena: The Afroasiatic Roots of Classical Civilization*, 3 vols. (New Brunswick, NJ: Rutgers University Press, 1987, 1991, and 2006). The first two volumes had been published by the time O'Grady delivered these remarks. [Ed.]

Flannery and Other Regions

Published in Sarah Gordon, ed., *Flannery O'Connor: In Celebration of Genius* (Athens, GA: Hill Street Press, 2000), 73–78.

1 Quoted in Ross Mullins Jr., "Flannery O'Connor: An Interview," *Jubilee* 11 (1963): 32–35; reprinted in Rosemary M. Magee, ed., *Conversations with Flannery O'Connor* (Jackson: University Press of Mississippi, 1987), 106. [Ed.]

2 Flannery O'Conner, "The Fiction Writer and His Country," in *Mystery and Manners: Occasional Prose*, selected and ed. Sally Fitzgerald and Robert Fitzgerald (New York: Farrar, Straus & Giroux, 1961). [Ed.]

Responding Politically to William Kentridge

Published in Alan de Souza, ed., special issue, *X-Tra* 5, no. 3 (Spring 2003). A version of this article was originally read as a paper for "Animating Insights: A Conversation on the Work of William Kentridge," a panel moderated by David Theo Goldberg at the Los Angeles County Museum of Art on September 14, 2002. The title here is that of the original panel presentation at LACMA.

Sketchy Thoughts on My Attraction to the Surrealists

Unpublished first draft for Simone Leigh's presentation at the Performa Institute conference, "Get Ready for the Marvelous: Black Surrealism in Dakar, Fort-de-France, Havana, Johannesburg, New York City, Paris, Port-au-Prince, 1932–2013," New York University, Steinhardt School of Culture, Education, and Human Development, February 8–9, 2013.

1 Although she had admired Katherine Dunham's work as a choreographer and dancer, and her sister-in-law Billie Allen had danced in Dunham's international company, O'Grady would not learn until 2015, while preparing the premiere of the *Rivers, First Draft* installation, that it was Dunham who had introduced Deren to Haitian Vodoun. While engaged in her dance career, Dunham had also completed her undergraduate degree in social anthropology at the University of Chicago. A grant from the Julius Rosenwald Foundation enabled her to do fieldwork on dance in the West Indies. Dunham hired Maya Deren as her private secretary to help with studio administration and with organizing the Haitian field data key to the master's thesis she would submit to the University of Chicago. After being stunned by this sadly ironic but not unfamiliar path of knowledge transmission, from the African American Dunham to the Jewish American Deren to herself, O'Grady's response was typically sardonic: "Only in America," she said. [Ed.]

2 The structure of the crossroad is at the heart of O'Grady's *Rivers, First Draft* installation, which organizes images of the one-time performance into a series of single lines which, in turn, are sporadically interrupted by vertical image stacks that invoke the crossroad concept spatially so as to capture the work's narrative complexity and meaning. [Ed.]

Introducing: Lorraine O'Grady and Juliana Huxtable

1 The panel took place on December 5, 2015. Moderated by William J. Simmons, it included David J. Getsy, a professor of art history at the School of the Art Institute of Chicago; Gordon Hall (an artist from New York); Kimberly Drew (founder of Black Contemporary Art); and Juliana Huxtable. "Salon: Transgender in the Mainstream," YouTube video, 1:09:07, accessed March 10, 2020, https://www.youtube.com/watch?v=zsHXmS1jJYE&t=51s. [Ed.]

2 "Juliana Huxtable: In Conversation with Jarrett Earnest," in NYAQ/LXAQ/SFAQ: International Art and Culture, March 9, 2016, http://sfaq.us/2016/03/juliana-huxtable-in-conversation-with-jarrett-earnest/.

3 Martin Bernal, *Black Athena: The Afroasiatic Roots of Classical Civilization*, 3 vols. (New Brunswick, NJ: Rutgers University Press, 1987, 1991, and 2006). [Ed.]

4 Chancellor Williams, *The Destruction of Black Civilization: Great Issues of a Race from 4500 BC to 2000 AD* (Chicago: Third World, 1974). [Ed.]

Five. Other Art Worlds

A Day at the Races

Published in *Artforum International* 31, no. 8 (April 1993): 10–12.

1 Roberta Smith, "Mass Productions," *Village Voice*, March 23, 1982, 84; "Outsiders Who Specialized in Talking Pictures," *New York Times*, November 19, 1989, sec. 2, 35; "Basquiat: Man for His Decade," *New York Times*, October 23, 1992, C1 ff.

2 Luis Camnitzer, "Art, Politics and the Evil Eye; El arte, la politica y el mal de ojo," *Third Text* 20 (Autumn 1992): 69–75.

SWM: On Sean Landers

Published in *Artforum International* 32, no. 8 (April 1994): 65–66.

1 The idea was elaborated for an English-speaking audience in Julia Kristeva, *The Powers of Horror: An Essay on Abjection*, trans. Leon S. Rudiez, European Perspectives (New York: Columbia University Press, 1982). [Ed.]

2 The exhibition O'Grady refers to, *Abject Art: Repulsion and Desire in American Art*, was organized by three participants in the Whitney Independent Study Program—Craig Houser, Leslie C. Jones, and Simon Taylor—in 1993. In the catalogue for the show, the curators described their aims: "Employing methodologies adapted from feminism, queer theory, post-structuralism, Marxism, and psychoanalysis, our goal is to talk dirty in the institution and degrade its atmosphere of purity and prudery by foregrounding issues of gender and sexuality in the art exhibited." [Ed.]

3 Jack Bankowsky, "Slackers," *Artforum* 30, no. 3 (November 1991): 96.

4 Kobena Mercer, "Skin Head Sex Thing: Racial Difference and the Homoerotic Imaginary," in *How Do I Look? Queer Film and Video*, ed. Bad Object-Choices (Seattle: Bay Press, 1991), 187.

5 Hal Foster, *Compulsive Beauty* (Cambridge, MA: October Books/MIT Press, 1993), 211–12.

Poison Ivy

This letter—a response to "Crimson Herring: Ronald Jones on 'Black Like Who?'" (Harvard University symposium on stereotypes in art), *Artforum International* 36, no. 10 (Summer 1998): 17–18—was published as "Poison Ivy," *Artforum International* 37, no. 1 (October 1998): 8.

1 Included in the latter group of "most currently certified names" were Glenn Ligon and Lorna Simpson. [Ed.]

The Black and White Show, *1982*

Published in *Artforum* 47, no. 9 (May 2009): 190–95.

Email Q&A with Artforum *Editor*

1 This was certainly true in 2009, when O'Grady was composing these re-
sponses. The 2014 Whitney Biennial was perhaps the most explicit refusal of
"multiculturalism" to date, with a paltry 20 percent artists of color and 30
percent women, approximately (the two categories overlap). Since the 2017
iteration of the exhibition, curated by Christopher Lew and Mia Locks, the
tide seems to have turned: despite controversy around the exhibition, it was
the most diverse in the museum's history and included a notable number of
works that dealt directly with race, in its classed and gendered inflections.
And in the 2019 biennial, organized by Rujeko Hockley and Jane Panetta,
over half of the participating artists were black, indigenous, or other people
of color. [Ed.]

My 1980s

O'Grady's lecture was cosponsored by the Museum of Contemporary Art and
Columbia College, Chicago. A slightly different version of this article was
published as "This Will Have Been: My 1980s," *Art Journal* 71, no. 2 (Summer
2012): 6–17.
1 Thelma Golden, "Introduction," in *Freestyle: The Studio Museum in Harlem*,
ed. Christine Y. Kim and Franklin Sirmans (New York: Studio Museum of
Harlem, 2001). [Ed.]
2 The definition of "postblackness" in the years since Golden introduced it has
been impressionistic at best. Among the other challenges, the term suggests
a picture of generational "progress" that does not hold up under historical
scrutiny, as recent shows such as *We Wanted a Revolution* and *Soul of a Nation*
demonstrate clearly: in the age of Black Power, there were a large number of
prominent artists who rejected the call to make what they saw as politically
didactic art (including Sam Gilliam, Alma Thomas, and others who explored
pure abstraction), while others—including O'Grady—were making work that
used ideas of multiculturalism and cultural hybridity to deepen and expand
the meaning of "black experience" beyond the monolithic, rather than reject-
ing the phrase as a categorical or essentialist term. [Ed.]
3 The phrase is from Helen Molesworth, "This Will Have Been," in *This Will
Have Been: Art, Love, and Politics in the 1980s*, exhibition catalogue (Chicago: Mu-
seum of Contemporary Art Chicago; New Haven, CT: Yale University Press,
2012), 43. Writing of Félix González-Torres's *Untitled (Perfect Lovers)*, 1987–90,

"in which two store-bought clocks hang plainly, side by side," Molesworth elaborates: "Synchronized at the time of their installation, they slowly, inevitably grow out of step with each other. . . . Now, more than two decades later . . . these two clocks, ticking ever so slightly in and out of rhythm with one another, offer a model of history and subjectivity. . . . There is never one story, one account, one sense of time that prevails. There is always more than one. The game—of history, of politics, of art, of love—is to figure out how to let the clocks strike differently without losing time."

4 See Lorraine O'Grady, "Olympia's Maid: Reclaiming Black Female Subjectivity," in *The Feminism and Visual Culture Reader*, ed. Amelia Jones (London: Routledge, 2010), 208–20 [reprinted in this volume].

5 Molesworth, "This Will Have Been," 15.

6 "The last movement" is the curator Ann Goldstein's phrase to describe, according to Molesworth, "the last time artists, however seemingly disparate their respective bodies of work may have appeared, nonetheless held in common a set of hopes and assumptions about the role of art in the public sphere." Molesworth, "This Will Have Been," 17.

7 It's hard to avoid magical thinking with the term "postmodernism"—in my case, the barely disguised longing for pluralisms with enough weight to unseat the master narratives of modernism. In general, though, my definitions oscillate between the evolving and necessarily inconsistent view of postmodernism in the earlier and later Stuart Hall, i.e., between seeing it as a primarily American view of history (as in "the end of") and then seamlessly appropriating it as an analytic tool to understand "globalized" ethnicity and the diasporic subject. I also wonder if the older white male audience member who, after this talk, advised me to use the word more carefully because postmodernism was not a sociological or cultural theory but an aesthetic style, might not have had a valid point.

8 See Johanna Burton, "A Few Troubles with 'The Eighties,'" in *This Will Have Been*, 254.

9 The French forces had a 73 percent casualty rate (combined dead, wounded, imprisoned, and missing), an almost unimaginable figure. See John Graham Royde-Smith and Dennis E. Showalter, "World War I: Killed, Wounded, and Missing," Encyclopaedia Britannica, published March 27, 2020, https://www.britannica.com/event/World-War-I/Killed-wounded-and-missing. The British Empire's military deaths were three times those of World War II. Wikipedia, s.v. "World War I casualties," last modified March 11, 2020, http://en.wikipedia.org/wiki/World_War_I_casualties; and Wikipedia, s.v. "World War I casualties," last modified February 29, 2020, http://en.wikipedia.org/wiki/World_War_II_casualties.

10 The preeminent war historian John Keegan has written: "The First, unlike the Second World War, saw no systematic displacement of populations, no deliberate starvation, no expropriation, little massacre or atrocity. It was . . .

a curiously civilized war. Yet it damaged civilization, the rational and liberal civilization of the European enlightenment, permanently for the worse. . . . Pre-war Europe, imperial though it was in its relations with most of the world beyond the continent, offered respect to the principles of constitutionalism, the rule of law and representative government. Post-war Europe rapidly relinquished confidence in such principles." John Keegan, *The First World War* (New York: Knopf, 1999), 6, quoted online in the *New York Times*, accessed September 10, 2012, www.nytimes.com/books/first/k/keegan-first.html?_r=1.

Rivers *and Just Above Midtown*

"Intro," conference presentation, *Now Dig This!* symposium, February 8, 2013, Museum of Modern Art, New York; "Text," in *Lorraine O'Grady*, exhibition catalogue (New York: Alexander Gray Associates, 2015).

1 Just Above Midtown/Downtown members mentioned in text: Linda Goode Bryant, David Hammons, Senga Nengudi, Maren Hassinger, Houston Conwill, Randy Williams, Tyrone Mitchell, George Mingo, Fred Wilson, Sandra Payne, Cynthia Hawkins, Coreen Simpson, Dawoud Bey, Danny Dawson, Charles Abramson, Dan Concholar, Candida Alvarez, plus Lowery Simms and Kynaston McShine.

Six. Retrospectives

Interview with Laura Cottingham

Interview collected in James V. Hatch, Leo Hamalian, and Judy Blum, eds., *Artist and Influence 1996*, vol. 15, Artist and Influence series (New York: Hatch-Billops Collection, 1996), 204–19. The interview took place on November 5, 1995.

1 My teenaged marriage ended in divorce, and the child I'd had at 18 was being raised by his paternal grandparents.

2 I did not know how old Piper was, or that she was black, as the book had no biographical information.

3 In 1980–81, videotaped documentation was prohibitively expensive. Of the still-photograph documents I received of the performance, none showed the precise moment of the "throw-down," because I forgot to alert the photographers to it.

4 In a recent correspondence, O'Grady reassessed her interpretation of Hammons's reaction: "I've changed my feeling about David's comment since then. He wasn't annoyed. Given his continued welcoming treatment of me, now I think he was more surprised, even shocked." [Ed.]

5 I had shared one of those "the more things change, the more they stay the same" stories, about how shocked the students had been that they could re-

late more to a young poet from 2,000 years ago talking honestly about his sexual and emotional experience than they could to a contemporary writer who had been dishonest.

6 It was important that the gloves had been worn, that they'd belonged to women who'd in some sense actually believed in them.

7 The feeling of black fair-skinned superiority took on a different valence in the Caribbean than in the States because it was often accompanied by a greater degree of real economic power.

Interview with Jarrett Earnest

"Lorraine O'Grady, in Conversation with Jarrett Earnest," *Brooklyn Rail*, February 3, 2016, 56–63.

1 Womanhouse was a feminist installation and performance space organized by Judy Chicago and Miriam Schapiro in Los Angeles. The site was an old Victorian house not far from California Institute of Arts campus, where the two artists had established the Feminist Art Program. Running for two months in 1972, Chicago, Schapiro, and a number of their colleagues and students installed works that grappled with the relationship between femininity and domesticity; the exhibition, which was open only to women on its first day, eventually drew ten thousand visitors over the course of its run. [Ed.]

First There Is a Mountain, Then There Is No Mountain, Then . . . ?

1 O'Grady adapted the article's title from a line in "There Is a Mountain" (1967), the Donovan Leitch hit on which the Allman Brothers would later build their thirty-minute instrumental "Mountain Jam," her favorite cut on the *Eat a Peach* album (1973). Donovan's chorus—"First there is a mountain, then there is no mountain, then there is"—was in turn borrowed from the ninth-century Buddhist master Qingyuan Weixin (Ch'ing-yüan Wei-hsin). It is generally known that, in 1971, both codrummer Butch Trucks and coguitarist Dickey Betts of the Allman Brothers were reading Buddhist writings.

This aspect of the band's interests was appealing to O'Grady, as she recounted in a recent conversation:

The Allmans were hardly spiritual. But I think all of them knew deeply about things like flow and openness to other ideas because of the way they had learned and lived music. Especially Duane and Gregg. As kids, they'd sought out older black musicians to teach them how to play and black kids their own age to jam with.

As for me, though I'd been religious as an adolescent, I'd gradually rejected religion both as institution and as a system of understanding. When my sister died in January 1962, I put it behind me. The only thing vaguely

Buddhist I read in the '60s were two newly published collections of haiku poetry. I would become a bit more familiar with Buddhist culture and aesthetics after 1982 when I began reading Murasaki Shikibu. I read the *Tale of Genji* five times! I was obsessed with learning from this woman who lived in 1,000 CE and who, while she was the tutor of the Japanese Empress and had never even seen a novel, was able to write the world's first psycho-philosophical narrative—at the level (and the length!) of Proust. Reading Murasaki's *Genji* is the largest literary commitment I've ever made. I can't say I studied it. It was more intuitive than that. After reading Ralph Ellison and James Baldwin, Toni Morrison and Alice Walker, Jane Austin and Charlotte Brontë, Flannery O'Connor, Jean Rhys and Charles Baudelaire, it was strange to find myself so confirmed by someone so close and so dissimilar, so near and so alien. But I think that, like the Allmans, you can arrive at and deepen anti-binarism in many different ways. [Ed.]

2 In a recent communication, O'Grady writes: "So much for assumptions! I was wrong, of course. The black drummer is Jai Johanny Johanson, who will later be known just by a single name: 'Jaimoe.'" [Ed.]

The Wailers and Bruce Springsteen at Max's Kansas City

Written for the *Village Voice*, but rejected with an editorial note that it was "too soon for these two," the review was first published in 2010 as "A Review of Max's," in Steven Kasher, ed., *Max's Kansas City: Art, Glamour, Rock and Roll*, with contributions by Lou Reed, Lenny Kaye, Danny Fields, Lorraine O'Grady, and Steven Watson (New York: Abrams Image, 2010), 106.

Index

252–53, 255, 268; LOG's entry into, 46, 223; and postmodernism, 206; invisibility of black artists, 158–60; and black art, 237; biennial circuit, 160; and market, 172

Attille, Martina (filmmaker), *Dreaming Rivers*, 92

audience: coming in future, as preservers of artwork, xxii–xxiii, 47–48, 157–58; unimagined, 129; enabling, 170; those who need to find a home in the work, 48; minorities a new and more aware, 128; consuming, and art market, 170; a problem for black artists, 237; Michael Jackson breaks ghettoization of, for popular culture, 57; Basquiat isolated from, 172; young artists as LOG's primary, 202; and performance, 38, 146; LOG's first performance for, 50–51; of *Miscegenated Family Album*, 220, 237; of *Mlle Bourgeoise Noire*, 255; of *Rivers, First Draft*, 214

Augeri, Lynne, 258; *Torso Number 38*, 194

avant-garde art: and African Americans, 24–25, 62, 111, 159, 173–74, 211; influence on LOG, 45. See also *Art as a Verb*; *The Black and White Show*; Just Above Midtown

Baker, Stan, 37

Baldwin, James, 128

Baldwin, Mary, 265

Barrow, Willie, 265

Basquiat, Jean-Michel, xxxiv; and art market, 169–71; isolation of, 172–73; retrospective at Whitney Museum, 169–75; validated by white gallery system, 173; and *The Black and White Show*, 172–73, 185, 196; *Hollywood Africans* (painting), 286p36; *Jean-Michel Basquiat and His Friends Being Stopped by the Police* (drawing by Lack), 196. *See also* "A Day at the Races"; "Email Q&A with *Artforum* Editor"; "Introducing: Lorraine O'Grady and Juliana

Huxtable"; "The *Mlle Bourgeoise Noire* Project"; "Some Thoughts on Diaspora and Hybridity"; "swm: On Sean Landers"

Baudelaire, Charles: and modernism, 54–56; and *Les Fleurs du Mal*, 31, 58; and Jeanne Duval, 30–33, 54–55, 236, 292–93n1; debt to Jeanne Duval, 31–32; LOG's interest in, 53–54; and Michael Jackson, 57–59, 247–48; photos of, 32; in *The First and the Last of the Modernists*, 53, 286p38; in *Flowers of Evil and Good*, 30–32, 53, 285p29–30

Bausch, Pina, 216

beauty: and political art, 155–56; and performance, 246; in non-European Surrealism, 137; of Egyptian culture, 150; Mende feminine beauty, 95; fashion models and black beauty, 245; contradictory and ambiguous, of Jeanne Duval, 31; Michael Jackson, 248; *Mlle Bourgeoise Noire* as beauty queen, xxxiii, 8, 78, 246; of *Nefertiti/Devonia Evangeline*, 82, 149; "Black Is Beautiful," 97

bells tolling, 160–61

Beloved (Morrison), 96

Benjamin, Walter, 70–71

Bennett, Joseph D., 31–32

Benson, Frank, 146

Bergman, Ingmar, *Seventh Seal*, 134

Bernal, Martin, *Black Athena*, 51, 122, 150

Betts, Dicky, 271, 275–76

Between the Lines (exhibition), 6

Bhabha, Homi, xxvi, 120

Billboard (magazine), 25, 57, 62

Billops, Camille, 92, 219

binaristic thinking, xxvii–xxviii, 5, 65, 69, 98, 100–107, 123, 228–29; and hierarchy, xxix–xxx, 5, 58, 65, 98, 140–41, 233; vs. hybridity, 124; as barrier to questioning subject, 102; hidden third term of, 139–40; critique of, 103–5; LOG's work as argument against, 139–40, 229–33; art may yet pierce, 117,

203–4, 207–9; embrace of, central to both/and, xxviii

black performance art: segregation of, xxii–xxiii, 48; Afro-American Pop Culture performance series, 48

black surrealism, 136–37. *See also* "Get Ready for the Marvelous"; "Sketchy Thoughts on My Attraction to the Surrealists"

black woman therapist: difficulty of finding, 69–71; dream of, 74–75

black women: invisibility of, 88–89, 91, 95–96, 237; defined by whiteness, 95–97, 117; black female body, 101; and clothing (on or off), 89, 117, 236–37, 244–45; self-images of, need to be lured from the depths to the surface of the mirror, 109; as first postmoderns, 111; as questioning subjects, 124; and performance, 227–28; and slavery, 299n13; and feminism, 298n7; and Women's Action Coalition (WAC), 86–87. *See also* black female subjectivity; "The Cave"; "Dada Meets Mama"; "*Mlle Bourgeoise Noire* and Feminism"; nude/nudes; "Olympia's Maid"; women

black women film directors, xxv, 88–93; ignored in *New York Times* article on black directors, 89; ignored in *Time* article on women directors, 90; paucity of, 88; Reel Black Women, 90. *See also* black film directors; "Email Q&A with *Artforum* Editor"; film; "*Mlle Bourgeoise Noire* and Feminism"; "Olympia's Maid"; *Rivers, First Draft*; *names of individual directors*

black women writers, 91, 97, 99, 128

Blum, Judy, *Small Songs*, 189

body/bodies: mind/body binarism, xxvii, 100–107, 233; black female body in the West, 94–96, 101; always already colonized, 97; as site of black female subjectivity, 98–99, 244; problematics of black body, 100; and subjectivity, 101; black body exceeds culturally constructed identity, 102–3; and clothing (on or off), 89, 117, 236–37, 244–45; and aging, 99, 227; in Kentridge, 134; and performance, 146; and rhythm (musical), 270–71; trans bodies, 148; unexplored work on, 148. *See also* binaristic thinking; nude/nudes; "Olympia's Maid"

Body Is the Ground of My Experience (photomontage series), xxx–xxxi, 11; image descriptions, and collapsed diptychs, 27–29. *See also* "Black Dreams"; "Interview with Laura Cottingham"; "Introducing: Lorraine O'Grady and Juliana Huxtable"; "Olympia's Maid"; "On Being the Presence That Signals an Absence"; "Two Exhibits"

Boone, Sylvia A., *Radiance from the Waters* (book), 95

Boston: birth of LOG in, 3, 70; family's emigration to, 29, 31, 55, 119–20, 208–9, 241; black Brahmins of, 72, 120, 209; teenage years, 24, 51, 78; Girls Latin School, 79, 120, 252, 265–66; LOG's return to, 83, 227

Boston Public Library, Copley Square: "babysitter" and "pre-Kindergarten" for LOG, 144

both/and: and diptych, xxx–xxxi, 4–5, 65, 140–41, 245; and collapsed diptychs, 27–28; in LOG's practice, xxxiii; as cultural goal, xxx, 140–41; and double consciousness, 233; and African American subjectivity, 106; alien to West, 103; means dealing with absence of resolution, 140–41; and *The Clearing* (diptych), 28, 116, 229–33, 283p12–13; vs. white supremacy, xxviii. *See also* binaristic thinking; biographical statements: Biographical Statement (2019); diptych; either/or; hybridity; "On Creating a Counterconfessional Poetry"; "Two Exhibits"; West

Brecht, Bertolt, 106, 143

Brentje, Burchard, *African Rock Art*, 173

Breton, André, 45, 136; inspiration for *Cutting Out the New York Times*, 6–7

Brockington, Horace, 11

Brooklyn Museum, xiii–xiv, 143

Brooklyn Rail, "Interview with Jarrett Earnest," 239–49

Bruno Bischofberger (gallery), 185

Bryant, Linda. *See* Goode Bryant, Linda

Bucknell University, 173

Budge, E. A. Wallis, 122

Burton, Johanna, 206

Butler, Connie, xxi, 110, 239, 255, 289n17

Butler, Octavia, 162–63

Cairo, Egypt, 51, 122, 149

Camnitzer, Luis, 170–71

Cannon, Steve, 216

Cantor, Ellen, 115, 117–18

Carby, Hazel, 96

Carnival, 25, 61, 133, 211

Carpenter Center (Harvard), 240, 242

Catalyses (Piper), 46

Catullus (poet), 231, 247

"The Cave: Lorraine O'Grady on Black Women Film Directors" (article), xxv, 88–93. *See also* black film directors; black women film directors; "Email Q&A with *Artforum* Editor"; film; "*Mlle Bourgeoise Noire* and Feminism"; "Olympia's Maid"; *Rivers, First Draft*

CBS News, 264

Césaire, Aimé, 136–37

Chicago, xxii, 24, 56, 264–67, 269, 273

Chicago, Judy: *Dinner Party* (installation), 89, 96; and Womanhouse, 308n1

Chong, Ping, 43, 46

Citibank, 266–67

class: black Brahmin Boston, 72, 120, 209; bourgeois black life, and white world, 81; middle-class black culture, 77–78, 111, 220; intersectionality, 38, 110–11, 244; black feminism as middle-class construction, 111; white bourgeois feminism, xxv, 84–87, 110–11, 205, 236–37, 244; and Women's Action Coalition (WAC), 84–87

The Clearing: or, Cortés and La Malinche, Thomas Jefferson and Sally Hemings, N. and Me (diptych), xxx, 27–28, 115–18, 229–30, 236–37, 283p12–13; and both/and, 28, 116, 230; and nudes, 100, 116–17, 230; LOG's most controversial images, 229; response to, 115–16, 233; and sex, 115, 229–30, 233; title change, 230; at Harvard's Bunting Institute, 230. *See also Body Is the Ground of My Experience*

Coates, Ta-Nehisi, 153

cocktail waitress, 265

Coker, Gilbert, 11, 48

collage, as predominant aesthetic of LOG's artwork, 41. *See also Cutting Out CONYT; Cutting Out the New York Times*

College Art Association, xxiv, xxxii, 94, 101, 116–17, 237

Colo, Papo, 212

colonialism: and modernism, 31; and the Other, 99; religion as tool of, 133; master narratives, 206; and immigration experience, 235; in Basquiat's art, 170; postcolonial thought, 120–21

The Color Purple (Walker), 91, 170

Coming to Power: 25 Years of Sexually X-plicit Art by Women (unpublished catalogue), 115, 117–18. *See also* "On Being the Presence That Signals an Absence"

contemporary art, 80, 101, 107, 121, 162, 201; and photography, 228; Harvard symposium on stereotypes in contemporary art, 181–83

contradiction, 40, 244–45

Cornelius, Don, 57

Cortor, Eldzier, 97, 117

Cottingham, Laura, interview for Hatch-Billops *Artist and Influence*, 219–37

counter-confessional poetry, 7, 64, 66

courtly love, 26, 118, 230

critics/criticism: and art, inseparability of, xxiv–xxv; critique of binarism, 103–5; institutional critique,

geoise Noire Project"; "My 1980s"; "Performance Statement #1"; political/politics; "*Rivers* and Just Above Midtown"; segregation

employment, "Job History (from a Feminist 'Retrospective')" (interview), 260–68. *See also* government job; rock criticism; teaching at School of Visual Arts; translation business

Encyclopaedia Britannica, 266–67

entertainment: art as market sport, 169–70; vs. performance, 51; vs. fine art, 58; parades as, 62

Enwezor, Okwui, 3

Erving, Julius, 7

Europe: moves to, xxii, 264; Denmark, 221, 265; Norway, 221; elegance of, 75; sex as against civilization, 102, 105; and false rationality of West, 137; LOG and modernism, 54. *See also* "My 1980s"; "Olympia's Maid"; "Sketchy Thoughts on My Attraction to the Surrealists"

Exit Art (cultural center), 199, 212

The Faces of Mlle Bourgeoise Noire (diptych), 281p1–2

family: and "Black Dreams," 75; anti-family rituals, 77–78; parents from Jamaica, 119–20; became black when they emigrated to U.S., 222; immigrant experience, 219–20, 222, 235, 241; difficulty imagining becoming an artist, 220; interview about LOG's job history, 260; and *Nefertiti/Devonia Evangeline*, 224. *See also* Devonia; Lena

fascism, 46, 70, 288n9

Faulkner, William, 190, 257

Fekner, John, 185, 200–201; *Toxic Junkie*, 186, 255

female body, in West, 94–96, 101. *See also* "Olympia's Maid"

feminism: white bourgeois, xxv, 84–87, 110–11, 205, 236–37, 244; second wave, 85, 111; and women defined by white-

ness, 96–97; sexual liberation, 206; white feminist film criticism, 104–5; and black women, 298n7; and clothing (on or off), 89, 117, 236–37, 244–45; black, 96, 110–11; intersectionality, 38, 110, 244; and critique of binarism, 103; on postmodernism's dissolving subject position, xxvii; and performance, 244; feminist agit-prop performance, 45; and Women's Action Coalition (WAC), 84–87; "Job History (from a Feminist 'Retrospective')" (interview), 260–68; struggle continues, 268; "*Mlle Bourgeoise Noire* and Feminism" (statement), 110–11; and *Nefertiti/Devonia Evangeline*, 82. *See also* "The Cave"; "Olympia's Maid"

film: black film directors, xxv, 89; black women film directors, xxv, 88–93; industry run by white men for white boys, 90; white feminist film criticism, 104–5; black actors, cultural fear of, 159–60; *New York Times* on black film directors, 89; Reel Black Women, 90; music video, 163; Surrealist film, 137; animation film by Kentridge, 133–34. *See also names of individual films and filmmakers*

film criticism, 104–5

fir-palm, 11–12

The Fir-Palm (collapsed diptych), 11, 28, 283p15. See also *Body Is the Ground of My Experience*

The First and the Last of the Modernists (photo installation), xxviii, 30, 53, 56, 247–48, 286p38–39; Baudelaire and Michael Jackson and, 56–58, 247–48

"First There Is a Mountain, Then There Is No Mountain, Then . . . ?" (feature article), 269–77. *See also* Allman Brothers Band; music; "My 1980s"; O'Connor, Flannery; "On Creating a Counter-confessional Poetry"; "Performance Statement #3"; "Some Thoughts on Diaspora and Hybridity"

images from adversely affecting reception, 255; recuperated with positioning in *Wack!*, xxxiv. See also *The Black and White Show*; "Interview with Amanda Hunt on *Art Is...*"; "Interview with Laura Cottingham"; "Interview with Linda Montano"; *Mlle Bourgeoise Noire 1955*; "*Mlle Bourgeoise Noire* and Feminism"; "The *Mlle Bourgeoise Noire* Project"; "My 1980s"; "Statement for Moira Roth re: *Art Is...*"

Mlle Bourgeoise Noire 1955 (performance chronicle), 8–10

"*Mlle Bourgeoise Noire* and Feminism" (statement), 110–11. See also "Dada Meets Mama"; "Job History"; "My 1980s"; "Olympia's Maid"

"The *Mlle Bourgeoise Noire* Project" (article), 250–59; agency to create persona, 251, 253; belated realization of, 83; as critique of art world segregation, 184, 250, 252–53; projects included, 210; and *Art Is...* (performance), 250–52, 258–59; and *The Black and White Show* (exhibition), 255–58; and *Mlle Bourgeoise Noire* (performance), 252–55. See also "Email Q&A with *Artforum* Editor"; "A Day at the Races"; "My 1980s"; "Performance Statement #1"; "Performance Statement #3"

modernism: and colonialism, 31; and art, 54; and black female subjectivity, 107; and Jeanne Duval, 54–56; Baudelaire and Michael Jackson and, 56–58; vs. postmodernism, 205; end of, 206; leaving open the question of modernism's demise, 107

Molesworth, Helen, 203, 205

Moments of Perception (diptych), 284p23–24

Montano, Linda: interview, 77–83; *Performance Artists Talking in the Eighties: Sex, Food, Money/Fame, Ritual/Death*, 77

Morris, Calvin, 265

Morrison, Toni, xxiv, 89, 99; and O'Connor, Flannery, 129; on art, beauty, and politics, 155; *Beloved*, 96

Mousse (art magazine), 53

mulatto, xxix, 47, 75, 81. See also miscegenation; race

multiculturalism, 170, 177–78, 180, 182; and postblack moment, 204; of 1993 Whitney Biennial, 174, 201, 305n1

multiplicity: of centers, in subjectivity 107; being never arrives, we are always only becoming (Hall), 108

Murasaki Shikibu, *Tale of Genji*, 308–9n1

Museum of Contemporary Art (Chicago), 203

Museum of Contemporary Art (Los Angeles), 110, 142

Museum of Contemporary Hispanic Art (MOCHA), 199, 201

music: in *Rivers, First Draft*, 11, 21; in "Black Dreams," 73; Allman Brothers Band, feature article on, 269–77; The Wailers and Bruce Springsteen at Max's Kansas City, review of, 278–80; and race, 270–76; white radio, 270; rap music/videos, 91, 95, 117–18; Michael Jackson, 57–58; TLC (band), 163; Hype Williams, 163; DJ mixing, 164; jazz, 191–92. See also rock criticism; *names of individual artists*

"My 1980s" (article), critical view of career and work to date, 203–12; postblack moment, 203–4, 207–9; need by others to translate mainstream cultural expression, 206–7; you have to tell your own stories, 207. See also biographical statements; "On Creating a Counter-confessional Poetry"; "Performance Statement #1"; "Performance Statement #2"; "Performance Statement #3"; *Rivers, First Draft*; "Some Thoughts on Diaspora and Hybridity"

mythology: making myths, 144–45; mathematics of myth, 89, 93

222; education of, 79; art epiphany of, at Antin's presentation of "Eleanora Antinova, black ballerina," 208; becoming an artist, 46, 219–20, 223, 267–68; out as an artist, 24, 128, 223, 251; as artist who writes, xix–xxi, xxiv, 143; influences on, 45–47, 143; Duchamp years of, 24–25; from post-black to black, 203–4, 207–10; both/and approach of, xxxiii; as equal-opportunity critic, xxxiii; unified approach to artwork of, 247; "Portfolio: Art, Affinities, and Interests," 281–86, color insert; archive at Wellesley, 5, 240; LOG's website as abbreviated archive, 5; audience of, 48, 237; picture of, from *Art Is . . .* , 251. *See also* Boston; education; family; government job; rock criticism; teaching at School of Visual Arts; translation business; writing; *names of individual artworks*

Olympia (Manet), xxvi, 89, 282*p10*; Laure, model for Olympia's maid, 95–96

"Olympia's Maid: Reclaiming Black Female Subjectivity" (essay), xxiii–xxiv, 94–109, 236–37, 244–45; as critique of Western thought, xxviii; on black female subjectivity, xxvi, 98–99, 148; women defined by whiteness, 95–97; invisibility of black women, 95–97, 237; winning back the questioning subject, 101–2, 109. *See also* binaristic thinking; biographical statements: Biographical Statement (2019); *"Black Dreams"*; black female subjectivity; black women; body/bodies; *Body Is the Ground of My Experience*; "The Cave"; nude/nudes; "On Creating a Counter-confessional Poetry"; *Rivers, First Draft*; "Some Thoughts on Diaspora and Hybridity"; "SWM"

"On Being the Presence That Signals an Absence" (essay), 115–18; *The Clearing*, 283*p12–13*; black artists and nudes, 116–18. *See also* "Black Dreams"; *Body*

Is the Ground of My Experience; "Olympia's Maid"; "Two Exhibits"
"On Creating a Counter-confessional Poetry" (article), 64–66. *See also* biographical statements: Biographical Statement (2019); *Cutting Out CONYT*; *Cutting Out the New York Times*; Murasaki Shikibu, *Tale of Genji*; "My 1980s"; "Some Thoughts on Diaspora and Hybridity"; "Two Exhibits"
O'Neal, Shaquille, 169
O'Neill-Butler, Lauren, 64; "On Creating a Counter-confessional Poetry" (article), 64–66
Orientalism (Said), 153
others/otherness, 54; African female at outermost reaches of, 95; and psychoanalysis, 104–5; and literature, 236; as audience, 129; in Kentridge, 134; miscegenation as exploitation of, 230; and self, 99, 209; everyone as each other's other, 212
Outlaw Aesthetics (exhibit), 208–9

paintings: legions of black servants in shadows of, 95–96; of miscegenation, 233
Palcy, Euzhan, 91; *A Dry White Season*, 89; *Sugar Cane*, 89
Paris Triennial, 3
Payne, Sandra, 99
performance: as writing in space, 43–45, 143; as shifting dimensions, 44; as uncovering possibilities, 45; and Futurism, Dada, and Surrealism, 45; encounter with *Six Years: The Dematerialization of the Art Object* (Lippard), 45–46, 80; teaching literature before entry into, 30; beginning of, for LOG, 50–51; freedom of, 50–51, 154; spatial narrative, 51–52; novel-in-space, 60; ambiguity of, 163–64; and diptych, 120; politics and aesthetic form as motives, 37–38; vs. entertainment, 51; problem with name of, 43; cost of, 227–28; and limited audience,

performance (*continued*)

38, 146; lack of critical response, 226; segregation of, xxiii, 48; and black women, 227–28; and feminism, 244; and body, 146; and aging, 99, 227, 246; and beauty, 246; and end of, for LOG, 8, 11–12, 227–28, 246; translation from, to photo installation, 60–62; French soldiers marching to deaths baaing like sheep in World War I, still best, 207; Just Above Midtown, continues to be formative, 226. See also *Art Is . . .* ; black performance art; "Interview with Laura Cottingham"; "Interview with Linda Montano"; *Mlle Bourgeoise Noire*; "*Rivers* and Just Above Midtown"; *names of individual artists and performances*

Performance Artists Talking in the Eighties: Sex, Food, Money/Fame, Ritual/Death (Montano), 77

"Performance Statement #1: Thoughts about Myself, When Seen as a Political Performance Artist," 37–38. See also *The Black and White Show*; "Dada Meets Mama"; "A Day at the Races"; "Email Q&A with *Artforum* Editor"; "Flannery and Other Regions"; "Introducing: Lorraine O'Grady and Juliana Huxtable"; "The *Mlle Bourgeoise Noire* Project"; "Responding Politically to William Kentridge"

"Performance Statement #2: Why Judson Memorial? or, Thoughts about the Spiritual Attitudes of My Work," 40–42. *See also* "Interview with Linda Montano"; "*Rivers* and Just Above Midtown"; "Sketchy Thoughts on My Attraction to the Surrealists"

"Performance Statement #3: Thinking Out Loud: About Performance Art and My Place in It," xxii–xxiii, 43–48. *See also* "First There Is a Mountain"; "*Mlle Bourgeoise Noire* and Feminism"; "The *Mlle Bourgeoise Noire* Project";

"My 1980s"; *Nefertiti/Devonia Evangeline*; "On Creating a Counterconfessional Poetry"; *Rivers, First Draft*

Persistent (video installation), xv, 283p11

Persona (exhibition), xxxiv, 8, 224, 254

photography: of Baudelaire, 32; and body, 98; and contemporary art, 228; LOG's first photographic work, 228; and myth making, 144–45; pornography, 98, 194, 258; for *Art Is . . .* , 62; in *Mlle Bourgeoise Noire*, 228; in *Nefertiti/Devonia Evangeline*, 228. See also *The First and the Last of the Modernists*; *Flowers of Evil and Good*; *Miscegenated Family Album*

Picasso, Pablo, 30, 171; *Les Demoiselles d'Avignon*, 31–32, 58, 89

Piper, Adrian, xxiii, 43, 45–47, 89, 111, 158–59, 177, 212, 227, 253; *Catalyses*, 46; *Food for the Spirit*, 98, 244; in *The Black and White Show*, 187, 200–201; *Funk Lessons*, 187, 255; retrospective at Alternative Museum, 199

Playboy (magazine), 265–67

Poetic Justice (Singleton), 90

poetry: Catullus, 231, 247; newspaper poems, 141, 207–8; counterconfessional poetry, 7, 64, 66; Damas, 10, 81, 290n3; and *Flowers of Evil and Good*, 30–31; *Flowers of Evil* (Baudelaire) as source of transformation, 31. See also *Cutting Out CONYT*; *Cutting Out the New York Times*; literature; *Mlle Bourgeoise Noire*; teaching at School of Visual Arts

"Poison Ivy" (letter to editor), 181–83. *See also* "A Day at the Races"; "Email Q&A with *Artforum* Editor"; "My 1980s"

police, 74, 196, 222, 258

political/politics: and art, 37–38, 41–42, 155–56; and performance, 38; personal and political balance, 41–42; and subjectivity, 106; and art market, 171; and beauty, 155; and *Nefertiti/Devonia*

white bourgeois feminism, xxv, 84–87, 110–11, 205, 236–37, 244

white fear: of black actors, 134–35; and sex, 229

white feminist film criticism, 104–5

white male/black female, 229–33: vs. black male/white female, 229–30; John Waters calls black-and-white sex "the last taboo," 229; and rejection of *The Clearing* at Harvard, 230–32; *The Clearing* argues against the West's dualism, 130, 133; problem of showing act and results of miscegenation simultaneously, 232–33. *See* both/and; diptych; either/or; West

white masculinity, xv, xxvii; and postmodern theory, 94; Sean Landers, single white male, 176–80. *See also* male gaze; nude/nudes

whiteness: in Kentridge, 134–35; in Landers, 179; women defined by, 95–97

white radio, 270

white supremacy, xxiii; vs. both/and, xxviii, 5; vs. hybridity/miscegenation, xxix

white world, 81–82, 172–73

Whitfield, Tony, 43

Whitley, Zoe, 250

Whitney Biennial, 30, 36, 53, 184–85, 199, 201, 226; 1993 as "multicultural biennial," 174, 201, 305n1

Whitney Museum of American Art, 5, 177, 199, 202; *Abject Art* (exhibit), 177; Basquiat retrospective, 169–75

Whitten, Jack, 159, 256; *Omikron I*, 192, 258

Wide Sargasso Sea (Rhys), 99

Williams, Chancellor, *The Destruction of Black Civilization*, 150

Williams, Hype, 163

Williams, Randy, 215; *Between the White Man and the Land*, 190, 200, 257

Williams, William T., 237

Wilson, Fred, 11, 214

Wilson, Judith, xiv, xxvi, 95, 97–98, 174, 182, 215; on images of miscegenation, 233; on paucity of black nudes, 97

Wilson, Martha, 50

Wilson, Robert (experimental theater), 43, 46; *Deafman Glance*, 46

Womanhouse, 244

women: discrimination against, at LOG's government job, 263; defined by whiteness, 94–97; segregated art world, xxiii–xxv, 4, 48; nonwhite women erased in art of even white feminists, 96; but no alternative to cooperation while being sensitive to differences, 97. *See also* black female artists; black female subjectivity; black women; feminism; "Olympia's Maid"

The Women of Brewster Place (Naylor), 91

Women's Action Coalition (WAC), xxv, 84–87, 239; race and class issues, 86–87; white feminists of, 84–87; and women of color, 86–87; and Dada, Surrealism, 85–87; intensity of, 85; as guilty pleasure for LOG, 84, 86. *See also* contradiction; feminism; "*Mlle Bourgeoise Noire* and Feminism"; "Olympia's Maid"

Woodstock Times, 173

World War I: and breakdown of bourgeois certainties, 84; shock of, 65, 207

writing: emphasized in this book, xxi; aids deferred comprehension of artwork, xxiii; layers LOG now perceived required simultaneity of time and space, xix–xx, 43–44; and performance, 44; novel-in-space, 44, 60, 143; spatial narrative, 51–52; and art, 143, 236, 240; and art criticism, xxiv; helping images not yet understood persist until they can be, 156–59. *See also* critics/criticism

writing in space, xix–xxi, 143; performance as, 43–45; spatial narrative, 51–52

Z Magazine, 23, 25

Credits

"*Mlle Bourgeoise Noire 1955*" first appeared in *High Performance #14* 4, no. 2 (Summer 1981).

"*Nefertiti/Devonia Evangeline*, 1980" first appeared in CAA's *Art Journal*, Winter 1997.

"Interview with Cecilia Alemani: Living Symbols of New Epochs" first appeared in *Mousse*, no. 24 (Summer 2010).

"Interview with Amanda Hunt on *Art Is . . .* , 1983" first appeared in *Studio: The Studio Museum in Harlem Magazine*, Summer/Fall 2015.

"On Creating a Counter-confessional Poetry" first appeared as "Interviews: Lorraine O'Grady," by Lauren O'Neill-Butler, © Artforum, November 19, 2018.

"Black Dreams" first appeared in "Racism Is the Issue," special issue, *Heresies*, no. 15 (1982): 42–43.

"Interview with Linda Montano" first appeared in *Performance Artists Talking in the Eighties*, by Linda M. Montano (Berkeley: University of California Press, 2001), © 2001 by the Regents of the University of California.

"Dada Meets Mama: Lorraine O'Grady on WAC" first appeared as "Dada Meets Mama: Lorraine O'Grady on WAC," by Lorraine O'Grady, © Artforum, October 1992.

"The Cave: Lorraine O'Grady on Black Women Film Directors," first appeared as "The Cave: Lorraine O'Grady on Black Women Directors," by Lorraine O'Grady, © Artforum, January 1992.

"Olympia's Maid: Reclaiming Black Female Subjectivity" appeared in *Art, Activism, and Oppositionality: Essays from Afterimage*, ed. Grant Kester (Durham, NC: Duke University Press, 1998).

"*Mlle Bourgeoise Noire* and Feminism" first appeared in *Art Lies* 54 (Summer 2007).

"Flannery and Other Regions" first appeared in *Flannery O'Connor: In Celebration of Genius*, ed. Sarah Gordon (Athens, GA: Hill Street Press, 2000).

"Responding Politically to William Kentridge" first appeared as "Lorraine O'Grady on William Kentridge" in *X-TRA* 5, no. 3 (Spring 2003).

"Introducing: Lorraine O'Grady and Juliana Huxtable" first appeared as "Introducing: Lorraine O'Grady and Juliana Huxtable" on the Museum of Contemporary Art's website.

"A Day at the Races: Lorraine O'Grady on Jean-Michel Basquiat and the Black Art World" first appeared as "A Day at the Races: Lorraine O'Grady on Basquiat and the Black Art World," by Lorraine O'Grady, © Artforum, April 1993.

"SWM: On Sean Landers" first appeared as "Sean Sucks . . . Not: SWM," by Lorraine O'Grady, © Artforum, April 1994.

"Poison Ivy" first appeared as "Letters: Poison Ivy," by Lorraine O'Grady, © Artforum, October 1998.

"*The Black and White Show, 1982*" first appeared as "The Black and White Show: A Portfolio by Lorraine O'Grady," by Lorraine O'Grady, © Artforum, May 2009.

"My 1980s" first appeared in CAA's *Art Journal*, Summer 2012.

"Interview with Laura Cottingham" first appeared in *Artist and Influence*, vol. 15, ed. James V. Hatch, Leo Hamalian, and Judy Blum (New York: Hatch-Billops Collection, 1996).

"Interview with Jarrett Earnest" first appeared in the *Brooklyn Rail*, February 2016.

"First There Is a Mountain, Then There Is No Mountain, Then . . . ?" first appeared in the *Village Voice*, August 2, 1973.

"The Wailers and Bruce Springsteen at Max's Kansas City, July 18, 1973" first appeared in *Max's Kansas City: Art, Glamour, Rock and Roll*, ed. Steven Kasher (New York: Abrams Image, 2010).